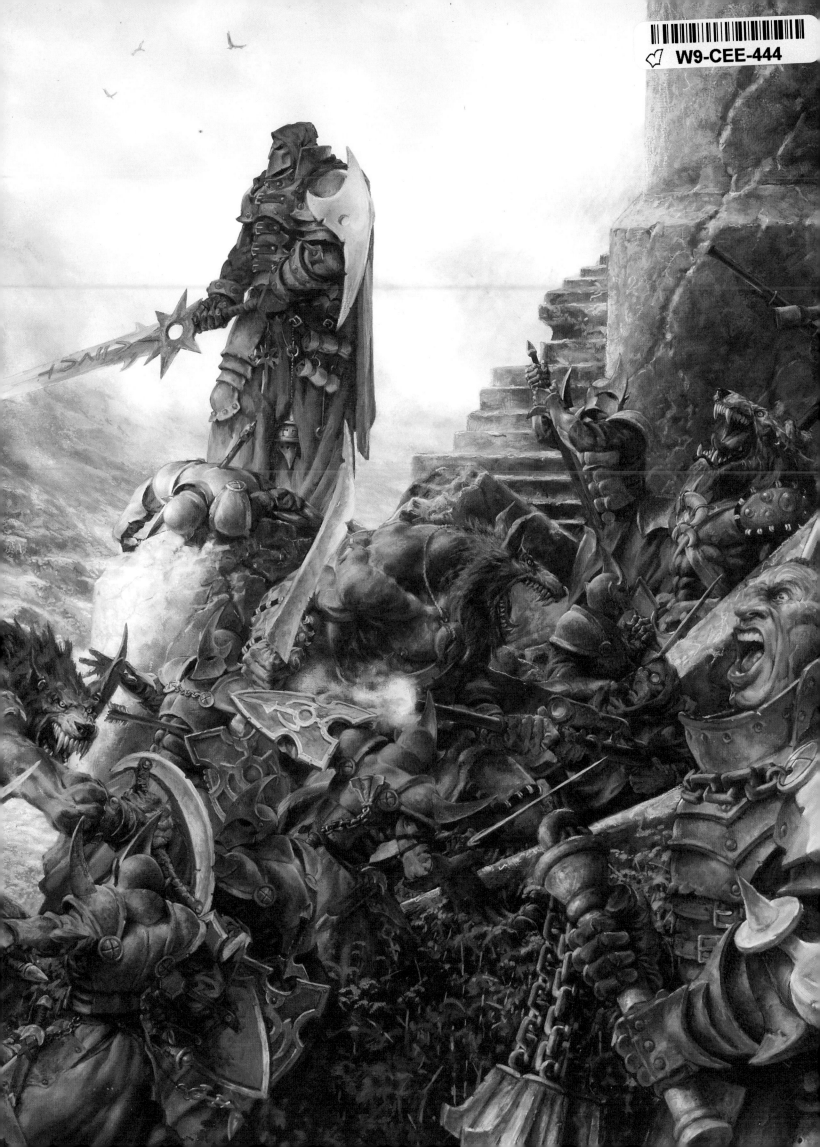

SPECTRUM

15

The Best in Contemporary Fantastic Art

edited by Cathy Fenner & Arnie Fenner

Underwood Books • Nevada City • CA

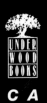

UNDER WOOD BOOKS

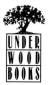

Published by
UNDERWOOD BOOKS
P.O. BOX 1919
NEVADA CITY, CA 95959
www.underwoodbooks.com
TIM UNDERWOOD/*Publisher*

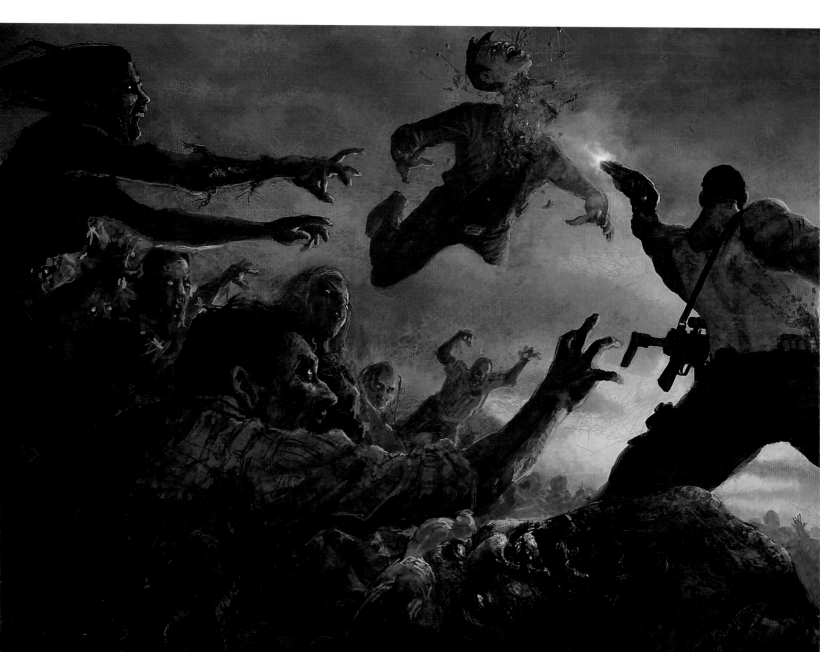

CONTENTS

Chairman's MESSAGE

Photograph by Arnie Fenner

As I write this introduction in early July we are in the final stages of preparing for the San Diego Comic-Con International while finishing *Spectrum 15*. The state of California is ablaze, gas is $4+ a gallon, the presidential race is gearing up for the sprint to the finish line and Brad and Angelina are on the verge of becoming the parents to twin girls and the center of a media circus. Change is in the air. Some good and some bad. In our 15th year of doing the competition and annual we are trying to decide what changes might be beneficial in taking *Spectrum* into the future. We started down the road of modification last year with the revamping of our website and bringing Arlo Burnett on board to serve as administrator. Planning began for the second Spectrum Exhibition at the Museum American Illustration, scheduled to open in September of 2009. We also packaged a *2009 Spectrum Calendar* for Andrews McMeel Publishing (it turned out great!) and divided the advance between the featured artists. Arnie and I have had many conversations about possible projects and I'm very excited about the direction we are headed. We are going to make changes—of the good kind—and rest assured that the competition and book (and other...*stuff*) will be around for a long time to come.

The judging this year was held the weekend of February 22-24 at the Hyatt Regency in Kansas City. Two previously-announced jurors were unable to attend due to scheduling conflicts, but we couldn't have asked for better replacements. The weather was cooperative this year and only one judge, Frank Cho, was slightly delayed (easy for me to say since I wasn't stuck in the airport for 7 hours) when his flight was cancelled. Thanks to his tenacity—he booked a flight on another airline—he made it to KC on time.

Saturday's judging started at 8:30 AM and lasted till 5:00 PM. Because of the increase in entries we worked out of two large rooms after the lunch break: since we could reset one room while the other room was being judged it really helped to move things along. As always each judge voted anonymously, could not vote for their own works, and were ineligible for awards consideration (Arnie and I do not have votes, of course: it's the jury's show). Unlike years past the hotel didn't provide any added diversions like weddings or arriving rock stars: everyone was very focused. The judges did a great job of keeping up with our crew and we were able to cut the support team loose earlier than in the past. The jurors' awards debates were lively and insightful—no blood was shed and no one drank the other's milkshake. That evening we took the judges to Pierpont's for dinner and ghost stories for the now-traditional formal close to the event.

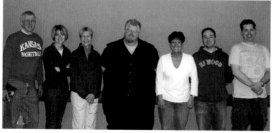

Our heroes, left to right: *Terry Lee, Gillian Titus, Armen Davis, Lazarus Potter, Lucy Moreno, Chris Haefke, and Arlo Burnett.*

The support team assisting Arnie and I this year in tabulating votes, setting and resetting the room, and keeping things moving at a very efficient pace this year were Arlo Burnett, Armen Davis, Chris Haefke, Terry Lee, Lucy Moreno, Lazarus Potter, and Gillian Titus. They are an amazing crew and have our sincere gratitude for willingly giving up their Saturday to help us (and be bossed around).

Of course we also could never do it without all of the artists who choose to take a chance each year and participate. We also must thank the readers who buy the book each year and art directors that use *Spectrum* as a reference. Without *all* of your support none of this would be possible. Thank you all for helping us to keep this project moving forward.

—Cathy Fenner/Show Co-Chairman

DAREN BADER
Artist/Art Director: Rockstar Games

TIM BODENDISTEL
Artist/Art Director: Hallmark Cards

Spectrum 15

KELLY SEDA
Artist/Jury Chairperson

JUSTIN SWEET
Artist

FRANK CHO
Artist

ARNIE FENNER, CATHY FENNER, JUSTIN SWEET, DAREN BADER, FRANK CHO, TIM BODENDISTEL, KELLY SEDA

John Jude Palencar

born 1957, Fairview Park, Ohio

"John is one of our masters in the field. He has a truly unique voice that can be haunting, ethereal, sensual, and disturbing...often all at the same time."

Irene Gallo
ART DIRECTOR: TOR BOOKS

In a field known for flash and excess, for vibrant colors and exuberant and sometimes outlandish compositions, for characters that literally shout, "Hey! Look at this!" at the audience, the art of John Jude Palencar stands out because of its... Quiet.

There is a sedate coolness that invites the eye to linger, an apparent calm which engages the subconscious. The languid beauty, the muted color palette, and the overall sense of melancholy is simultaneously affecting and subversive. John's art has an uncanny way of making the viewer happy while at the same time it ever so slyly breaks their heart (and once in a while it pokes them in the eye just for mischief)—they don't quite understand *why* the art touches them, they only know that it *does*.

In this increasingly digital age John Jude Palencar is something of a rarity among contemporary illustrators, mixing a meticulous technique reminiscent of the old masters with an edgy and darkly surreal imagination. There are touches of Bosch and Da Vinci in his visual allegories of hellscapes and tortured characters while there's more than a hint of Wyeth in his portraits of heroes and heroines (who exhibit a sense of nobility without devolving into stereotypes or losing their humanity).

John attended the Columbus College of Art and Design in Ohio (from which he graduated in 1980 with a BFA) and received a scholarship during his senior year to study in Paris with iconic illustrators Bernie Fuchs, Alan Cober, Mark English, Bob Peak, and Robert Heindel. From there he was propelled into the free-lance world and in the years that followed he has painted hundreds of book covers for everyone from Ursula K. LeGuin, Marion Zimmer Bradley, and P.D. James to Charles de Lint, David Brin, and Stephen King. He has also created memorable works for clients as diverse as *Time, Smithsonian*, and *National Geographic Magazine* while the Philadelphia Opera has employed his talents for their publications and productions. John has worked on entertainment projects for Lucas Arts, Paramount Pictures, and Vivendi Universal and, when time permits, paints commissions for corporate and private collections as well as for galleries on both coasts.

His art has received numerous honors through the years, including Gold and Silver Medals from the Society of Illustrators, two Gold Book Awards from *Spectrum*, and four Chesley Awards from the Association of Science Fiction and Fantasy Artists [ASFA]. In 2007 John was presented the award for "Artistic Achievement" by ASFA at the World Science Fiction Convention held in Yokohama, Japan.

He enjoys an on-going artist-in-residence position as part of a program in County Kerry, Ireland. His personal paintings were included in a special exhibit entitled "Images of Ireland" which was held at the National Museum in Dublin.

Underwood Books published a sumptuous full color collection of his book covers and gallery works in late 2006 titled *Origins: The Art of John Jude Palencar*. He has frustrated some by his refusal to knock out work for the sake of a check and has horrified collectors with his admission that he routinely burns art (including published works) that he doesn't feel meets the standards he's set for himself. "It's very cathartic," he says with a laugh, "you should try it sometime." But all of the accolades, the awards (including this Grand Master recognition), and a retrospective book might seem to be an indication that John has reached his peak and has nothing left to prove, nothing new to say. Anyone who believes that is only fooling themselves and certainly doesn't know what makes John Jude Palencar tick.

It's not his past that interests him: he's not into nostalgia. It's the unknown that sparks his enthusiasm. It's the *next* challenge, the *next* work, the *next* assignment or idea or opportunity that motivates him, that excites and pushes him forward.

In an intensely *quiet* way, of course.

GRAND MASTER HONOREES

FRANK FRAZETTA DON IVAN PUNCHATZ LEO & DIANE DILLON JAMES E. BAMA JOHN BERKEY ALAN LEE JEAN GIRAUD KINUKO Y. CRAFT
MICHAEL WILLIAM KALUTA MICHAEL WHELAN H.R. GIGER JEFFREY JONES SYD MEAD JOHN JUDE PALENCAR

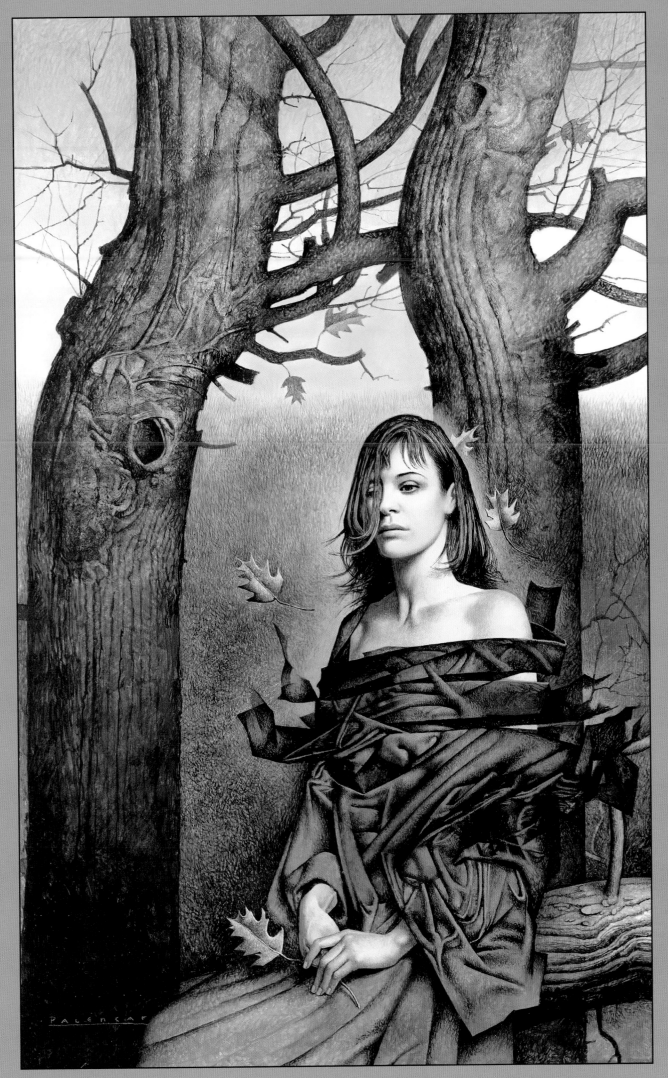

"We're not too old for this shit, but we're too old to kill ourselves for this shit."

Heidi MacDonald putting things into proper perspective on her popular news blog, The Beat

"Was there an open competition to supply the designs? If so, what on earth do the *rejected* ones look like?"

Olympics spokesman Bob Neill after seeing the logo for the 2012 London Games, which he described as "hideous" and "a waste of money"

"*I* should do a *freebie* for *Warner Brothers?* What, is Warner Brothers out with an eye patch and tin cup [begging] on the street? *Fuck no! ...* I don't take a piss without getting paid."

Harlan Ellison® in the documentary Dreams With Sharp Teeth *talking about the attempts by corporations to get something for nothing*

THE YEAR IN REVIEW
by Arnie Fenner

When looking back at 2007, I think what strikes me most is that it seemed to be a year of waiting. Not necessarily happily (though that was certainly true in some cases) and not exactly with dread at what might be ahead, either. We were collectively kicking our heels waiting to see what happened with the ongoing occupation of Iraq, waiting to see what happened with the sputtering economy, waiting to see what happened in the political arena, waiting to see what happened in Russia and Pakistan and France and Iran and China and England. Waiting to see if oil prices were going to abate (fat chance, thanks to demand and greed) or continue to shoot up (bingo!). Waiting to see what happened to Harry Potter and Tony Soprano...

Just...*waiting.* Waiting for it all to sink in. Waiting for change or waiting for things to settle down. Waiting for questions to be asked or answers to be given. Waiting for the other shoe to drop, for the check that's "in the mail," for the door to open or for it to slam shut, just as long as something, *any-thing*, was resolved. 2007 seemed to resemble an episode of the TV series *Lost*: there was a lot of inconclusive running in place.

Almost five years after the invasion of Iraq a controversial surge of fresh troops—in an attempt to quell insurgent attacks and grow-ing sectarian violence—was widely condemned by politicians and pundits, but eventually seemed to yield some successful results. How long-term any gains might be remained to be seen by year's end. Conflicts with an obstinate Taliban in Afghanistan increased (compounded by their use of bases across the border in Pakistan—which had its own troubles to deal with); the Palestinians engaged in something of a civil war as Hamas and Fatah battled it out for

Above: *Cirque du Soleil helped James Gurney open his "Return to Dinotopia" show at Wisconsin's Oshkosh Public Museum.* **Opposite:** *Michael Whelan's painting, "The Big Question" (48"x60", acrylics on canvas), was part of a show at the Tree's Place Gallery in Massachusetts.*

control of the Gaza Strip; the crisis in Darfur persisted, there were a pair of botched (thankfully) terrorist bombings in the U.K.—one in London, the other at the Glasgow Airport—perpetrated by a batch of Muslim doctors (whatever happened to the Hippocratic Oath?), while Burma's/Myanmar's military junta brutally sup-pressed protests led by Buddhist monks.

Gordon Brown replaced Tony Blair as Britain's Prime Minister; Nicolas Sarkozy became President of France; Hillary Clinton, Barack Obama, John Edwards, Rudy Giuliani, Mitt Romney, and John McCain (and a host of others!) all lined up for a run at the White House; and Russia's Vladimir Putin and Pakistan's Pervez Musharraf winked and said publically that they were all for Democracy (as long as it was clear that *they* weren't going *anywhere* anytime soon).

Growing concerns regarding the ecology, global warming, diminishing energy resources, and bio-engineered food had more and more people thinking "green" and "organic" and trying to limit their "carbon footprint." Which was all laudable...but (there's always a "but") every reaction and every solution leaves their own impact on the environment, the economy, and the quality of life for people the world over. As in Ray Bradbury's classic story "A Sound of Thunder," even the smallest things can have long-term effects (and unforeseen repercussions). Surfing the web for news or social interaction or shopping may seem "green," but a burgeoning net-work of server farms (making browsing possible in the first place) drinks up energy like Amy Winehouse on a Saturday night bender. Suspicion, if not outright rejection, of genetically altered crops and livestock may be justified (though it's perhaps too early to know

whether such feelings are right or wrong), but also almost assuredly guaranteed that impoverished, malnourished regions would remain...impoverished and malnourished. Drilling for oil or mining for coal impacts the environment, *not* drilling or mining makes what's available more expensive and more finite. Nuclear power creates problems, wind turbines so far provide relatively tiny amounts of electricity (and blemish the landscape), ethanol takes more energy and resources to produce than it gives back in affordable power and, shoot, even those super-efficient fluorescent lightbulbs are a

increased the price of *everything* and started to make finances extremely tough for everybody. The "bad" sometimes tends to occupy our minds more than the "good." And I mention some of the negative events of the previous year, not because I want to bum anyone out, but simply because the effects of some of them will be felt in the months ahead (hopefully some in a positive way, if we're lucky—adversity can be the mother of invention). But that doesn't mean there wasn't plenty of the "good" in 2007 to give us respite from the "crummy."

A new species of dinosaur was discov-

Spielberg informed authorities that a Rockwell in his collection ("Russian Schoolroom") appeared to be hot. The art had been taken during a late-night burglary at a gallery in Clayton, MO, on June 25, 1973; the Oscar-winning filmmaker had bought the painting in 1989 from a legitimate dealer and didn't know it was stolen. Where it's going to wind up (assuming an insurance company had paid for the loss decades ago) is still up in the air.

Last November scientists in Japan and Wisconsin announced that they had discovered a way to "reprogram" human

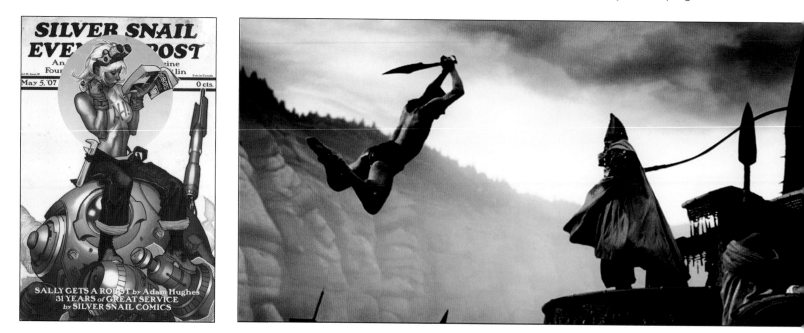

bio-hazard when improperly disposed of. As Kermit the Frog sang, it's not easy being green (or cheap). No kidding.

The nation was horrified by the mass murder perpetrated by an emotionally stunted psychopath at Virginia Tech, shocked at the massive bridge collapse in Minneapolis, and humbled by the F5 tornado that obliterated Greensburg, Kansas. Wounded veterans suffered under disgraceful conditions at the Walter Reed Medical Center in Washington D.C., tainted goods (toys, food, medicine, you name it) from China were recalled en mass, the sub-prime lending debacle was the pin that popped the housing bubble and created problems both domestically and abroad, and a two-week strike by stagehands darkened Broadway in NYC while the 14-week Writer's Guild strike brought Hollywood to a standstill (and cost the Los Angeles economy over a billion bucks). Fires in California, floods in England, war, crime, recession, and jealous astronaut Lisa Nowak's attempted kidnapping of a romantic rival (while wearing a super diaper), and let's not forget those astronomical gas prices that

ered in the Erlian Basin of Inner Mongolia: feathered and about the size of a T-Rex, it was named *Gigantoraptor erlianensis*. Do Jim Gurney, John Gurche, and Bob Eggleton have their paintbrushes poised? The International Space Station continued to be a busy place, hosting a space tourist (Microsoft tycoon Charles Simonyi) and the first woman to serve as commander of the outpost, NASA's Peggy Whitson, while the twin Rovers (Spirit and Opportunity) continued to putt along and explore Mars five years after landing.

Efforts began in France to save the Lascaux cave paintings (the oldest known pictorial narrative) from a fungal infection while Edvard Munch's "The Scream" underwent restoration for damage it sustained when it was stolen in 2004 (the art was recovered by Norwegian police in late 2006). Sotheby's sold a Rothko painting for a record-setting $73M and a Francis Bacon for an equally impressive $53M. Christie's sold a Norman Rockwell Santa cover for *The Saturday Evening Post* for $2.17M (I'd say that's a record for a piece of "fantasy art," wouldn't you?) while representatives of director Steven

skin cells to behave like embryonic stem cells—without having to destroy any embryos in the process (which might finally put the kibosh on opposition from detractors of embryonic stem cell research—or might not, given that many of the arguments were based on religious beliefs that "man should not meddle...").

Eight of the top ten films at the box office were fantasy-themed, with *Spider-Man 3* perched at the top of the list (despite generally being considered a disappointment by critics and fans). Zack Snyder's adaptation of Frank Miller's and Lynn Varley's graphic novel *300* was a surprise mega-hit (Steve Reeves lives!) while the lovely translation of Neil Gaiman's and Charles Vess' *Stardust* was an inexplicable financial failure. And then there were the "manias": Potter-mania (*Harry Potter and the Deathly Hallows* sold a record 8.3 million copies in its first 24 hours in the U.S while the *Harry Potter and the Order of the Phoenix* movie was #5 at the box office), Wii-mania (stand in line, folks, no pushing), IPhone-mania (200,000 units sold on day one), and *Halo3*-mania ($300M in sales in the first week) all had

people happily plunking down their cash.

The Institute of Contemporary Art of Boston opened a stunning facility in the city's Seaport District overlooking the harbor: the new building coincided with the museum's launch of its first permanent collection. Closer to home (ours that is), the controversial addition of the Bloch building to Kansas City's venerable Nelson Atkins Museum opened to glowing reviews. Created to house their photography and modern art collections, the construction followed the slope of the hill the Nelson perches on prompting *Time* magazine to enthuse, "There's nothing quite

TV screen during a program to promote something coming in an hour or a day or a week; commercials are classified as "entertainment" for theater patrons before a movie (and the coming attractions—*more* commercials!) starts, and product placement in films and television programs got even more blatant (if that were possible). Facebook, UTube, Flickr, and MySpace were less about being venues for social networking and more about pushing goods and services while the newer interactive phones became just another way to receive unwanted junk.

These are semi-hard times for tradi-

some cases, used robots to destroy the devices. The suspicious objects were revealed to be ads for a film based on the Cartoon Network's animated television series, *Aqua Teen Hunger Force*—which didn't prevent several of the employees installing the things from being arrested for creating a public nuisance. The network's parent company, Turner Broadcasting, agreed to pay $2 million to the state of Massachusetts to make amends and the company's executive vice president, Jim Samples, resigned. So much for cheap advertising!

Robert Rodriguez and Quentin

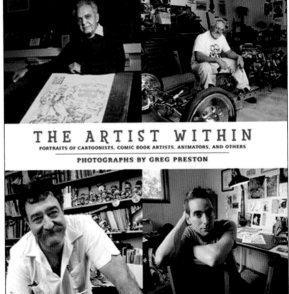

Far left: *Adam Hughes created this poster for the Canadian bookshop, Silver Snail.* **Near left:** *A scene from the film* 300. *"They got the name* 300 *by measuring how gay it was on a scale from 1 to 10," joked Sarah Silverman.* **Above left to right:** *Jim Gurney journeyed to* Chandara, *Mike Mignola went to* Baltimore, *and a bunch of artists stayed home for Greg Preston to snap their pictures for* The Artist Within *book.*

like it anywhere in the U.S." And literally in our back yard the Nerman Museum of Contemporary Art in Overland Park, KS, was completed (in a style that echoed Boston's new museum, sans the ocean view, naturally) and boasted a very nice collection of figure paintings and amazing sculptures.

What will 2008 bring? Ah, that's the big question. Higher prices—for gas, food, entertainment, goods—are a given. A new batch of politicians will take office. There will be new problems and new solutions, more good news and more bad. More new books, films, art, games. and comics; more people and events and stuff in general to make us excited and happy and hopeful and just as many to make us angry and sad and discouraged. What and who and when and where? Well, for the answers we simply have to...wait.

A D V E R T I S I N G

We're living in the age of hustle and promotion, of spin, hype, and product placement (as if you didn't already know). Characters walk across the bottom of the

tional television and print advertising (though don't cry for them, they're still raking in dough). Between commercial-skipping services like TiVo and a devotion to the Web (which is itself awash in ads), television, newspapers, and magazines are increasingly losing their position as the prime advertising mediums. Consumers have grown desensitized to the constant bombardment of logos and ads emblazoned on everything from clothing to take-out coffee cups to movie-ticket stubs to eggs (yeah, ads have even appeared on eggshells). "Guerrilla" advertising seemed to be growing in popularity, though the pay-off remained nebulous. Guerrilla campaigns had the perceived advantage that they could generate media coverage (free advertising—whoopee!) and word-of-mouth, but as I mentioned in last year's essay, sometimes those efforts could come back to bite the perpetrators in the butt. On January 3, several magnetic light displays in and around Boston were mistaken for explosive devices. A massive panic caused several subway stations, bridges, and a portion of Interstate 93 to close as police examined, removed, and in

Tarantino failed to learn the lesson of the previous year's *Snakes On a Plane* with their *Grindhouse* "double bill" (*Planet Terror* and *Death Proof*)—that lesson being that geek buzz can only take a film so far. Despite an effectively retro-'70s-tacky ad campaign, generally positive reviews, and massive promotions on the web and at fan-friendly conventions the conceit didn't attract large audiences. The movie flopped in its original incarnation and again when the attempt was made to re-release each film separately. Both directors talked of a sequel, but the possibility seemed overly optimistic at best.

As always, credits for advertising are hard to come by, but I spotted some effective art for various print campaigns by Ana Juan (for United Airlines), Jody Hewgill (for Arena Stage), Scott McKowen (for the Denver Center Theater), Thuy Phan-willmOtt (for Mountain Dew), and Gary Taxali (for Aimee Mann's album).

B O O K S

Did Amazon finally make a breakthrough in the e-book format with the

release of their Kindle reader in 2007? Ummm, maybe. Despite a hefty price tag ($359, plus the cost of each book or magazine that was downloaded), the Kindle sold out its initial inventory in less than six hours when unveiled in November and Amazon has struggled to meet demand ever since. The fact that it offers free wireless network access (via Sprint), can store about 200 titles, is fairly lightweight, features a keyboard, and also offers an adjustable 4-level grayscale view screen (forget "cover" art or color graphics for the moment), means that once the price drops sufficiently and the Kindle infiltrates

product created by a single bookseller. Publishers being placed in the position of having to provide content in a form that's exclusive to one retailer...worries me. But I always worry when opportunities narrow and one or two players seem to control not only what is readily available to the public, but also what publishers might ultimately decide to produce. Then there's the fundamental question: if publishers start producing content exclusively for electronic readers (and you know it's only a matter of time), won't that exclude a segment of the populace unable to afford the latest gadget? Wouldn't it make read-

But in the long run, we are all the Grateful Dead," he suggested.

Me? I never liked the Grateful Dead.

How much impact will the Kindle or other e-readers have? Time will tell.

So how were sales in 2007? Better. Showing an increase of around 3.2% ($25 billion) over 2006's 0.3% decline, the largest gains came in...the e-book segment (up 23.6% from the previous year to $67 million in sales). Hmmm...

Naturally *the* publishing event of the year was the release of Scholastic's *Harry Potter and the Deathly Hallows*. The final volume of J.K. Rowling's juggernaut fan-

Above left to right: *BeinArt* [www.beinart.org] *out of Australia published the very worthwhile* Metamorphosis *which included art by 50 contemporary surreal and fantastic artists, including Ernst Fuchs, Andrew Gonzalez, Chet Zar, and Brom among other notables;* Imaginistix *was the newest collection by Boris Vallejo and Julie Bell and proved a fitting showcase of the duo's expertise with color and anatomy;* David Michael Bowers: The Evolution of an Artist *was one of the best books of 2007* [www.dmbowers.com] *and also included a great essay about Fine Art and Illustration.*

other market regions there's a possibility that the traditional book format will be saddled with a true rival. Then again...just how necessary is a hi-tech gadget to read a book? Obviously, it's not. There's always a lot of excitement generated by new technology, but there are always questions as to "need" or actual worth. Computers and software become obsolete so quickly these days I'm hard-pressed to figure out the attraction of any of the e-readers when compared to the real McCoy. I mean, I can pick up and enjoy a paper-and-ink book that's 25, 30, 50 years old—or older—and not need anything special to do so. No power. No network. Just me and the printed page. How many computers have I had since 1984? (Answer: too damn many.) How many times have I had to upgrade to new systems and programs? Not because I necessarily got anything better than what I had before (other than maybe a little more speed and a lot more reasons to buy more crap), but because everything else changed for everyone else and without the upgrades nothing worked. Another concern about the Kindle is that it's a

ing even *more* the provenance of the privileged few? Then there's the long-term effects on brick-and-mortar stores if a majority of consumers are able to bypass them and purchase (and download) titles from an online retailer or directly from the publisher. Or consider the potential for filesharing of illegal scans, creating free "competition" for a medium generally thought to be fairly safe from the downloading-woes that have plagued the music and movie industries. As resistance to reading long-form works electronically softens, incidents of infringement are likely to increase. A recent *New York Times* article by Paul Krugman predicted a future in which most written content was available free and writers made their money from ticket sales to readings (which is wishful thinking at best). Shades of Charles Dickens and Mark Twain! Will vaudeville return next? Krugman (whom I assume was paid for his essay) made his prediction based on the "Grateful Dead model" (the band made money through concert tickets and T-shirt sales, not recordings, which were widely bootlegged). "It won't all happen immediately.

tasy series (illustrated by Mary GrandPré) sold a staggering 8.3 million copies in its first 24 hours on sale in the U.S. and 2.6 million in Great Britain. In December Sotheby's U.K auctioned a book of fairy tales created, handwritten and illustrated by Rowling for nearly $4 million. The copy of "The Tales of Beedle the Bard," is one of only seven in existence (the others were given as gifts) and was purchased by representatives for Amazon.com. The proceeds went to the author's charity, Children's Voice, a European organization to help victims of abuse. Now that the Potter saga has concluded, what will take it's place? Stephenie Meyer seems to be making a run for Rowling-level popularity with her series of teen-vampire novels (*Twilight, New Moon, Breaking Dawn*, etc.)—unfortunately, the books don't feature art on the covers or inside.

That's okay: there were *plenty* of books that featured wonderful images last year. Among the single artist collections that were produced I was especially impressed with *David Michael Bowers: The Evolution of an Artist* by Robert J. Trombetta [Warrior Publishing]: the combination of

exceptional paintings, thoughtful essays and commentary, and impeccable design and printing made this truly one of the highlights of 2007. Another excellent addition to my library was *Kent Williams Amalgam: Paintings and Drawings, 1992-2007* [ASFA], which was easily the most comprehensive look at Kent's gallery art to date. I'm constantly astonished by Paul Bonner's watercolors and was delighted with the release of his first collection, *Out of the Forests: The Art of Paul Bonner* [Titan]: there's a *lot* of fun and personality packed between the covers. *Kinuko Craft Drawings and Paintings* [Imaginosis] was a

sible for the 400-page *Scrap Mettle: Fast Art* by Scott Morse, Desperado published the meaty *The Art Of P. Craig Russell*, and The Fairy Whisperer was spotlighted in a pair of titles, *Brian Froud's World of Faerie* [Insight Editions] and *The Secret Sketchbooks of Brian Froud* [Imaginoisi]. The new collection by Boris Vallejo and Julie Bell—*Imaginistix* [CollinsDesign]—was crammed full of lovely paintings and I was happy to pick up a copy of *The Beast Within: The Art of Ken Barr* [SQP] and travel down memory lane with some fantasy art that had impressed me so much in my misspent youth (his cover for the 1971

Ruth Keegan, *Sanjulian Sketchbook* [published by Big Wow], and, naturally, the final pair of knockouts that I couldn't resist: *From the Vault: Covers, Pin-ups & Other Odd Bits* by Mike Mignola and *AH! 2007 Sketchbook* by Adam Hughes. Mentioned without comment is *Rough Work* by Frank Frazetta, a collection of sketches and concept art Cathy and I published as a joint venture with Ellie Frazetta.

Anthology (i.e. multiple artist) books that I spent my hard-earned money on included the incredibly fun *DC Comics Covergirls* by Louise Simonson [Universe], *Illustrators 48* edited by Jill Bossert

Above, left to right: *The Nerman Museum of Contemporary Art opened in Overland Park, KS (yes, smartypants, things* do *happen in Kansas) and featured a nice selection of figure paintings, some with a distinctly fantastic-flavor; David Michaelis biography of Peanuts' creator was largely denounced by the Schulz family, but nevertheless was fascinating reading; Adam Hughes' cover kicked off a great pictorial history of DC's super-powered heroines; Jane Frank refereed a debate about the impact of the computer on the illustration (and art collector) world in* Paint or Pixel.

luminous gathering of Kinuko's gem-like paintings, *The Art of Daron Mouradian* [Salbru] showcased the vibrant canvases of the Armenian symbolist, *The Art of Yasushi Suzuki* [Dr. Master Productions Inc.] included some meticulously designed works by the noted video game artist, *Process Recess 2: Portfolio* by James Jean [AdHouse Books] was a breathtaking compilation of thoughtful imagery, while *Pulphope: The Art of Paul Pope* [AdHouse Books] was a raucous (and sometimes rude) convergence of edgy illustrations. I had looked forward to *Emshwiller: Infinity x Two: The Life & Art of Ed & Carol Emshwiller* by Luis Ortiz [Nonstop Press], and while the actual content was first-rate (including an excellent introduction by Alex Eisenstein), the presentation felt a little too much like a dry 1960s textbook. Despite including a number of paintings, the Emsh art nevertheless seemed to take a backseat to the text. On the other hand I was very pleased with Flesk Publications' *Mark Schultz: Various Drawings Volume Three* (another stellar collection of black and white work) and their definitive *Steve Rude: Artist in Motion*. Image was respon-

fanzine, *Phase 1,* is still a favorite). I was intrigued by *The Art of Alex Gross: Paintings and Other Works* [Chronicle], provoked (happily) by *Abject Expressionism: The Art of Ron English* [Last Gasp], delighted by *Sparrow 2: Phil Hale* and *Sparrow 4: Shane Glines* [IDW], and a sucker for *Fastner & Larson's Tricks & Treats* [SQP]. Other '07 releases definitely worth your consideration were *Rafal Olbinski Women: Motifs and Variations* by Matthew Gurewitsch [Hudson Hills Press], *LeRoy Neiman: Femlin* [M Press], *John Howe Fantasy Art Workshop* [Impact], *Uno Tarino: Artwork by Ashley Wood* [IDW], *Dome* by Luis Royo [Heavy Metal]—and if you didn't snatch up a copy of *Donato Giancola: Dragons and Recent Works 2007,* boy did you miss out!

When it came to self-published single artist sketchbooks I was duly impressed by *Frank Cho Sketches and Scribbles Book 4* (what a wonderfully clean line Frank has), *Neal Adams Sketches, Brandon Peterson's Flights of Fantasy 3, Legion: A Sketchbook Retrospective* by Christopher Hawkes, *Douglas Klauba Sketchbook, Robert E. Howard and Two-Gun Bob* by Jim and

[CollinsDesign]—indispensable for anyone wanting to know what and who is hot in the field—and *Swallow Book Vol. 1 #3* edited by Ashley Wood [IDW], which featured killer art by James Jean, Greg Staples, Barron Storey, Robh Ruppel and, yes, even more worthies. *Conan The Phenomenon* by Paul Sammon [Dark Horse] provided a nice visual overview of the history of Robert E. Howard's seminal character with art by everyone from Frazetta to Gianni to Wood, *Good Girl Art* by Ron Goulart [Hermes] was packed with comicbook cuties, and *The Artist Within* by Greg Preston [Dark Horse] was a splendid compendium of artist portraits. From one side of the world (Australia, to be precise) came the significant *Metamorphosis: 50 Contemporary Surreal, Fantastic and Visionary Artists* [beinArt] and from the other (the Netherlands) *Venus and the Female Intuition* (gotta love Michael Parkes) and *Dreamscape: The Best of Imaginary Realism 2* [both from Salbru]—the latter thankfully bereft of the first volume's condescending comments about "illustration" that had me calling for a Cage Match with the editor last year. *Art*

of Midway: Before Pixels and Polygons, edited by Scott Robertson [Design Studio Press] was both informative *and* good-looking, *Digital Art Masters: Vol.. 2* [Focal Press] included both eye-popping work along with handy-dandy tips for artists, *Exposé 5*, edited by Daniel Wade [Ballistic], featured an eclectic (if uneven) mix of CGI imagery, *Fantasy Art Now: The Very Best in Contemporary Fantasy Art & Illustration*, edited by Martin Mckenna [CollinsDesign], fell *far* short of its subtitle's claim (but *did* feature *some* nice pieces), and *Paint or Pixel: The Digital Divide in Illustration Art*, edited by Jane

Brian Selznick [Scholastic], which was both unique and moving.

A very few of the covers that caught my eye included those by Dan Dos Santos (*Blood Bound* by Patricia Briggs [Ace]), Wayne Barlowe (*God's Demon* by—hey!—Wayne Barlowe [Tor]), Kinuko Y. Craft (*Wildwood Dancing* by Juliet Marillier [Knof]), Justin Sweet (*Beyond the Gap* by Harry Turtledove [Tor]), Cliff Nielsen (*Daughter Of Hounds* by Caitlin R. Kiernan [Roc]), and Donato Giancola (*The Mirror of Worlds* by David Drake [Tor]). Factor in pieces by Craig Howell, Jon Foster, Todd Lockwood, Mark Summers,

revenues, rocketing sales in the mass market, mainstream attention and—dare I say it?—*respect*, made 2007 a pretty good time to be working in comics, um, I mean manga, er, that is...graphic novels. Oh, there was still plenty of grousing and fisticuffs and controversies and disappointments to go around. There was even the trial and conviction of a British comics retailer for the murder of an 11-year-old *and* the arrest and extradition of a popular Pittsburgh retailer/convention organizer to face cold-case charges for killing his wife to keep people talking—when they weren't arguing about statues of Mary

Above progressing left to right: *Sana Takeda's cover for* Heroes for Hire #13 *created a battle-of-the-sexes firestorm in the blogosphere last year and Marvel's initial responses didn't do much to douse the flames. Divided almost evenly down gender lines, women held the cover up as an example of what's wrong with comics and men...mostly shrugged; everyone agreed that Mike Choi's cover for* Marvel's X-23: Target X *was a winner; Travis Charest's gem-like drawings were well-displayed in his sketchbook,* Stuff Wot I Drew; Wired *magazine helped convince gamers to spend $170 million on 9/25 when* Halo3 *was released;* Star Wars *designer Iain McCaig painted the cover for the briefly-revived* Thrilling Wonder Stories.

Frank [Nonstop Press], was an illustrated forum for illustrators' and collectors' to share their views regarding the impact of computer art on the field and included an introduction by some smart-aleck. Oh, wait—that was me.

Stepping over to the "Illustrated Books" section, I loved Jim Gurney's *Dinotopia: Journey to Chandara* [Andrews McMeel Publishing], Brom's contemporary horror-western *The Devil's Rose* [Abrams], Alan Lee's moody watercolors for *The Children of Húrin* by J.R.R. Tolkien [Houghton Mifflin], Mike Mignola's woodcut-flavored drawings for his and Christopher Golden's *Baltimore, Or, The Steadfast Tin Soldier and the Vampire* [Spectra], and John Howe's paintings for *Beowulf: A Tale of Blood, Heat, and Ashes* by Nicky Raven [Candlewick]. And I can't forget *The True Meaning of Smekday*, written and illustrated by Adam Rex [Hyperion]—a hoot all the way around—*Mars Needs Moms!* by Berkeley Breathed [Philomel], the Charles Vess-illustrated *The Coyote Road: Trickster Tales,* edited by Ellen Datlow and Terri Windling [Viking], and *The Invention of Hugo Cabret* by

Stephan Martiniere, and an army of others and you had to conclude that 2007 featured some exciting covers.

I only read two artist biographies last year, but both were meaty and enlightening. *Meanwhile...: A Biography of Milton Caniff* by R. C. Harvey [Fantagraphics], at 800-some pages, should be the first, middle, and last word on the influential creator of *Terry and the Pirates* and *Steve Canyon*, whereas David Michaelis' exhaustive and mildly controversial *Schulz and Peanuts: A Biography* will probably have people talking about Good Ol' Charles "Sparky" Schulz—his insecurities, obsessions, and extramarital affair—for many years to come.

I haven't mentioned him for awhile (I mean, why preach to the converted?), but Bud Plant's venerable company has changed it's name to reflect a renewed focus on—whoopee!—art books. Visit **www.budsartbooks.com** to check out their new look—and to *shop*, of course!

C O M I C S

Gajillion dollar multi-media licensing

Jane Watson or the final settlement (through mediation) of the Great Ellisonfield & McFantagraphics Feud.

I doubt you could find more contentious behavior, more passion and expressions of one-sided public rancor than in the comics community. I'm sure that a lot of it is a sense of "ownership" that stems from growing up with comics coupled with the interactivity between the publishers and readers (originally thanks to conventions, but now increasingly because of internet forums). Yeah, I know people have issues periodically with editors or policies or schedules or some damn thing or another—that's across the industry as a whole and not aimed exclusively at any one company (I read the blogs and news sites). A hot topic last year had to do with everyone getting into web-comics which had everybody fussing about restrictions or contracts. When it comes to the Big Boys I have to say I admire the way DC handles itself: through thick and thin, they behave like *pros*. I *like* DC and what they do—I have since I was a kid, wishing I could draw Sgt. Rock as well as Russ Heath. DC has always exuded

"confidence," for lack of a better word. The look, the feel, the talent, the mix of the traditional with the experimental—they surprise me each year, almost always in a good way. Since they signed a new distribution deal with the brobdingnagian Random House, perhaps more of the general public will come to the same conclusion. Their big event for 2007 was the weekly multiple-creator *Countdown* series (in which everybody got to fight everybody). I was bowled over last year—yet again—by Darwyn Cooke's and J. Bone's spin on Will Eisner's *The Spirit*, enjoyed Alex Ross' and Doug Braithwaite's work

stinker, *Ghost Rider*), it was hard for the company not to have something of a spring in it's corporate step. The influx of film and licensing dough made the executives confident enough to announce that they would be financing their own movies in the future instead of partnering with the Hollywood studios as they had in the past. Their comics circulation took an upward surge with the *World War Hulk* mini-series and their reimagining of *Spider-Man* (so-long Mary Jane) and *Captain America* (he's *dead*, Jim—again!). Zombies were still wandering around the Marvel Universe and selling quite well

Darkness Calls mini-series by Mike Mignola (story and covers) and Duncan Fegredo (art, with colors by Dave Stewart). Conan sliced his way through the Hyborian Age thanks to Cary Nord's art on the monthly comic and Jason Shawn Alexander's moody covers for the *Conan and the Midnight God* mini-series. And you couldn't ask for better work than was delivered by James Jean, Jo Chen, Richard, Corben, Tim Bradstreet, Eric Powell, and Greg Ruth.

Strolling around the racks, I was pleased to see some nice work by Greg Capullo, Brian Haberlin, Michael Kaluta,

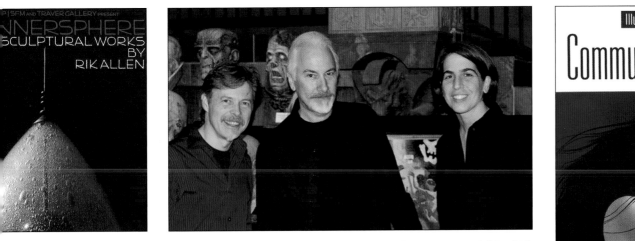

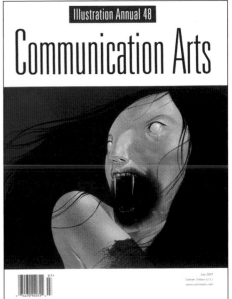

Above left: *Seattle's Science Fiction Museum and Traver Gallery mounted an amazing exhibit of Rik Allen's sculpted spaceships in '07.* **Above:** *They look so* real, *too! Make-up effects guru Rick Baker hosted a Halloween-themed art show, "October Shadows," in his Hollywood studio and welcomed Greg Manchess and Irene Gallo to his inner sanctum.* **At right:** *Sam Weber's startling cover for the* Communication Arts Illustration Annual *had some of their more conservative readers seeing red.*

on *Justice*, was impressed by John Watkiss' art for *Deadman*, got a huge kick out of Jeff Smith's *Shazam*, and was stunned by the superlative covers by Adam Hughes (for *Catwoman*) and James Jean (for *Fables*). I *had* to buy *The Absolute Sandman Vol.. 2* by Neil Gaiman & Co. and *The Absolute Batman: The Long Halloween* by Tim Sale and writer Jeph Loeb and was glad I did. But though I had looked forward to Alan Moore's collaboration with Kevin O'Neill on *The League of Extraordinary Gentlemen: The Black Dossier*, it just didn't hit the mark for me: the focus and overall power of the storytelling of the first two (highly recommended) books in the series was missing in the new (and last with DC as publisher) rather disjointed title. On a happier note, I thoroughly enjoyed miscellaneous covers and stories throughout '07 by Simone Bianchi, Tim Bradstreet, Brian Bolland, Tomer Hanuka, Sam Keith, Stephanie Roux, and the legendary Joe Kubert.

Marvel, simply put, dominated the market in 2007. With $891 million in global theatrical boxoffice receipts for *Spider-Man 3* (and over $200 million for a

(frankly, I don't get it) and Jai Lee/Richard Isanove/Peter David/Robin Furth's adaptation of Stephen King's *The Dark Tower* sat comfortably on the bestseller lists. There was more experimentation, more diversity in art styles, across the line than in recent years—and I see that as a good thing. I really liked Mike Choi's art for *X-23: Target X*, Ariel Olivetti's work on *Punisher War Journal*, and a whole passel of stories and cover art by Marko Djurdjevic (what a range!), Frank Cho, Tim Bradstreet, Travis Charest, Adi Grandv, Art Adams, Paolo Rivera, and Nic Klein—and that's just to name a few. In other words...it was a very good year for Marvel.

Hollywood also contributed to Dark Horse's coffers, thanks to the unexpected success ($200 million+ in American b.o. receipts) of the stylish adaptation of Frank Miller's and Lynn Varley's *300*. The graphic novel that inspired the movie sold like hotcakes as did *300: The Art Of The Film*. DH continued to expand the *Star Wars* franchise with a variety of titles and storylines (and there was Travis Charest again with *more* noteworthy covers) and kept Big Red in the public eye with the *Hellboy:*

Ben Templesmith, and Michael Allred at Image, while over at IDW the contributions by Ash Wood, Templesmith again (the more the better), and Alex Sanchez caught my eye. Drawn & Quarterly released Chris Ware's latest installment in his *Acme Novelty Library* (volume #18, thank you very much), Fantagraphics turned *I Shall Destroy All the Civilized Planets: The Comics of Fletcher* Hanks into a surprise cult hit (Hanks was a weird Golden Age artist who did...*really* weird stories), and Top Shelf continued to count the cash generated by Alan Moore's and Melinda Gebbie's high-style-porn fantasy graphic novel, *Lost Girls*, surprisingly without complaint from the Morality Patrol (maybe they couldn't afford the $75 price tag). I spotted some nice work by Frank Cho, Steve Firchow, Michael Gaydos, Greg Horn, Joe Jusko, J.G. Jones, and James Turner among others. And, yeah, there was a mountain of manga and manga-looking stuff in the stores, but honestly, I just looked straight ahead and kept walking.

The comics-focused magazines like *Back Issue, Comics Buyer's Guide, The*

Comics Journal, Alter Ego, and *Draw!* all continued to struggle with declining circulations and advertising revenues through the year and there were reports of financial challenges and lay-offs at *Wizard,* the field's most popular periodical. *Publisher's Weekly* on-line comics newsletter did double-duty as a professional trade journal and news/commentary resource, thanks to Heidi MacDonald's "The Beat. The New York Comic-Con enjoyed a surge in attendance and seemed on track to become the Eastern Seaboard's answer to San Diego's Comic-Con International, complete with expensive hotel rooms, but minus the palm trees, of course. SDCCI was bigger than ever and for the first time in memory, they stopped selling tickets

sword or battleaxe or helmet—but as close as I got was my dad's helmet liner from WWII. Eventually the models got blown up on the 4th of July and all of the soldiers and tanks and creatures and gee-gaws were given to neighbors when I discovered girls and decided that I was too old, too sophisticated, for such stuff.

What can I say? I was a doofus.

Anyway, maybe that's part of the reason I like 3D stuff as much as I do: it reminds me of things I enjoyed (and, yes, in some cases blew up) in my youth. But the interest goes far beyond mere nostalgia: these artworks and artifacts *say* something—can make an intellectual artistic statement—that's unique to the form. And it doesn't matter if the sculp-

Collector Figures when I was a sprout my G.I. Joe would've been loopy for their bodacious "Power Girl." DC Direct also began producing a variety of figures based on *World of Warcraft*: it was no surprise that gamers snapped them up in record numbers.

Marvel's 3D offerings (produced by themselves and multiple licensees) continued to improve in quality: Randy Bowen sculpted marvelous (heh, heh) figures of "Thor" and "Black Bolt" while William Paquet created a stoic "Nick Fury, Agent of Shield" and Joy and Tom Snyder produced the iconic (if wordy) "Marvel Milestones Spider-Man on Flagpole."

Todd MacFarlane added more tasty dragons to their line, Clay Moore sculpted

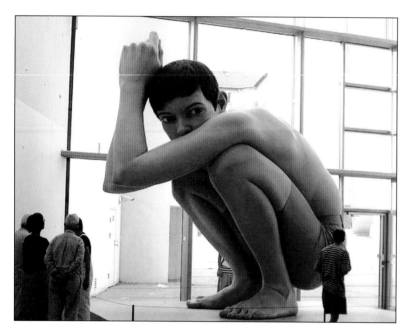

At left: *Ron Mueck's humbling large-scale statues were exhibited at the National Gallery of Canada and at the Modern Art Museum of Ft. Worth.* **Above:** *The exceptional "Allegory of the American Empire" (36" x 48", oil on paper on panel) was included in Donato Giancola's 2007 solo show, "Transitions," at the Southern Vermont Arts Center.*

because there was simply too many damn people wanting in. We exhibited under the Donato Arts umbrella (which also included Rebecca Guay, Dan Dos Santos, Jon Foster, and Stephan Martiniere)—it was grueling, exhausting, and f-u-n. If you've never been to Comic-Con, *go!*

D I M E N S I O N A L

When I was a kid (the late Cretaceous Period, for the curious), I had tons of Marx toy soldiers and Aurora monster model kits and G.I. Joes and Hamilton Invaders and, oh, all kinds of neat plastic crap. My love for 3D went beyond toys and I learned to appreciate the Grecian statues I'd stumble across in books and magazines (thank you, *National Geographic*) and I looked forward to seeing the displays of armored knights on horseback in the great hall at the Nelson Atkins Museum (mentioned earlier in this essay). I always thought it would be way cool to have an artifact or prop for display like a

tures are being done for a multi-national corporation, a high-end New York gallery, or are simply the expressions by a week-end garage kit maker, they're engaging expressions of both thought and craft.

Plus...they're pretty dang cool.

DC Direct continued to produce some incredibly nice additions to the collectors' case. I especially liked Jack Matthews' additions to the Women of the DC Universe line, including, "Black Canary," "Big Barda," and "Donna Troy,' and thought James Shoop's big "Batman 1:4 Scale" statue was first rate. The Dark Knight was also nicely interpreted by Adam Beane ("Batman: Dark Crusader") and Karen Palinko ("Alex Ross: Batman Black & White"), Todd MacFarlane Toys did a joint venture with the massive "Batman/Spawn" statue, while the "Catwoman" and "Supergirl" vinyl statues provided by Kotobukiya were as nicely crafted as they were provocative. And I'd hazard a guess that if they had been producing their line of 13" Deluxe

a nice "King Kull," and Tim Bruckner beautifully translated Frazetta's "Moon Maid" painting into 3D for ReelArts/Dark Horse. Mindstyle released the first pair of creepy figures based on characters from Brom's novel, *The Plucker*, as well as a very funny take on Frank Cho's "Monkeyboy" persona.

And I *still* want one of the steampunk rayguns that I mentioned previewing last year, but no one will take the hint and buy one for my birthday. The folks at Weta have actually worked up an entertaining backstory for "Dr. Grodbort's Infallible Aether Oscillators & Other Marvelous Contraptions" that you'll discover by visiting their website (and *maybe* purchasing one for that *special* someone) at **www.wetanz.com**. (I had mistakenly said in last year's essay that the rayguns were available from Sideshow: *wrong.* Go to Weta's site for the straight scoop.)

There were plenty of statues, busts, and toys based on *Star Wars, Harry Potter, 300, Halo,* miscellaneous comics charac-

ters, tv shows, movies, realistic, animated, deformed, micro, life-size...you name it, probably someone has sculpted it and offered it for sale. Factor in all of the designer toys and international figurines and vehicles (like the sweet die-cast Tachikoma tank from *Ghost In the Shell*) and plush and how about all of the gallery pieces and Fine Art and one-of-a-kind dolls and, oh, goddamnit, just literally mountains of worthwhile *stuff* and you'll quickly reach the conclusion that it's much easier to go look for it yourselves than it is for me to talk about it any any meaningful way. Some good "guidebooks" to help get you started include the magazines *Amazing Figure Modeler, Toyfare, Sci Fi & Fantasy Modeler, Hi Fructose, Giant*

assigned. Of course, you might feel exactly the same way standing in front of the crammed-to-the-bursting-point magazine rack at your favorite bookstore and you have to try to figure out what's worth your $5 (or $7 or $15—godfrey daniels!) at a glance and what isn't.

Once again the short-fiction magazines struggled with declining circulations and rising costs. *Realms of Fantasy* still made the biggest visual statement, featuring some well-done story illustrations and artist profiles/portfolios by the likes of Scott M. Fischer and Adam Rex. *Weird Tales* got something of a design makeover with a new logo and some effective covers by Anita Zofia Siuda and Oliver Wetter, *The Magazine of F&SF* sported some nice

tured notable artworks and interviews: some perked along nicely, some sputtered and conked out (like *Newtype* and *Rocket*—which only managed one issue before being absorbed by *Geek*). There seemed to be quite a few glossy, jam-packed publications coming out of the U.K. like *SFX, Deathray,* and *Starburst,* but there were equally informative titles closer to home like *Sci Fi Magazine* and the always indispensable *Entertainment Weekly. Discover, Time, Newsweek, Cricket,* and *Rolling Stone* all regularly featured imaginative illustration and *National Geographic* compromised their recent decision to only use photos and graphs and hired Greg Manchess to paint some memorable scenes. Hopefully that will be

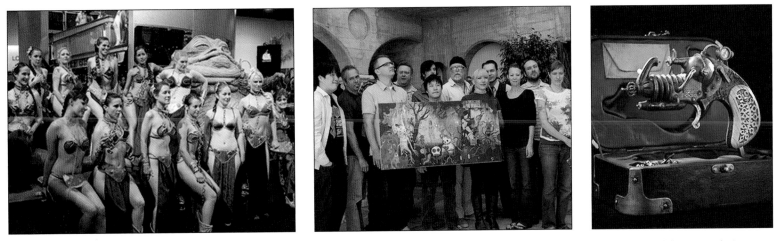

Above left: *The San Diego Comic-Con International is interesting for loads of reasons, not the least of which are the number of folks wandering the floor in costumes. The Gentle Giant display featuring a life-sized Jabba the Hut was a magnet to all of the Princess Leias in the city. Our exhibit space with Donato Arts gave us a nice view of the activities.* **Middle:** *Bob Self's Baby Tattooville Event (www.babytattooville.com) offered collectors' a weekend with their favorite artists, complete with cool swag.* **Above right:** *No well-dressed gentleman should go out at night without their own Victorious Mongoose 1902a pocket ray pistol (designed by Greg Broadmore and built by David Tremont for Weta: www.wetanz.com).*

Robot, Sculpture Review, ARTnews, and *World Sculpture News.*

EDITORIAL

Speaking of magazines, they tend to come and go when you least expect them. As I've said in the past, it's a tough market, made even tougher by Internet competition. Nevermind that most virtual magazines are very superficial and intended for people with short attention spans, their immediacy—and the fact that most are free—gives them an edge over their more thoughtful designed and printed brethren. Which is a shame, really, because while the vastness of the web literally *does* put the world at your finger tips (depending on the country you're in, that is), it is also by its very nature a cybernetic mess, a jumbled and confusing arena with little focus and fewer standards and even less accountability. It's hard to know what's good, where to find it, and who to blame if blame needs to be

work by Cory and Catska Ench, Max Bertolini, and Kent Bash, while *Isaac Asimov's SF* and *Analog* could boast some some excellent covers by Donato Giancola, Bob Eggleton, David Mattingly, and Michael Whelan. *Thrilling Wonder Stories* was able to snag a tasty cover painting by Iain McCaig that nicely update a classic pulp scenario, but that didn't seem to be enough to effectively relaunch the magazine and it pretty much disappeared after its Summer '07 (ne, first) issue. The Fall issue of *Tin House* featured an arresting cover by Julie Heffernan while the Brit's *Interzone* included some memorable work by Kenn Brown and Jim Burns. Rumors began to circulate that *Omni* might make a come back—which, if true, would be excellent news for artists and writers alike when you consider that *Omni* was the highest-profile, most graphically sophisticated, and best-paying magazine the field has ever known.

There were a number of rewarding pop-culture/media magazines that fea-

a new beginning and illustration will return on a regular basis to their pages. And I can't forget *Playboy*: Rob Wilson became their new art director, but carried on their superlative graphic tradition (no jokes, please) by utilizing the talents of such worthies as Dave McKean, Yuko Shimizu, and Phil Hale.

Favorite "artist" publications last year included Dan Zimmer's excellent *Illustration* (and equally good, but struggling little brother, *Illo*, which only managed one issue in 2007), *Juxtapoz* (which was the best way to keep track of the happenings of the "outsider" art and toy community), *Communication Arts* (who got a surprising number of letters from crusty readers complaining about the use of Sam Weber's vampire on the cover of their illustration annual), *Print, How, Art Scene International, Airbrush Digest* (yes, people still use them), and *ImagineFX: Fantasy & Sci-Fi Digital Art* (which, despite its title and focus, increasingly included profiles of traditional artists).

The fantasy/sf/fantastic field is both intimate and ginormous: there are a lot of people "in" it and a lot of them know each other (or know people who know people). Anyway, rather than devolve into a convoluted game of connect-the-dots, let me cut to the chase and suggest once again that the best way to keep track of our field is to subscribe to *Locus*. While it might *seem* to be aimed primarily at the writing community (okay, it is), each issue actually features quite a bit of news, trends discussions, market notices, and just basic information that is of import to artists and designers. Check them out on the web at **www.locusmag.com.**

INSTITUTIONAL

Where does all the cool (or "kewl," if you're a youngster) art go if it doesn't exactly fit into one of the other categories? Why "Institutional," naturally. Works that were created for products for use as package design, promotions, greeting cards, prints, corporate reports, or any number of other possibilities all fit quite nicely in the tent with room to spare.

There was a lot of anger and accusations about various companies that were plagiarizing artists' works for T-shirts and greeting cards (among other things) that kept the internet buzzing. In the meantime there was a call to arms among artist groups to oppose an "orphan works" legislation winding its way through the Senate that, if passed, would limit artists' chances of recovering significant damages in copyright infringement cases. Whoever thinks artists are meek and mild, especially when it comes to their rights, haven't been paying attention.

Some of the art calendars I saw and liked in '07 included *Tori Amos Rainn Benefit* (which featured work by Thomas Canty and Gary Lippincott), *Victoria Francis: Dark Angel of the Night, Luis Royo, Family Guy Artist Series, Simon Bisley, Dragons by Ciruelo,* and *Boris Vallejo & Julie Bell's Fantasy Calendar.*

Each year there are any number of worthwhile gallery shows and exhibitions featuring works for every taste and interest. Rick Berry's oil paintings of new abstract and figurative works were shown at the Newton Free Library Gallery, Kent Williams' "In Animate: New Paintings" show was hosted by L.A.'s Merry Karnowsky Gallery, the Copro/Nason Gallery was the venue for the "Blab Group Show" (which featured works by Travis Louie, Shag, and John Pound among others), Eric Joyner's exhibit, "Malfunction," was at the Shooting

As we were putting Spectrum 14 *to bed last year we received the sad news that Glen Angus, one of the artists included in the volume, had died on the 19th of July from apparent complications due to an aneurysm. A Senior Artist at Raven Software, Glen was also an active freelancer for Wizards of the Coast and taught art classes at St. Clair College in Windsor, Ontario. He had begun working on an arresting series of fantasy pin-ups under the titled "Victory Gals" (two of which are included above) to expand his artistic range. A fund has been set up to aid his wife and two young children (that's Glen and son Ted above):* **Glen Angus Memorial Fund c/o Park Bank, P.O. Box 8969, Madison, WI 53791**

Gallery, and the "October Shadows" shindig was held on the first floor of make-up effects legend Rick Baker's studio and included art by Jon Foster, Gregory Manchess, and Melissa Ferriria. Baby Tattooville was a weekend-long event geared toward the art community. The brainchild of Baby Tattoo publisher Robert Self, it was touted as a "Limited Edition Retreat" because only 50 attendees were allowed to spend three days participating in both scheduled and spontaneous activities with a select group of guest artists. Members received a package of collectible gifts, including originals, prints, and limited edition toys. Plans are to make the retreat an annual occurence.

Naturally there are many places to buy original art, but I like to suggest people check with Jane Frank, Mitch Itzkowitz, and Albert Moy as good places to start (or complete) their search for something special:
www.wow-art.com
www.graphiccollectibles.com
www.www.albertmoy.com

REQUIEM

In 2007 we noted the passing of these talented creators:
Glen Angus [b 1970] artist
Martha Arguello [b 1917] artist

James W. Babcock [b 1919] cartoonist
Robert Bindig [b 1920] illustrator
Giovanni Boselli [b 1924] illustrator
Robert "Buck" Brown [b 1936] cartoonist
Manny Curtis [b 1924] cartoonist
Jack Drummey [b 1926] cartoonist
Roberto Fontanarrosa [b 1944] cartoonist
David Gantz [b 1922] comic artist
John Garcia [b 1954] illustrator
Wesley Groenewoud [b 1977] sculptor
John B. Hadelsman [b 1922] cartoonist
Robert G. Harris [b 1911] illustrator
Wayne Howard [b 1949] comic artist
James Kemsley [b 1948] cartoonist
Bill Kitchen [b 1929] cartoonist
Harishchandra Lachke [b 1919] cartoonist
Raphael Marcello [b 1929] comic artist
Doug Mariette [b 1949] cartoonist
Angus McBride [b 1931] illustrator
Gerald Melling [b 1934] cartoonist
Paul Norris [b 1914] comic artist
Kevin Patrick [b 1924] cartoonist
Silas Rhodes [b 1915] co-founder of SVA
Al Scaduto [b 1928] cartoonist
Gualtiero Schiaffino [b 1943] cartoonist
Howie Schneider [b 1930] cartoonist
Cheng Shifa [b 1921] artist
Oscar Smyrl Jr [b 1923] cartoonist
Art Stevens [b 1915] animator
Jerry Warshaw [b 1928] cartoonist
Mike Wieringo [b 1963] comic artist
Kevin Woodcock [b 1942] cartoonist
Bob Zahn [b 1934] cartoonist †

The Show

Call For Entries poster by Marc Gabbana

James Jean

As a way to mark the 15th anniversary of the *Spectrum* competition and annual, we asked the jury at the conclusion of the awards debates to designate a work as "best in show." With little hesitation they quickly reached an agreement and presented the honor to James Jean.

James Jean, of course, is no stranger to *Spectrum*'s readers, having received a Silver and two Gold awards for his work in volume #14. He was born in 1979 in Taiwan, but his family emigrated to the United States shortly after his birth and he was raised in Parsippany-Troy Hills, New Jersey. A graduate of the School of Visual Arts in New York City in 2001, he quickly became an acclaimed cover artist for DC Comics, garnering five consecutive Eisner awards and three consecutive Harvey awards. James rapidly branched out and began contributing to many national and international publications including *Time Magazine, The New York Times, Rolling Stone, Playboy*, and *Spin*. His portfolio also boasts high-profile assignments for ESPN, Atlantic Records, Target, Knopf, and Prada among others.

But some of his best known and most popular works are his covers for the *Fables* comics series published by Vertigo, an imprint of DC Comics. *Fables* began in 2002 and is the creation of (and is written by) Bill Willingham. The series deals with a variety of characters from fairy tales, children's literature, and folklore who have been forced out of their Homelands by a mysterious enemy. They have journeyed to the "real" world and formed a clandestine community in New York City known as Fabletown. James Jean's memorable covers have helped cast a new light on such characters as Cinderella, Shere Khan, Sinbad, Rose Red, and "Bigby" Wolf. His award-winning mixed media painting (James often adds finishes to traditionally-created works digitally) on the facing page not only helps explain why his *Fables* covers are so highly regarded, but also beautifully epitomizes the "sense of wonder" that is the heart of fantastic art and the spirit of discovery that the *Spectrum* competition has always tried to convey.

artist: **James Jean**
art director: Shelly Bond *client:* DC Comics/Vertigo *title:* Fables #67: The Good Prince *medium:* Mixed

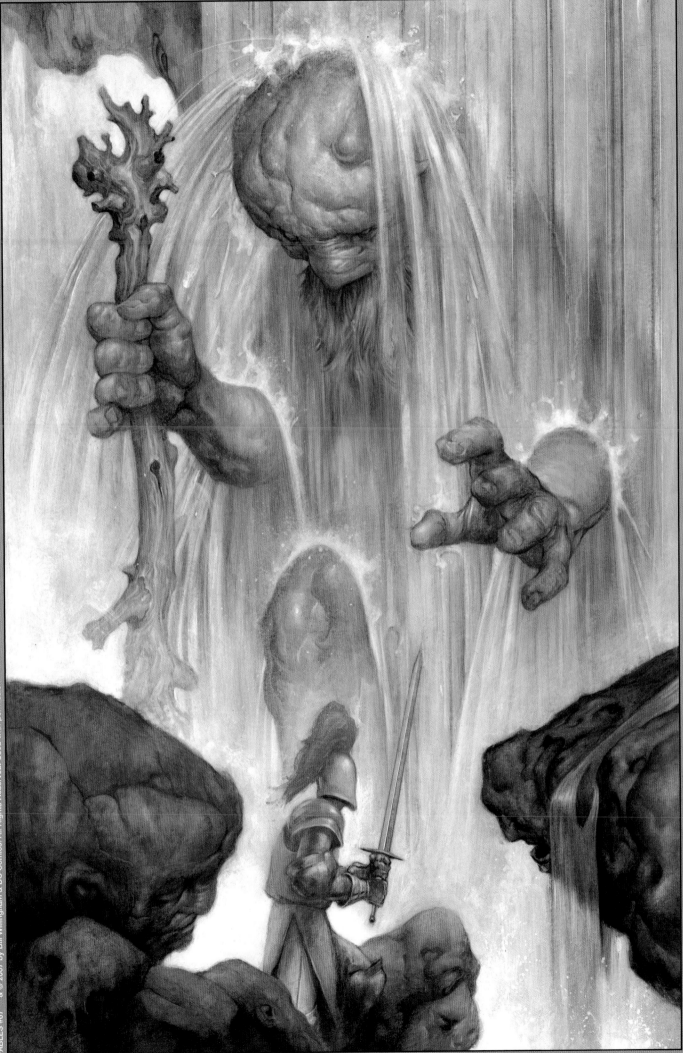

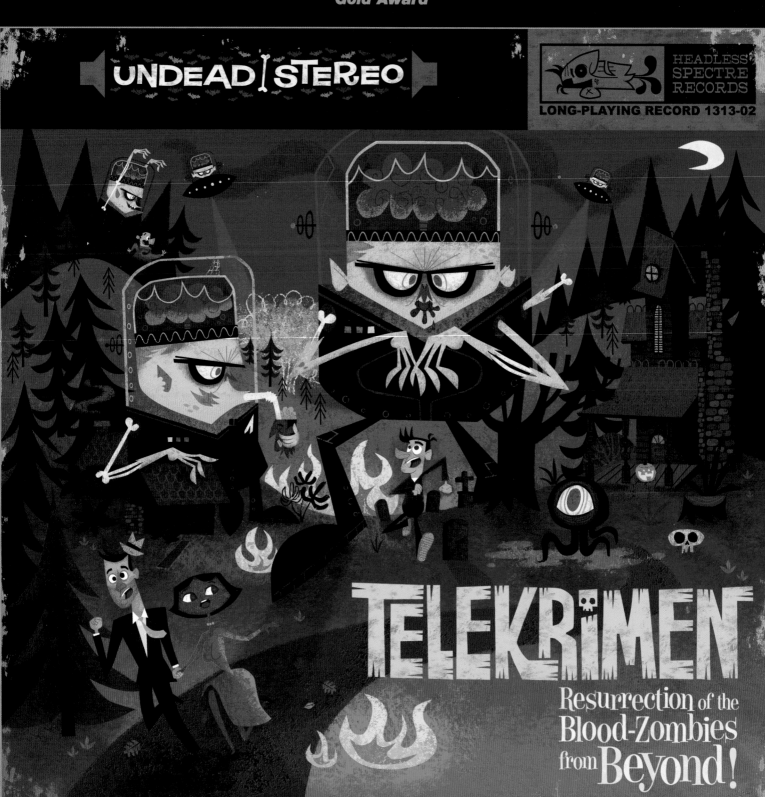

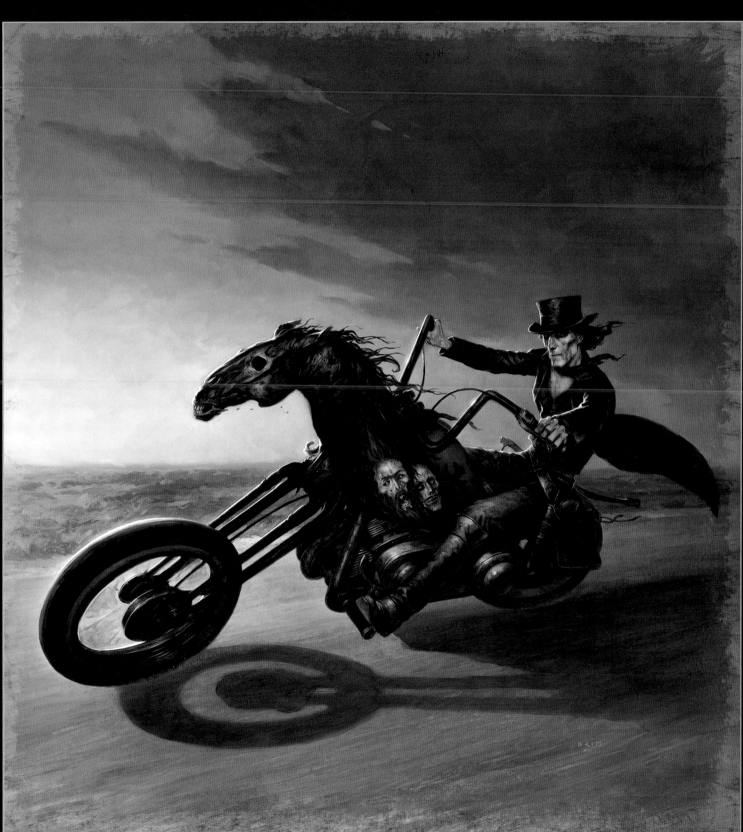

1 *artist:* Hoang Nguyen
art director: Rob Carney *client:* ImagineFX *title:* Flight
medium: Photoshop *size:* 9"x12"

2 *artist:* Jeff Wack
art director: John Norman *designer:* Darren Hughes
client: Coca-Cola *title:* Happiness Factory: The Movie
medium: Digital *size:* 40" tall

3 *artist:* Andrew Bawidamann
art director: Mark Painter *designer:* Andrew Bawidamann
client: Wizards of the Coast *title:* Secret Weapons
medium: Digital *size:* 18"x24"

4 *artist:* Alessandro "Talexi" Taini
client: Ninja Theory/SCEE *title:* Heavenly Sword
medium: Photoshop

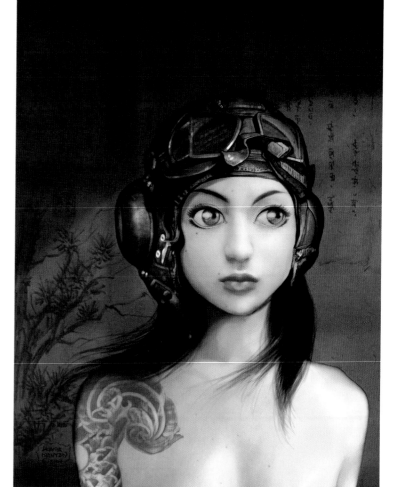

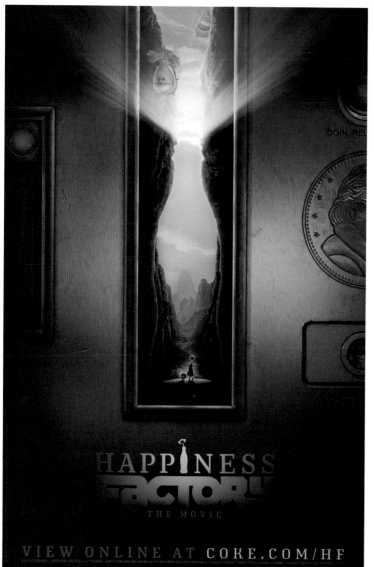

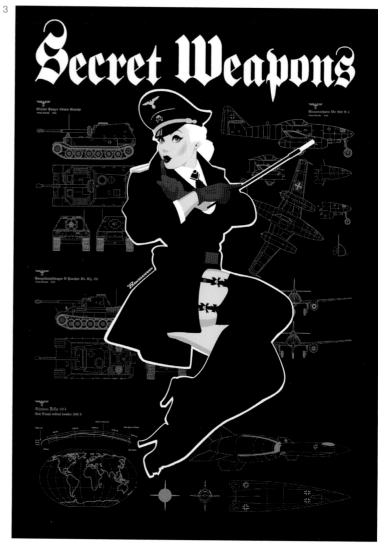

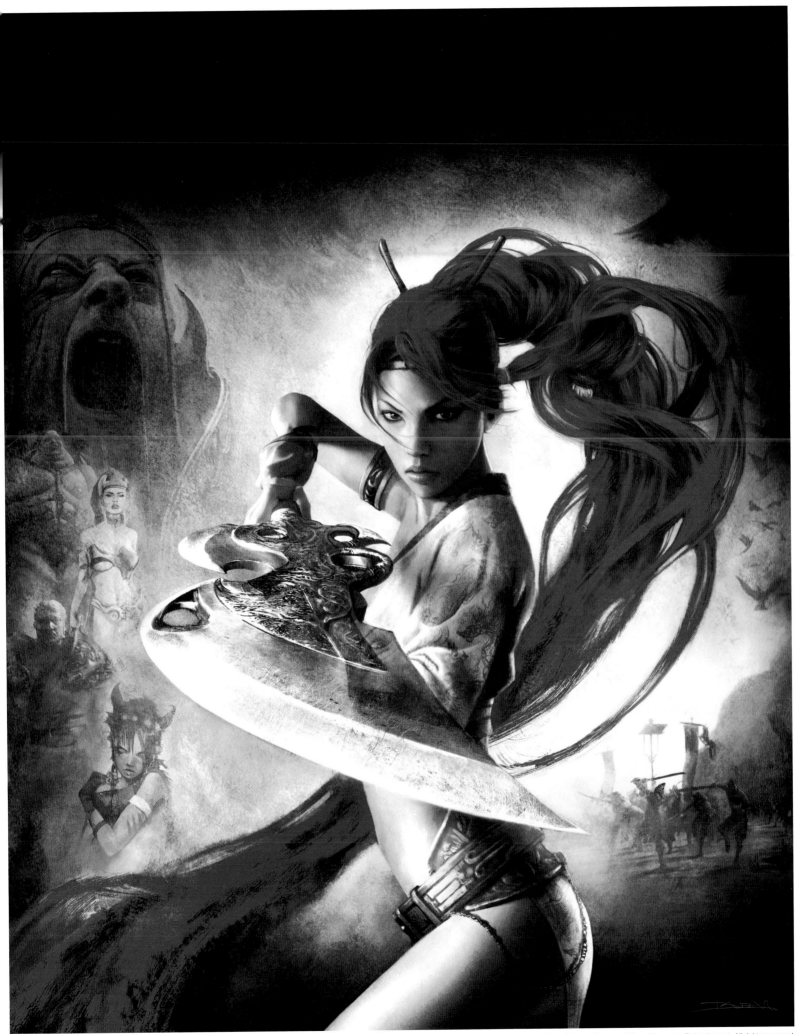

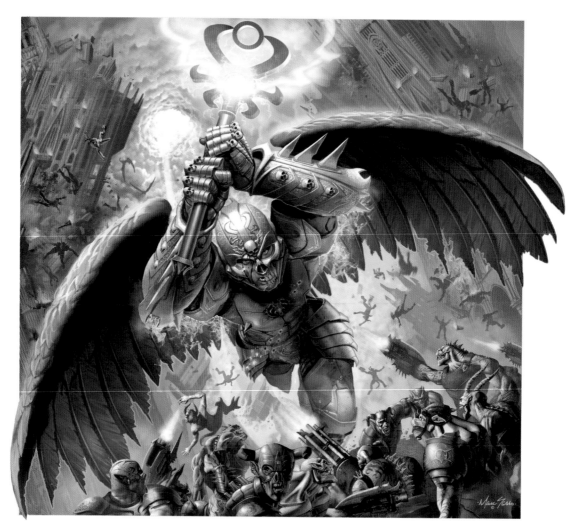

artist: **Marc Sasso**
art director: Marc Sasso/Sean Peck client: Cage Music Ltd. title: Nell Destroyer medium: Mixed/digital

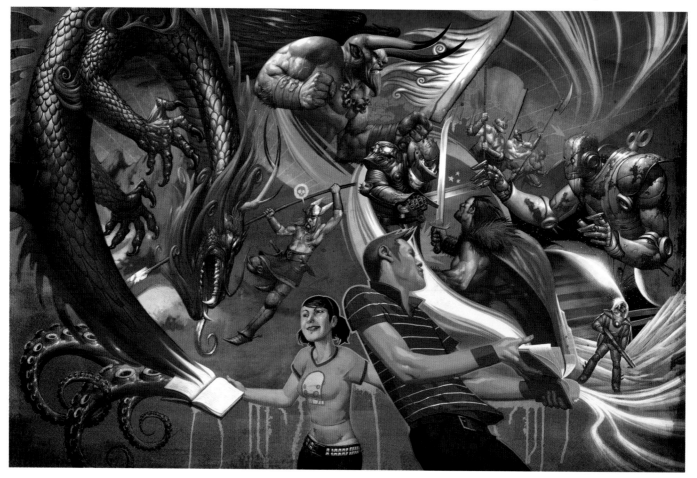

artist: **Nic Klein**
art director: Sarah R. Smith client: Bantam/Dell Publishing title: Spectra Pulse 1 medium: Digital

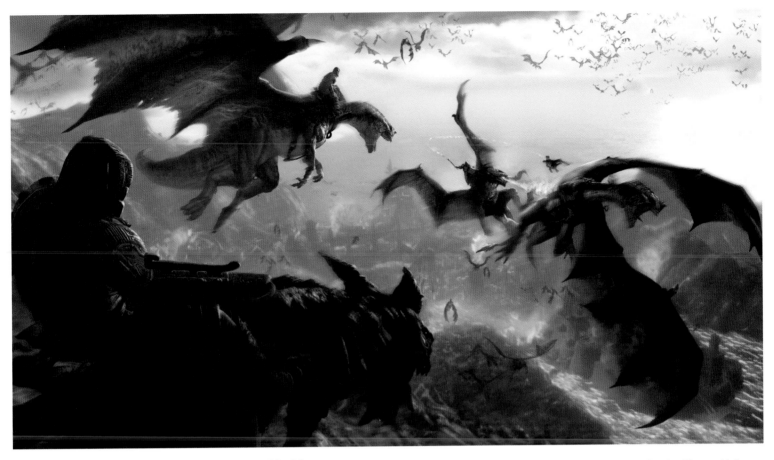

artist: **Andrea Blasich, Wayne Lo, David LeMerrer** *models:* Alessandro Briglia, Danny Lei, Andrea Blasich *textures:* Cory Strader, Magnus Hollmo
art director: Wayne Lo *designer:* Steve Hui, Anthony Ermio, Pat Presley *client:* Factor 5 *title:* Lair: Sky Battle *medium:* Digital

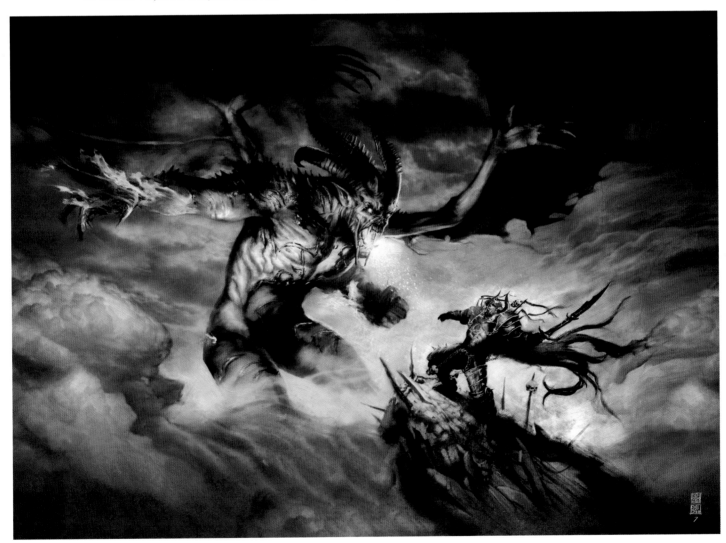

artist: **J.S. Rossbach**
art director: Jeremy Jarvis *client:* Wizards of the Coast *title:* Korlash Vs Tombstalker *medium:* Digital

1
artist: **Joao Ruas**
art director: Muriel Curi
client: Dissenso Records
title: Chromo
medium: Watercolor/gouache
size: 21¹/₂"x21¹/₂"

2
artist: **Nathan Baertsch**
art director: Eric Treadaway,
Eric Mayse, Jim Preziosi,
Chris Dahlberg
client: Four Horsemen Toy Design
title: Ramathorr
medium: Digital
size: 10"x6"

3
artist: **René Milot**
art director: Christopher Milligan,
René Milot
client: Cincinnati Opera
title: Faust
medium: Digital
size: 14"x19"

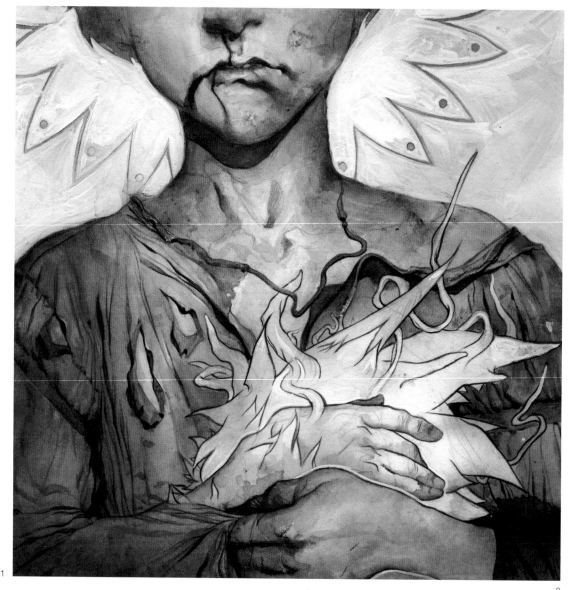

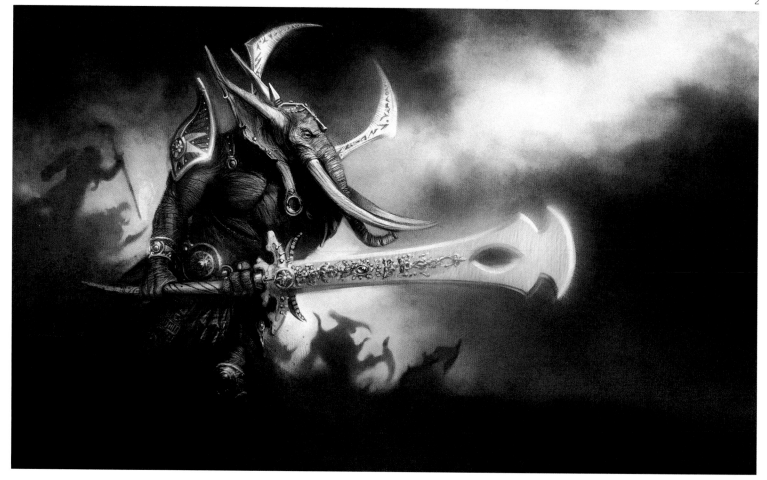

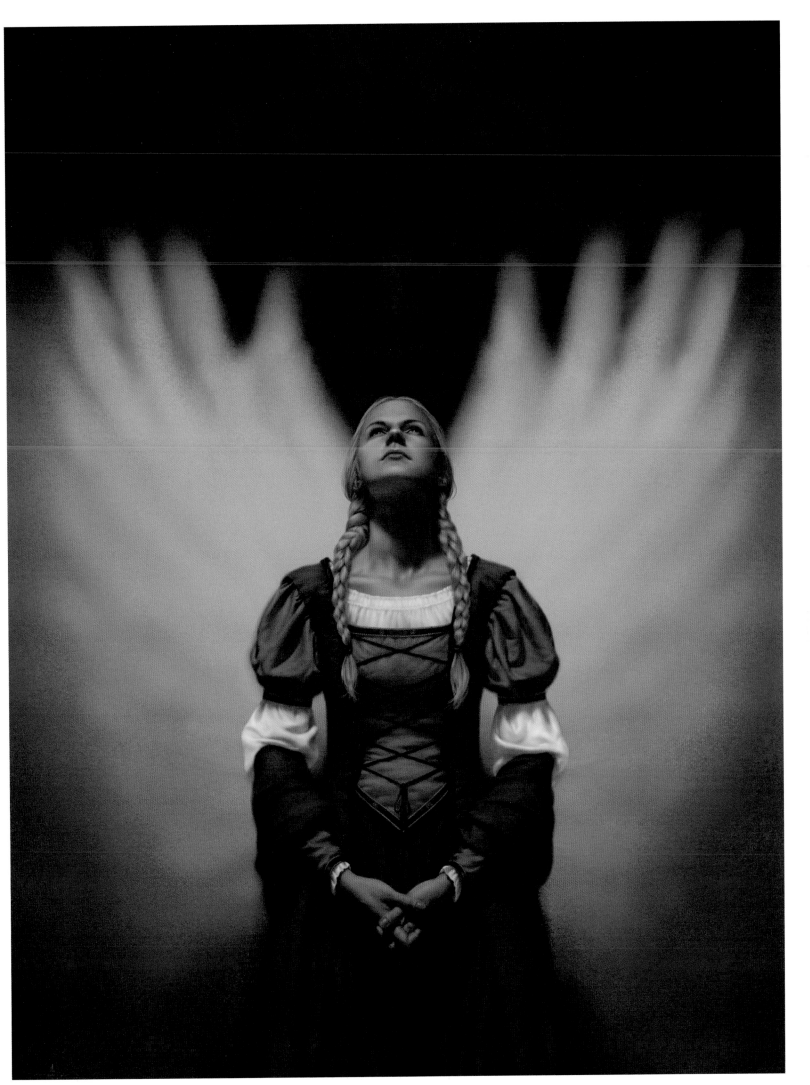

1
artist: **Dave McKean**
art director: Steve Joh
designer: Dave McKean
client: A&R/Century Media
title: Suicide Silence
medium: Mixed
size: 6"x8"

2
artist: **Kei Acedera**
art director: Kelly Fuligni
designer: Kei Acedera
client: Borders Bookstores
title: Holly & Marshmallo
medium: Digital
size: 19"x27⁵/₁₆"

3
artist: **Rusty Zimmerman**
art director: Mike Boston
client: Starting Arts
title: Dracula
medium: Acrylics/gouache
size: 17"x27"

4
artist: **Julie Bell & Boris Vallejo**
art director: Jacob Escobedo
client: Cartoon Network
title: Aqua Teen Hunger Force
medium: Oil
size: 27"x37"

1

2

3

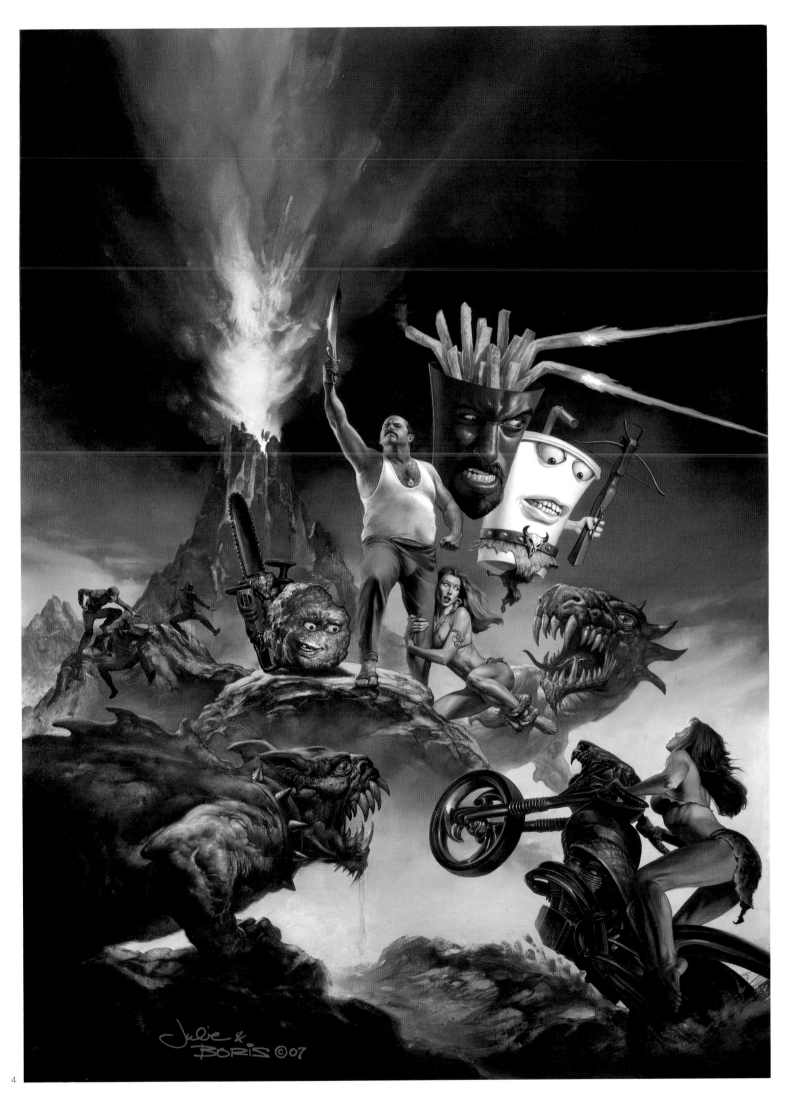

4

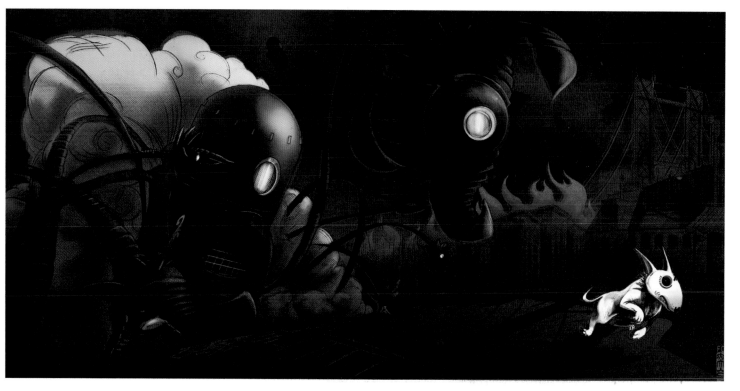

artist: **Henry Fong**
art director: Henry Fong *client:* See Spot Run *title:* Touching Down *medium:* Graphite pencil/Photoshop

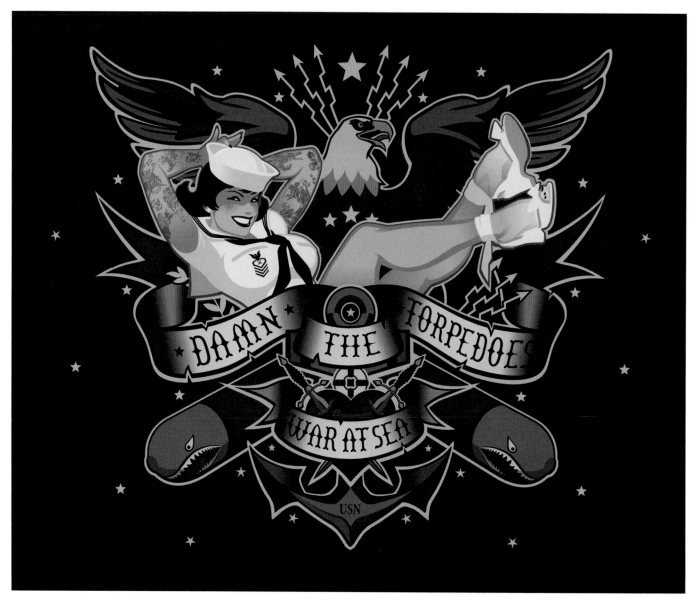

artist: **Andrew Bawidamann**
art director: Mark Painter *designer:* Andrew Bawidamann *client:* Wizards of the Coast *title:* The War at Sea *medium:* Digital *size:* 18"x24"

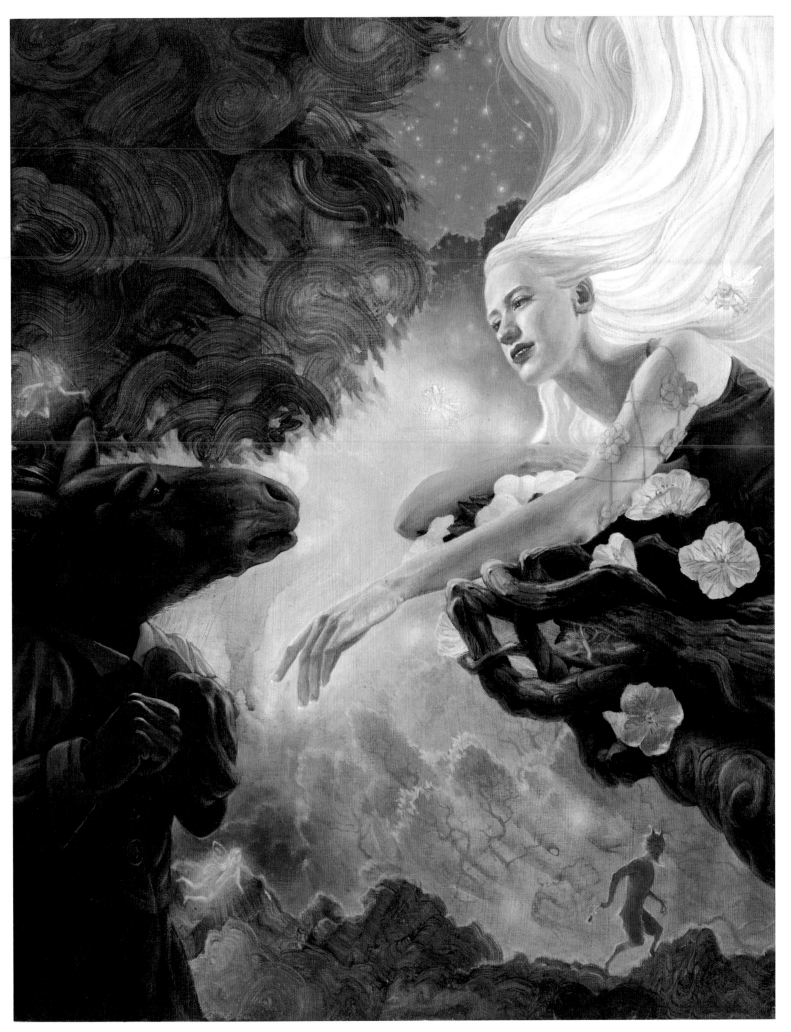

artist: **Michael Phipps**
art director: Kirsten Park *client:* Pioneer Theatre Company *title:* A Midsummer Night's Dream *medium:* Acrylics on board *size:* 11¹/₂"x14¹/₂"

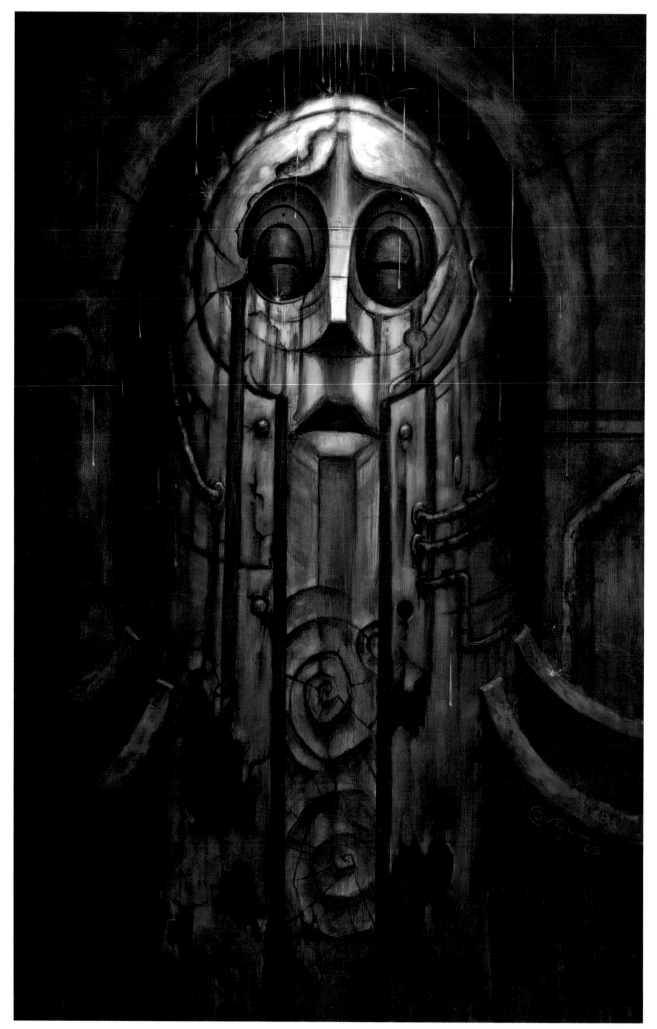

artist: **Mark Covell**
client: Copro Nason Gallery *title:* Tears *medium:* Oil *size:* 13"x20"

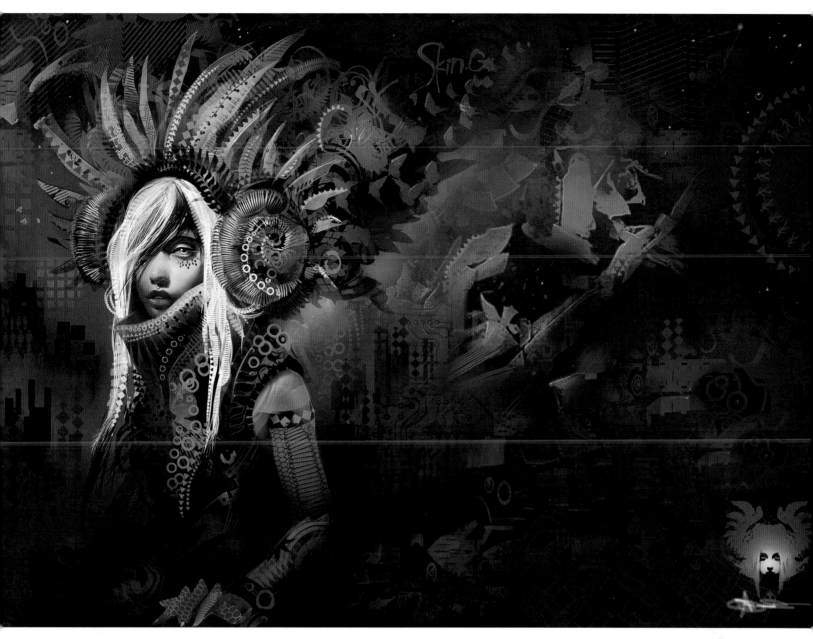

artist: **Andrew Jones**
art director: Elliot Dunwoody III client: Skin Graft Designs title: Breana medium: Mixed

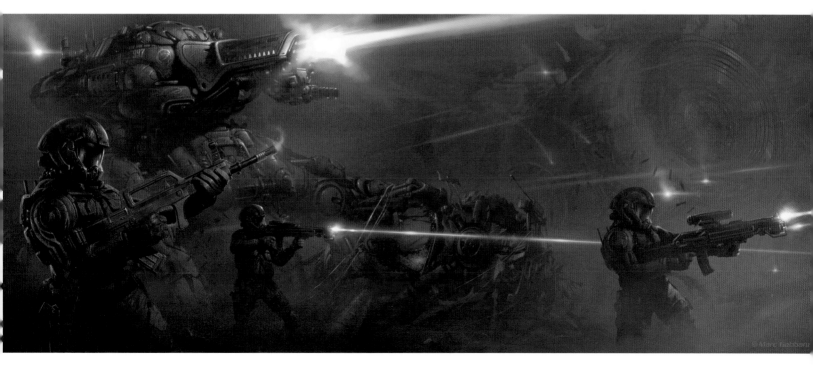

artist: **Marc Gabbana**
client: Crossfire title: Crossfire Assault medium: Digital size: 32"x13"

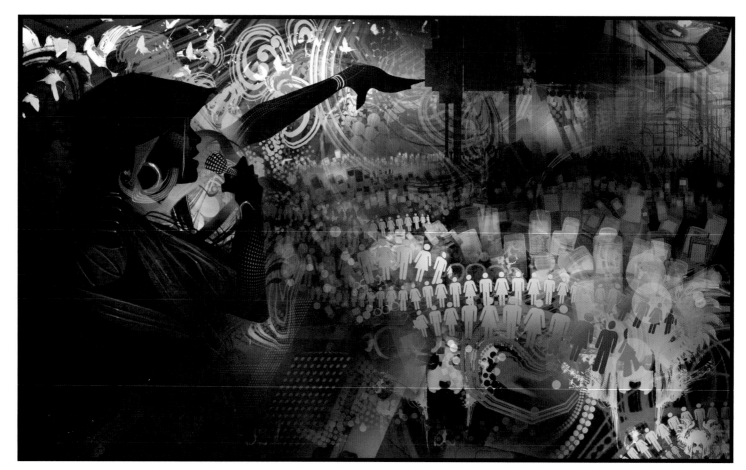

artist: **Andrew Jones**
art director: Divine Feminine *client:* Cypher Town *title:* Nikila *medium:* Digital

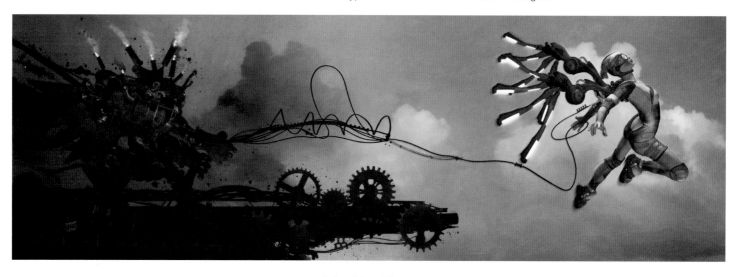

artist: **John Van Fleet**
art director: Brian Patton *designer:* Heather Parson *client:* Metal Blade Records *title:* Soylent Green *medium:* Digital *size:* 36"x12"

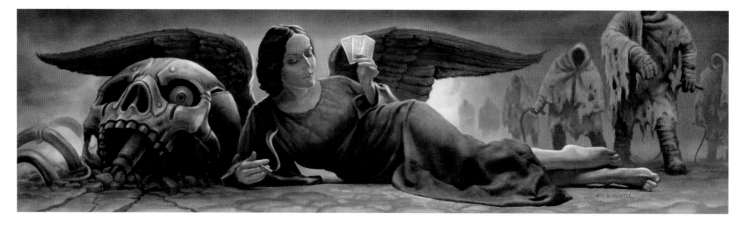

artist: **Wes Benscoter**
art director: Masaki Koike *client:* Rhino Records *title:* Black Sabbath—The Dio Years *medium:* Acrylics/digital

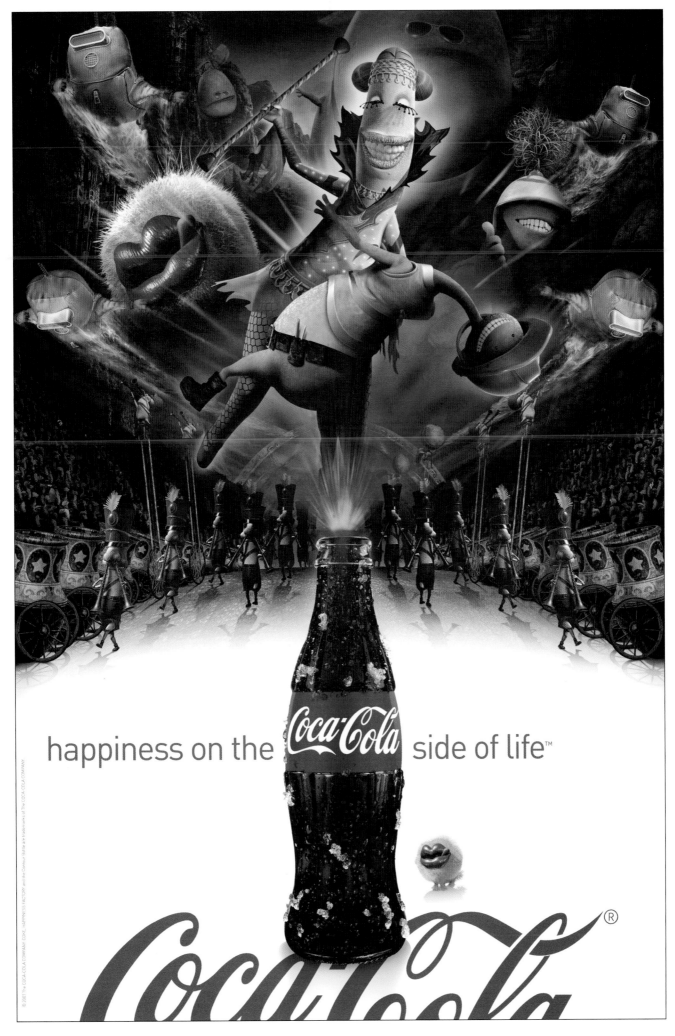

happiness on the **Coca-Cola** side of life™

artist: **Jeff Wack**
art director: John Norman, Darren Hughes, Marquis Palmer *client:* Coca-Cola *title:* Happiness Factory: Celebration *medium:* Digital *size:* 70" tall

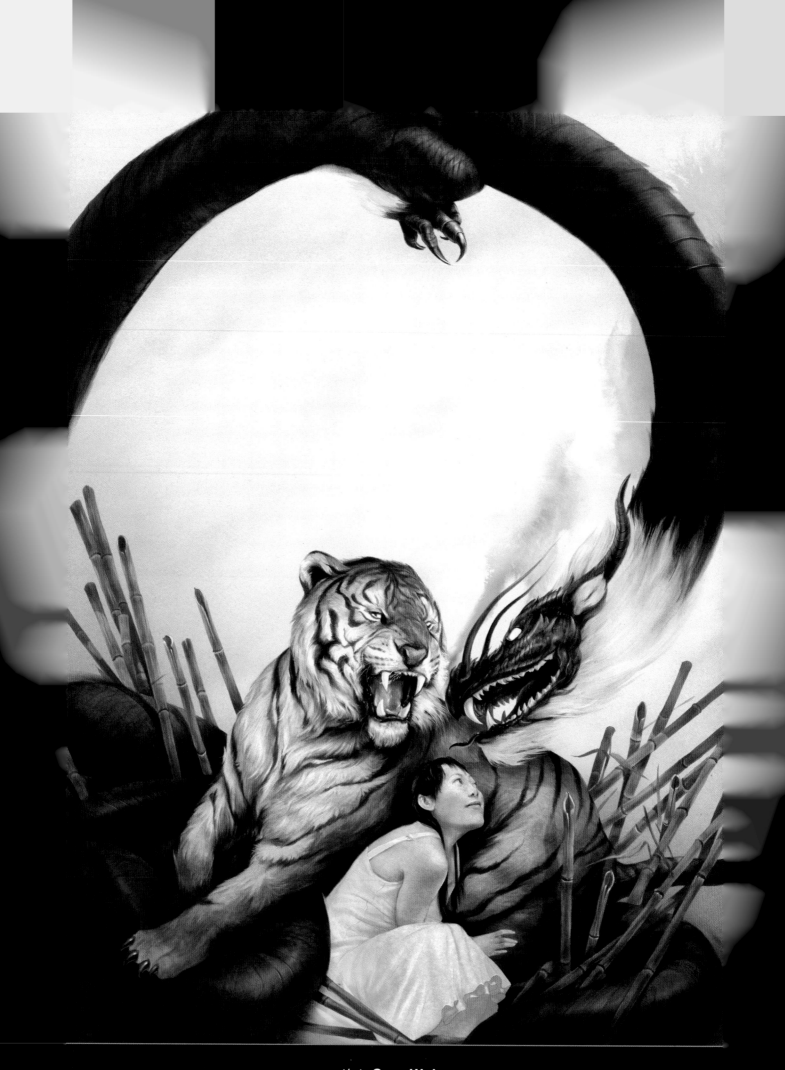

artist: **Sam Weber**

art director: Irene Gallo client: Tor Books title: Thirteen Orphans size: 7"x7" medium: Oil

artist: **Stephan Martiniere**
art director: Lou Anders *client:* Pyr Books *title:* City Without End *medium:* Digital

1 *artist:* Dopepope
art director: Dopepope *designer:* Dopepope
client: Metalman Project Book 2 *title:* Metalman with Flames
medium: Digital *size:* 11"x14"

2 *artist:* Mark Harrison
art director: Jon Oliver
client: Abaddon Books *title:* El Sombra
medium: Digital *size:* 3⁷/₈"x6³/₄"

3 *artist:* Lim Ri Kai
client: Imaginary Friends Studios *title:* Sons of Orion
medium: Digital

4 *artist:* Dylan Cole
designer: Daniel Simon
client: Design Studio Press *title:* Icetrain
medium: Digital

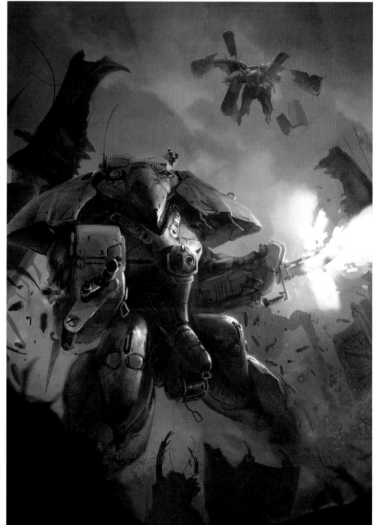

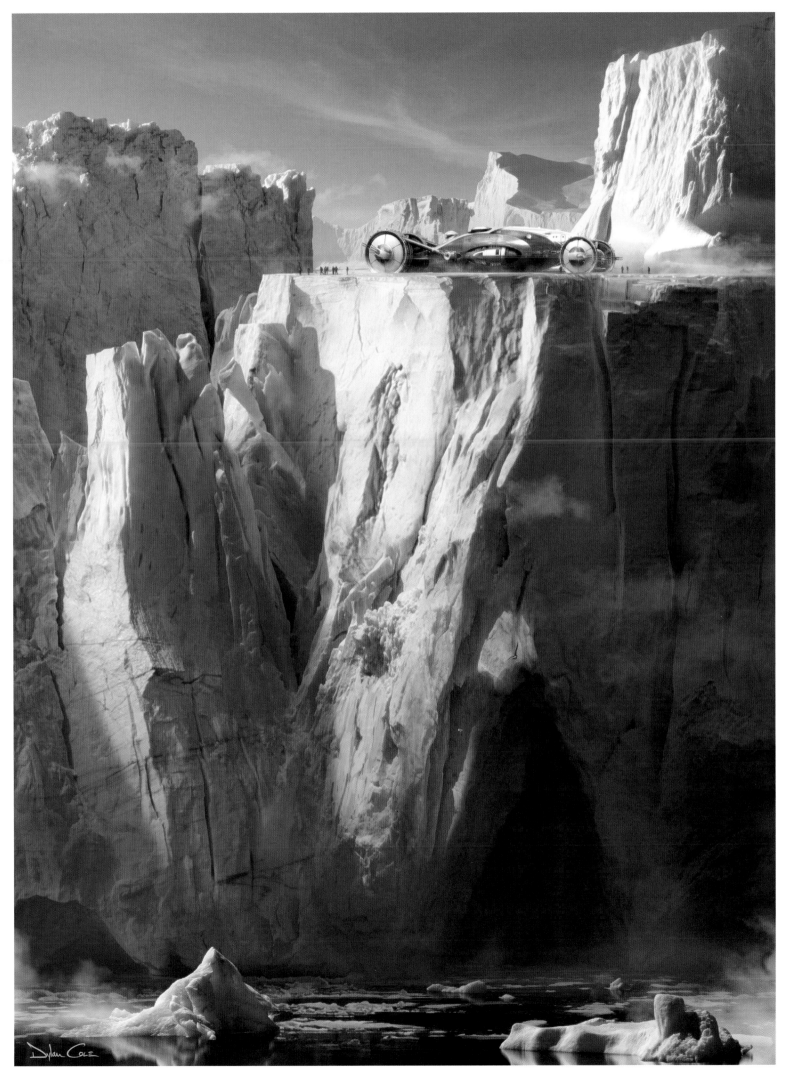

4

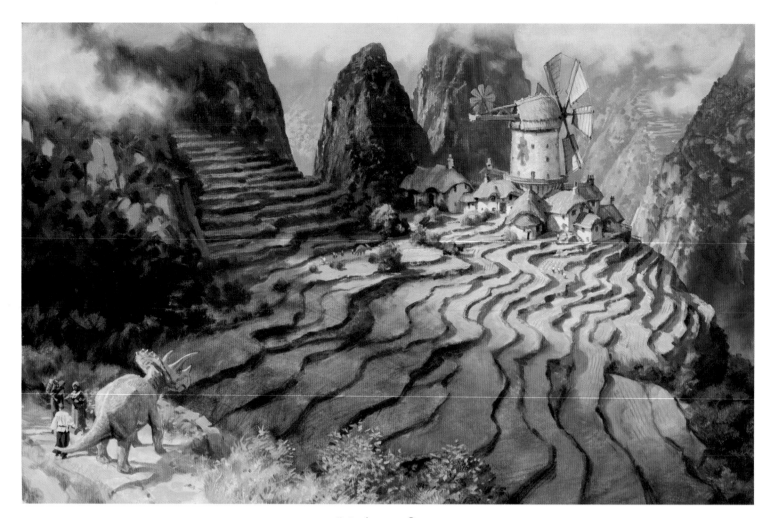

artist: **James Gurney**
art director: James Gurney *client:* Andrews McMeel Publishing LLC *title:* Windmill Village *medium:* Oil *size:* 18"x12"

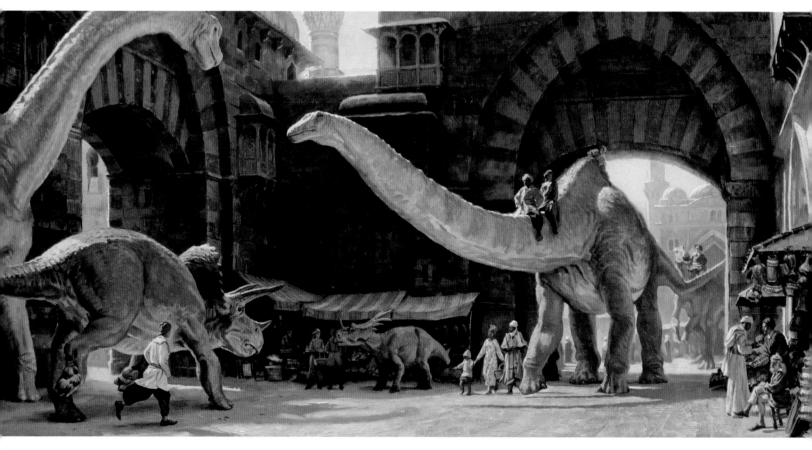

artist: **James Gurney**
art director: James Gurney *client:* Andrews McMeel Publishing LLC *title:* Market Square *medium:* Oil *size:* 28"x14"

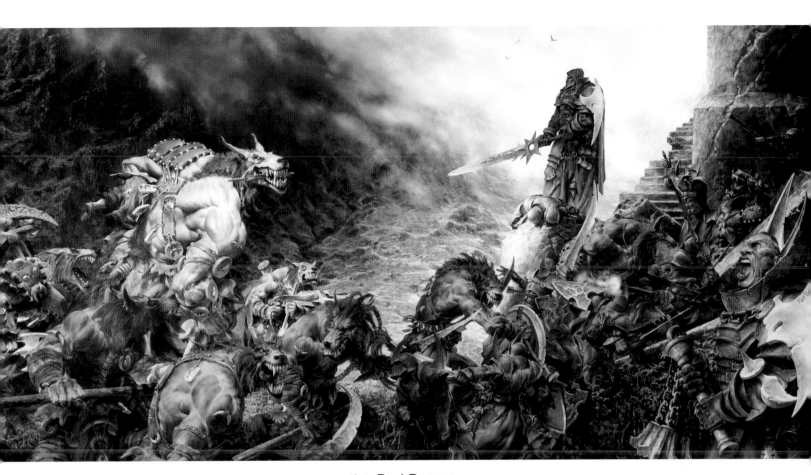

artist: **Paul Bonner**
art director: Jean Bey *client:* Rackham *title:* Confrontation *medium:* Watercolor *size:* 31$^{1}/_{2}$"x19$^{5}/_{8}$"

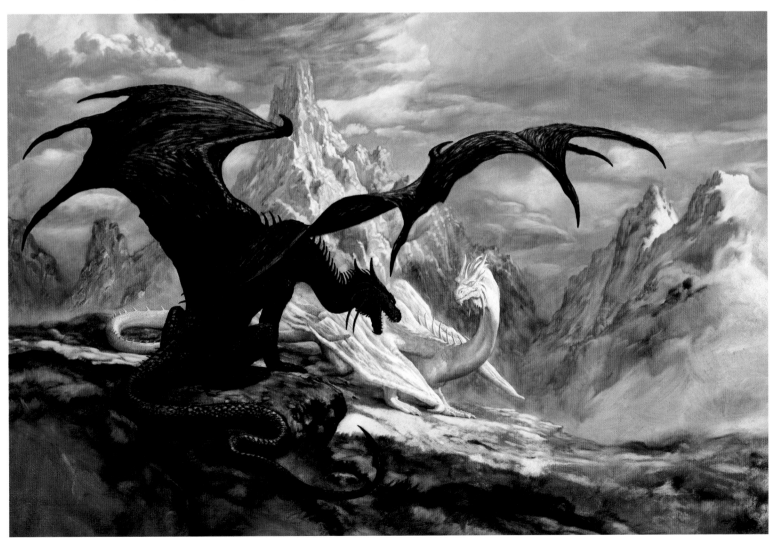

artist: **Ciruelo**
client: DAC Editions *title:* Dark Dsurion and Hobsyllwin *medium:* Oil *size:* 27"x20"

1 *artist:* **Jon Foster**
art director: Bill Schafer
client: Subterranean Press *title:* Dreadful Skin
medium: Digital

2 *artist:* **E.M. Gist**
art director: Dawn Murin *designer:* Dawn Murin
client: Wizards of the Coast *title:* The Howling Delvie
medium: Oil *size:* 24"x40"

3 *artist:* **Lucas Graciano**
art director: Julie Joubinaux
client: Quarto Publishing *title:* Psycopomp
medium: Oil *size:* 12"x16"

4 *artist:* **Jon Foster**
art director: Irene Gallo
client: Tor Books *title:* Dark Harvest
medium: Digital

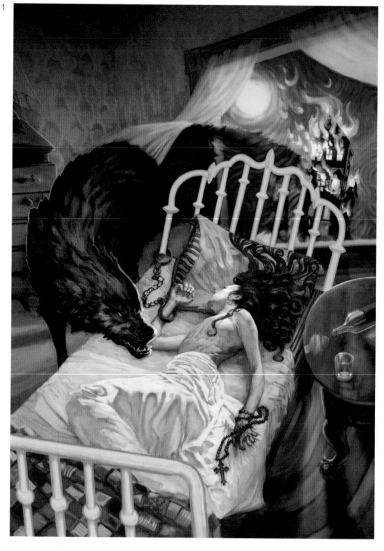

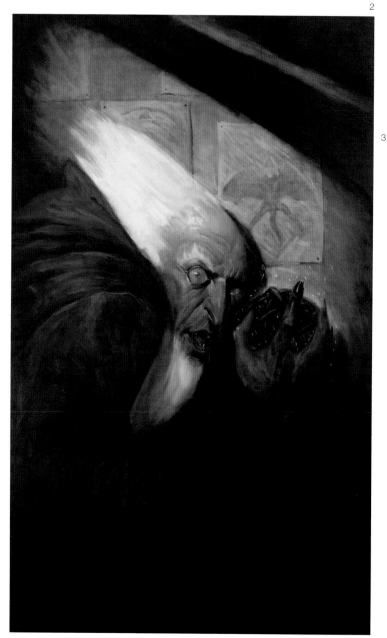

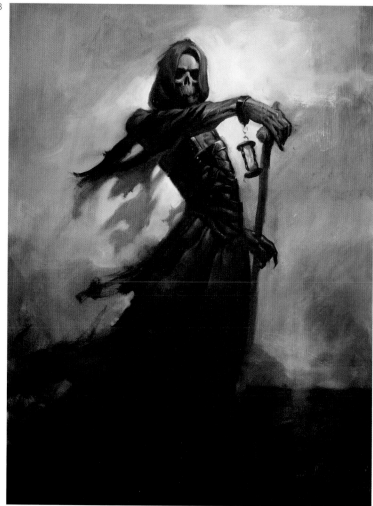

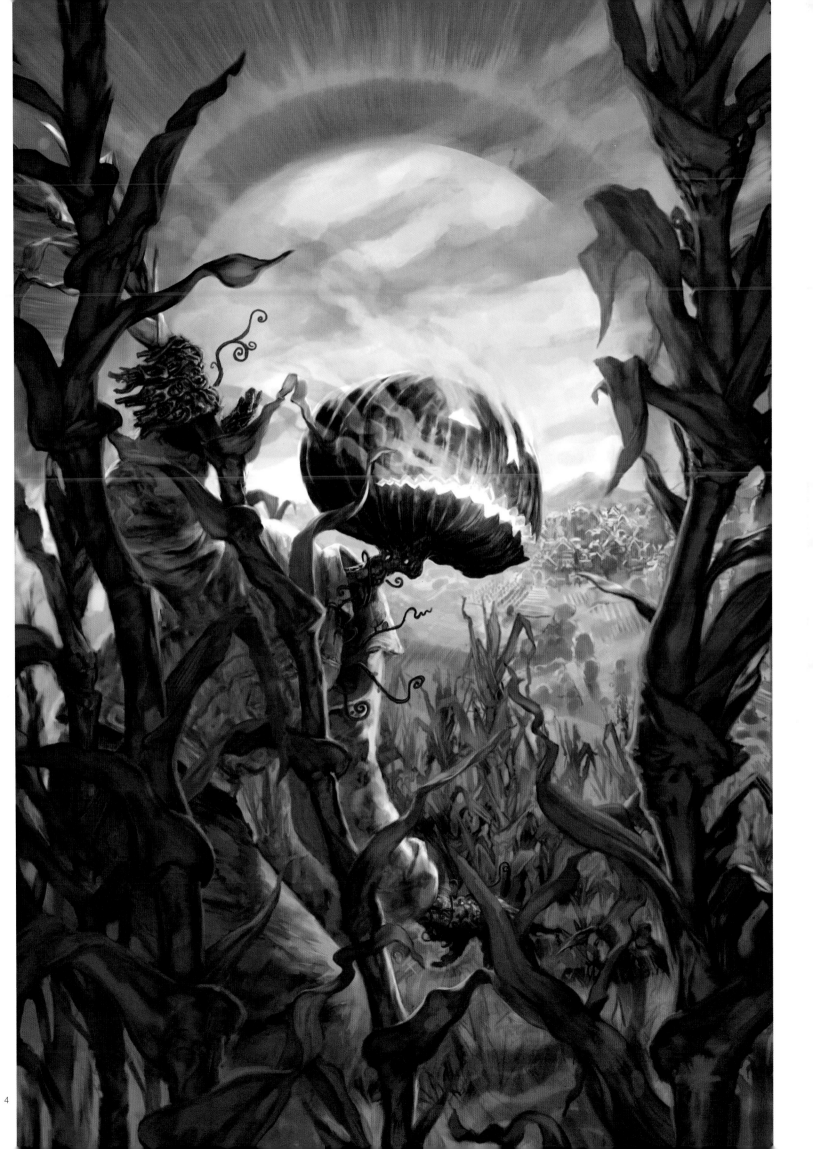

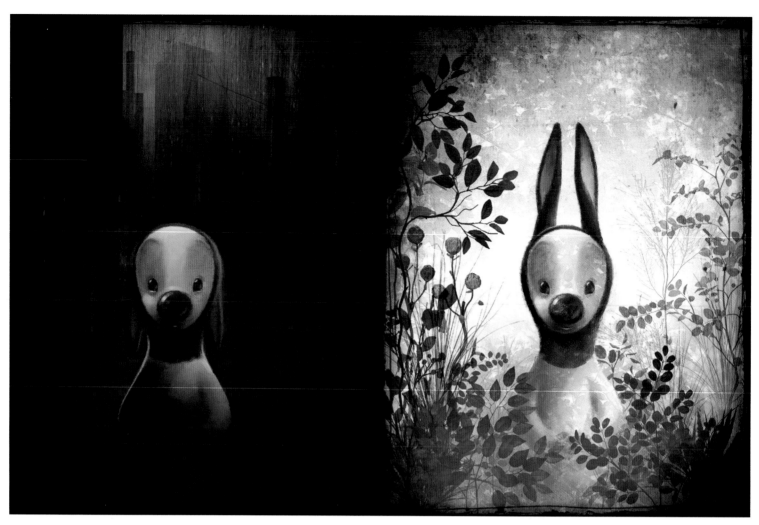

artist: **Marc Craste**
art director: Mike Jolley client: Templar Publishing title: Varmints [cover] medium: Digital

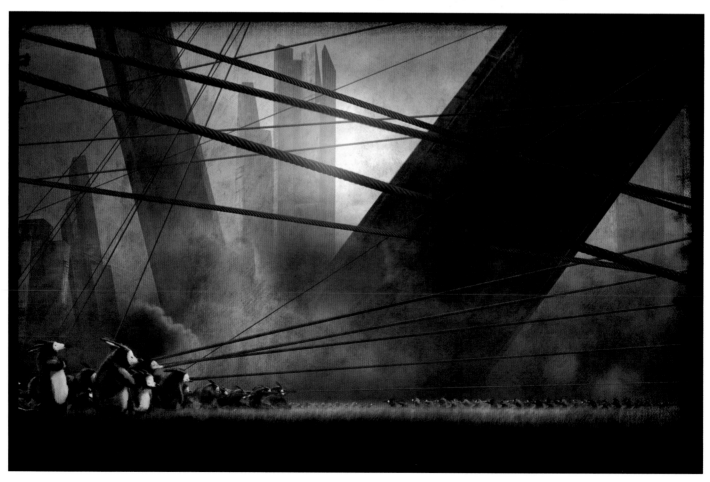

artist: **Marc Craste**
art director: Mike Jolley client: Templar Publishing title: Varmints [inside spread] medium: Digital

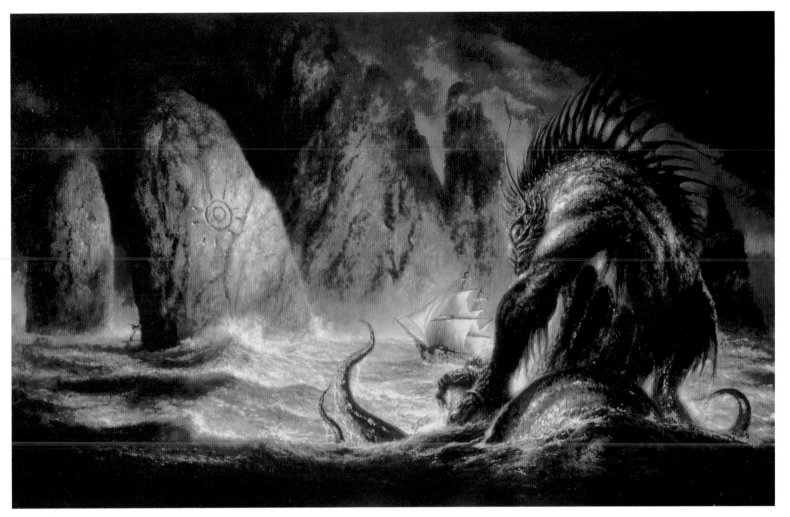

artist: **Bob Eggleton**
designer: Gail Cross *client:* Subterranean Press *title:* Dagon *medium:* Oil *size:* 30"x17"

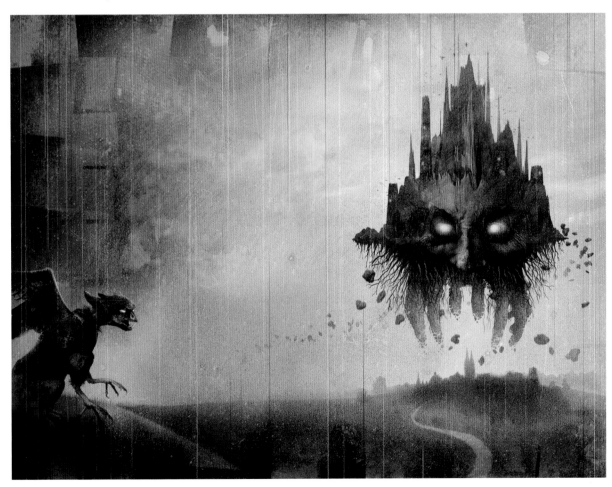

artist: **David Seidman**
art director: Dawn Murin *designer:* Dawn Murin *client:* Wizards of the Coast *title:* Obsidian Ridge *medium:* Digital *size:* 9¹/₂"x7"

1 *artist:* **Donato Giancola**
art director: Matthew Kalamidas
client: The Science Fiction Book Club *title:* Shaman
medium: Oil on paper on panel
size: 24"x36"

2 *artist:* **E.M. Gist**
art director: Dawn Murin *designer:* Dawn Murin
client: Wizards of the Coast *title:* Stardeep
medium: Oil *size:* 24"x40"

3 *artist:* **Dan Dos Santos**
art director: Irene Gallo
client: Tor Books *title:* Warbreaker
medium: Oil

4 *artist:* **Mélanie Delon**
art director: Mélanie Delon
client: Norma Editorial *title:* Elixer: Ghost of Winterland
medium: Digital

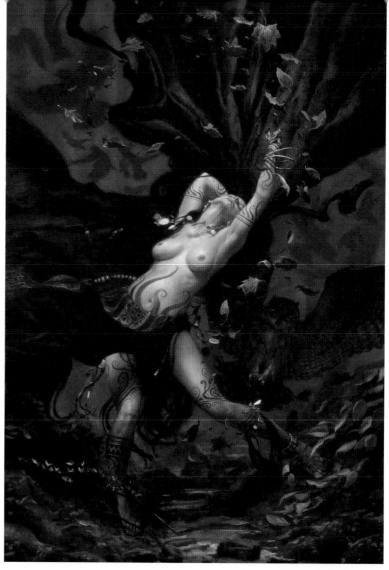

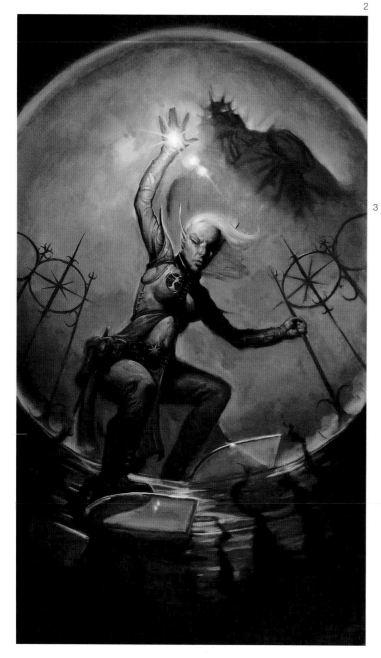

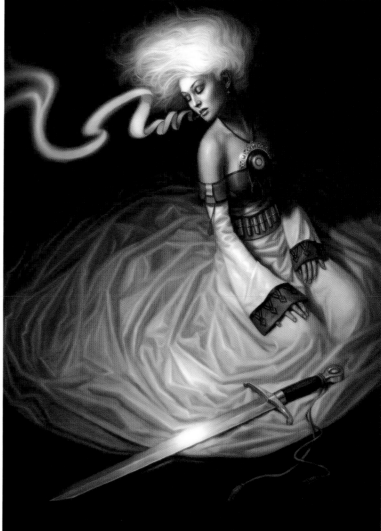

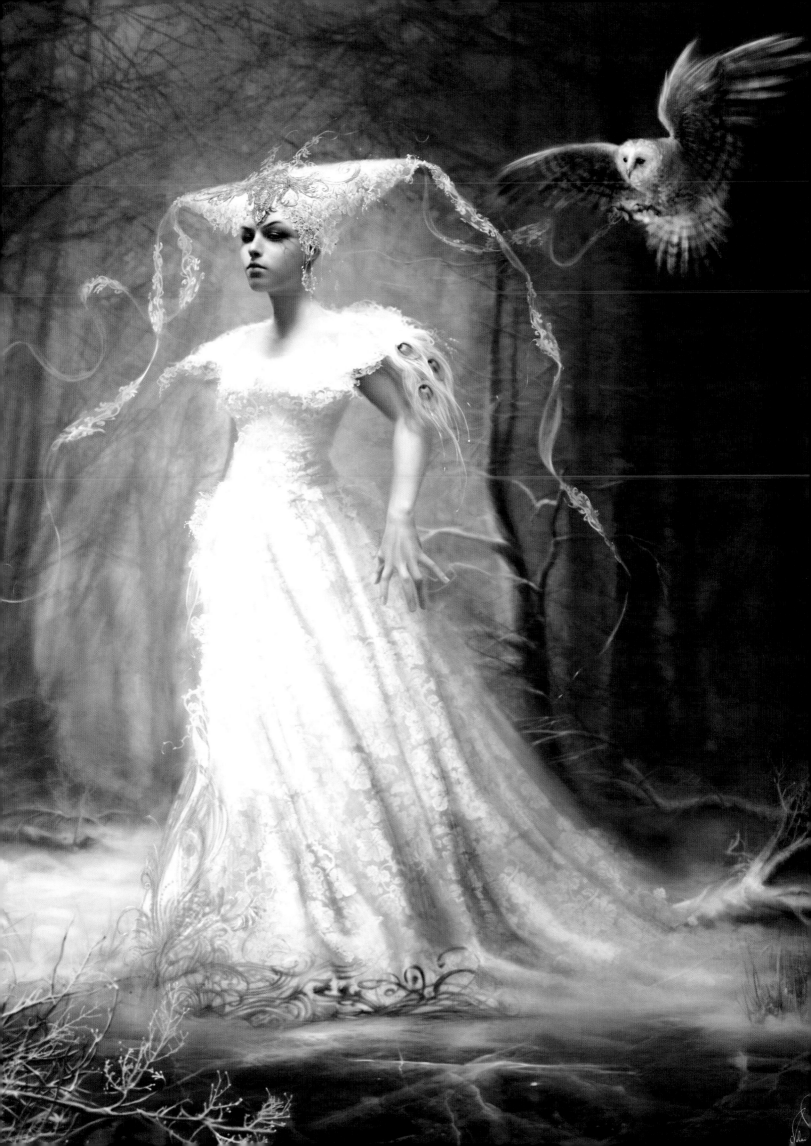

1 *artist:* **Les Edwards**
client: Cemetery Dance *title:* The British Invasion
medium: Oil *size:* 12¹/₂"x19"

2 *artist:* **Keith Thompson**
client: Quarto *title:* Apollonian Wight
medium: Mixed *size:* 5"x11"

3 *artist:* **Miles Teves**
art director: Frank Hopkinson
client: Salamander Books *title:* Creatures of the Night
medium: Pencil/digital *size:* 11"x17"

4 *artist:* **Miles Teves**
art director: Frank Hopkinson
client: Pavilion Books *title:* Creating a Vampire
medium: Pencil/digital *size:* 10"x12"

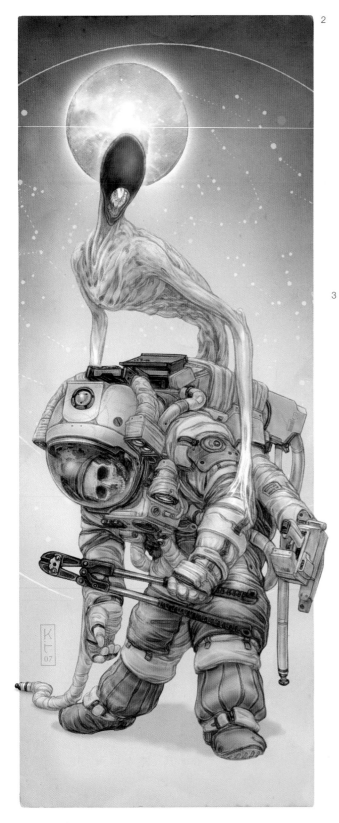

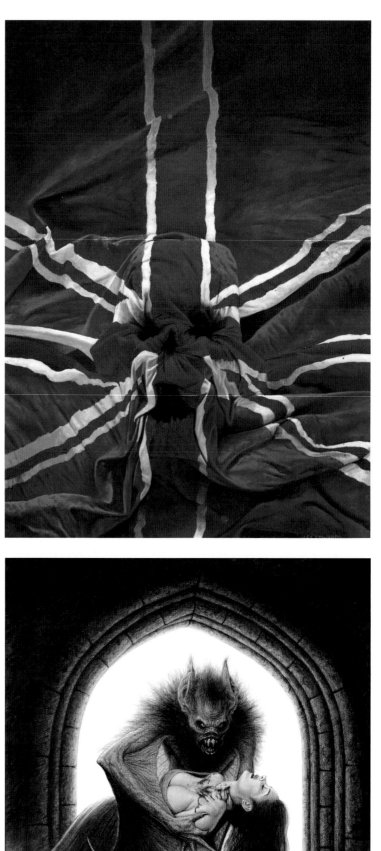

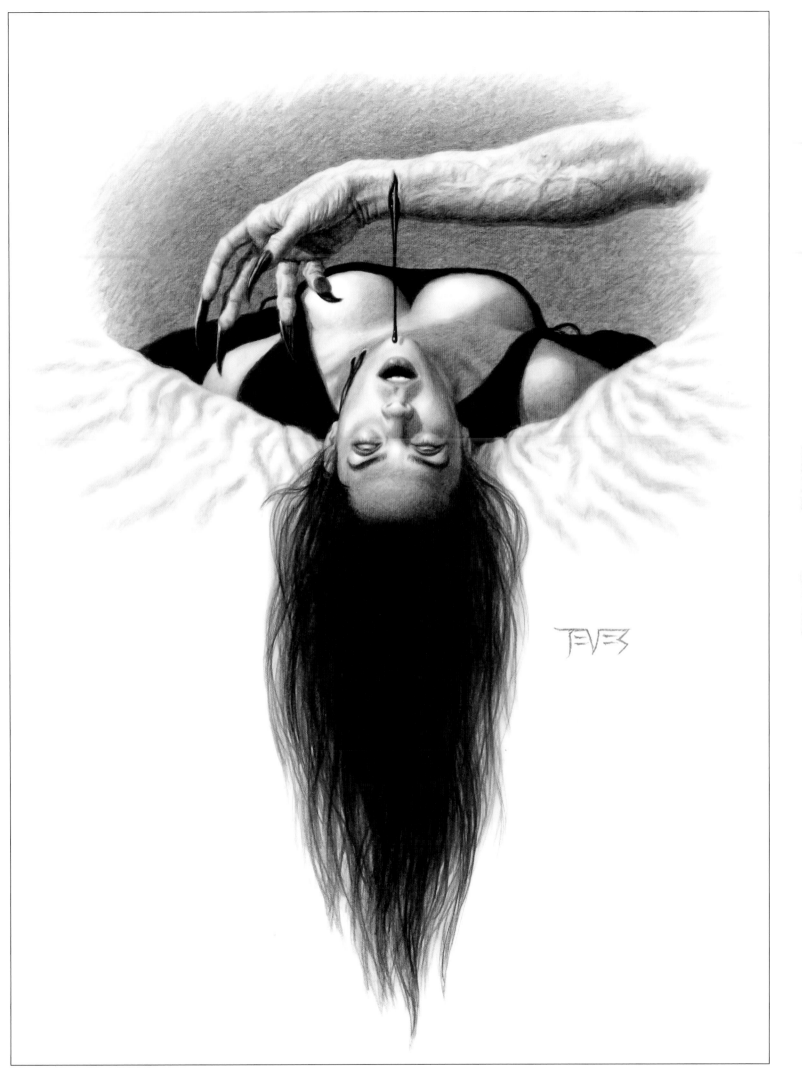

1
artist: **John Jude Palencar**
art director: Irene Gallo
client: Tor Books
title: Widdershins
medium: Acrylics
size: 19"x23"

2
artist: **John Jude Palencar**
art director: David Stevenson
client: Ballantine Books
title: The Horror in the Museum
medium: Acrylics
size: 36"x12¼"

3
artist: **Charles Vess**
art director: Nancy Brennan
client: Viking Books
title: The Coyote Road
medium: Colored inks
size: 11"x17"

4
artist: **Omar Rayyan**
art director: Alessandra Balzer
client: Disney/Hyperion Books
title: Mistmantle 4—Raven Wars
medium: Watercolor
size: 12"x16"

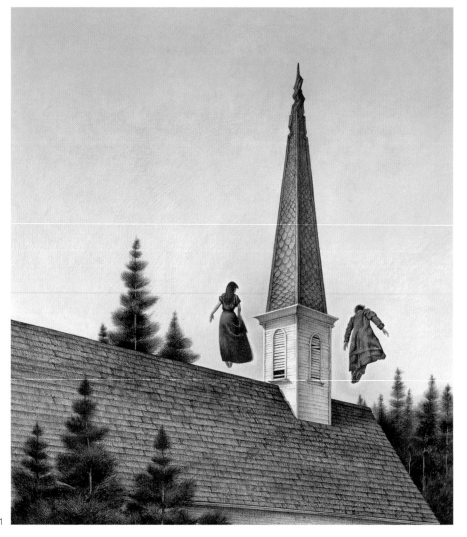

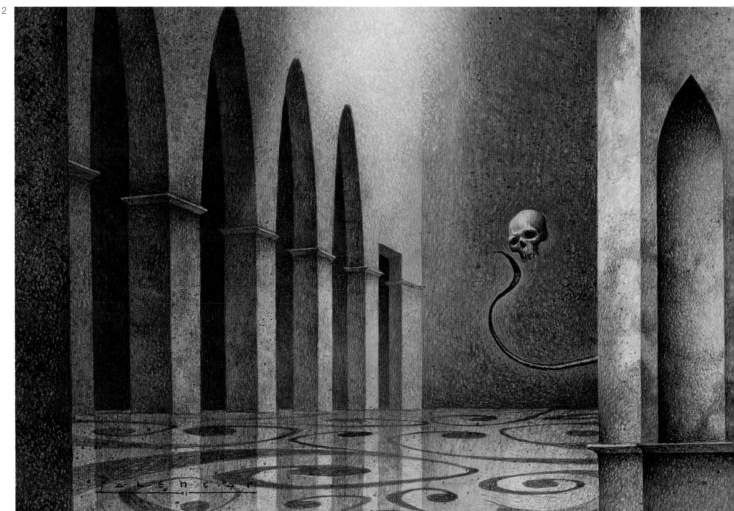

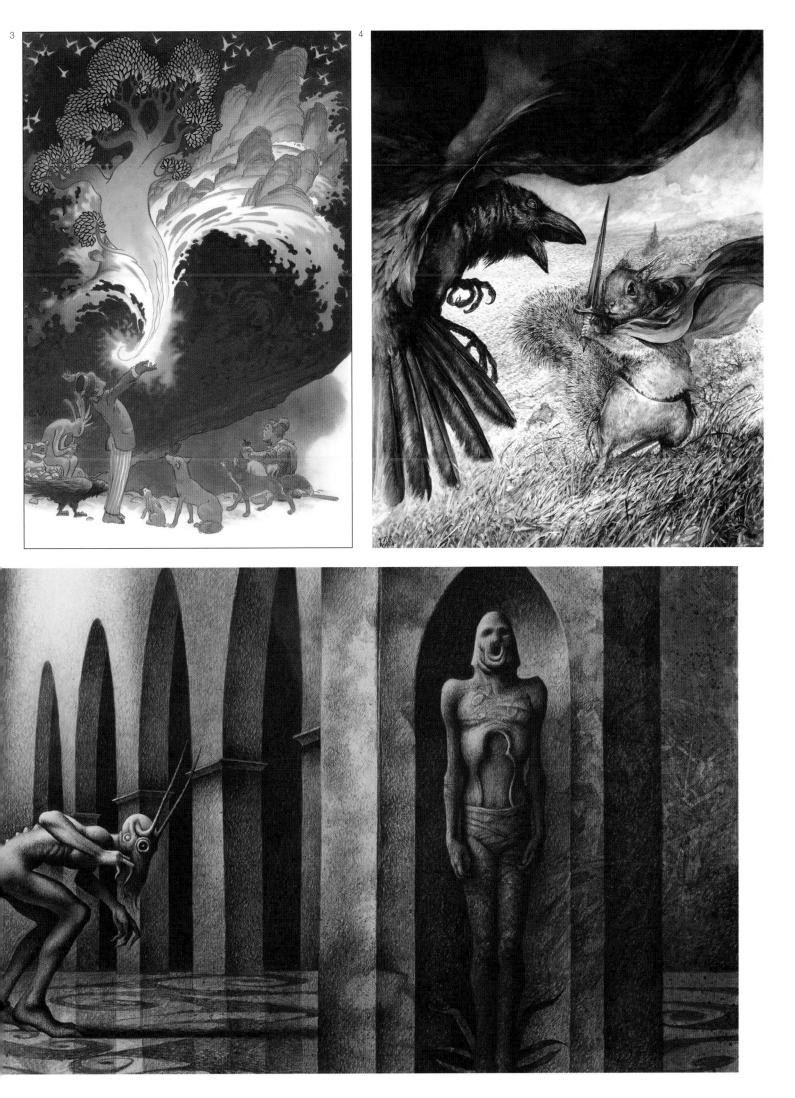

book

1 *artist:* **Stephan Martiniere**
art director: Irene Gallo
client: Tor Books *title:* Dragons of Babel
medium: Digital

2 *artist:* **J.S. Rossbach**
art director: J.S. Rossbach, Aleksi Briclot
client: Soleil Editions *title:* Portrait of Morgane
medium: Digital *size:* 9¹/₄"x16¹/₂"

3 *artist:* **Petar Meseldžija**
art director: Elizabeth Parisi *designer:* Phil Falco
client: Scholastic, Inc. *title:* Unicorn Chronicles 3
medium: Oil on Masonite *size:* 19¹/₂"x27¹/₂"

4 *artist:* **Donato Giancola**
art director: Irene Gallo
client: Tor Books *title:* The Golden Rose
medium: Oil on paper on panel *size:* 36"x48"

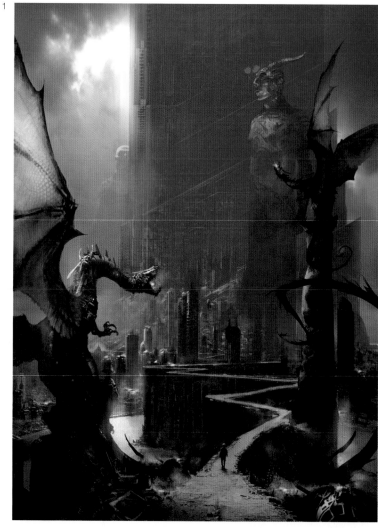

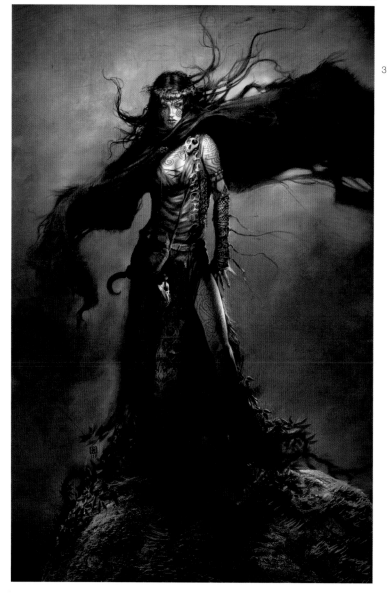

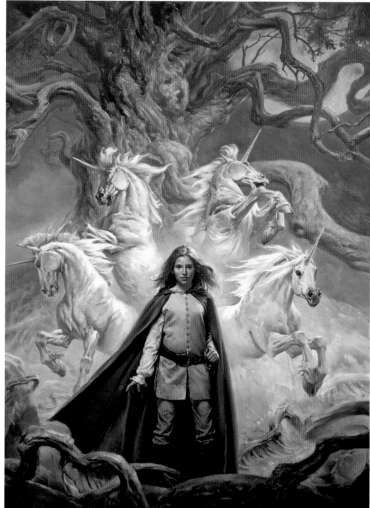

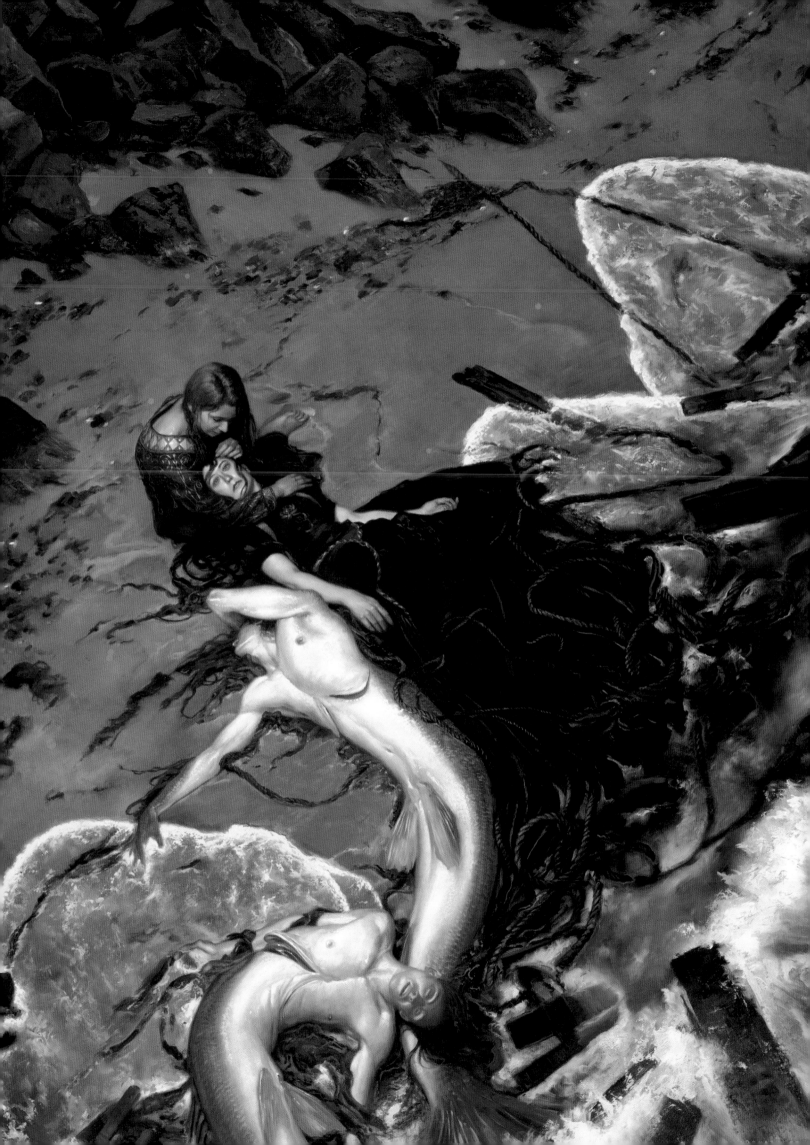

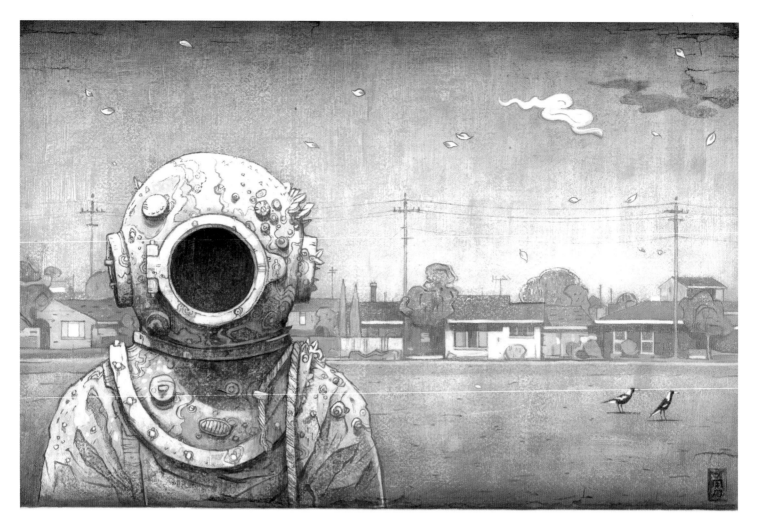

artist: **Shaun Tan**
art director: Shaun Tan designer: Shaun Tan, Inari Kiuru client: Allin & Unwin/Melbourne title: Tales From Outer Suburbia: The Diver
medium: Acrylics & oils size: 23⅝"x15¾"

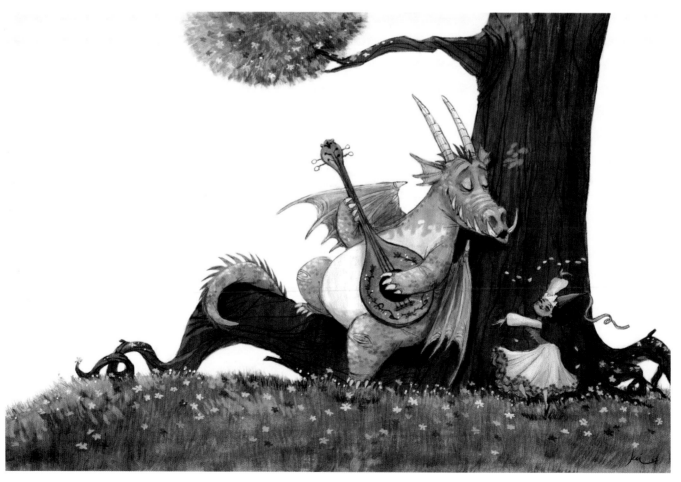

artist: **Kei Acedera**
client: Imaginism Studios title: Drago Song medium: Gouache/digital size: 10"x7"

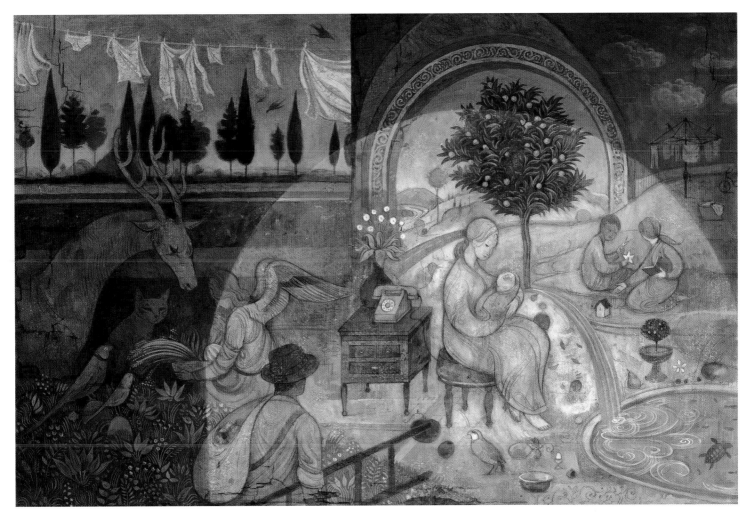

artist: **Shaun Tan**

art director: Shaun Tan designer: Shaun Tan, Inari Kiuru client: Allin & Unwin/Melbourne title: Tales From Outer Suburbia: No Other Country
medium: Acrylics, pencil, oils size: 23⅝"x15¾"

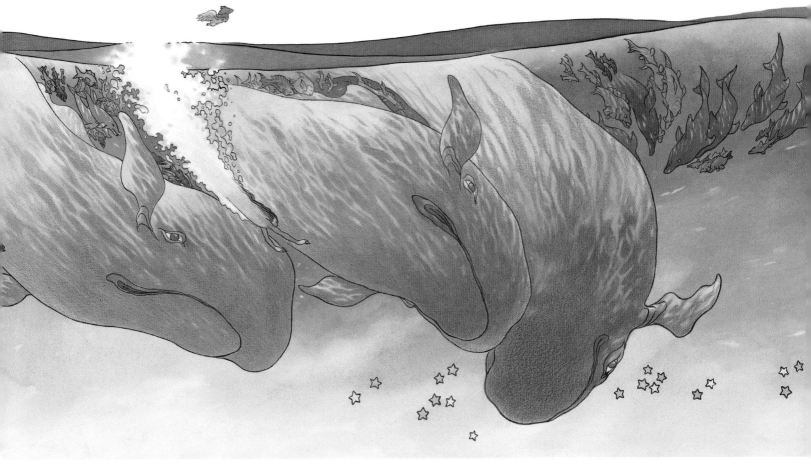

artist: **Charles Vess**

designer: Jeanne Hogel client: HarperCollins Children's Books title: Blueberry Girl medium: Colored inks size: 24"x13"

1 *artist:* **Scott Bakal**
art director: Scott Bakal
title: Hellhound On My Trail
medium: Acrylics *size:* 11"x14"

2 *artist:* **Scott Bakal**
art director: Scott Bakal
title: Crossroad Blues
medium: Acrylics *size:* 11"x14"

3 *artist:* **Yuko Shimizu**
art director: Irene Gallo
client: Tor Books *title:* They Came From Below
medium: Ink/digital

4 *artist:* **Brad Holland**
art director: Irene Gallo
client: Tor Books *title:* Somewhere In Time
medium: Oil

1

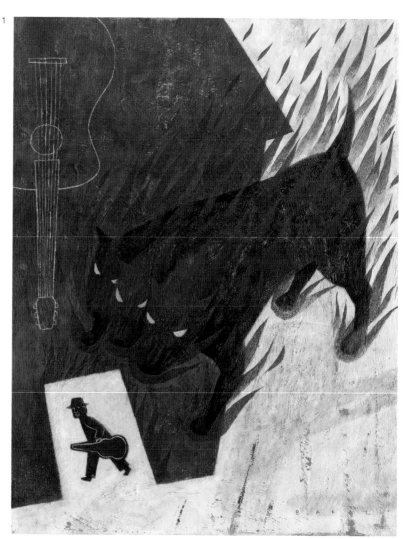

2

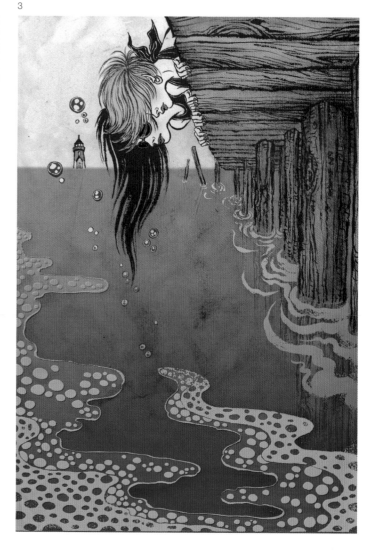

3

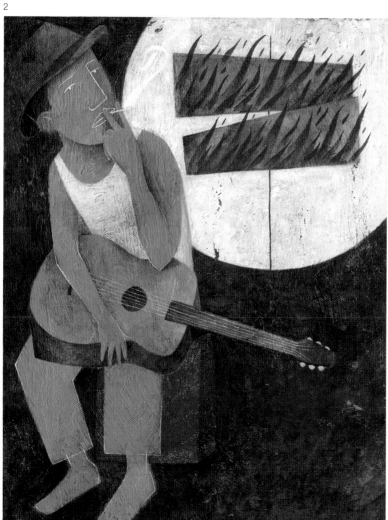

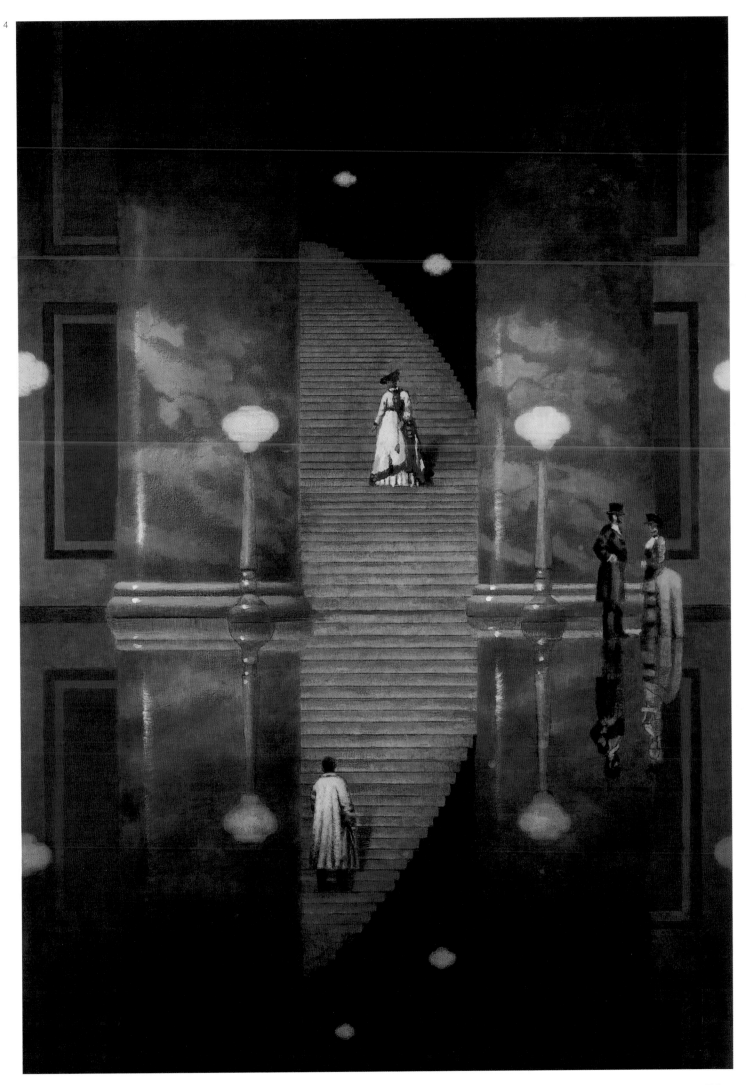

1
artist: Chris Beatrice
client: Penguin Readers
title: Gulliver in Liliput
medium: Digital
size: 7"x8"

2
artist: Tim Kirk
art director: Jane Hagaman
client: Hampton Roads Publishing
title: Lyra's Oxford
medium: Mixed
size: 12"x16"

3
artist: Agata Kawa
art director: Olivier Souillé
client: Daniel Maghen Editions
title: Three-headed Dragon
medium: Digital
size: 12"x16"

4
artist: Scott Gustafson
art director: Scott Usher, Wendy Wentworth
client: The Greenwich Workshop Press/
Favorite Nursery Rhymes from Mother Goose
title: Simple Simon
medium: Oil on panel *size:* 14"x16"

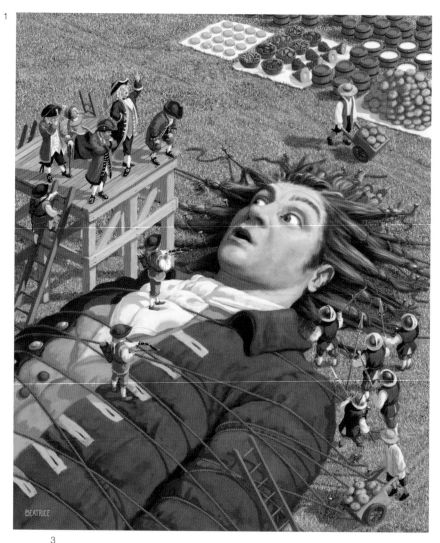

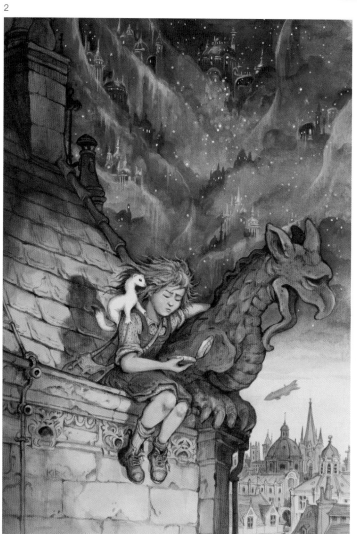

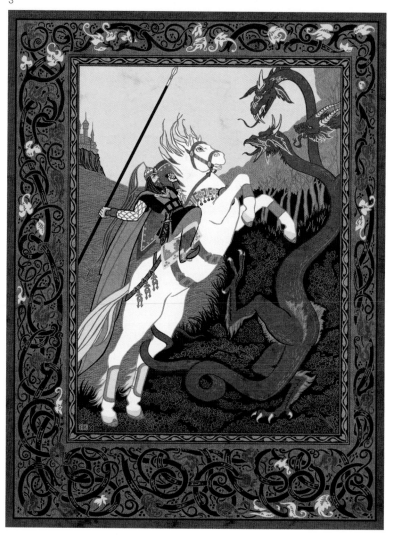

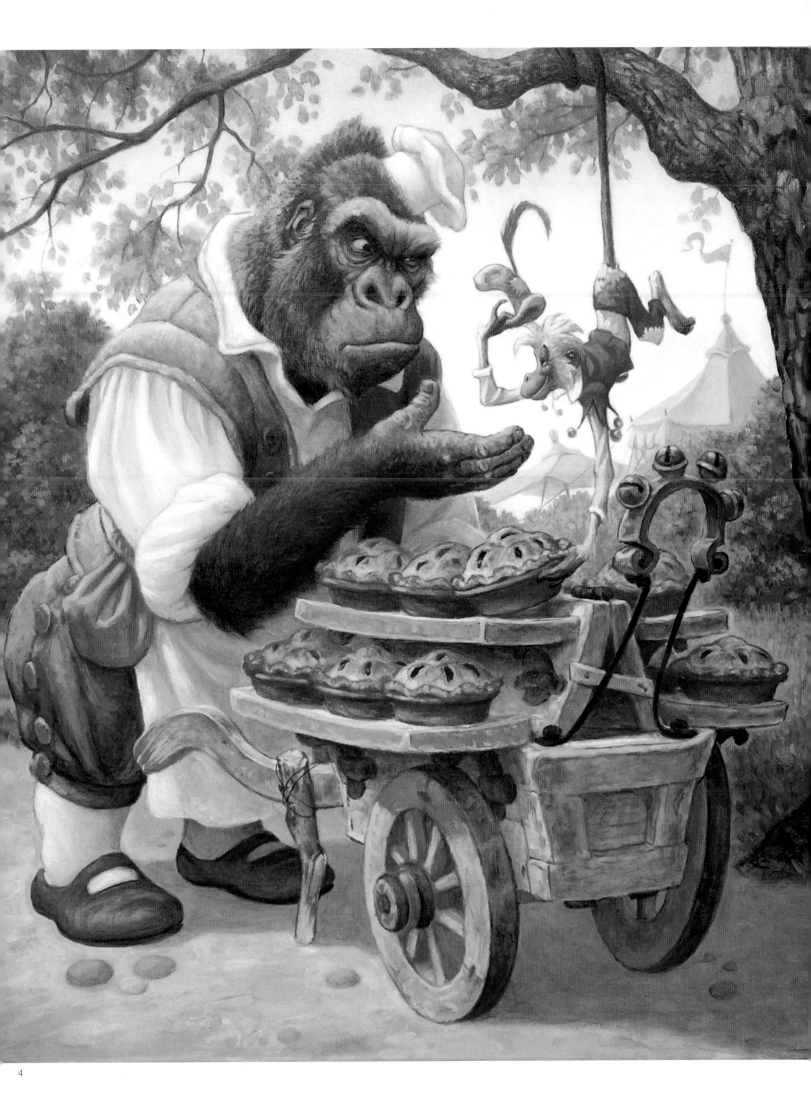

4

1 *artist:* John Picacio
art director: Betsy Mitchell *client:* Ballantine/Del Rey
title: Elric Vol. 1: Elric the Damned
medium: Pencil on crescent board
size: 11"x17"

2 *artist:* Vance Kovacs
art director: Deborah Kaplan
client: Dial Books
title: Seeing Redd
medium: Digital

3 *artist:* Franz Vohwinkel
art director: Sascha Manczak
client: Heyne Publishing House
title: Tristopolis II
medium: Digital *size:* 6$^7/_8$"x9$^1/_2$"

4 *artist:* Mélanie Delon
art director: Mélanie Delon
client: Norma Editorial
title: Elixir-Lya *medium:* Digital

5 *artist:* Keith Thompson
client: Quarto *title:* Viracmia
medium: Mixed *size:* 9$^7/_8$"x15"

6 *artist:* Christopher Gibbs
art director: Matt Adelsperger
client: Wizards of the Coast
title: The Man On the Ceiling
medium: Digital

1

2

3

5

6

1
artist: Matt Wilson
client: Privateer Press
title: White Out
medium: Oil on board
size: 20"x26"

2
artist: Jim & Ruth Keegan
art director: Marcelo Anciano
client: Random House
title: Valley of the Worm
medium: Ink wash on board
size: 15"x20"

3
artist: Jason Chan
art director: Irene Gallo
client: Tor Books
title: Dragon's Lair
medium: Digital

4
artist: Paul Bonner
art director: Theo Bergquist
designer: Paul Bonner
client: Riotminds
title: Trudvangs Aventyrare
medium: Watercolor
size: 11⁷/₈"x19⁵/₈"

1

2

3

1 *artist:* **Patrick Arrasmith**
art director: William K. Schafer
client: Subterranean Press
title: New Amsterdamn
medium: Scratchboard/digital
size: 7"x10"

2 *artist:* **Dan Dos Santos**
art director: Deborah Kaplan
client: Firebird
title: Indigara
medium: Oil

3 *artist:* **Glen Orbik**
art director: Irene Gallo
designer: Glen Orbik, Laurel Blechman
client: Tor Books *title:* The Automatic Detective
medium: Oil *size:* 15"x22"

4 *artist:* **Dan Dos Santos**
art director: Jeremy Lassen
client: Nightshade Books
title: Butcher Bird
medium: Oil

4

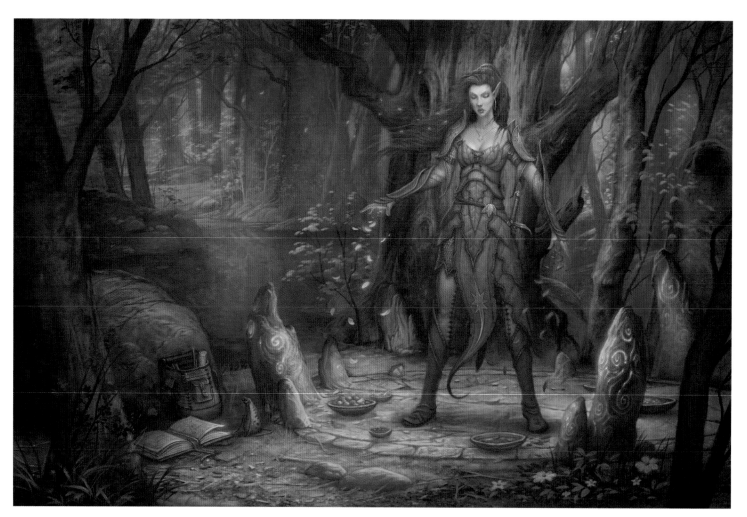

artist: **Howard Lyon**
art director: Stacy Longstreet client: Wizards of the Coast title: Elf Warlock medium: Digital size: 8"x5"

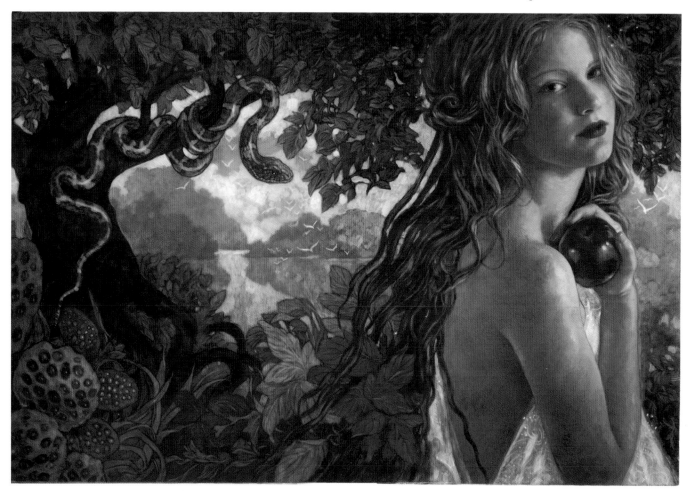

artist: **Rebecca Guay**
art director: Deb Sfetsios client: Simon & Schuster title: Drago Song medium: Oil size: 18½"x12½"

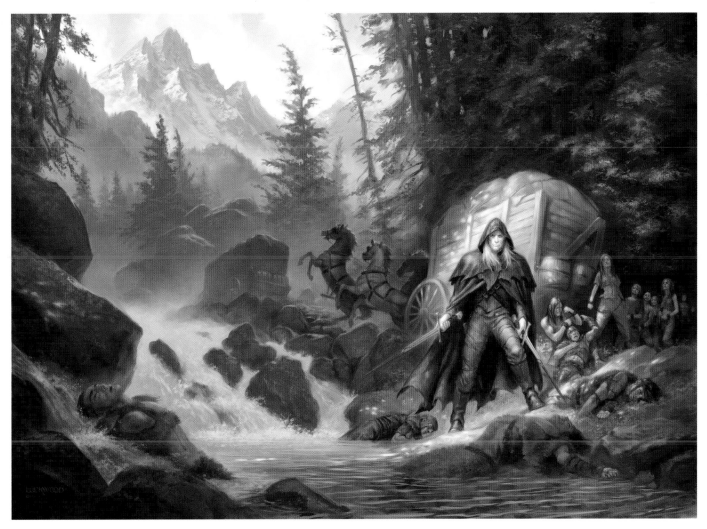

artist: **Todd Lockwood**
art director: Irene Gallo *client:* Tor Books *title:* Reaper's Gale *medium:* Digital *size:* 24"x15"

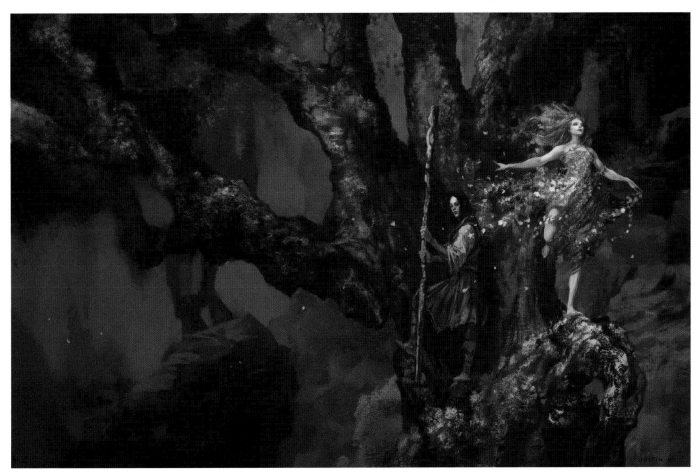

artist: **Justin Sweet**
art director: Deborah Kaplan *client:* Penguin Books *title:* Rhiannon *medium:* Digital

1 *artist:* **Jesper Ejsing**
art director: Christian Petersen
client: Fantasy Flight Games
title: Frozen Wasteland
medium: Acrylics *size:* 16"x19"

2 *artist:* **Paul Bonner**
art director: Theo Bergquist
designer: Paul Bonner
client: Riotminds
title: Stormländare
medium: Watercolor *size:* 6"x9"

3 *artist:* **Ralph Horsley**
art director: Zoe Wedderburn
client: Games Workshop
title: Curse of the Necrarch
medium: Acrylics *size:* 11"x18"

4 *artist:* **Eric Fortune**
art director: Irene Gallo
client: Tor Books
title: The Red Magician
medium: Acrylics *size:* 18"x30"

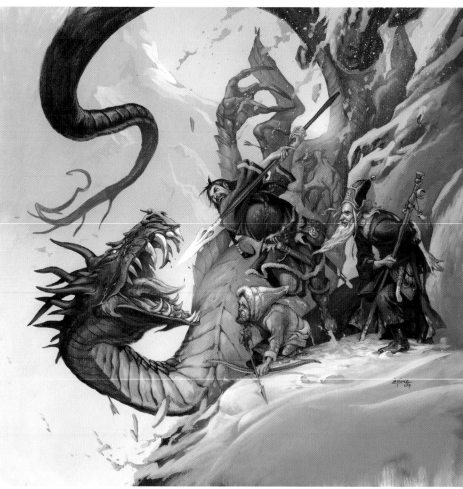

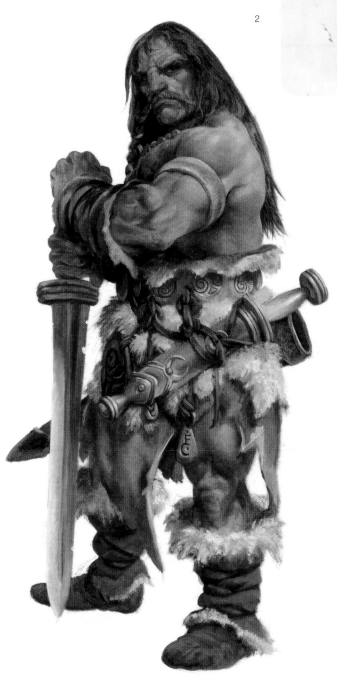

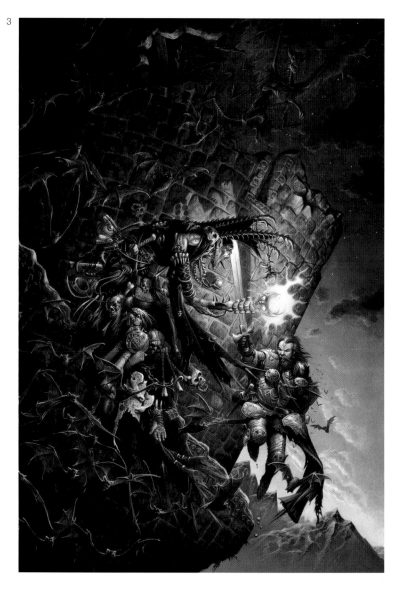

4

1 *artist:* Scott M. Fischer
art director: Lisa Vega
client: Simon & Schuster *title:* Daily Squealer #1
medium: Digital

2 *artist:* Karl Kopinski
art director: Paolo Parente
client: Rackham *title:* Karman Troops
medium: Oil *size:* 23¹⁄₂"x15¹⁄₂"

3 *artist:* John Harris
art director: Irene Gallo
client: Tor Books *title:* Zoe's Tale
medium: Oil on canvas *size:* 24"x30"

4 *artist:* Vincent Proce/Stephan Martiniere
art director: Sheila Gilbert
client: DAW Books *title:* Starstrike 2
medium: Photoshop *size:* 20¹⁄₂"x30¹⁄₄"

5 *artist:* Stephan Martiniere
art director: Lou Anders
client: Pyr *title:* A World Too Near
medium: Digital

6 *artist:* Stephan Martiniere
art director: Lou Anders
client: Pyr *title:* Brazyl
medium: Digital

1

2

1
artist: J.S. Rossbach
art director: J.S. Rossbach, Aleksi Briclot
client: Soleil Editions
title: The Dragon's Breath
medium: Digital
size: 10¹/₂"x9"

2
artist: Kinuko Y. Craft
art director: Melissa Nelson
client: Random House
title: Cybele's Secret
medium: Oil on gesso panel
size: 17"x22¹/₂"

3
artist: William Stout
art director: Olivier Souillé
designer: William Stout
client: Galerie Daniel Maghen
title: Feeding Time
medium: Ink & watercolor on board
size: 9"x13"

4
artist: J.S. Rossbach
art director: J.S. Rossbach, Aleksi Briclot
client: Soleil Editions
title: Assassination of the Priestess of Avalon
medium: Digital
size: 10¹/₂"x16"

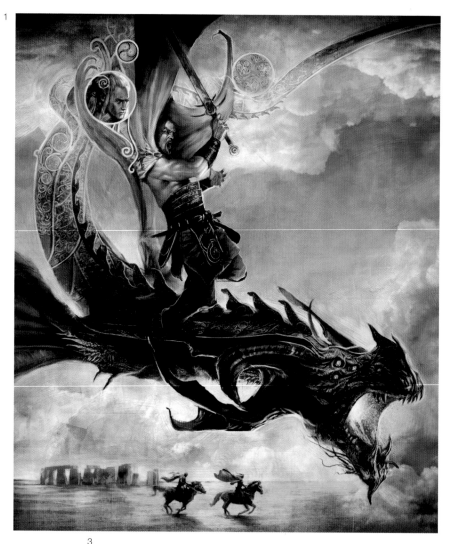

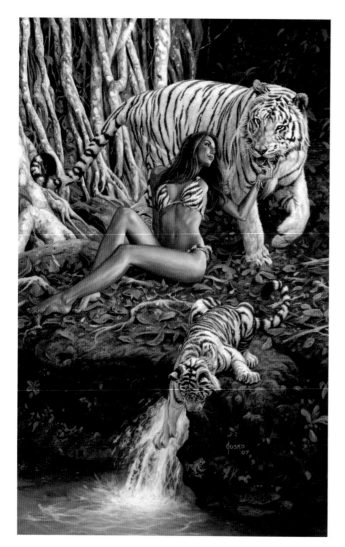

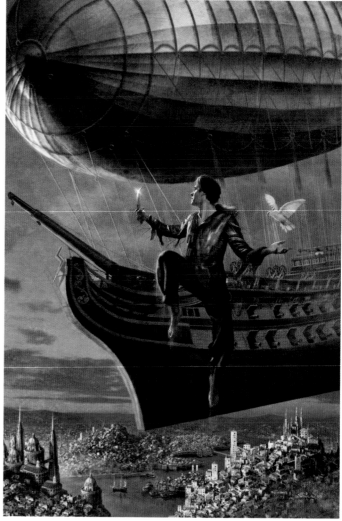

artist: **Joe Jusko**
client: Desperado Publishing *title:* Restful Interlude
medium: Acrylics *size:* 12"x19"

artist: **Stephen Youll**
art director: Jamie Warren *client:* Bantam Books *title:* Thunderer
medium: Digital *size:* 16"x24"

artist: **Dice Tsutsumi**
designer: Hiroko Mizuno *client:* Vertical, Inc. *title:* Season of Infidelity *medium:* Digital *size:* 12"x8½"

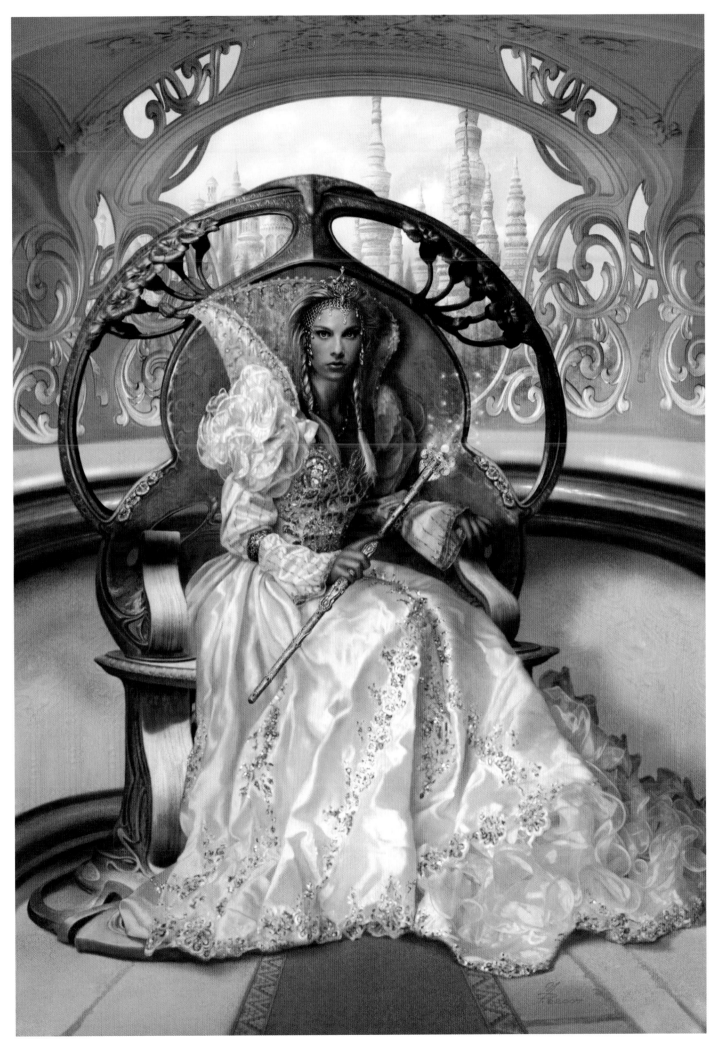

artist: **Paul Youll**
art director: Ray Lundgren *client:* Penguin/Roc *title:* Hell and Earth *medium:* Digital

1 *artist:* Shaun Tan
designer: Shaun Tan, Inari Kiuru
client: Allen Unwin, Melbourne
title: Tales From Outer Suberbia:
Wake
medium: Graphite pencil
size: 11⁷/₈"x11⁷/₈"

2 *artist:* John Walker
art director: Jason Kayser
designer: John Walker
client: Running Press Publishing
title: Alien Tagging
medium: Digital *size:* 12"x5¹/₂"

3 *artist:* Omar Rayyan
art director: Deb Geisler
client: NESFA Press
title: The One Right Thing
medium: Watercolor
size: 12"x17"

4 *artist:* Tony DiTerlizzi
art director: Lizzy Bromley
client: Simon & Schuster
title: Kenny and the Dragon
medium: Acrylics, gouache
size: 15"x20"

5 *artist:* Scott Gustafson
art director: Scott Usher
client: The Greenwich Workshop
title: The Man in the Moon
medium: Oil on panel
size: 20"x22"

6 *artist:* Scott Gustafson
art director: Scott Usher
client: The Greenwich Workshop
title: Little Tommy Tucker
medium: Oil on panel
size: 12"x14"

1

2

1 *artist:* David Ho
art director: David Stevenson
client: Random House *title:* The Engine's Child
medium: Digital *size:* 5¹/₂"x8¹/₂"

2 *artist:* Tristan Elwell
art director: Donna Mark
client: Bloomsbury *title:* Dussie
medium: Oil on board *size:* 8¹/₄"x12"

3 *artist:* Greg Swearingen
art director: Vaughn Andrews
client: Harcourt *title:* Garden of Eve
medium: Mixed *size:* 12"x14"

4 *artist:* Cathy Wilkins
art director: Craig Grant
client: White Wolf *title:* Bloodlines: the Chosen
medium: Digital *size:* 16¹/₂"x20¹/₂"

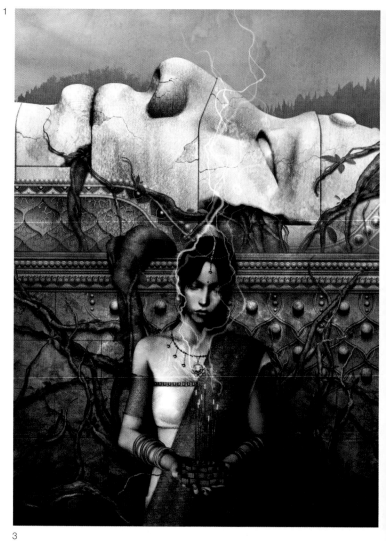

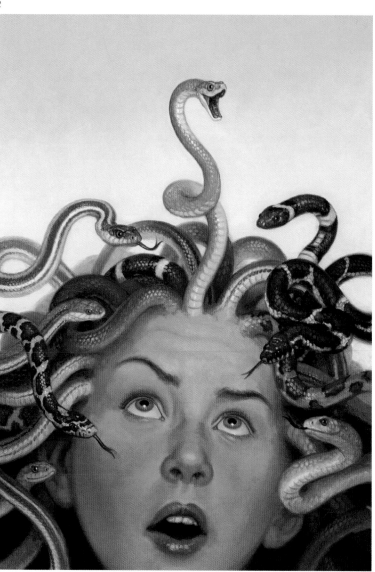

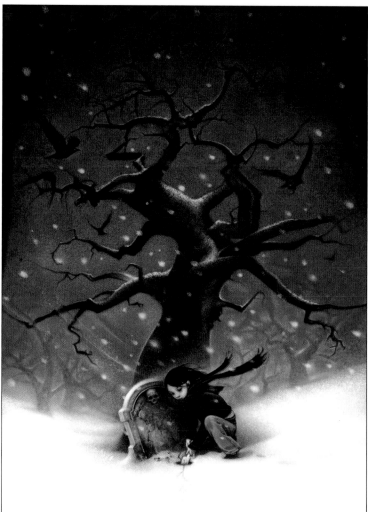

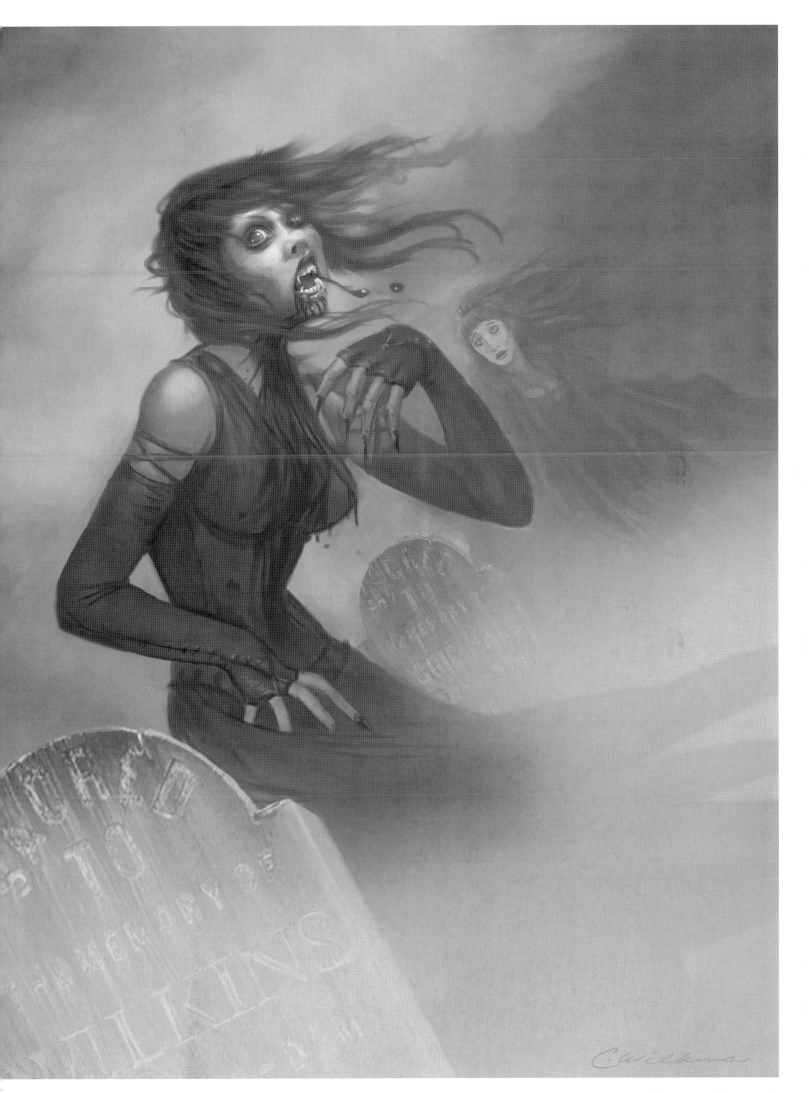

1
artist: **Matt Stawicki**
art director: Matt Adelsperger
client: Wizards of the Coast
title: Secret of Pax Tharkas
medium: Digital

2
artist: **Mélanie Delon**
art director: Mélanie Delon
client: Norma Editorial
title: Elixir-Columbine
medium: Digital

3
artist: **David Grove**
art director: Irene Gallo
client: Tor Books
itle: Pirate Freedon Chapter
medium: Pencil
size: 11"x14"

4
artist: **Shelly Wan**
art director: Irene Gallo
client: Tor Books
title: Mad Kestrel
medium: Digital

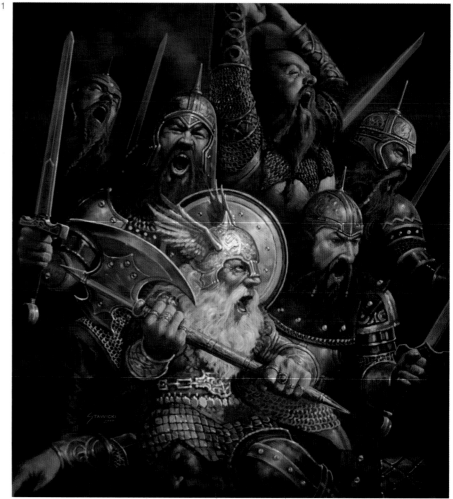

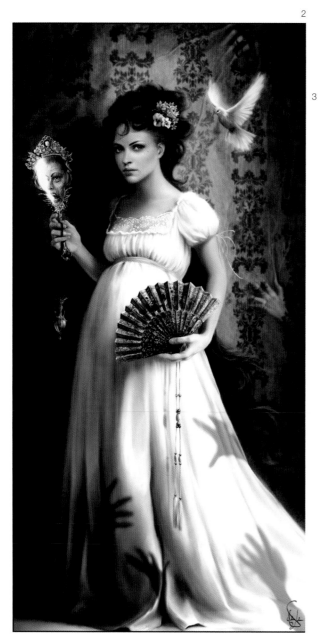

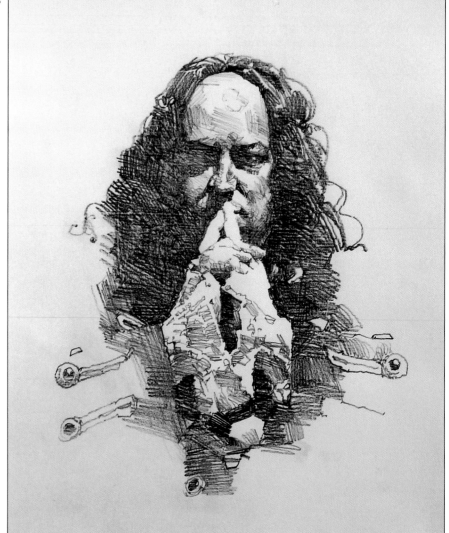

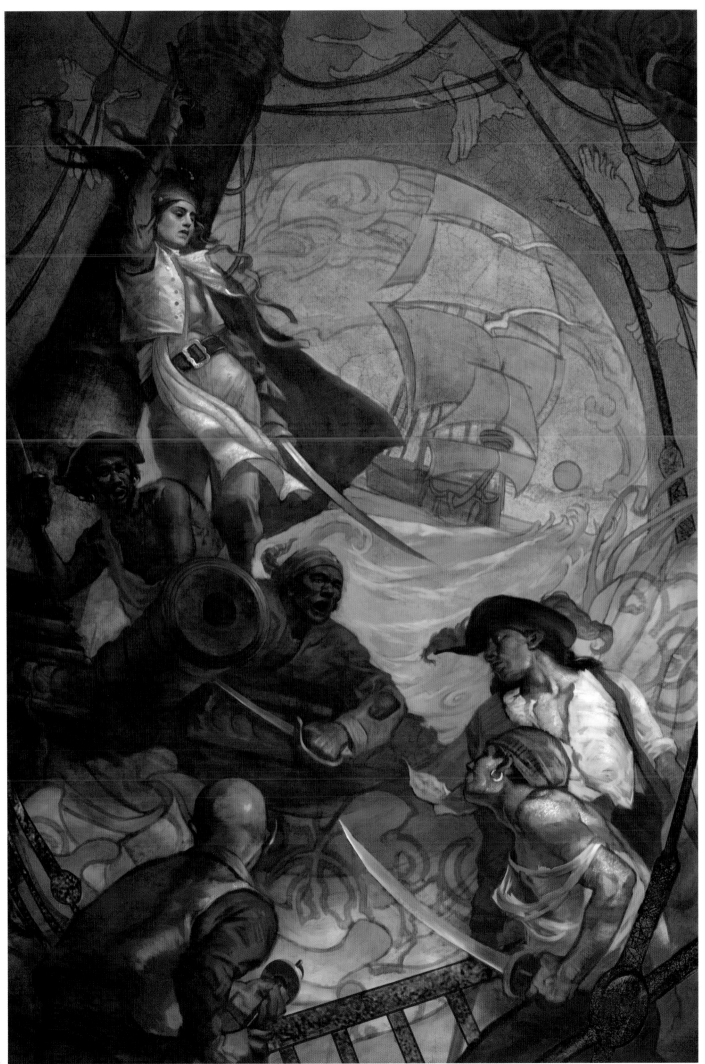

4

1 *artist:* Michael Komarck
art director: Matt Adelsperger
client: Wizards of the Coast *title:* The Darkwood Mask
medium: Digital

2 *artist:* Stephan Martiniere
art director: Irene Gallo
client: Tor Books *title:* Autumn War
medium: Digital

3 *artist:* Jeremy D. Mohler
art director: Neal Levin
client: Dark Quest Games *title:* Dweomercraft: Lich
medium: Mixed & Photoshop *size:* 10"x13"

4 *artist:* Raymond Swanland
art director: Irene Gallo
client: Tor Books *title:* Books of the South
medium: Digital

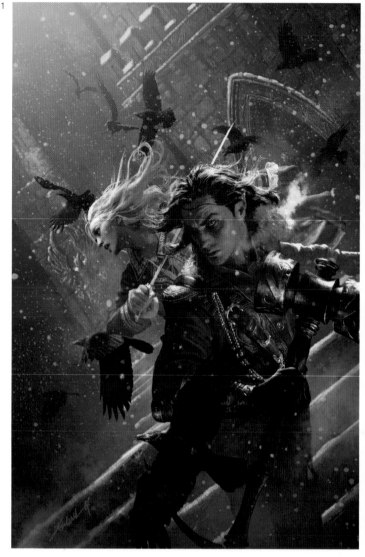

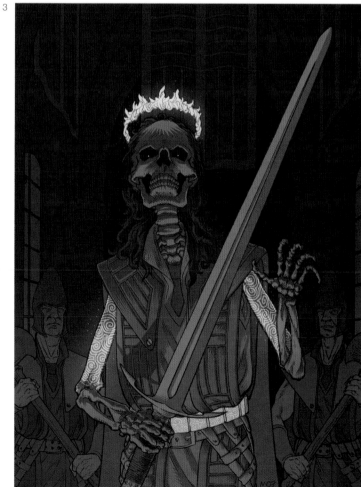

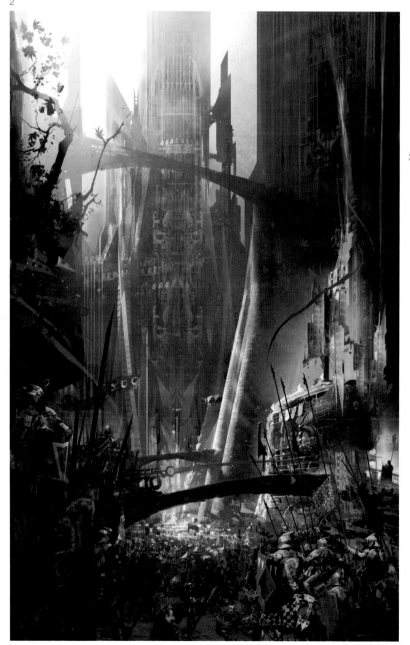

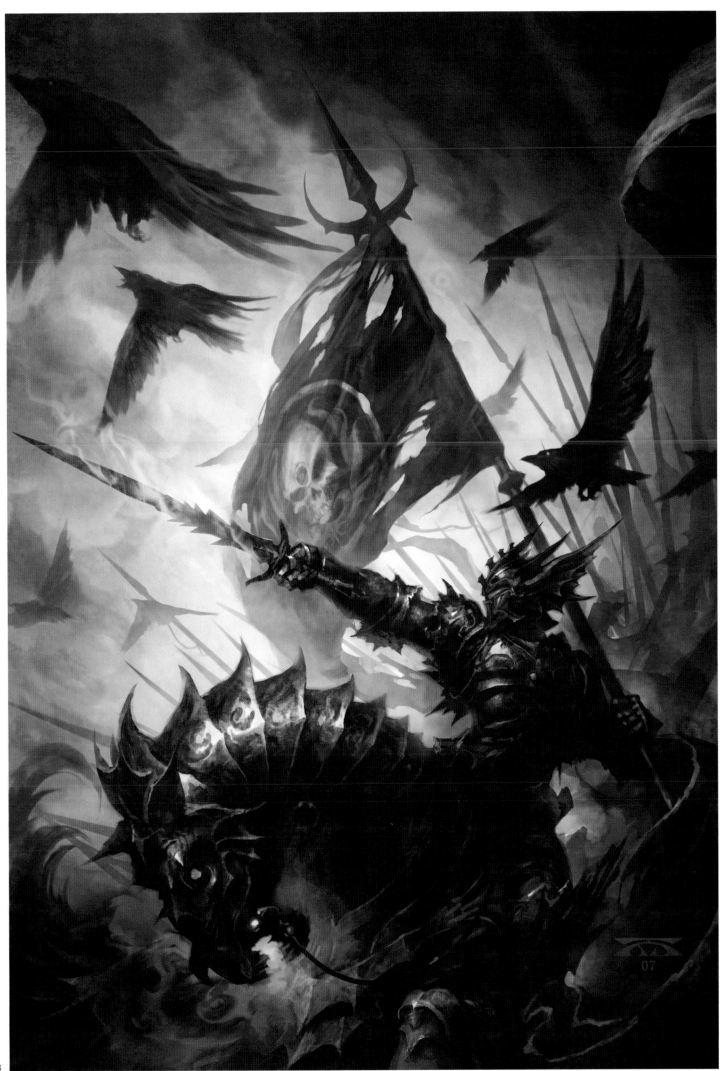

4

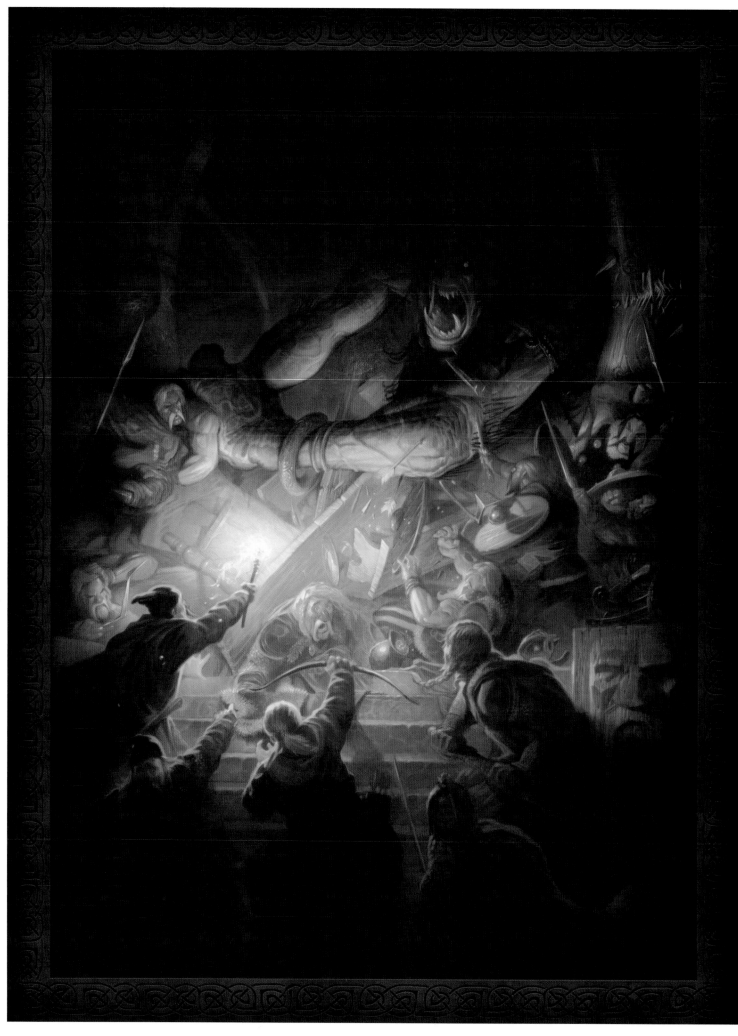

artist: **Justin Gerard**

art director: Justin Gerard *client:* Portland Studios, Inc. *title:* Beowulf Fights Grendel *medium:* Digital *size:* 11"x17"

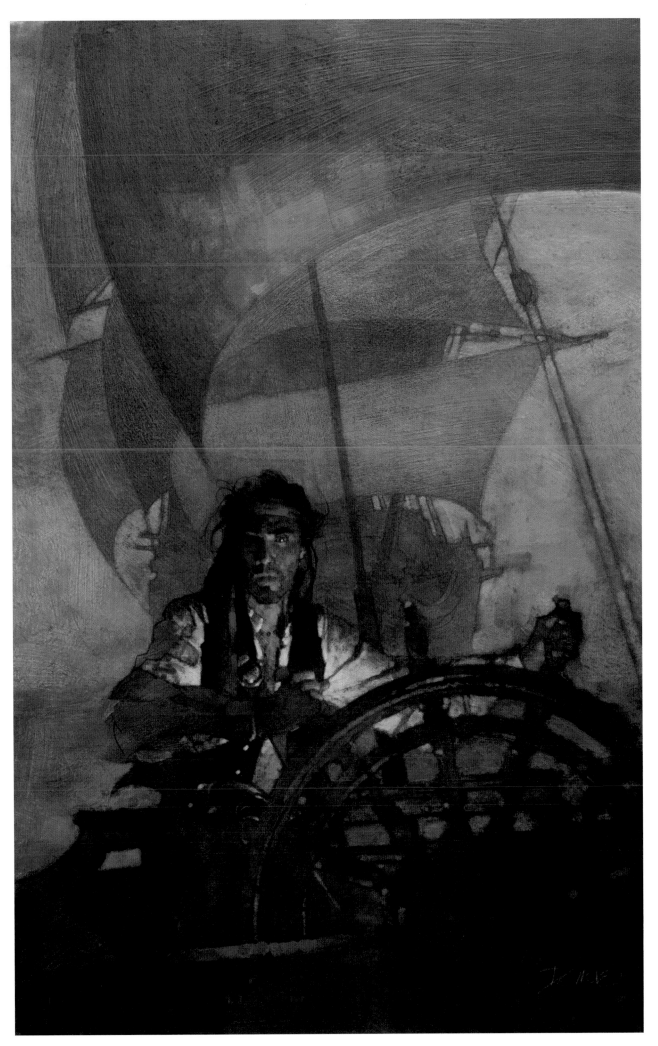

artist: **David Grove**

art director: Irene Gallo *client:* Tor Books *title:* Pirate Freedom *medium:* Gouache, acrylics *size:* 14"x20"

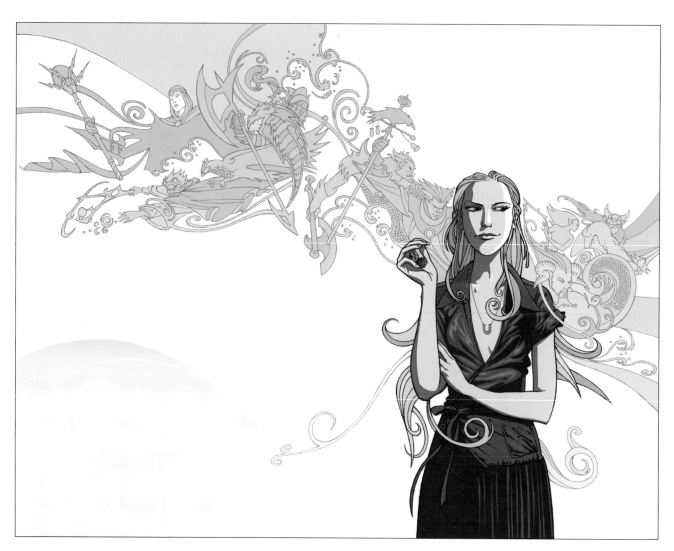

artist: **Craig Phillips**
art director: Karin Powell *client:* Wizards of the Coast *title:* Confessions of a Part-Time Sorceress *medium:* Digital *size:* 17"x11"

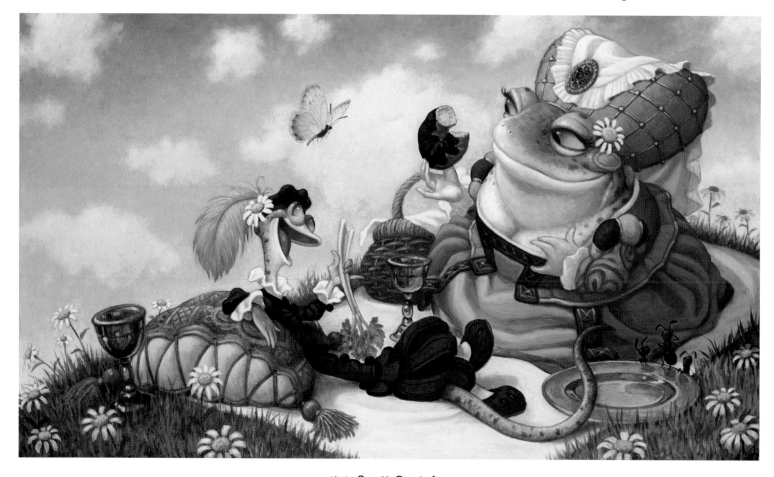

artist: **Scott Gustafson**
art director: Scott Usher, Wendy Wentworth *client:* The Greenwich Workshop Press *title:* Jack Sprat *medium:* Oil on panel *size:* 24"x14"

artist: **Jonny Duddle**
art director: Mike Jolley *client:* Templar Publishing *title:* Ye Pirate Muncher *medium:* Digital

artist: **James Jean**

art director: Shelly Bond *client:* DC Comics/Vertigo *title:* Fables #66: The Good Prince *medium:* Mixed

artist: **Adam Hughes**

art director: **Mark Chiarello** *client:* **DC Comics** *title:* **Catwoman #75** *medium:* **Mixed**

1 *artist:* **Frank Cho**
art director: Frank Cho *designer:* Frank Cho
colorist: Jason Keith
client: Dynamite Entertainment *title:* Jungle Girl #1
medium: Pen, ink, digital color *size:* 14"x21"

2 *artist:* **Frank Cho**
art director: Frank Cho *designer:* Frank Cho
colorist: Jason Keith
client: Marvel Comics *title:* The Mighty Avengers #7
medium: Pen, ink, digital color *size:* 14"x21"

3 *artist:* **Mike Wieringo, Daniel Cox**
art director: Rick Remender
client: Dark Horse Comics *title:* Fear Agent: The Last Goodbye #4
Tribute to Mike Wieringo
medium: Pencil/Painter X *size:* 7"x11"

4 *artist:* **Frank Cho**
art director: Frank Cho *designer:* Frank Cho
colorist: Jason Keith
client: Dynamite Entertainment *title:* Jungle Girl #3
medium: Pen, ink, digital color *size:* 14"x21"

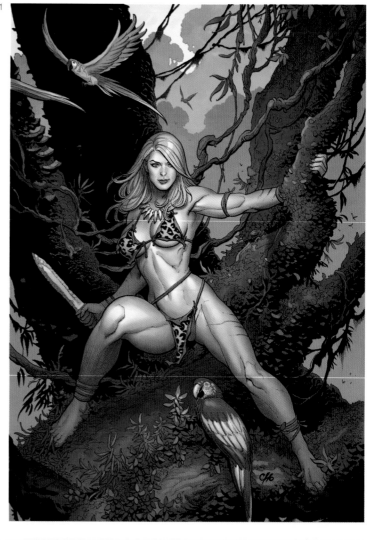

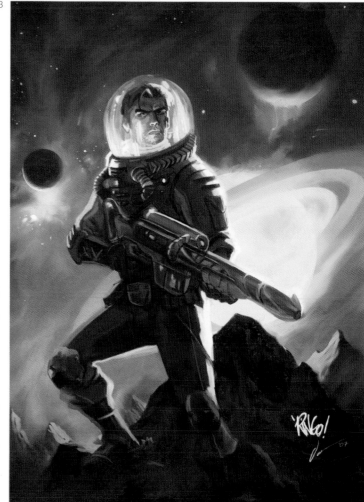

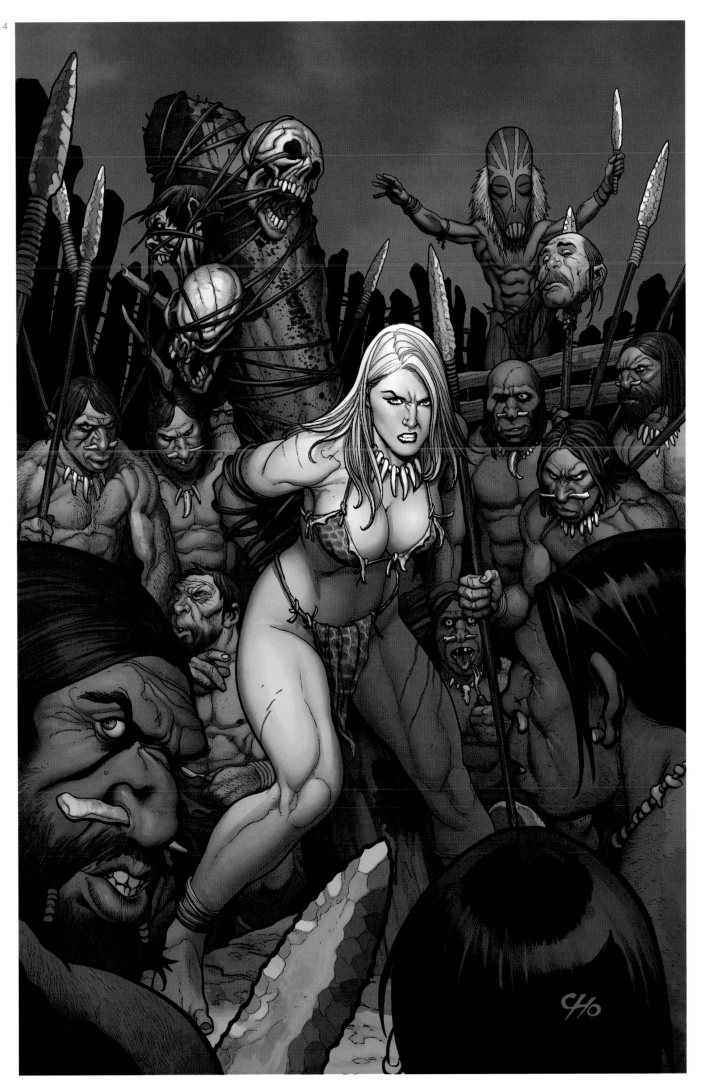

1 *artist:* Sho Murase
client: TokyoPop *title:* ME2
medium: Digital *size:* 8"x11"

2 *artist:* Brian Jon Haberlin
colorist: Andy Troy
client: Todd McFarlane Productions *title:* Spawn #177
medium: Pencil, ink, digital *size:* 11"x17"

3 *artist:* Nic Klein
art director: Bill Rosemann
client: Marvel Comics *title:* Starlord #2
medium: Pencil, digital

4 *artist:* Scott M. Fischer
art director: Maria Cabardo
client: Bungie/Marvel Comics *title:* Cortana & M.C.
medium: Mixed, digital *size:* 13"x19"

1 *artist:* Arthur Suydam
art director: Axel Alonso
client: Marvel Comics *title:* Hellstorm #3
medium: Oil, mixed *size:* 24"x36"

2 *artist:* Joe Quinones
art director: Tim Seeley
client: Devil's Due Publishing *title:* Hack/Slash #12 (Cover B)
medium: Pen, ink, digital *size:* 6$^7/_8$"x10$^3/_8$"

3 *artist:* Mike Mayhew
art director: Steve Blackwell
client: Wizard *title:* Captain America Tribute
medium: Acrylics *size:* 12"x18"

4 *artist:* Dave Wilkins
art director: John Barber
client: Marvel Comics *title:* Marvel Comics Presents
medium: Ink, Photoshop, Painter *size:* 11"x17$_2$"

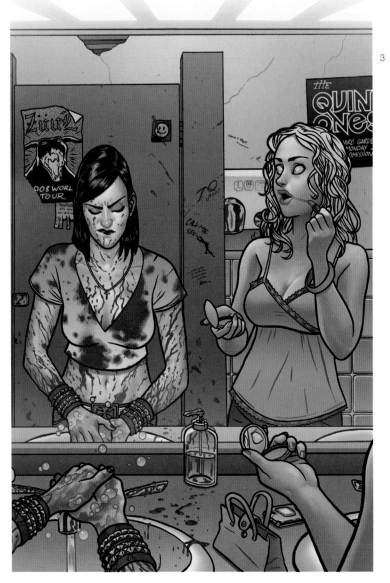

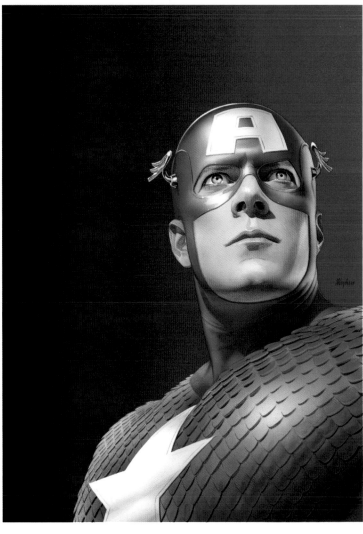

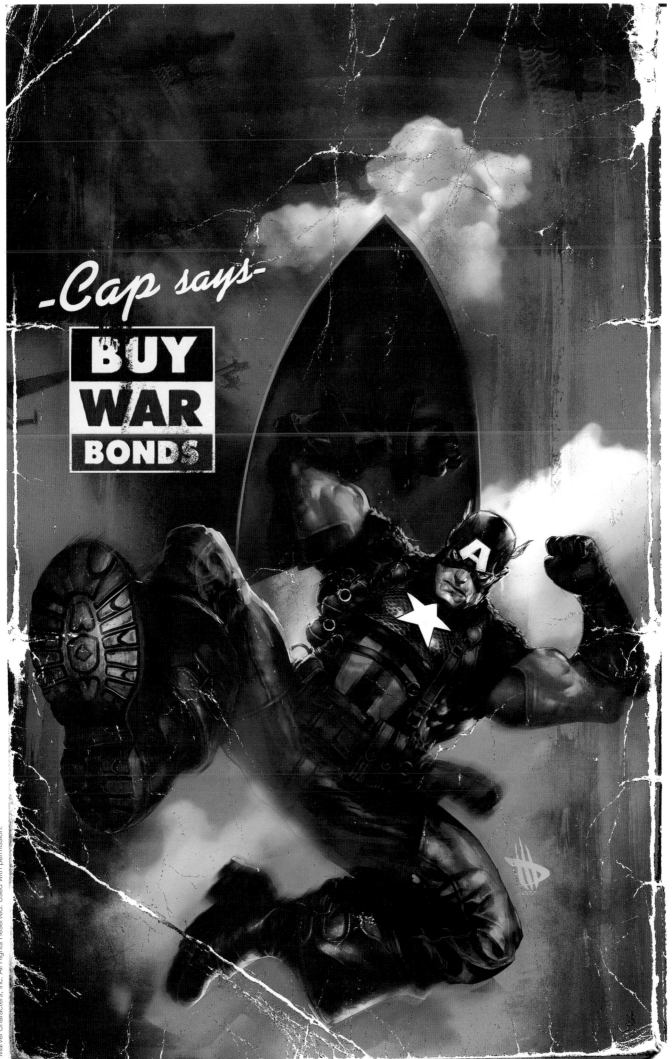

1 *artist:* **Thitipon Dicruen**
client: Summoner MTC *title:* Euphrates Disaster
medium: Digital *size:* 33"x46³/₄"

2 *artist:* **Ben Olson**
art director: Frank Forte
client: Asylum Press *title:* Asylum of Horrors
medium: Digital *size:* 6"x9"

3 *artist:* **Jason Engle**
art director: Aaron Alevedo
client: Talisman Studios *title:* Devil
medium: Digital *size:* 8¹/₂"x11"

4 *artist:* **Daren Bader**
client: Viscurreal *title:* Pridelands
medium: Digital

5 *artist:* **Jerrell Conner**
title: Revelations: The Prophets Chapter 1
medium: Digital *size:* 11"x17"

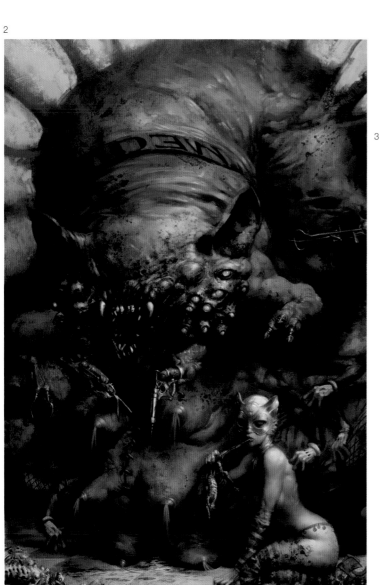

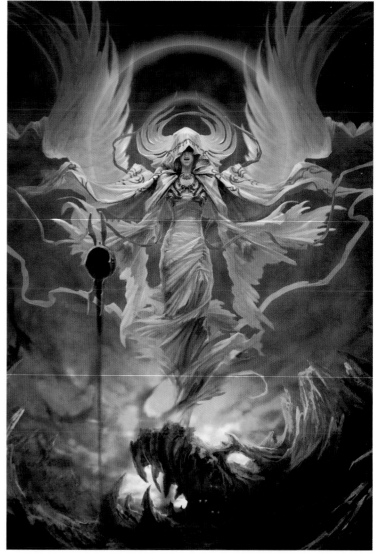

1 *artist:* **Chris Gossett, Stephen Crowe**
art director: Chris Gossett *designer:* Emil Petrinic
client: Archangel Studios *title:* The red Star: Sword of Lies #2
medium: Mixed

2 *artist:* **David Mack**
art director: Ralph Macchio *designer:* Nicole Boose
client: Marvel Comics *title:* Last of the Mohicans
medium: Mixed *size:* 8"x10"

3 *artist:* **Rolando Cicatelli**
art director: Pedro Adelante
client: Nicola Pesce Editore *title:* Levitazioni
medium: Oil on canvas *size:* 20"x28"

4 *artist:* **Joao Ruas**
art director: Barnaby Ward
client: Ancona Studios *title:* Merricks
medium: Mixed *size:* 8¼"x11³/₈"

1

2

3

4

1 *artist:* Paolo Rivera
client: Marvel Comics *title:* Mythos: Ghost Rider/Page 21
medium: Acryla gouache on bristol board *size:* 8½"x12"

2 *artist:* Arthur Adams
title: Arthur Adams Sampler VI Title Page
medium: Pen, ink *size:* 9"x17"

3 *artist:* Kevin Chin
client: Boom Studios *title:* Wings of Doom
medium: Digital

4 *artist:* Vincent Proce
art director: Michael Reidy
client: Charles D. Moisant—Silver Phoenix Publishing
title: Mystery Manor Haunted Theatre 3
medium: Pencil, Photoshop *size:* 32"x51¼"

1 *artist:* James Turner
client: SLG Publishing *title:* Rex Libris #7
medium: Digital *size:* 6³/₄"x8¹/₂"

2 *artist:* Joe Quinones
art director: Tom Palmer
client: DC Comics *title:* Teen Titans: Go! #53
medium: Pen, ink, digital *size:* 6⁵/₈"x10³/₈"

3 *artist:* Michael Golden
art director: Mark Paniccia
client: Marvel Comics *title:* Stampede
medium: Pen, ink, mixed *size:* 11"x17"

4 *artist:* Arthur Adams
client: Marvel Comics *title:* Avengers Classic #1
medium: Pen, ink *size:* 16¹/₂"x22₂"

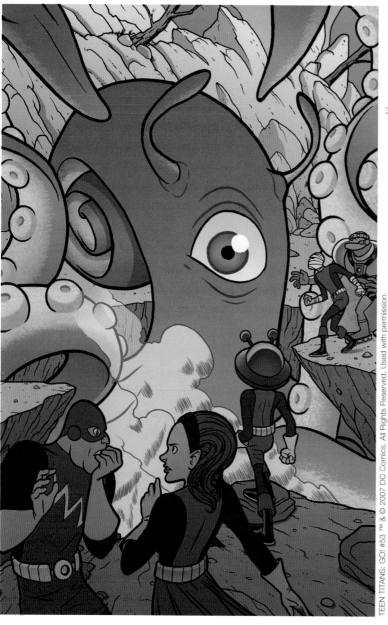

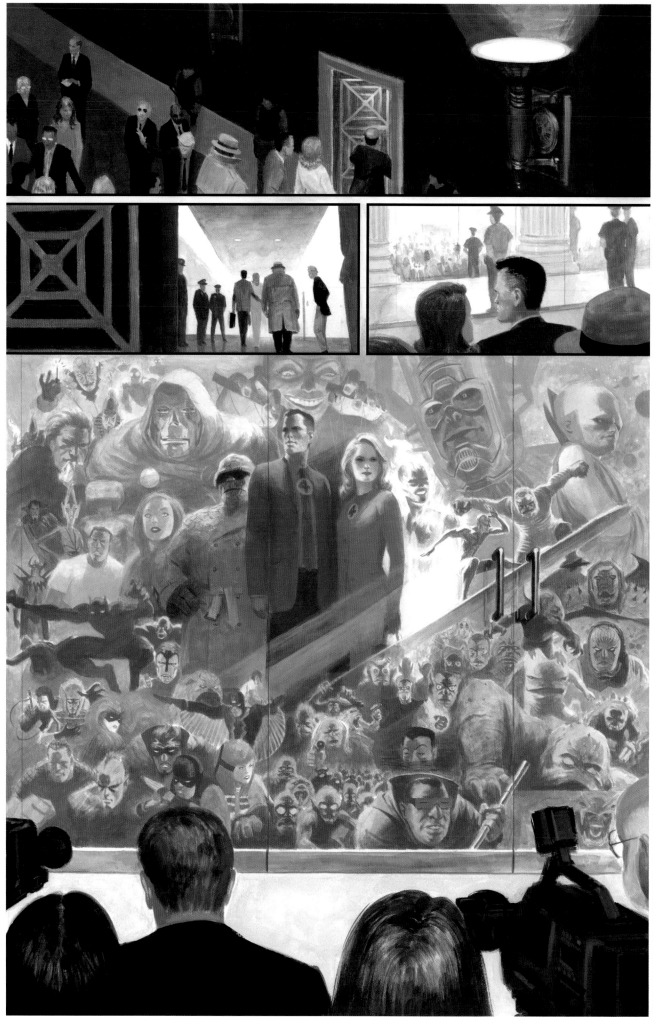

artist: **Paolo Rivera**
client: Marvel Comics *title:* Mythos: Fantastic Four [page19] *medium:* Acryla gouache on bristol board *size:* 11"x17"

artist: **Nic Klein**

art director: Bill Rosemann *client:* Marvel Comics *title:* Starlord #4 *medium:* Pencil, digital

1 *artist:* **Adam Hughes**
art director: Mark Chiarello
client: DC Comics *title:* Catwoman #72
medium: Pencil, digital

2 *artist:* **Joe Jusko**
client: Harris Comics *title:* Vampirella: Panther's Moon
medium: Acrylics *size:* 18"x27½"

3 *artist:* **Giuseppe Manunta**
client: Full Comics—Vokier 2000 *title:* Favolandia
medium: Watercolor *size:* 30"x42"

4 *artist:* **Greg Ruth**
art director: Scott Allie
client: Dark Horse Comics
title: Conan #46: Born on a Battlefield
medium: Mixed *size:* 11"x17"

4

artist: **Daniel Dociu**

art director: **Daniel Dociu** *client:* **Arena Net/GuildWars** *title:* **Defeated Dragon** *medium:* **Digital**

artist: **Daniel Dociu**
art director: **Daniel Dociu** *client:* **Arena Net/GuildWars** *title:* **Carnival Season** *medium:* **Digital**

artist: **Andrew Jones**
art director: ConceptArt.org client: Massive Black title: Sound/Bite medium: Digital

artist: **Coro**
art director: Coro client: Massive Black title: Girl On a Bike medium: Digital

artist: **Andrew Jones**
art director: Jason Manley *client:* Massive Black Shanghai *title:* Shanghai

1 *artist:* **Finch/Firchow**
art director: Renae Geerlings
client: Top Cow Productions *title:* Ascension
medium: Pencil, digital *size:* 11"x17"

2 *artist:* **Kekai Kotaki**
art director: Daniel Dociu
client: Arena Net/Guild Wars *title:* Jora
medium: Digital *size:* 55"x88"

3 *artist:* **Alon Chou**
client: Vector EA—Artes Electronicas *title:* A Lonely Heart
medium: Digital *size:* 8⁷/₈"x12"

4 *artist:* **Justin Sweet**
art director: Roger Ford
client: The Chronicles of Narnia: Prince Caspian/
Walt Disney Studios
title: Lucy and Aslan *medium:* Digital

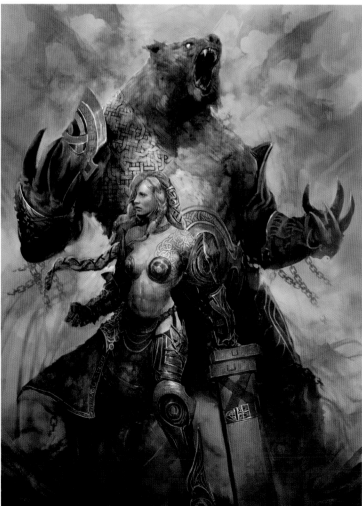

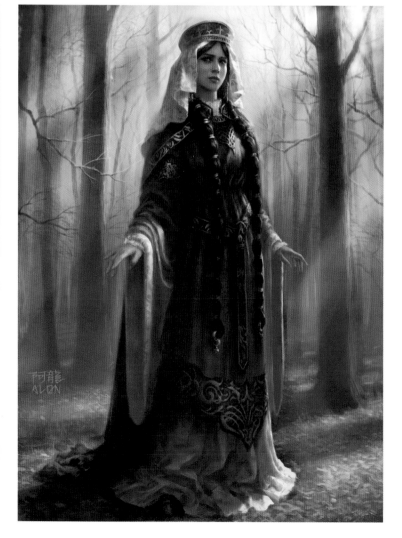

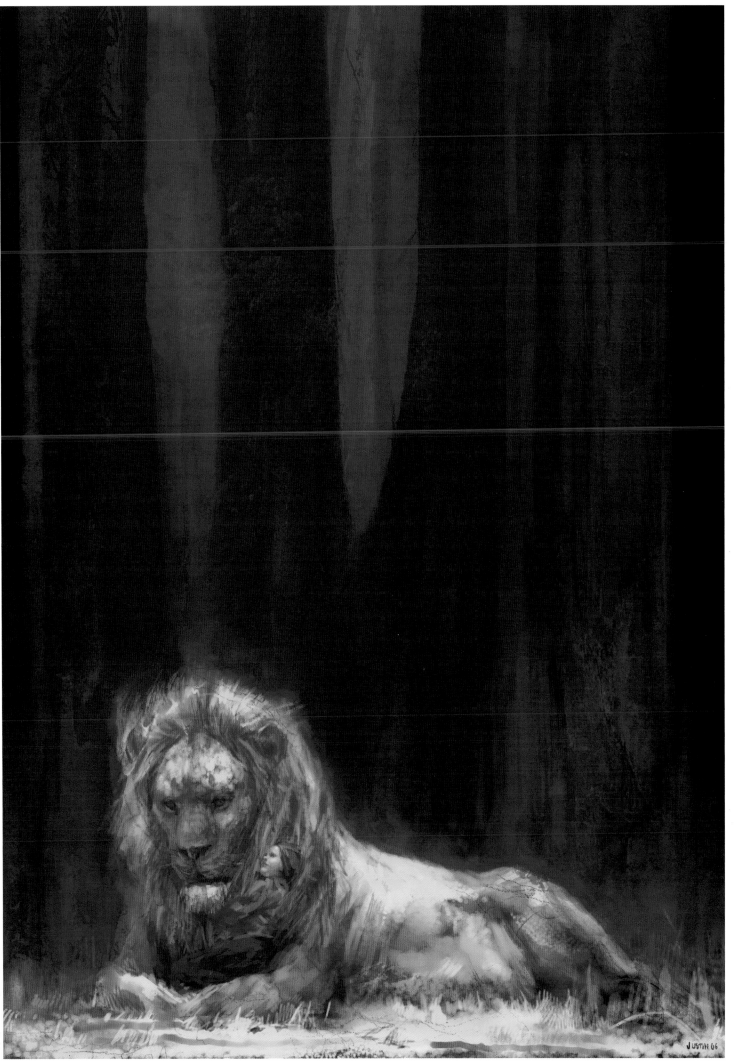

4

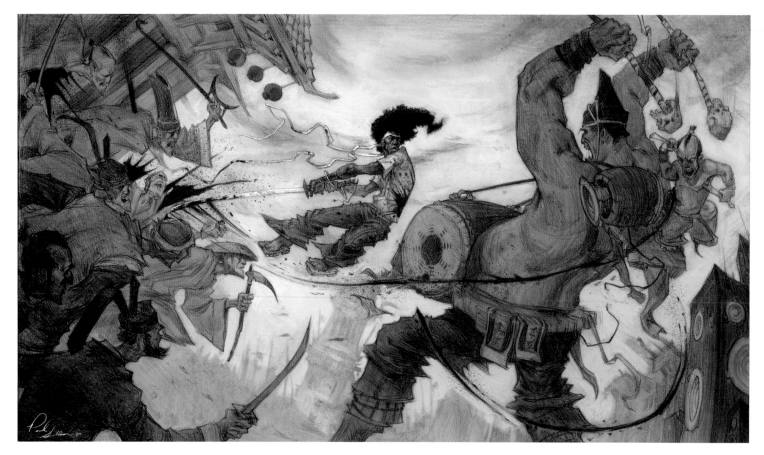

artist: **Paul Sullivan**
art director: Bryan Johnston *client:* Namco Bandai Games *title:* Afro's Funeral *medium:* Mixed, digital *size:* 17"x11"

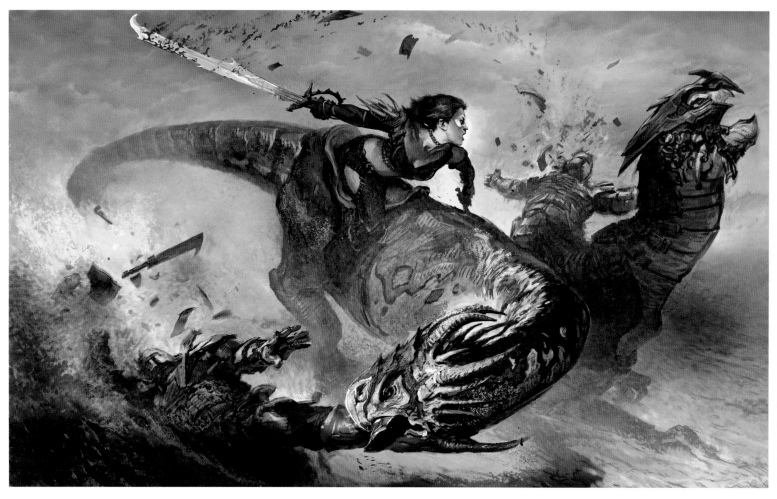

artist: **Jason Courtney**
art director: Silvio Aebischer *client:* Secret Level *title:* Abrax *medium:* Digital

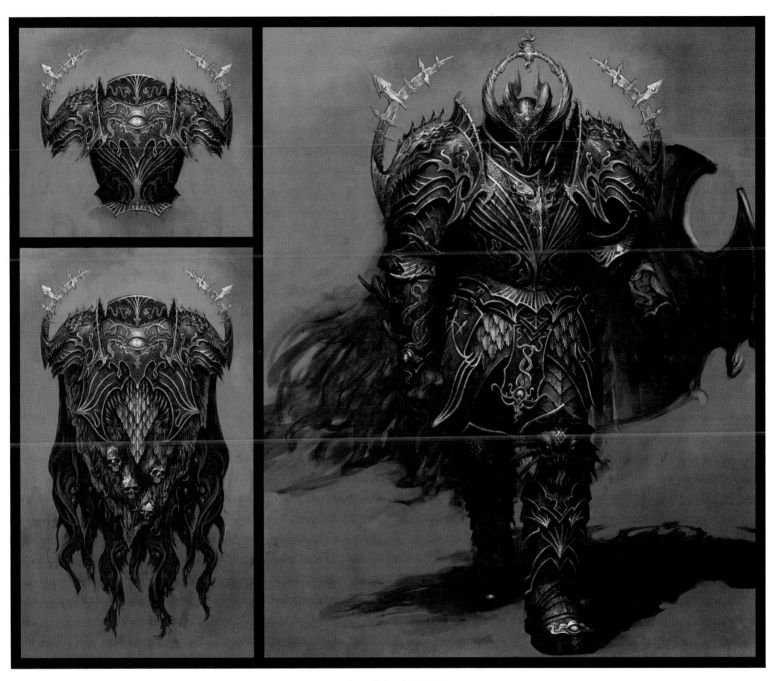

artist: **Eric J. Polak**
art director: Greg Grimsby *client:* EA Mythic *title:* Tzeentch Chosen *medium:* Digital *size:* 10"x10"

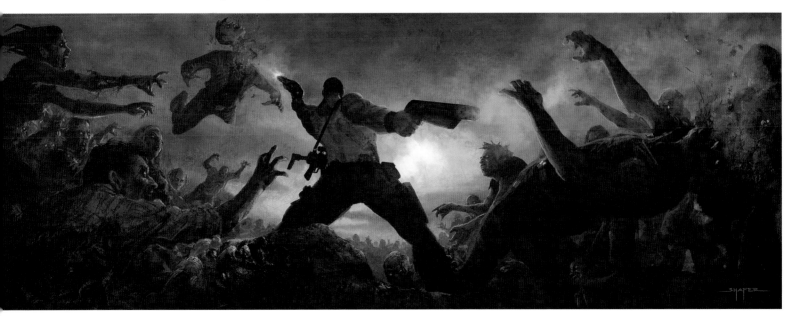

artist: **Ben Shafer**
art director: Bill Spence *client:* Z-Axis/Activision *title:* 45 Seconds *medium:* Digital

1 *artist:* **Coro**
art director: Coro
client: Massive Black *title:* Street Life
medium: Mixed *size:* 8½"x11"

2 *artist:* **Emmanuel Malin**
title: Meka/Maousse
medium: Digital *size:* 9⅞"x17¾"

3 *artist:* **James F. Hawkins II**
art director: Jerry O'Flaherty
client: Epic Games *title:* Marcus Fenix
medium: Photoshop *size:* 7"x11"

4 *artist:* **Coro**
art director: Coro
client: Massive Black *title:* Vices
medium: Oil on canvas *size:* 48"x60"

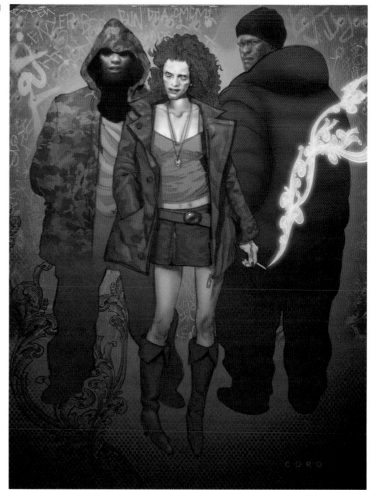

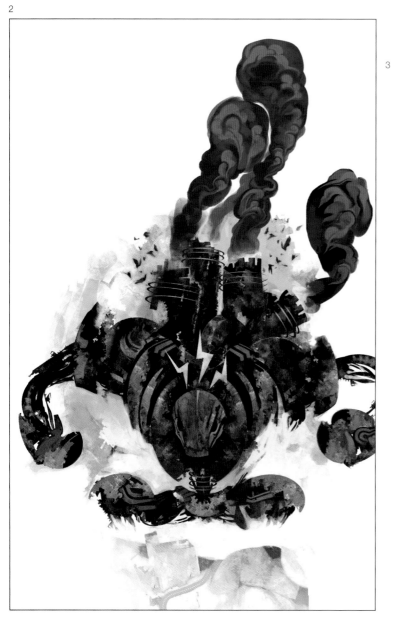

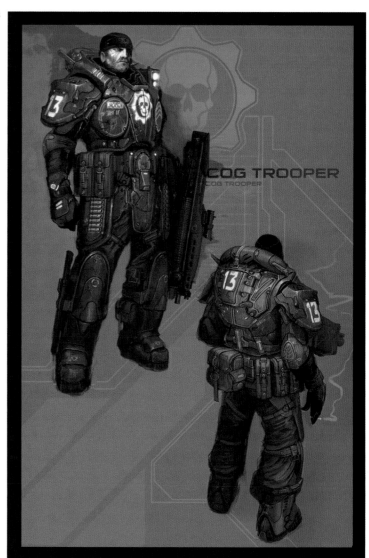

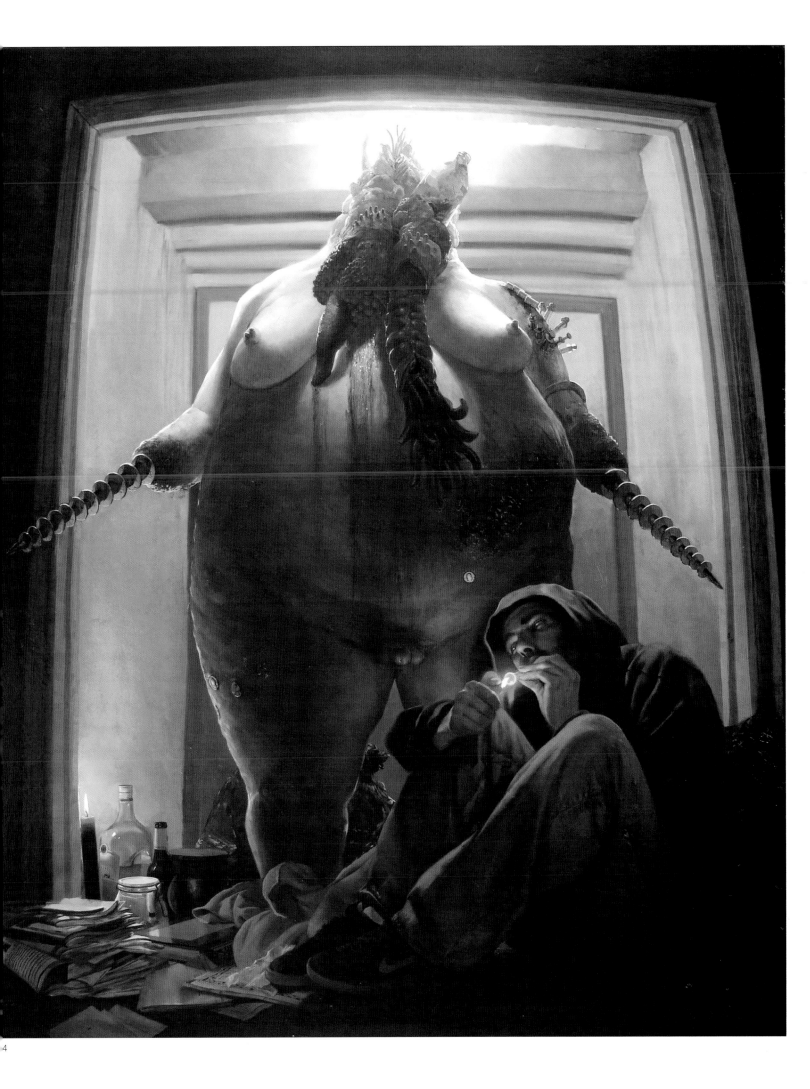

artist: **Craig Elliott**

art director: Christophe Vacher *client:* Enchanted/Walt Disney Studios *title:* Forest Hill *medium:* Digital

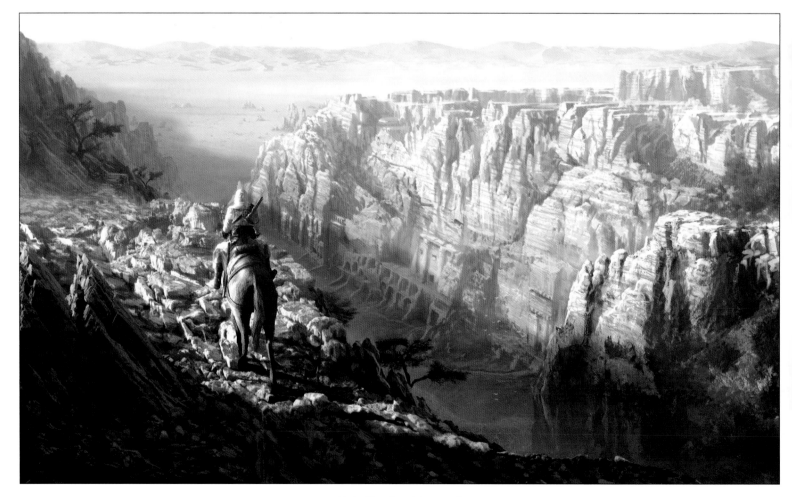

artist: **Raphael Lacoste**

art director: Raphael Lacost *client:* UbiSoft *title:* South Kingdom *medium:* Digital *size:* 13"x10"

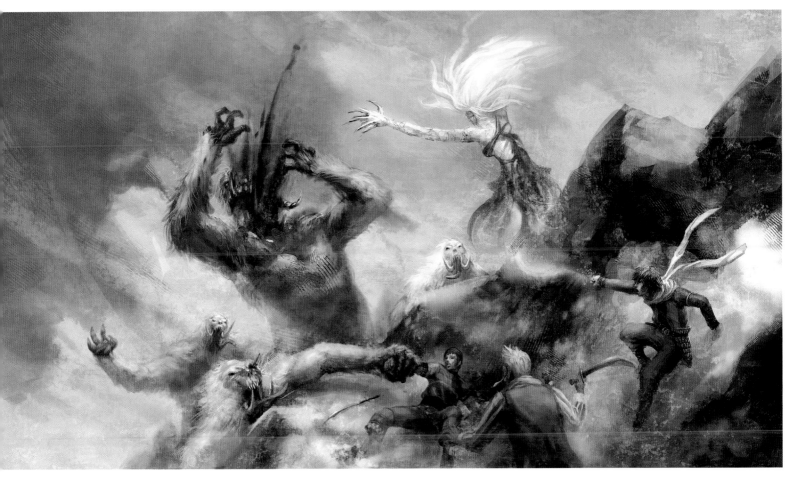

artist: **Kendrick Lim**
client: Radical Publishing title: Yetis medium: Digital

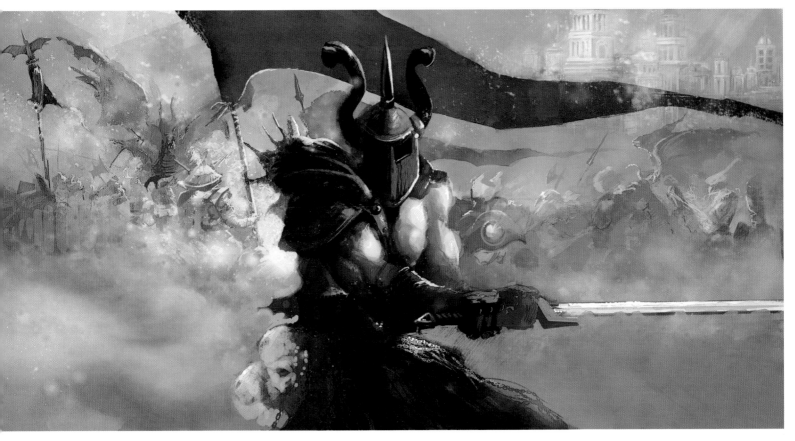

artist: **Scott Dylan Ewen**
client: Nexus War title: Horde medium: Digital size: 15"x8"

1 *artist:* **Matthew C. Barrett**
title: A Boy and His Dog
medium: Digital *size:* 8"x10"

2 *artist:* **Doug Williams**
art director: Daniel Dociu
client: Arena Net/Guild Wars *title:* Invasion
medium: Digital *size:* 25"x13"

3 *artist:* **Kekai Kotaki**
art director: Daniel Dociu
client: Arena Net/Guild Wars *title:* Norn Warriors
medium: Digital *size:* 44"x70"

4 *artist:* **Kekai Kotaki**
art director: Daniel Dociu
client: Arena Net/Guild Wars *title:* Tyrant
medium: Digital *size:* 50"x74"

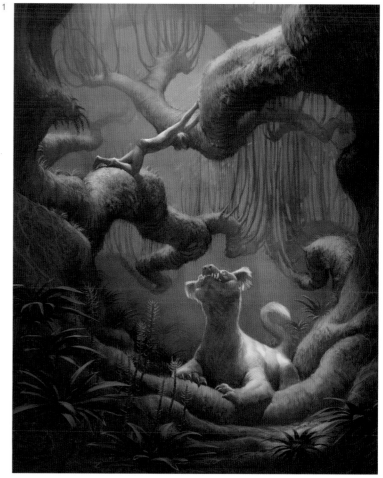

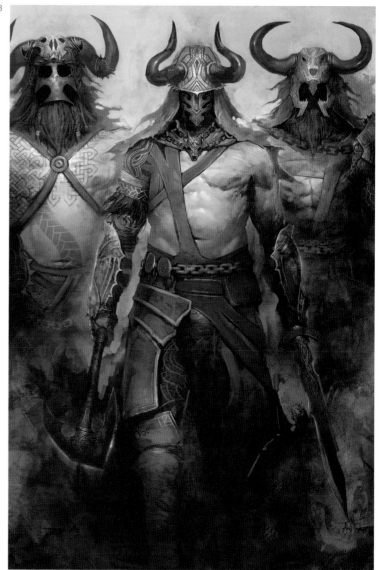

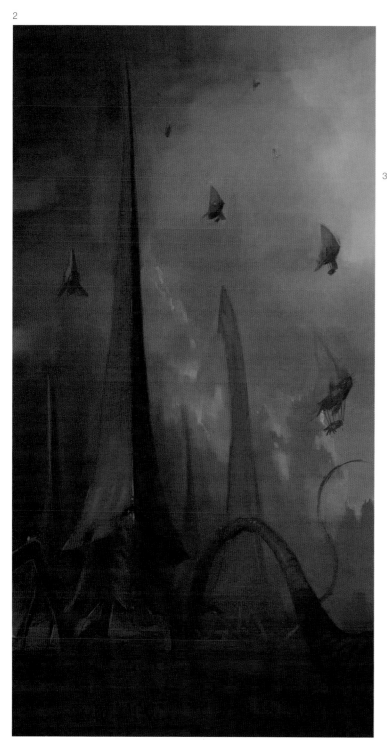

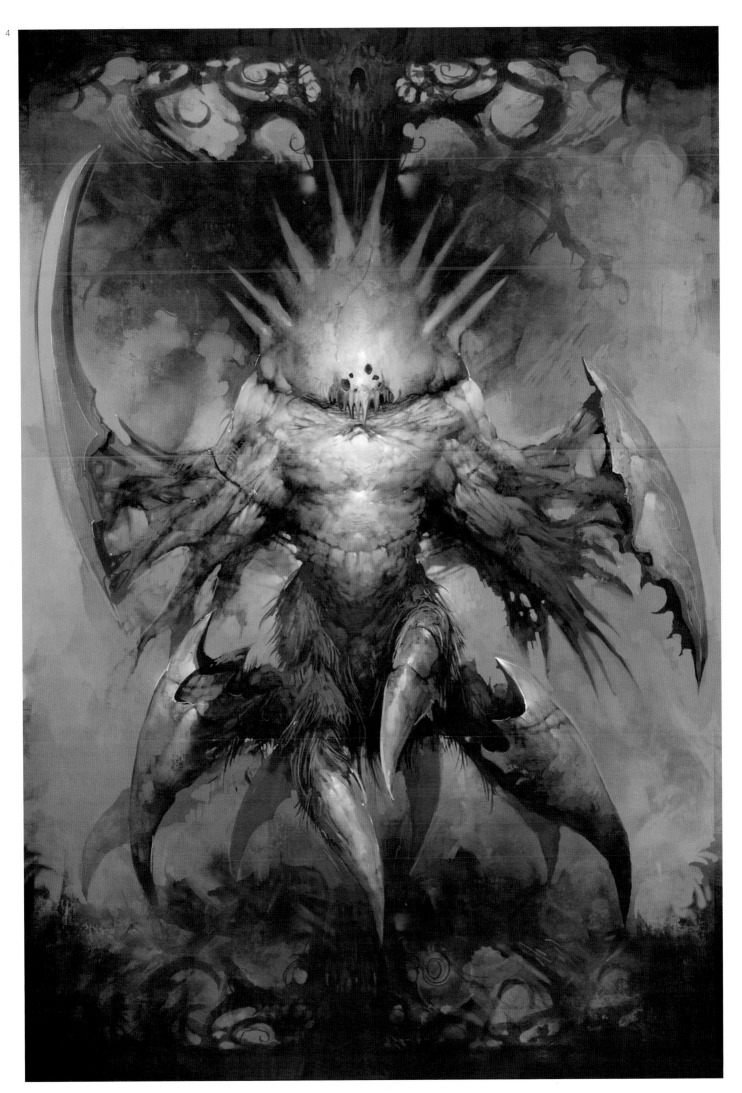

4

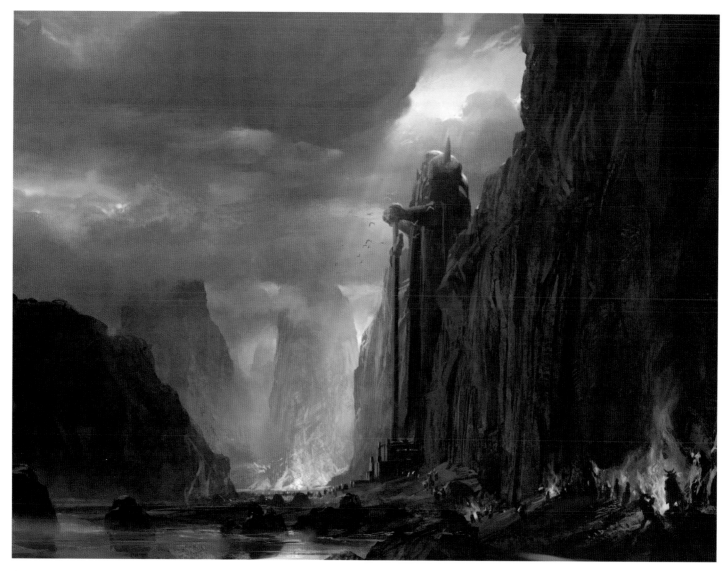

artist: **Jaime Jones**
art director: Daniel Dociu *client:* Arena Net/Guild Wars *title:* Balthazar Statue *medium:* Digital *size:* 11"x8 1/2"

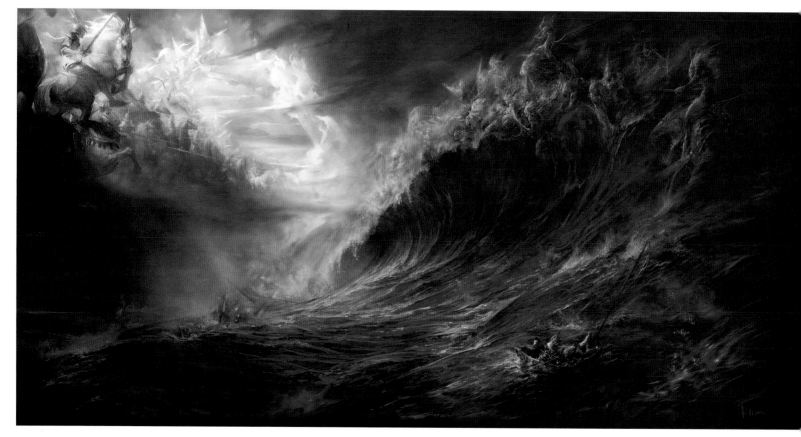

artist: **Dehong He**
art director: Dehong He *title:* Marvelous Journey *medium:* Mixed, digital *size:* 17 1/4"x8 3/4"

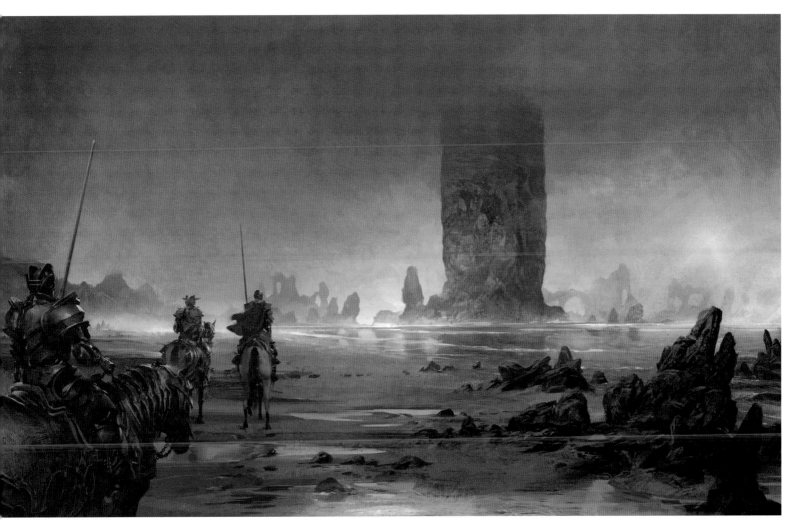

artist: artist: **Jaime Jones**
art director: Daniel Dociu *client:* Arena Net/Guild Wars *title:* Coast *medium:* Digital *size:* 11"x7"

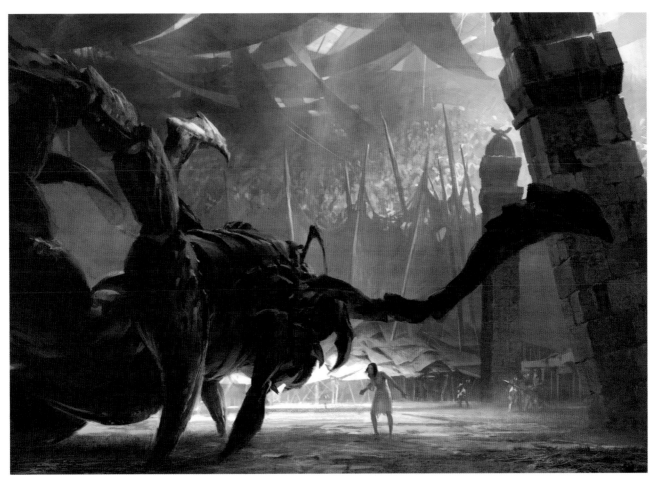

artist: **Jaime Jones**
art director: Daniel Dociu *client:* Arena Net/Guild Wars *title:* Charr Arena *medium:* Digital *size:* 10"x7"

1 *artist:* Daarken
art director: Greg Grimsby
client: EA Mythic *title:* Dark Elf Sorceress
medium: Digital *size:* 8"x10"

2 *artist:* Justin Sweet
art director: Roger Ford
client: The Chronicles of Narnia: Prince Caspian/
Walt Disney Studios
title: Blackwoods *medium:* Digital

3 *artist:* Jonathan Kirtz
art director: Greg Grimsby
client: EA Mythic *title:* Karak-Eight-Peaks Gate
medium: Digital

4 *artist:* Jason Wei-Che Juan
art director: Daniel Dociu
client: Arena Net/Guild Wars *title:* Chronomancer
medium: Digital *size:* 7"x12"

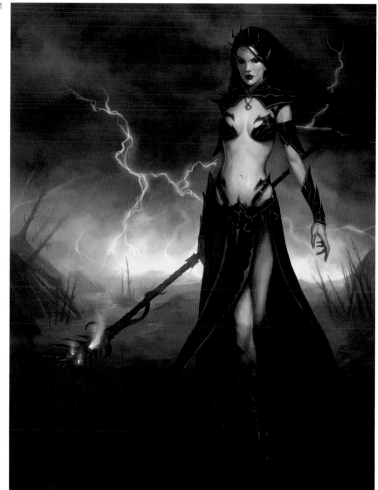

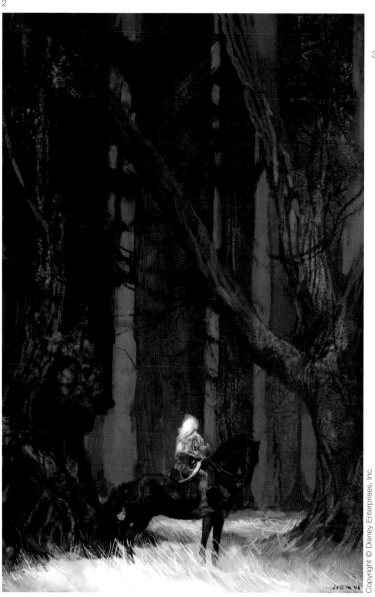

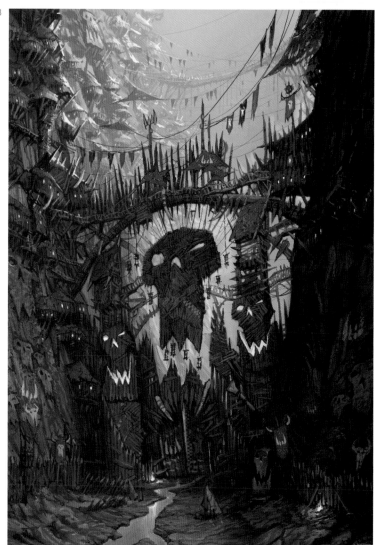

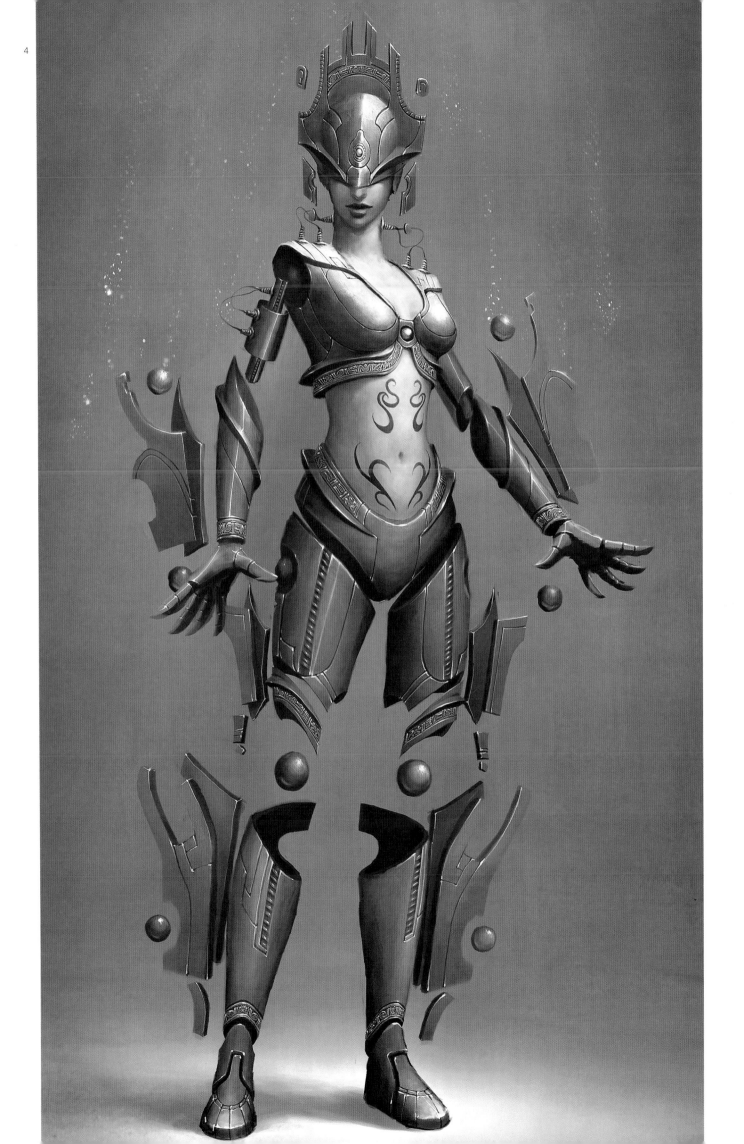

artist: **Daniel Dociu**
art director: Daniel Dociu *client:* Arena Net/Guild Wars *title:* Preparations For Take-off *medium:* Digital

artist: **Cory Strader**
client: Unknown Worlds *title:* Natural Selection 2: Specimen Lab *medium:* Digital

artist: **Jason Stokes**
art director: Daniel Dociu *client:* Arena Net/Guild Wars *title:* Land Fishing *medium:* Photoshop *size:* 10^1/$_2$"x9^7/$_8$"

artist: **A. Brent Armstrong**
photographer: Spatola Designer Images title: The Mummy Revisted size: 4' medium: Bronze

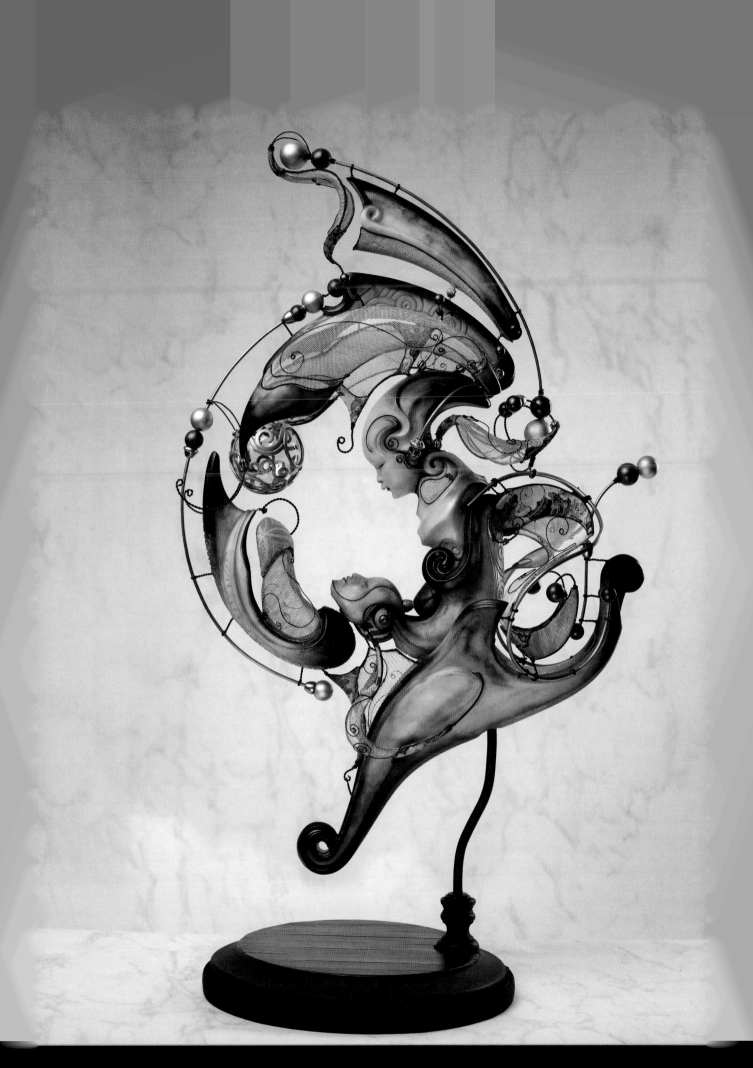

artist: **Akihito Ikeda**

art director: Akihito Ikeda client: Kazuhiro Tuji title: Heart of Art medium: Mixed size: H 31" x W 21"x D 10"

1 *artist:* **Mark Nagata**
client: Max Toy Company *title:* Boy Karma
medium: Soft vinyl *size:* 4¹/₂" tall

2 *artist:* **K.D. Matheson**
title: Bongi
medium: Clay *size:* H 18" x W 9"

3 *artist:* **David Meng**
art director: Richard Taylor *photographer:* Steve Unwin
painter: Les Nairn
client: Weta Workshop *title:* Dragon
medium: Resin *size:* H 18"

4 *artist:* **David Meng**
photographer: Steve Unwin
title: Sardonic
medium: Resin *size:* H 12¹/₂"

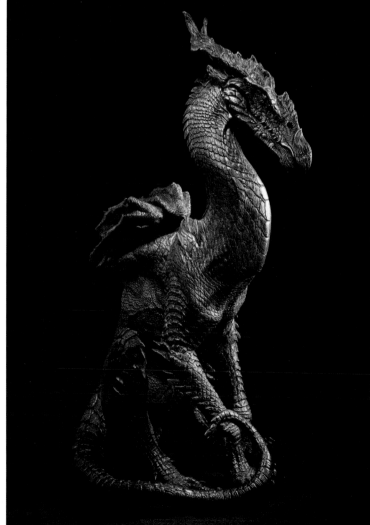

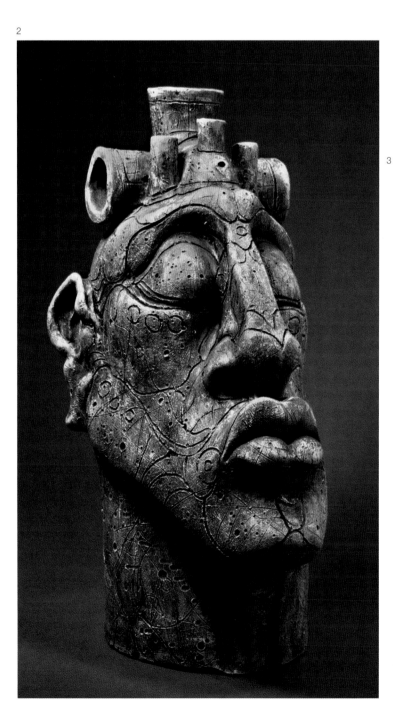

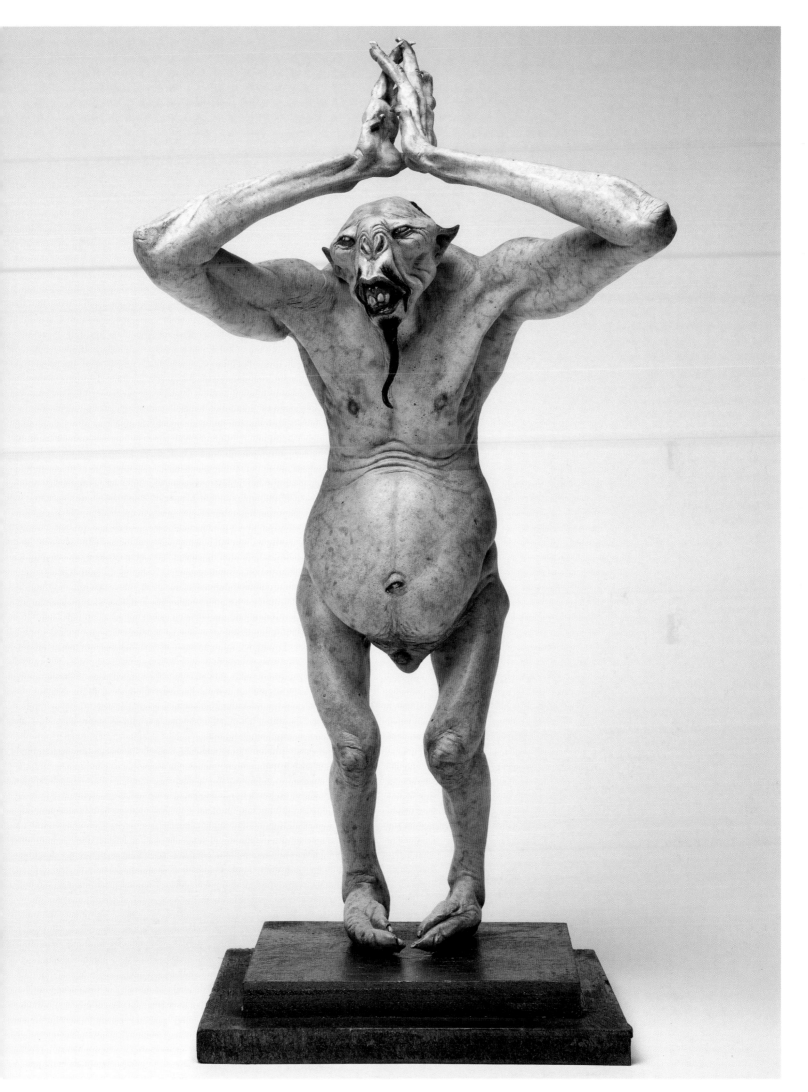

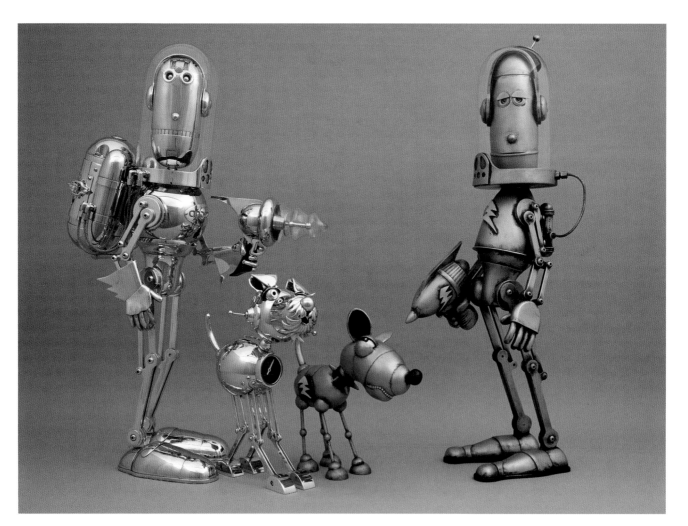

artist: **Lawrence Northey**
title: Intermission medium: Mixed size: H 33" x W 53"

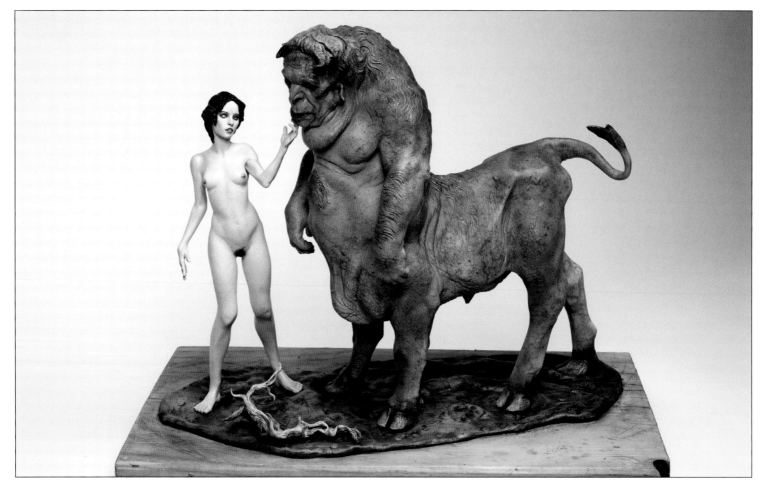

artist: **David Meng**
title: In the Wilderness medium: Resin size: H 13" x 15"

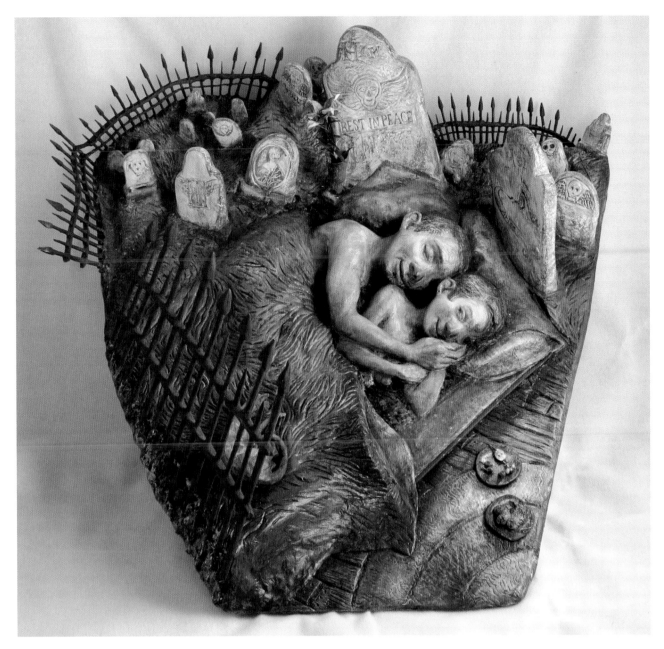

artist: **Melissa Ferreira**
title: Sleep *medium:* Wood, paper, clay, acrylic paint *size:* H 17" x L 17" x D 12"

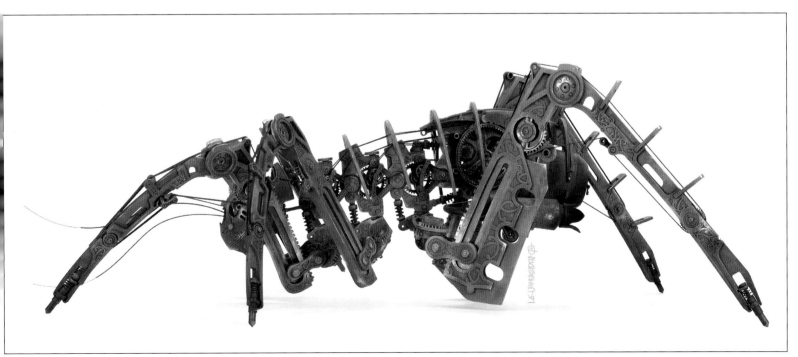

artist: **Stephen Lambert**
art director: Richard Taylor *photographer:* Steve Unwin *client:* Weta Workshop *title:* Wetabot *medium:* Mixed *size:* H 27$\frac{1}{2}$" x L 39$\frac{3}{8}$"

1 *artist:* **Randy Hand**
photographer: Jafe Parsons
title: Baby Drac
medium: Wax *size:* H 5" x W 5$1/4$" x D 3$1/2$"

2 *artist:* **Thomas S. Kuebler**
itle: The Show Must Go On
medium: Mixed, silicone *size:* Life-size

3 *artist:* **Mark Alfrey**
client: The Mark Alfrey Studio *title:* Kiriette
medium: Polystone *size:* H 12"

4 *artist:* **Thomas S. Kuebler**
itle: Kewpie & the Beast
medium: Mixed, silicone *size:* Life-size

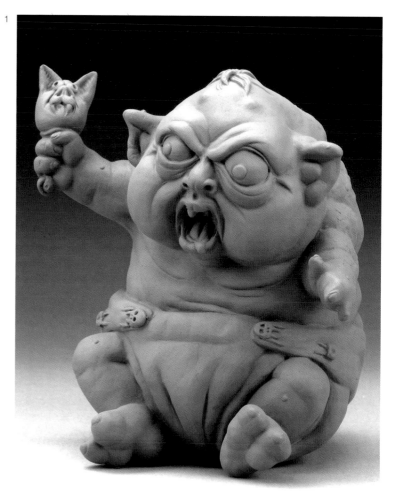

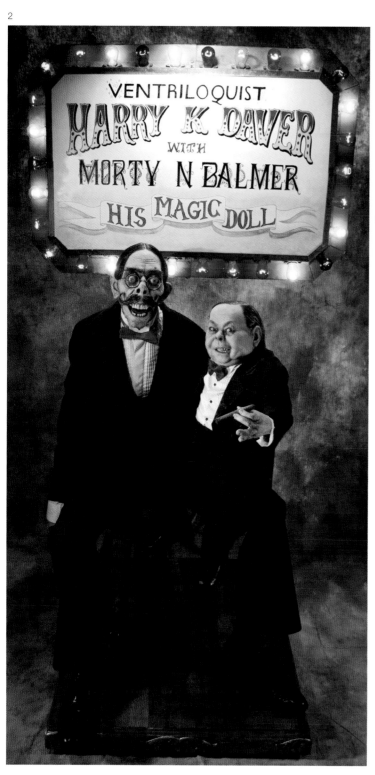

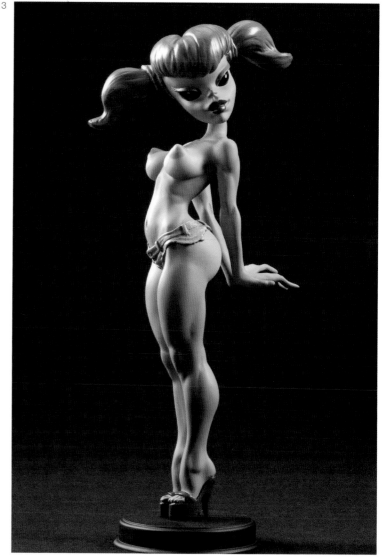

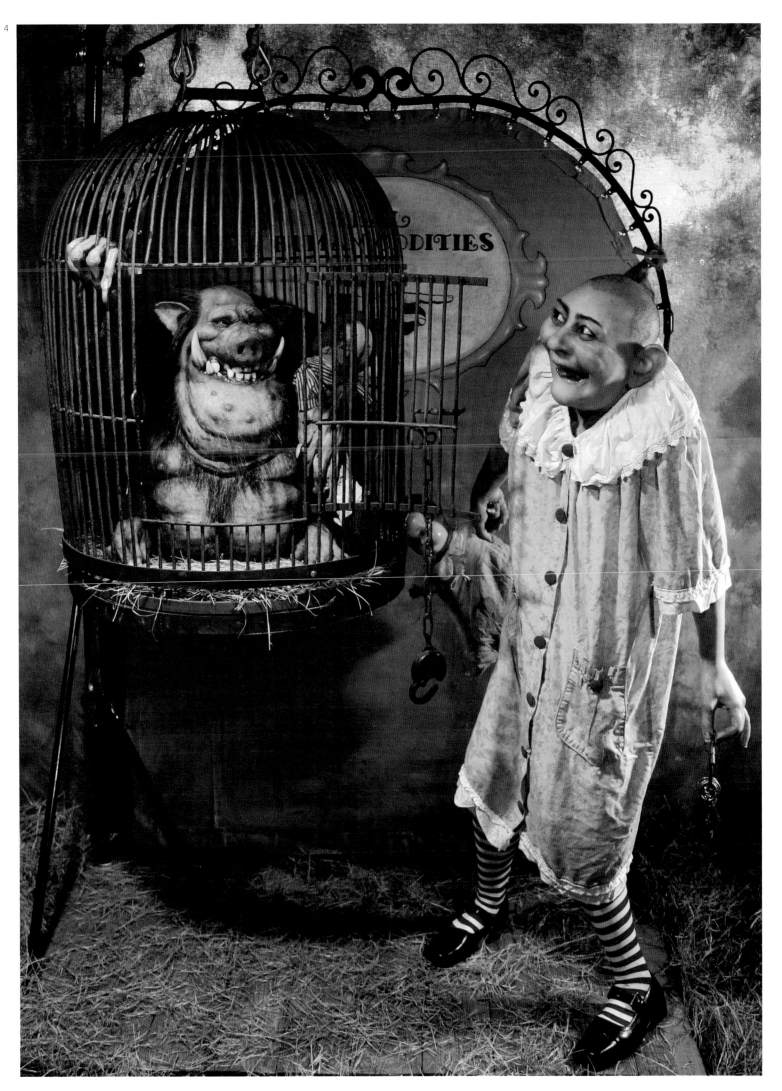

1
artist: Javier Diaz
photographer: Jose Rios
title: Homo Orcus
medium: Sculpey *size:* H 12"

2
artist: Kouei Matsumoto
art director: Tomomi Iwasaki, William Eng
client: DC Direst *title:* Catwoman
medium: Painted vinyl

3
artist: Alterton
title: The Minister
medium: Epoxy putty *size:* H 8"

4
artist: Alterton
art director: Shawn Knapp *designer:* Frank Miller
client: DC Direct *title:* Frank Miller's Batman B&W
medium: Epoxy putty *size:* H 7"

5
artist: Karen Palinko
art director: Jim Fletcher *designer:* Alex Ross
client: DC Direct *title:* Alex Ross' Batman B&W
medium: Painted resin

1

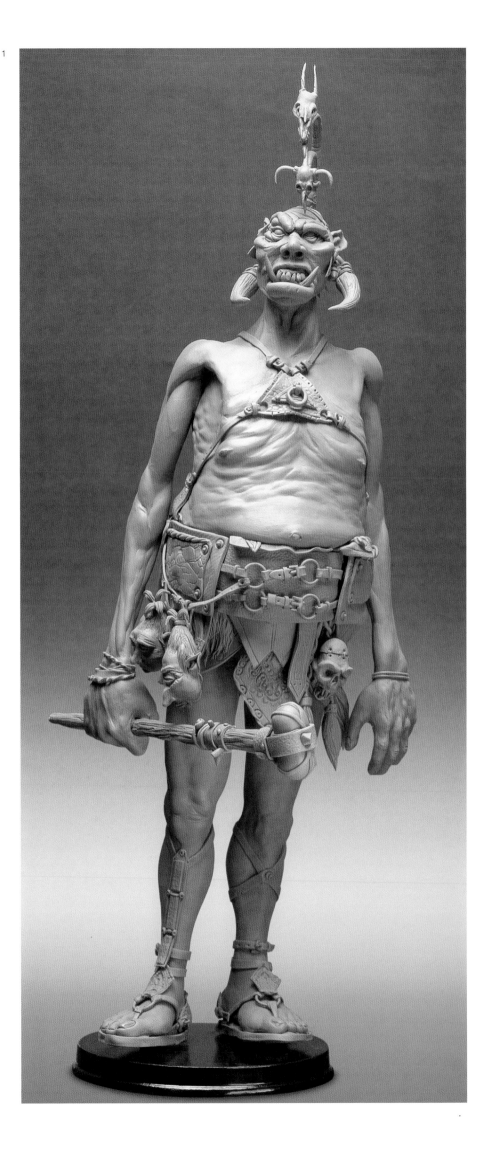

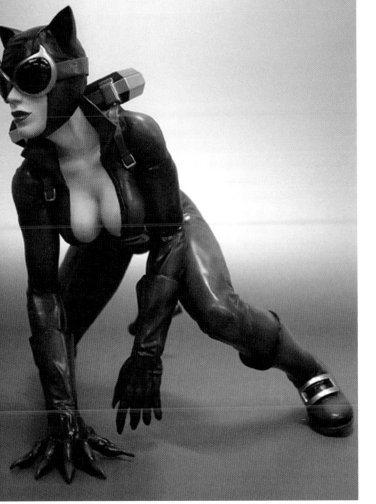

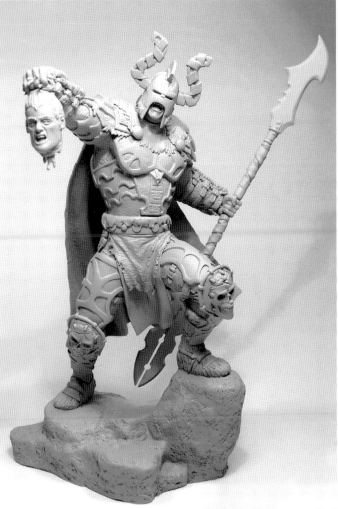

4

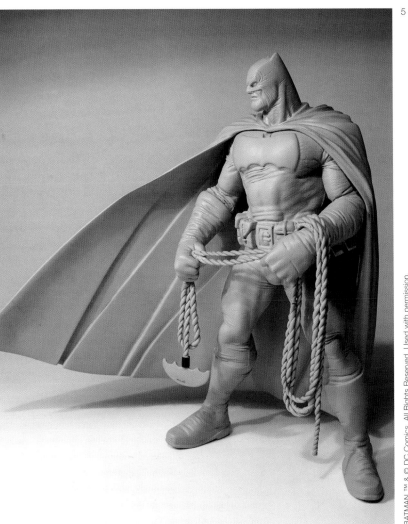

5

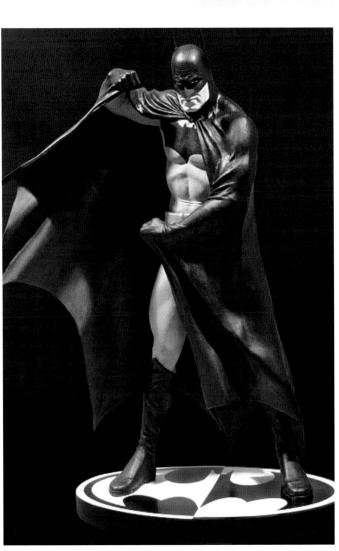

1 *artist:* **Virginie Ropars**
designer: Olivier Ledroit
title: Oberon [based on an illustration by Olivier Ledroit
medium: Mixed *size:* H 25"

2 *artist:* **Virginie Ropars**
client: Strychnin Gallery *title:* Wasp Queen
medium: Mixed *size:* H 25"

3 *artist:* **Virginie Ropars**
title: Tandis Qu'Autour, D'Elle
medium: Mixed *size:* H 27"

4 *artist:* **Virginie Ropars**
title: Cornua Lunae
medium: Mixed *size:* H 22"x W 22"

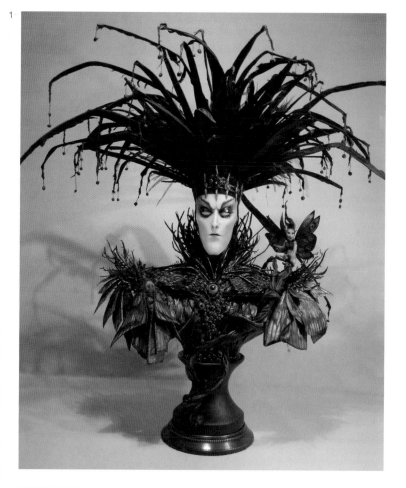

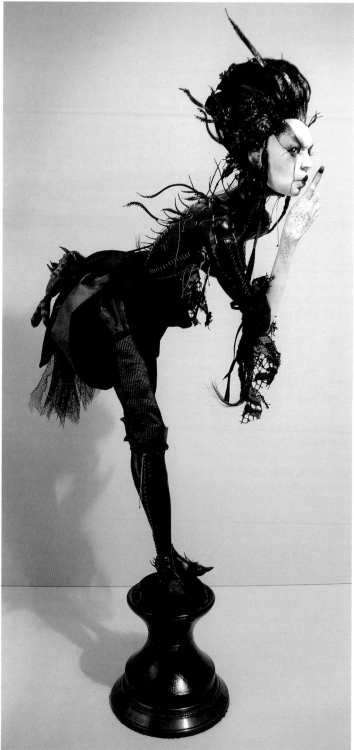

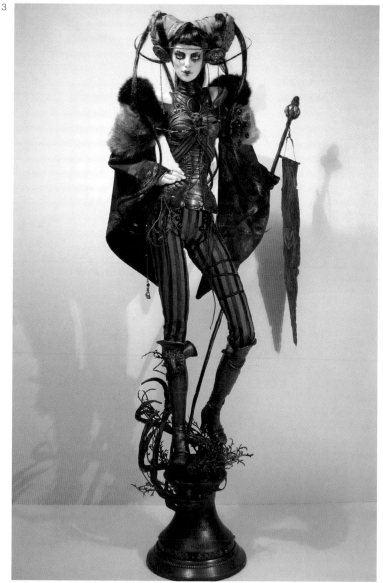

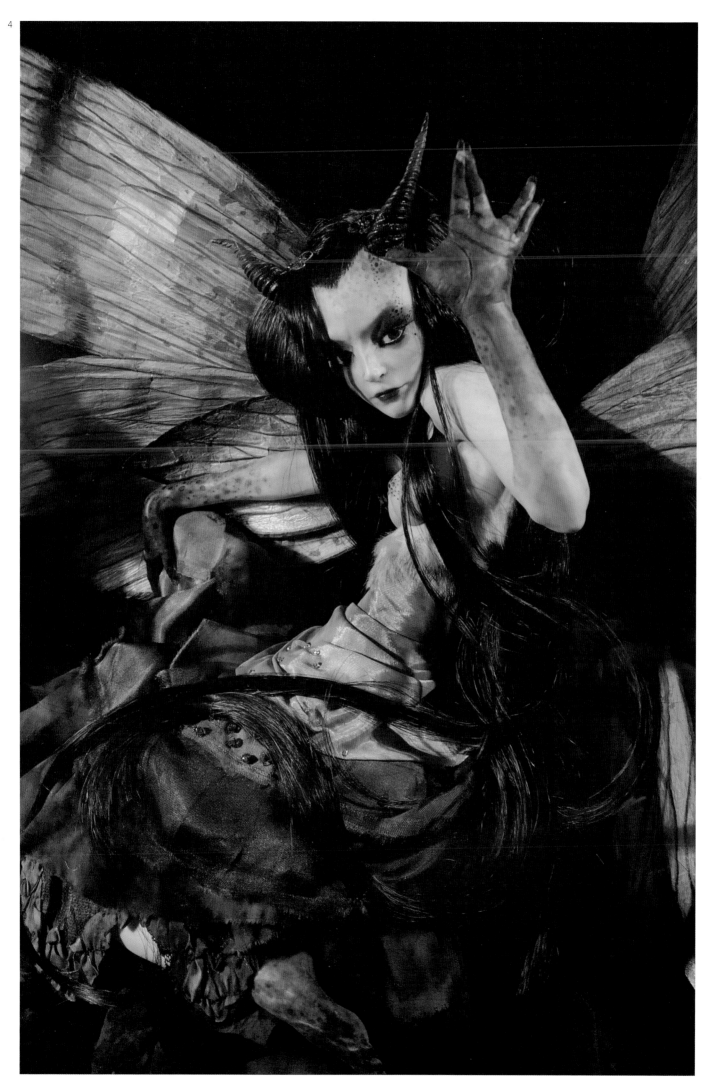

1
artist: Andrew Sinclair
art director: Ridgeway Sculpture Design
designer: Andrew Sinclair
client: Private Collection
title: When Night Falls
medium: Life-size
size: Bronze

2
artist: David Fisher
art director: David Fisher
photographer: Tisha Poling
client: Amazing Figure Modeling
title: Absinthe in Wonderland
medium: Mixed
size: H 12" x W 18" x D 11½"

3
artist: Daniel Robert Horne
client: Daniel Robert Horne Originals
title: Mouse Murtaugh, Wizard's Apprentice
medium: Polymer clay, cloth, oil paint
size: H 6"

4
artist: Julie Mansergh
art director: Faeries in the Attic [FITA]
designer: Julie Mansergh
client: Private Collection
title: Snowflake Faerie
medium: Polymer Clay
size: H 5"

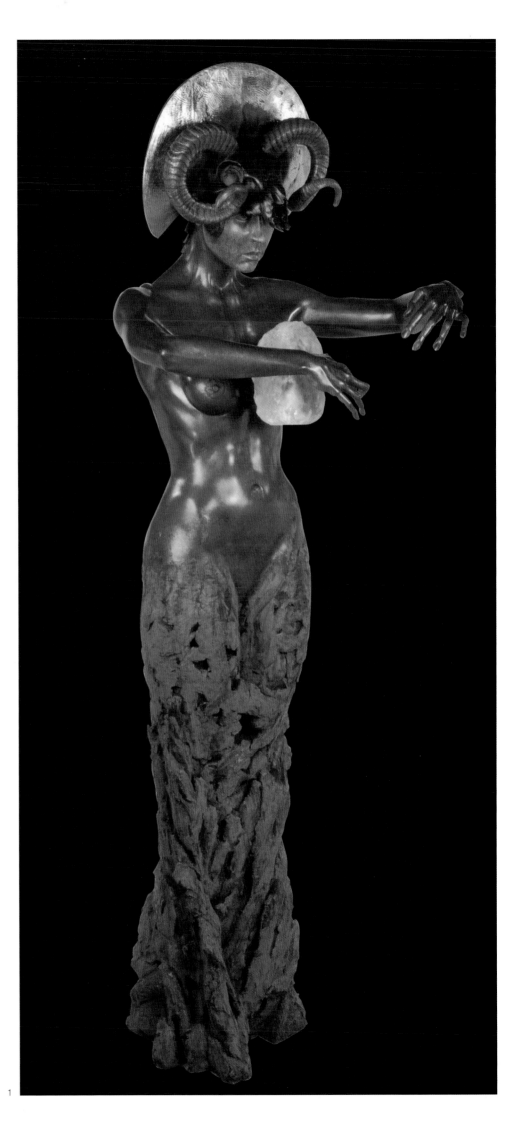

1

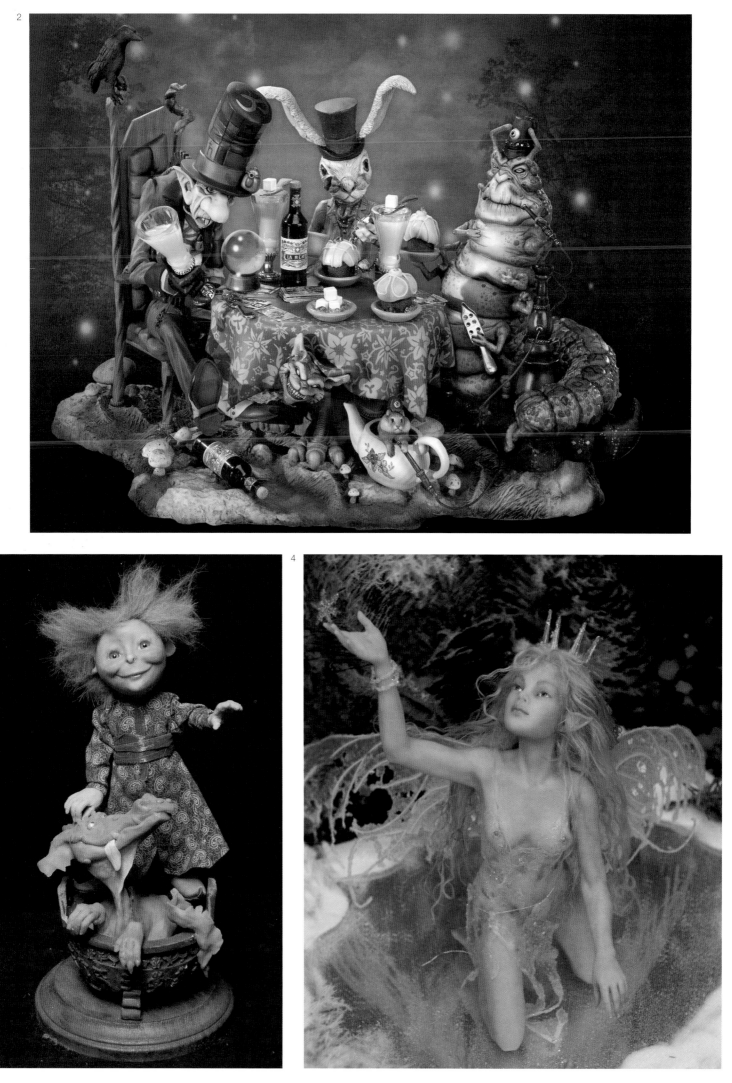

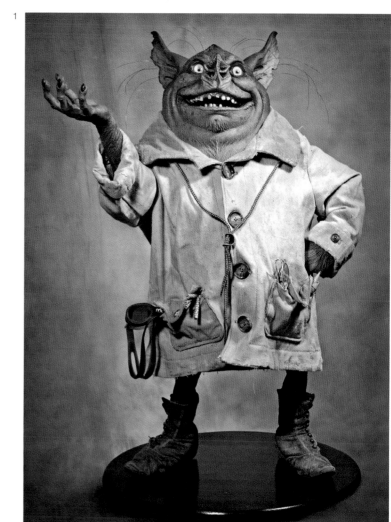

1 *artist:* **Miles Teves, Bill Basso**
art director: Jim Bissell
client: Paramount Pictures
title: A Notorious Hobgoblin
medium: Mixed
size: H 38"

2 *artist:* **Rich Klink**
title: Second Hand Superhero
medium: Mixed
size: H 20³/₄"

3 *artist:* **Schü**
designer: Ben Roman
painter: Mireya Romo
client: Gentle Giant Studio
title: Drac (from the Cryptics)
medium: Resin
size: H 8"

4 *artist:* **Schü**
designer: Schü
client: Gentle Giant Studio
title: Animated Boba Fett
medium: Resin
size: H 8"

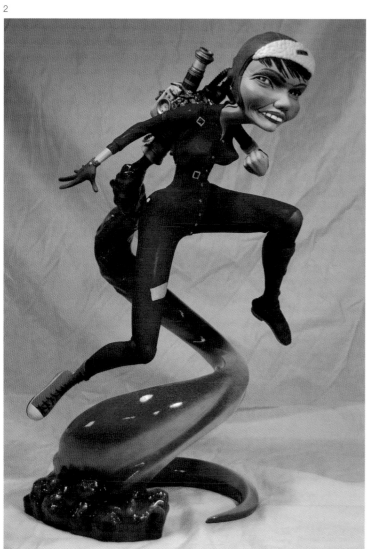

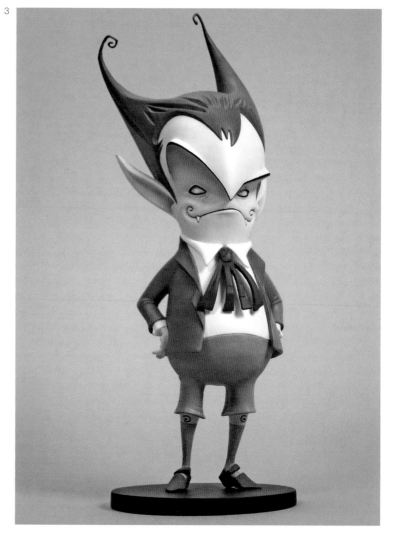

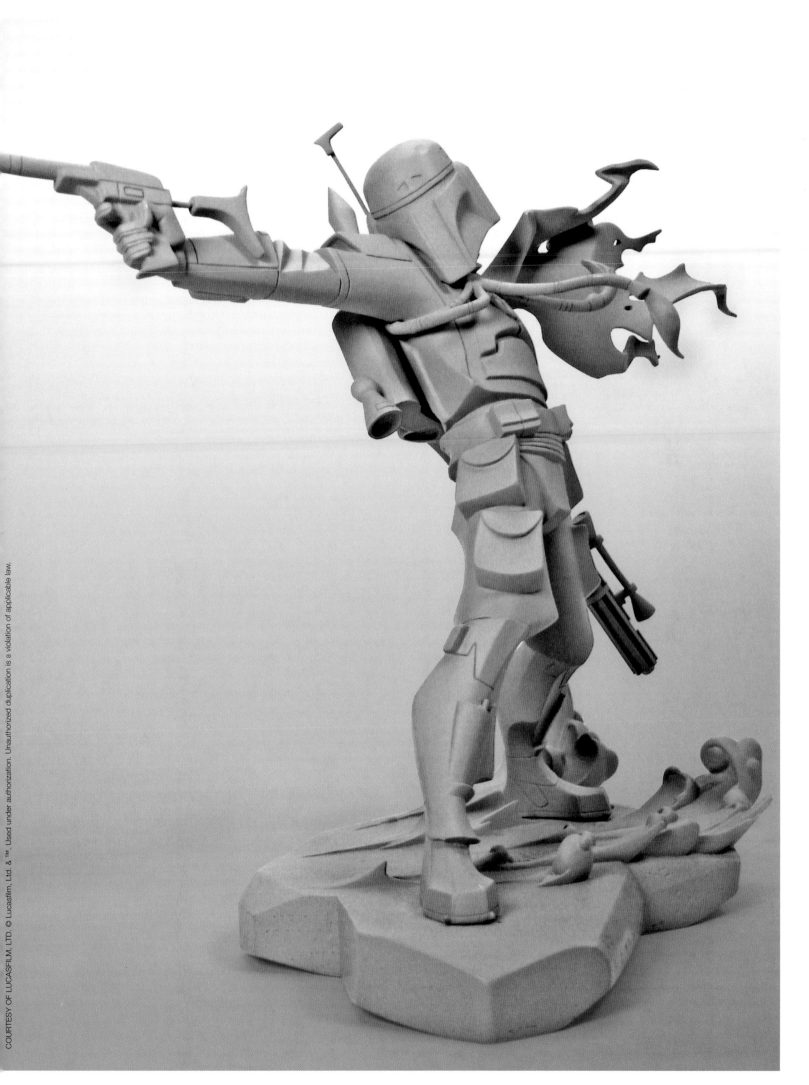

1 *artist:* **Matej Pasalic**
title: Mrs. Hunger
size: H 19¹/₂" x W 21" x D 12"

2 *artist:* **Mike Rivamonte**
title: Joe
medium: Found and created objects *size:* H 30"

3 *artist:* **The Shiflett Bros.**
art director: Jarrod Shiflett *photographer:* Chad Michael Ward
client: Shiflett Bros. Originals
title: Noynub in: Deal With the Devil
medium: Polymer clay *size:* H 11¹/₂"

4 *artist:* **Igor Grechanyk**
title: Eva or Experience of Irreal Knowledge
medium: Bronze *size:* H 37"

5 *artist:* **Arich Harrison**
client: Gentle Giant Studios *title:* Crusader
medium: Clay *size:* H 13" x W 9" x D 7"

6 *artist:* **Vincent Villafranca**
client: Private Collection *title:* A Conscious Entity and Its Maker
medium: Bronze *size:* H 15"

7 *artist:* **Akihito Ikeda**
art director: Akihito Ikeda *designer:* Kazuhiro
title: Bathing on Rodeo Dr.
medium: Mixed *size:* H 25" x W 16" x D 16"

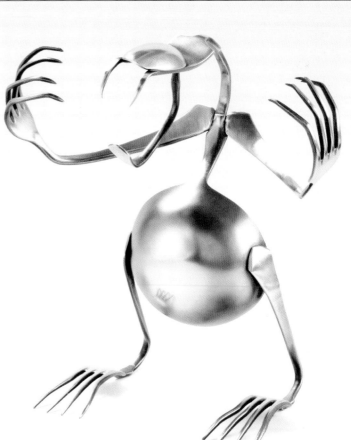

1

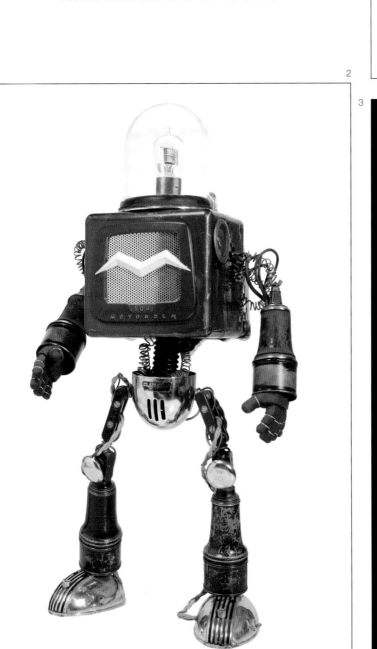

2

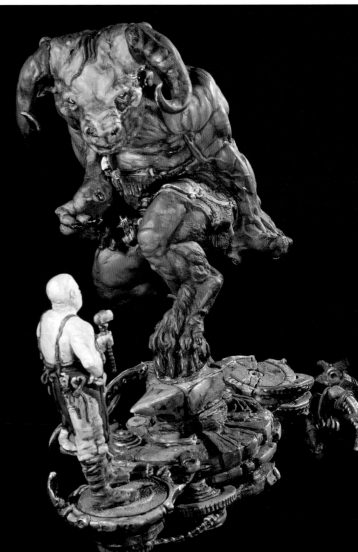

3

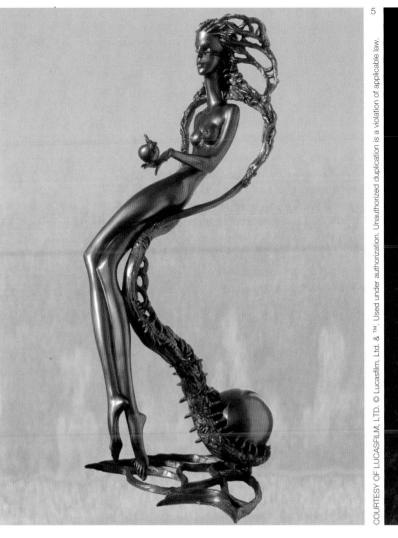

5

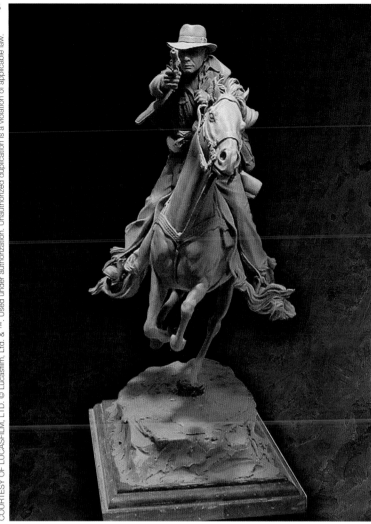

7

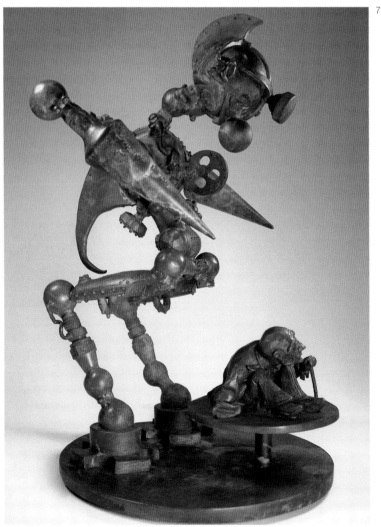

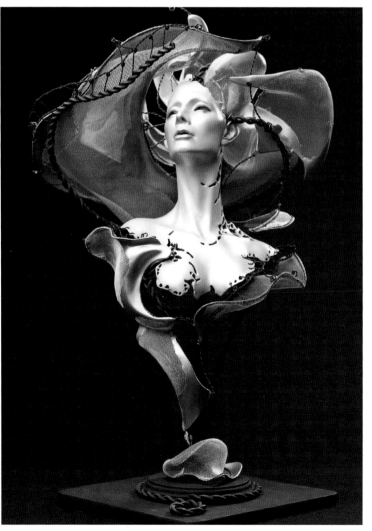

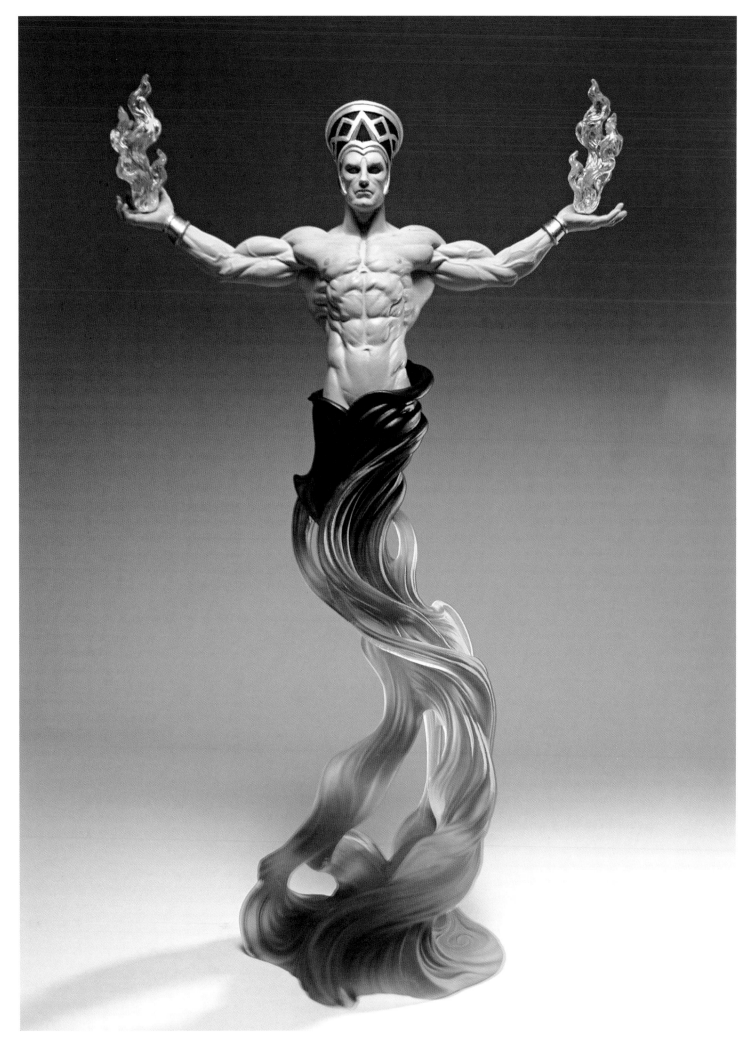

artist: **Tim Bruckner**
art director: Tim Bruckner *client:* The Art Farm, Inc. *title:* Prometheus *medium:* Painted resin *size:* H 10"

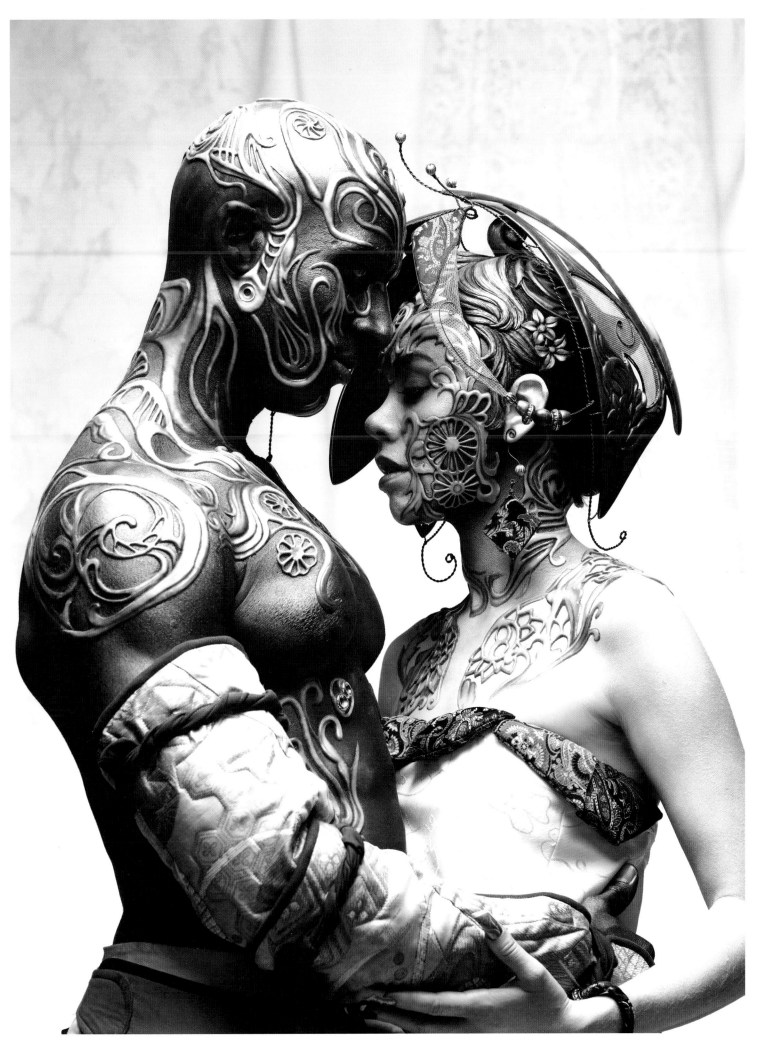

artist: **Akihito Ikeda**
art director: Akihito Ikeda *designer:* Kazuhiro Tuji *client:* Graphic-sha Publishing Co. Ltd. *title:* Arahan *medium:* Mixed *size:* Life-size

artist: **Phil Hale**
art director: **Tom Staebler** client: **Playboy Magazine** title: **The Interrogator** medium: **Oil on linen**

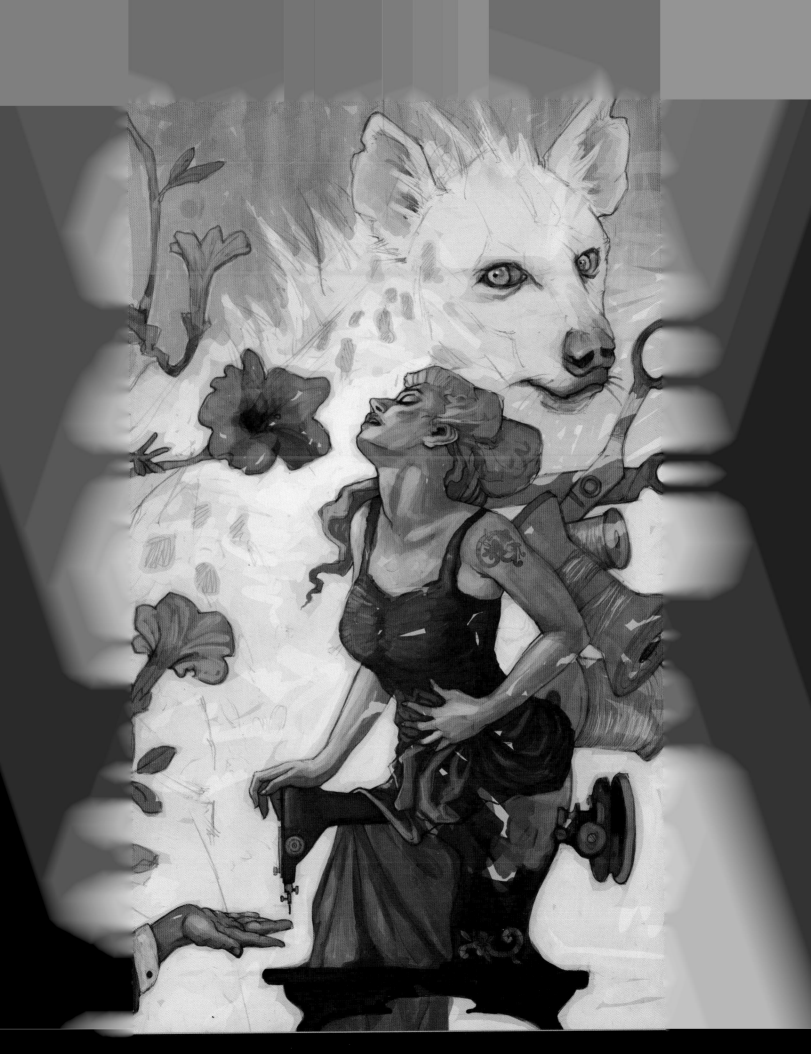

artist: **Kurt Huggins, Zelda Devon**
art director: Adam Lowe *client:* Polluto Magazine *title:* Singer *medium:* Digital

1 *artist:* Bryn Barnard
art director: Sue Beck *designer:* Sue Beck
client: Spider *title:* The Tooth Fairy
medium: Oil *size:* 18"x22"

2 *artist:* Woodrow J. Hinton III
art director: Andrew Jennings
client: CityBeat *title:* Stake Out
medium: Mixed *size:* 11"x17"

3 *artist:* Jonny Duddle
art director: Paul Tysall
client: Future Publishing *title:* Mars Needs You!
medium: Digital

4 *artist:* Viktor Koen
art director: Steven Heller
client: Baseline Magazine *title:* Toyphabet
medium: Digital *size:* 24"x24"

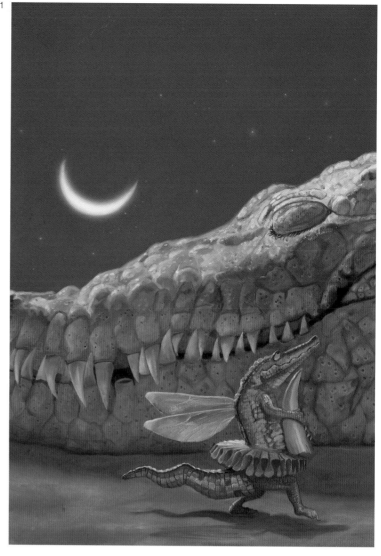

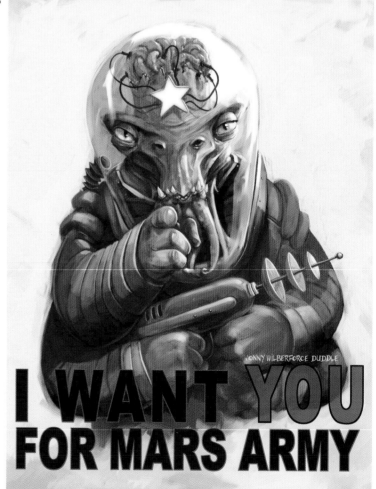

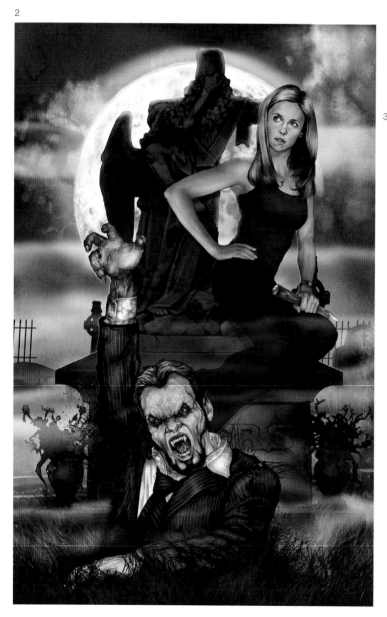

4

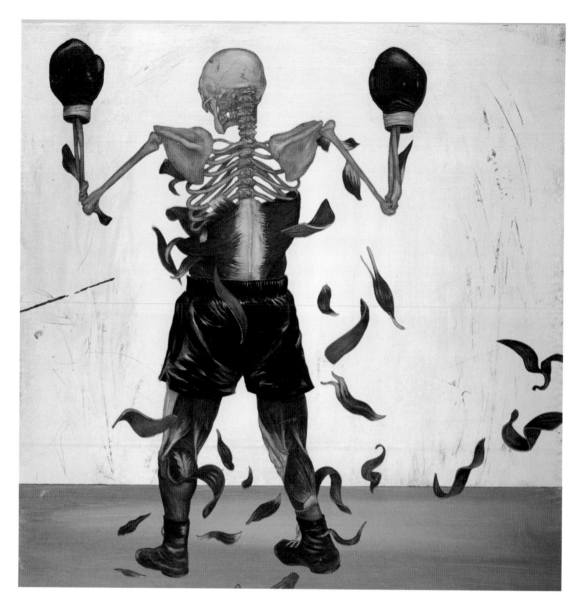

artist: **Jason Holley**
art director: Rob Wilson client: Playboy Magazine title: Mike Tyson Laid Bare

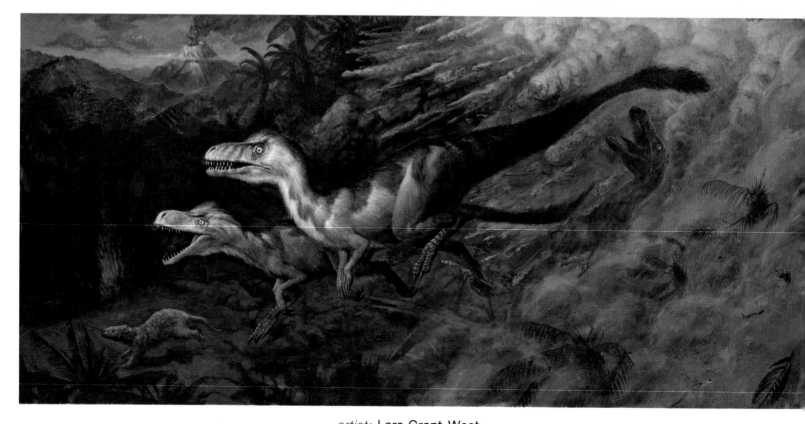

artist: **Lars Grant-West**
art director: Chris Klein client: National Geographic title: Tyrannosaurids in a Pyroclastic Flow medium: Acrylics on masonite size: 48"x24"

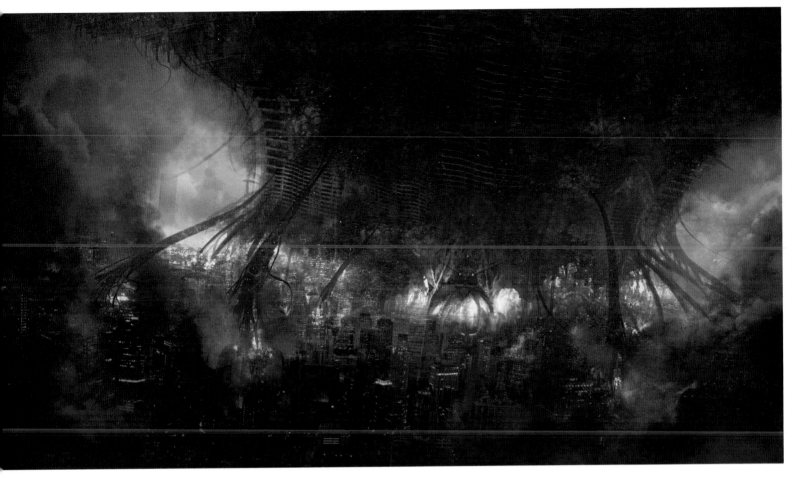

artist: artist: **Philip Straub**
art director: Rob Carney *client:* ImagineFX Magazine *title:* Death Dealer *medium:* Digital *size:* 15½"x8"

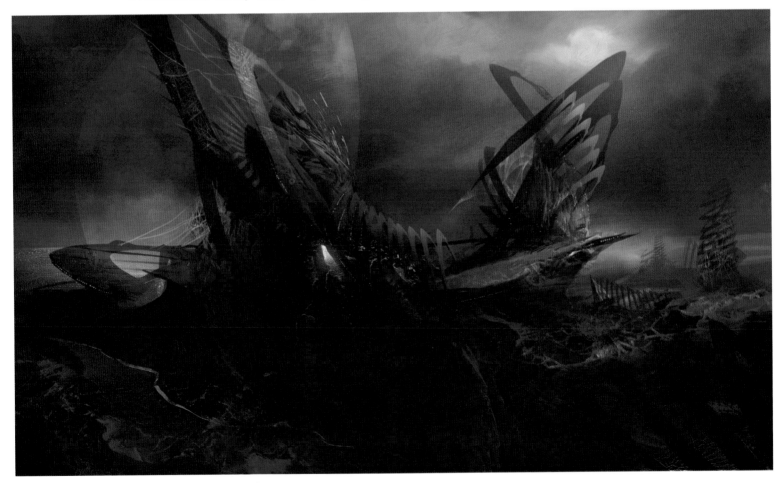

artist: **Philip Straub**
art director: Rob Carney *client:* ImagineFX Magazine *title:* In Search Of *medium:* Digital *size:* 15"x7"

1
artist: **Anita Kunz**
art director: David Harris
client: Vanity Fair Magazine
title: Intelligent Design [from the "green" issue]
medium: Mixed
size: 14"x11"

2
artist: **Mirko Ilic**
art director: Rob Wilson
client: Playboy Magazine
title: The Sexual Male Part One:
The Flight of the Spermatozoon

3
artist: **Ken Keirns**
client: Hi Fructose
title: The Business
medium: Oil on canvas
size: 18"x24"

4
artist: **Nate Van Dyke**
art director: Evan Pricco
client: Juxtapoz Magazine
title: Reign
medium: Mixed
size: 18"x24"

1

2

3

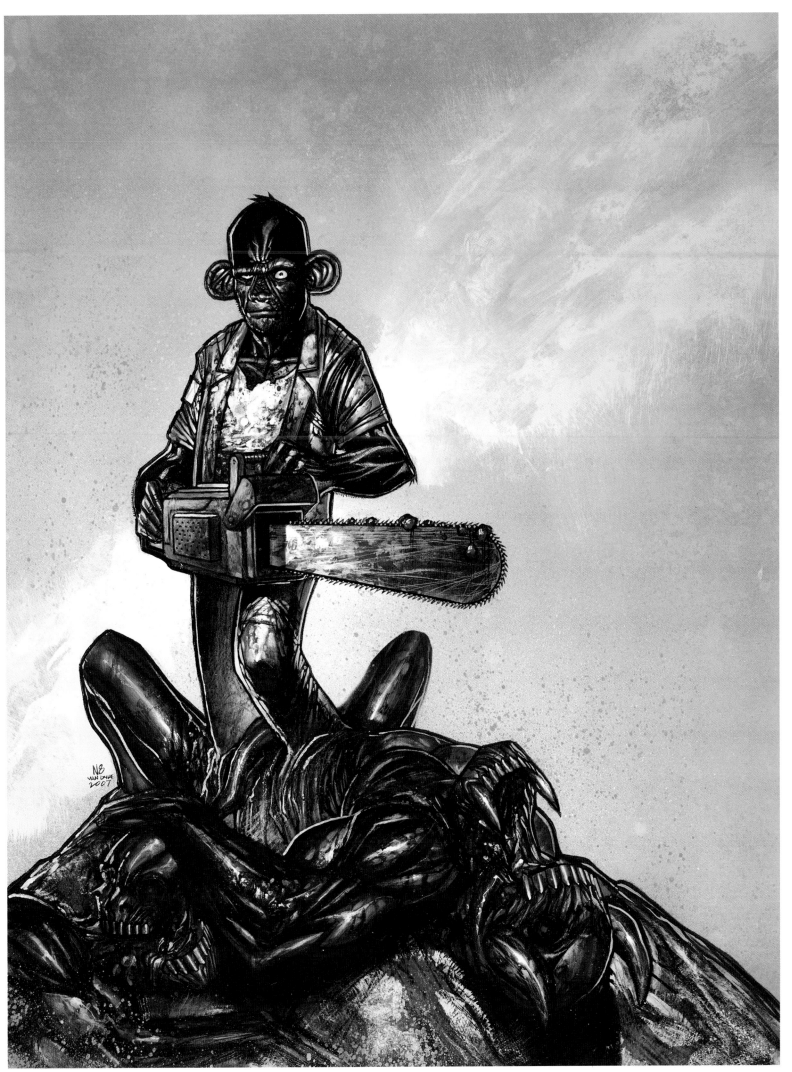

editorial

1 *artist:* John Malloy
art director: Rasha Kahil
client: Dazed & Confuse Magazine
title: Al Green: Soul Survivor
medium: Pen, ink, digital *size:* 8"x10"

2 *artist:* Alessandro "Talexi" Taini
client: Ninja Theory/SCEE *title:* Heavenly Sword
medium: Photoshop

3 *artist:* Tae Young Choi
art director: Rob Carney
client: ImagineFX *title:* Confrontation
medium: Digital *size:* 10"x12¼"

4 *artist:* Artgerm
art director: Stanley "Artgerm" Lall
client: Advanced Photoshop Magazine
title: Pepper Robot II
medium: Digital

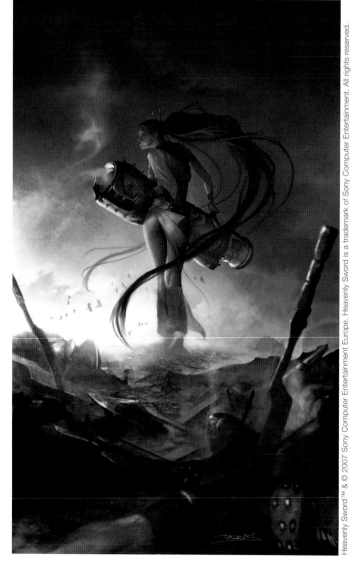

Heavenly Sword™ & © 2007 Sony Computer Entertainment Europe. Heavenly Sword is a trademark of Sony Computer Entertainment. All rights reserved.

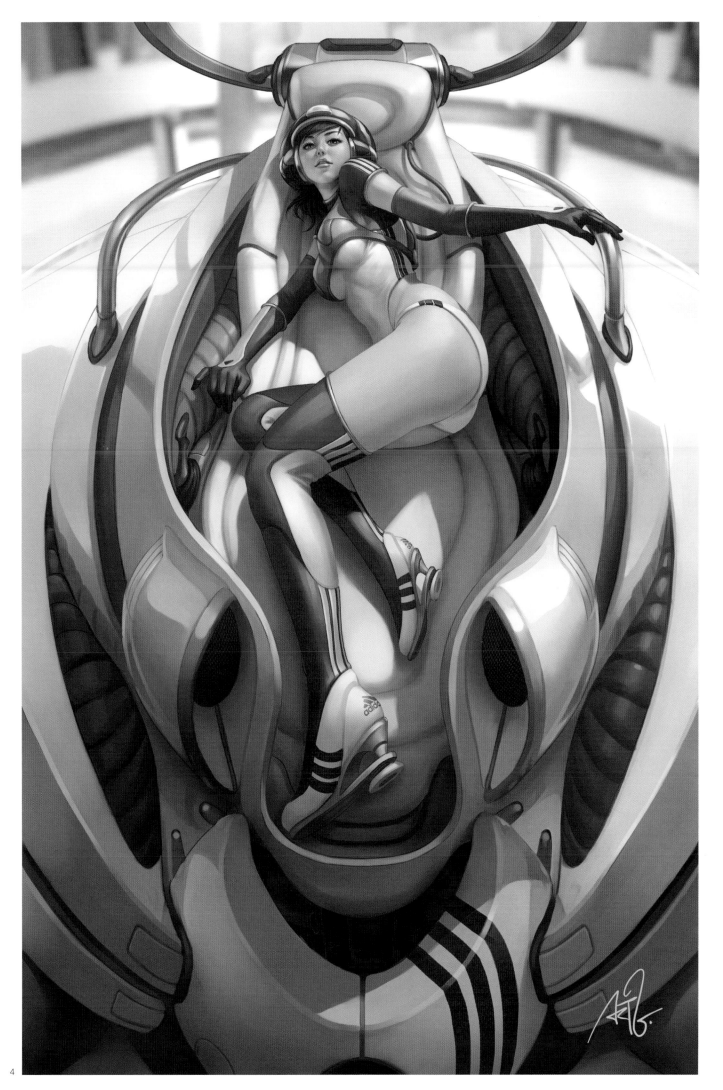

4

artist: **John Stamos**
art director: Zachary Trover client: The Pitch Weekly title: Burlesque medium: Digital size: 10"x6¹/₂"

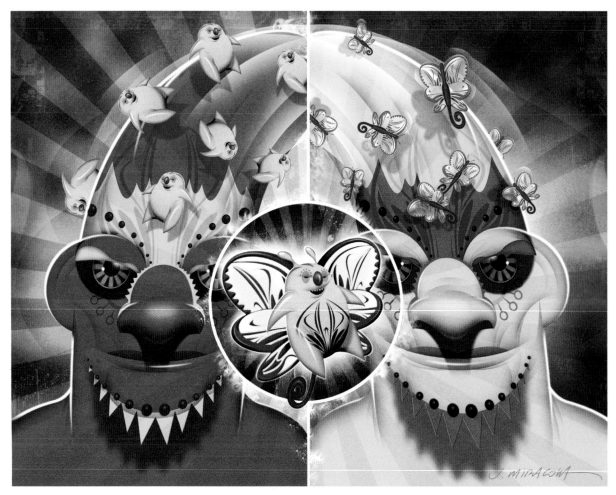

artist: **Jeff Miracola**
art director: Marcelo Furquim client: ImagineFX Magazine title: Collaboration medium: Digital size: 10"x8"

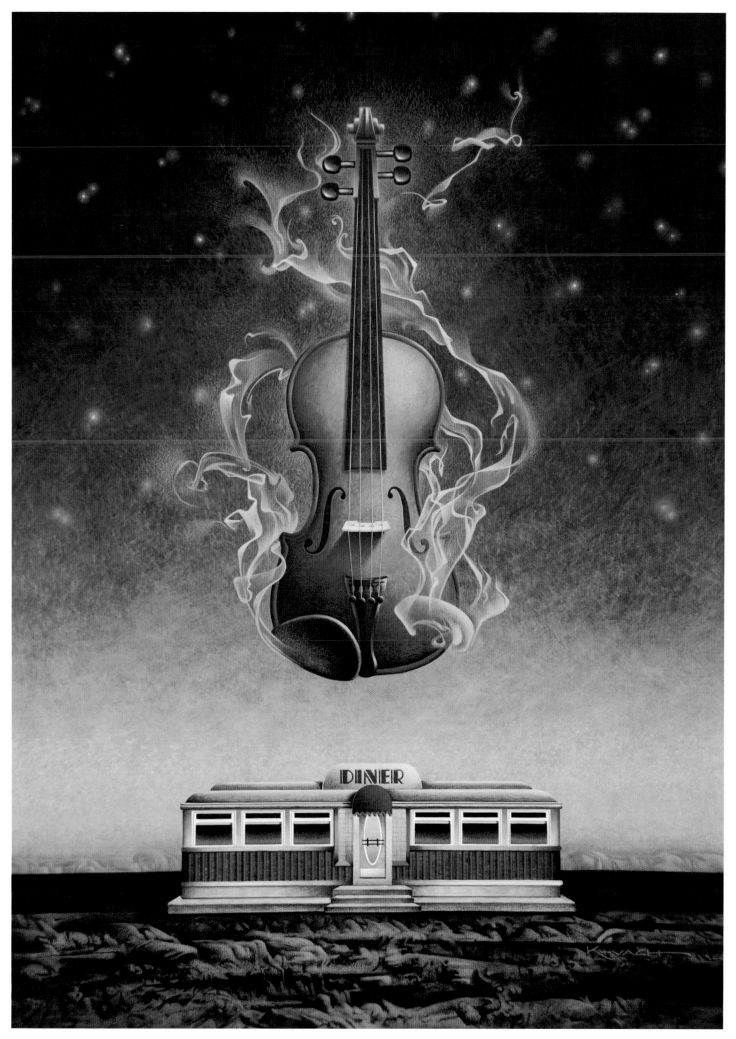

artist: **Joe Kovach**
art director: Laura Cleveland *client:* Realms of Fantasy Magazine *title:* Honest Man *medium:* Acrylics on board *size:* 16^1/$_2$"x22^1/$_2$"

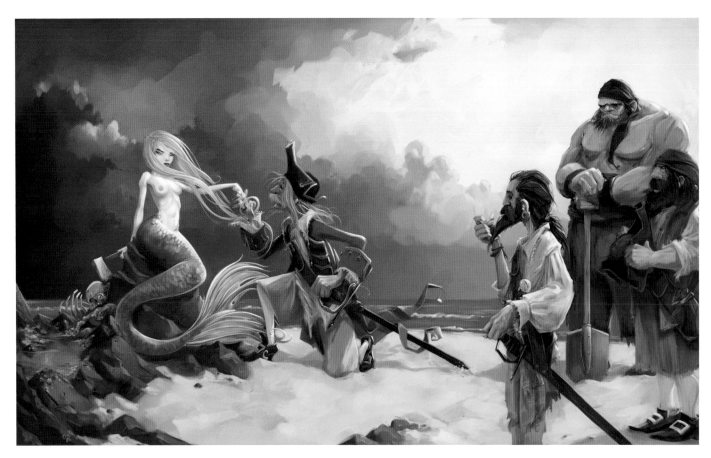

artist: **Jonny Duddle**
art director: Rob Carney client: Future Publishing title: The Siren medium: Digital

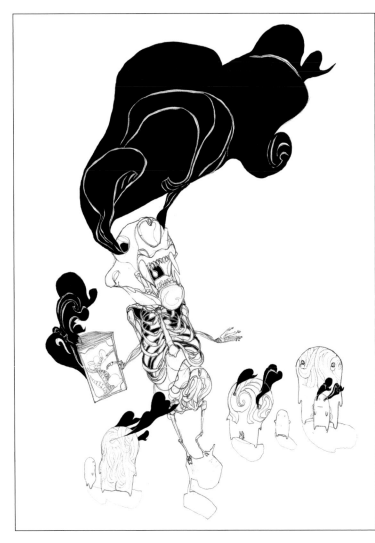

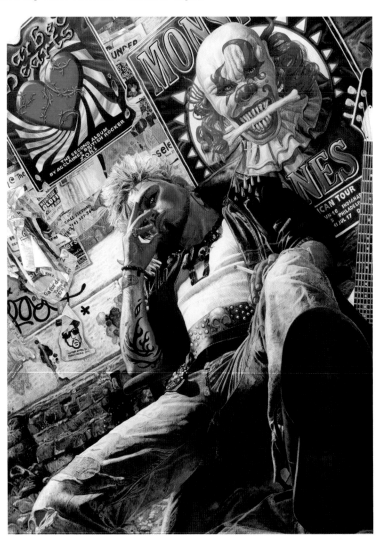

artist: **Emmanuel Malin**
client: Mikosa title: Necro Libra /3

artist: **Dave Leri**
art director: Laura Cleveland client: Realms of Fantasy Magazine
title: Holonoblin Blues medium: Oil size: 8 1/2x11"

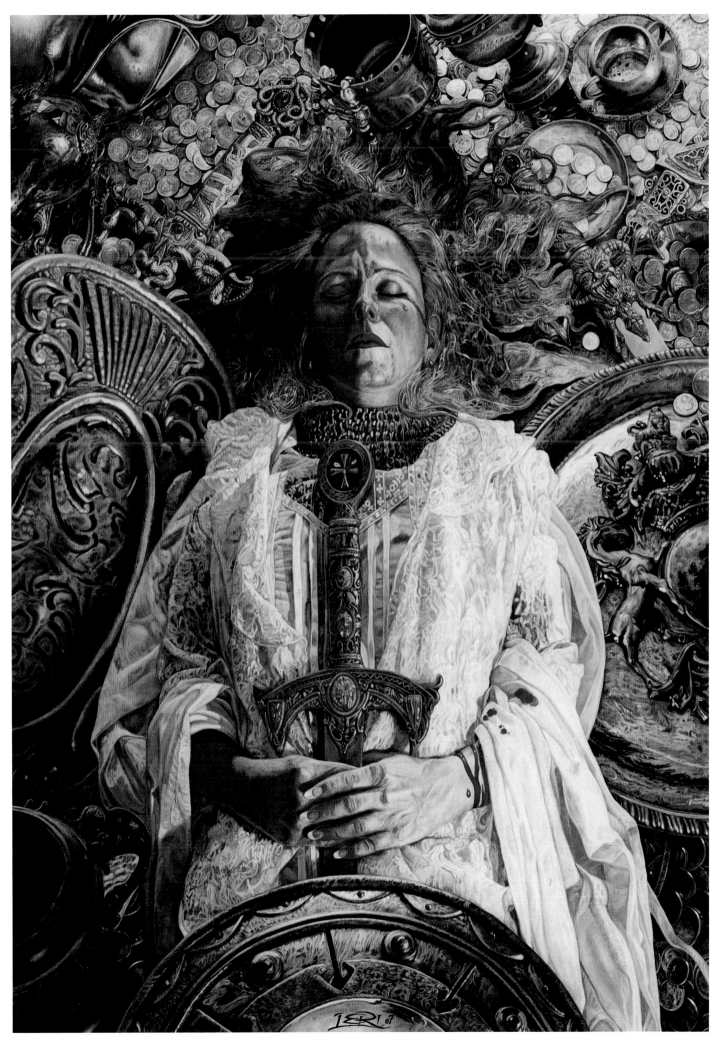

artist: **Dave Leri**
art director: Laura Cleveland *client:* Realms of Fantasy Magazine *title:* Roger Lambelin *medium:* Oil *size:* 8¹/₂"x11"

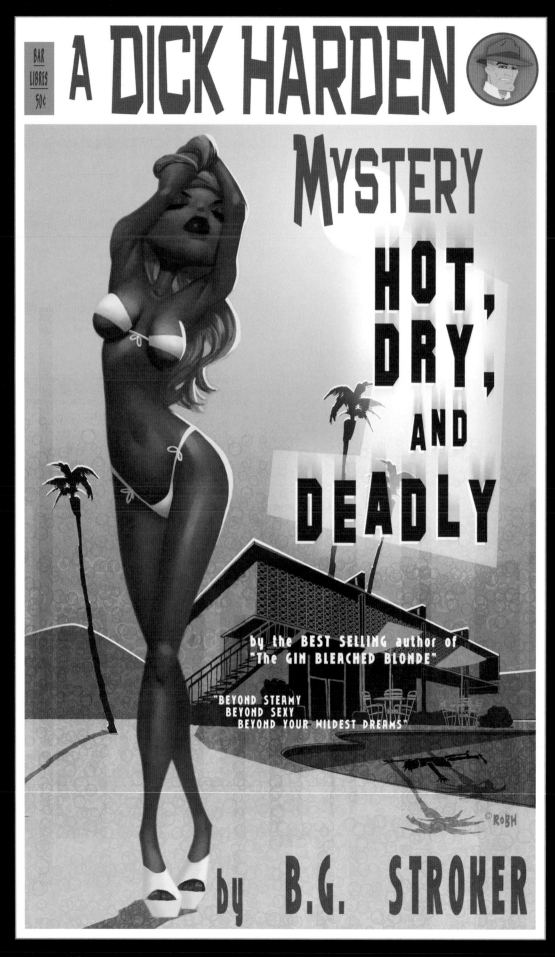

artist: **Robh Ruppel**
art director: **Robh Ruppel** *client:* **Broadview Graphics** *title:* **Hot, Dry, and Deadly** *medium:* **Digital**

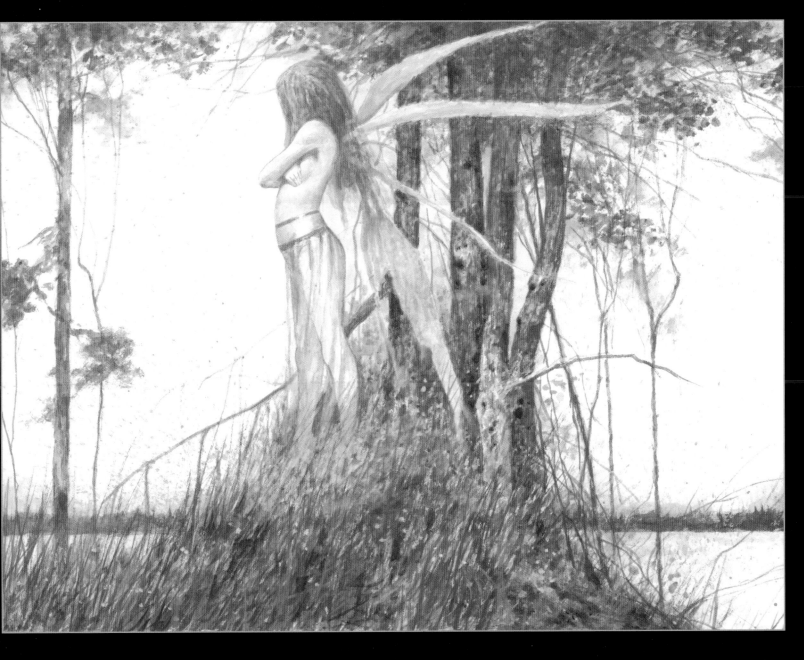

artist: **Larry MacDougall**
art director: **P.A. Lewis** *client:* **Underhill Studio** *title:* **Rainy River** *medium:* **Watercolor** *size:* **12"x9"**

1 *artist:* **Aleksi Briclot**
art director: Jeremy Jarvis
client: Wizards of the Coast *title:* Chandra Nalaar
medium: Digital

2 *artist:* **Adam Rex**
art director: Jeremy Jarvis
client: Wizards of the Coast
title: Oona, Queen of the Fae
medium: Oil

3 *artist:* **Jason Chan**
art director: Thomas Munkholt
client: Phabel *title:* Lucifer's Poison
medium: Digital *size:* 11"x16¹/₂"

4 *artist:* **Jason Chan**
art director: Coro
client: ConceptArt.Org *title:* Revelations
medium: Digital *size:* 11"x17"

1

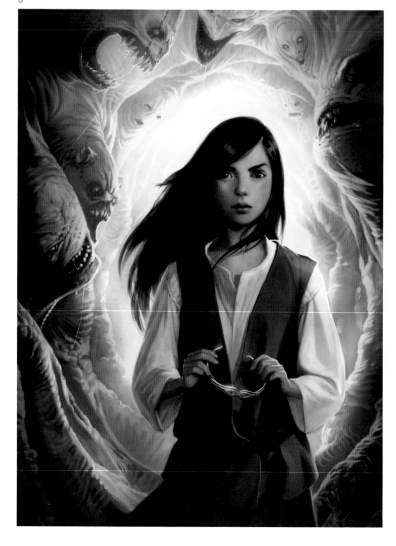

2

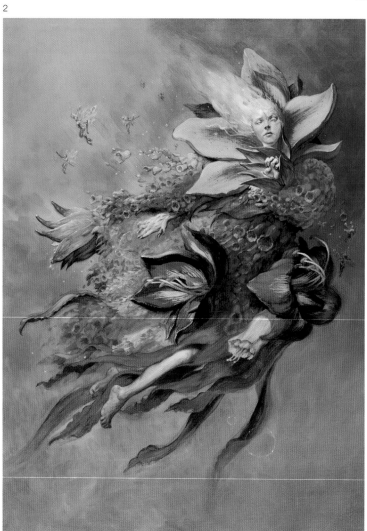

3

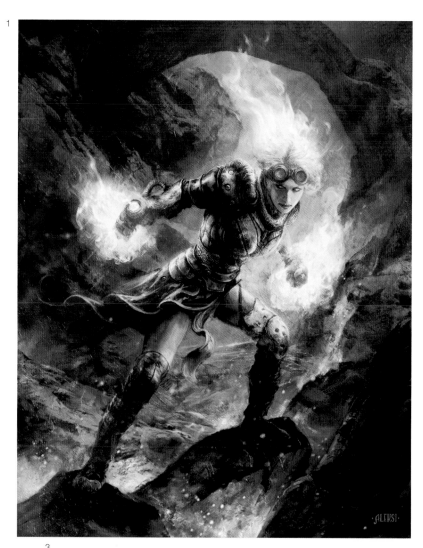

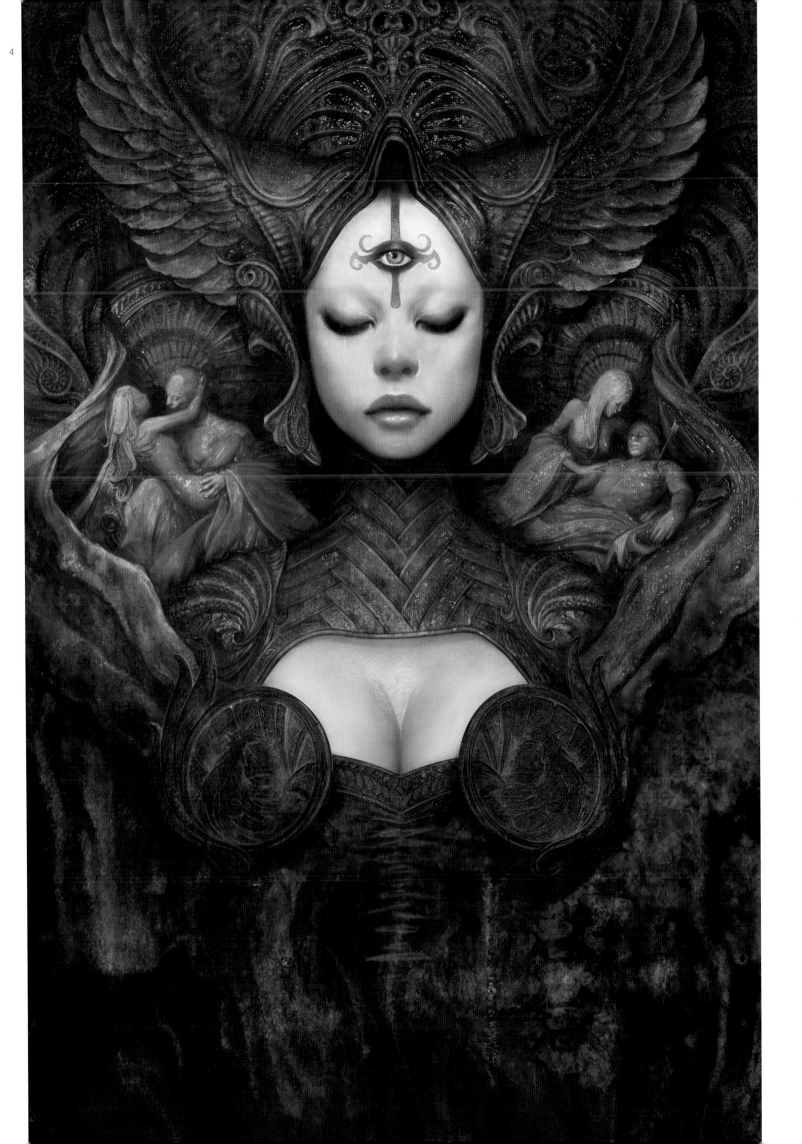

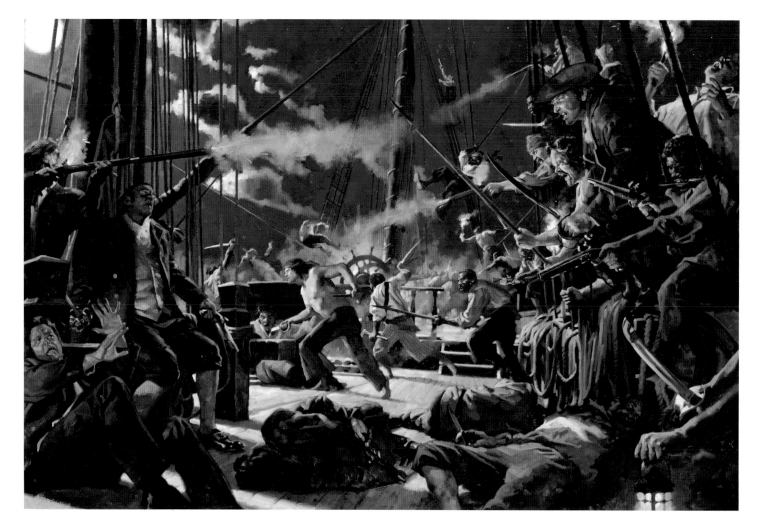

artist: **Gregory Manchess**
art director: Mark Lach *client:* Arts & Exhibitions, Inc. *title:* Midnight Pirate Battle *medium:* Oil on linen *size:* 45"x31"

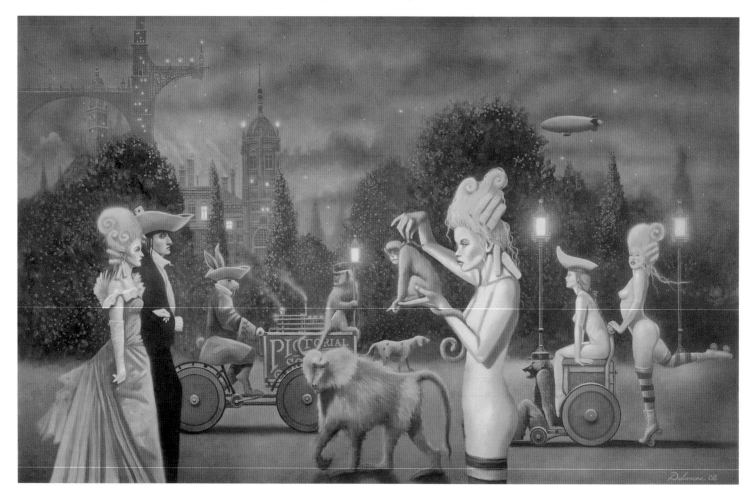

artist: **David Delamare**
title: Lumière Boulevard *medium:* Oil *size:* 48"x30"

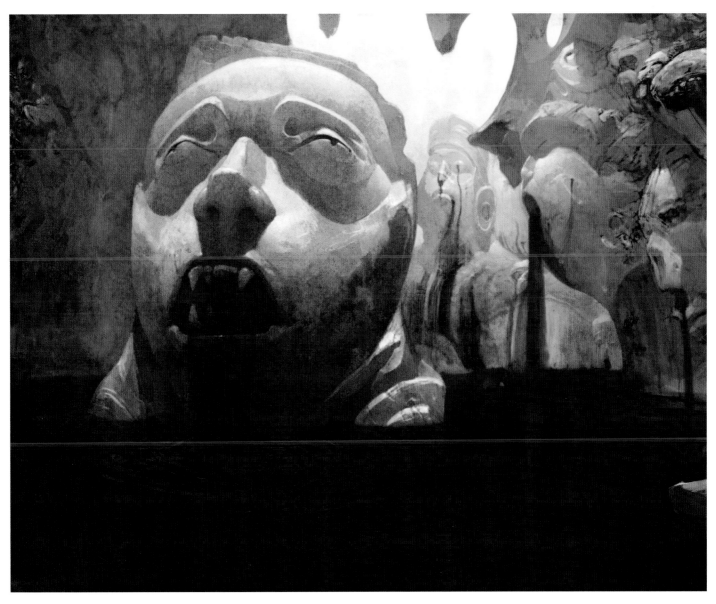

artist: **Anthony Scott Waters**
art director: Jeremy Cranford, Jeremy Jarvis client: Wizards of the Coast title: Graven Cairns medium: Digital size: 10"x8³/₈"

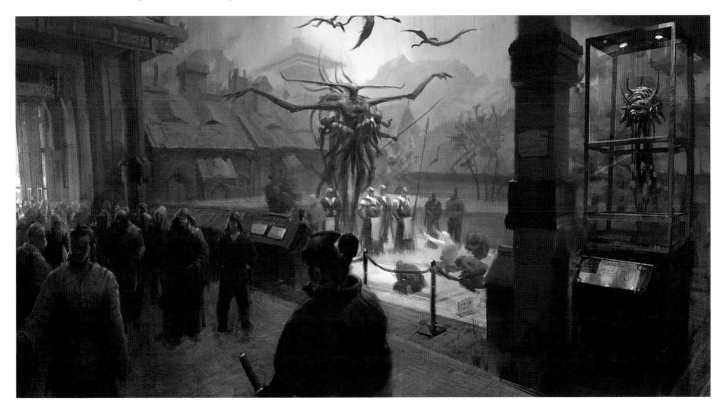

artist: **Whit Brachna**
client: ConceptArt.Org title: Underneath It All medium: Photoshop

1 *artist:* **Deseo**
art director: Deseo
client: The Lazarus Group *title:* Ninja Printer
medium: Pen, pencil, Photoshop *size:* 36"x36"

2 *artist:* **Chris Gall**
art director: Jim Burke
client: Della Graphics *title:* Frog Calendar
medium: Engraving, Photoshop *size:* 12"x16"

3 *artist:* **Mark A. Nelson**
client: Grazing Dinosaur Press *title:* Dragon's Breath
medium: Pencil, digital *size:* 11"x15"

4 *artist:* **Jonathan Bartlett**
art director: Kelly Buchanan
client: Kelly Buchanan Musician *title:* O Is For Orange
medium: Graphite *size:* 14"x14"

1

2

3

4

1
artist: **Gregory Manchess**
art director: Mark Lach
client: Arts & Exhibitions, Inc.
title: Black Sam Bellamy, Pirate
medium: Oil on linen
size: 20"x36"

2
artist: **Aleksi Briclot**
art director: Jeremy Jarvis
client: Wizards of the Coast
title: Garruk Wildspeaker
medium: Digital

3
artist: **Mark A. Nelson**
client: Grazing Dinosaur Press
title: SS: Goddess of War
medium: Pencil, digital
size: 10¹/₂"x13¹/₂"

4
artist: **Scott M. Fischer**
art director: Jeremy Jarvis
client: Wizards of the Coast
title: Imperious Perfect
medium: Mixed on canvas
size: 20"x30"

5
artist: **Sean "Muttonhead" Murray**
client: Bighugeartblog.blogspot.com
title: Skullneck
medium: Digital

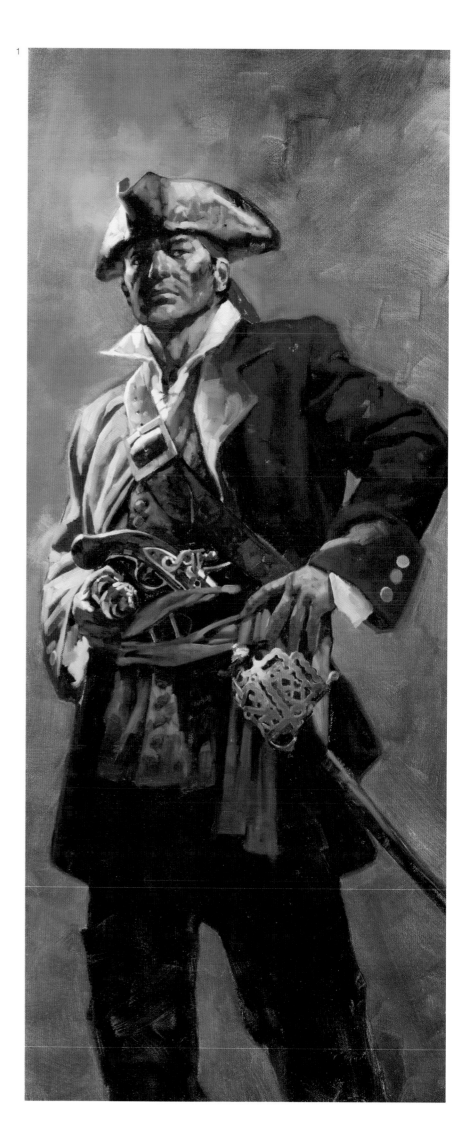

1

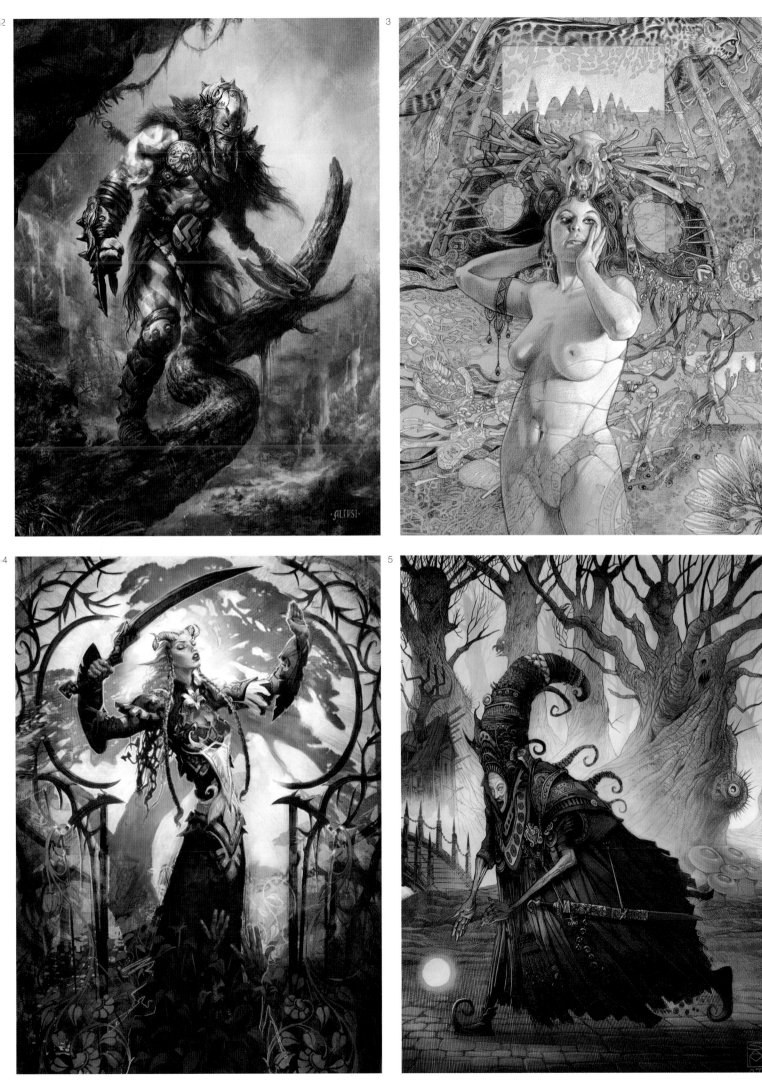

1
artist: **Victor Powell**
art director: Victor Powell
client: Victorpowell.com
title: Fifties Future
medium: Oil
size: 48"x48"

2
artist: **Raul Cruz**
art director: Racrufi
title: Water of Jade
medium: Digital
size: 15¹/₂"x23¹/₄"

3
artist: **Natascha Roeoesli**
title: Can't Stand the Light
medium: Digital

4
artist: **Andrew Bawidamann**
client: www.bawidamann.com
title: Cosmonaut Girl
medium: Digital
size: 18"x24"

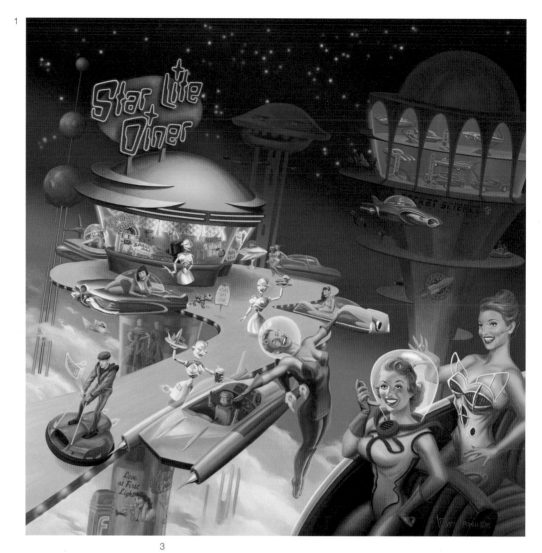

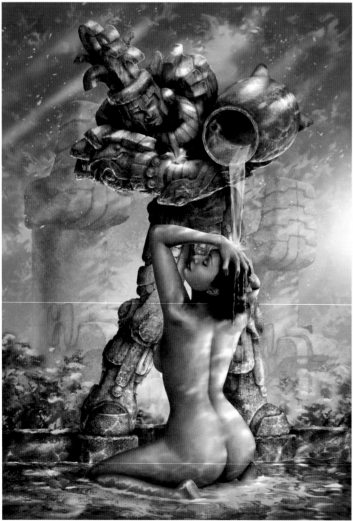

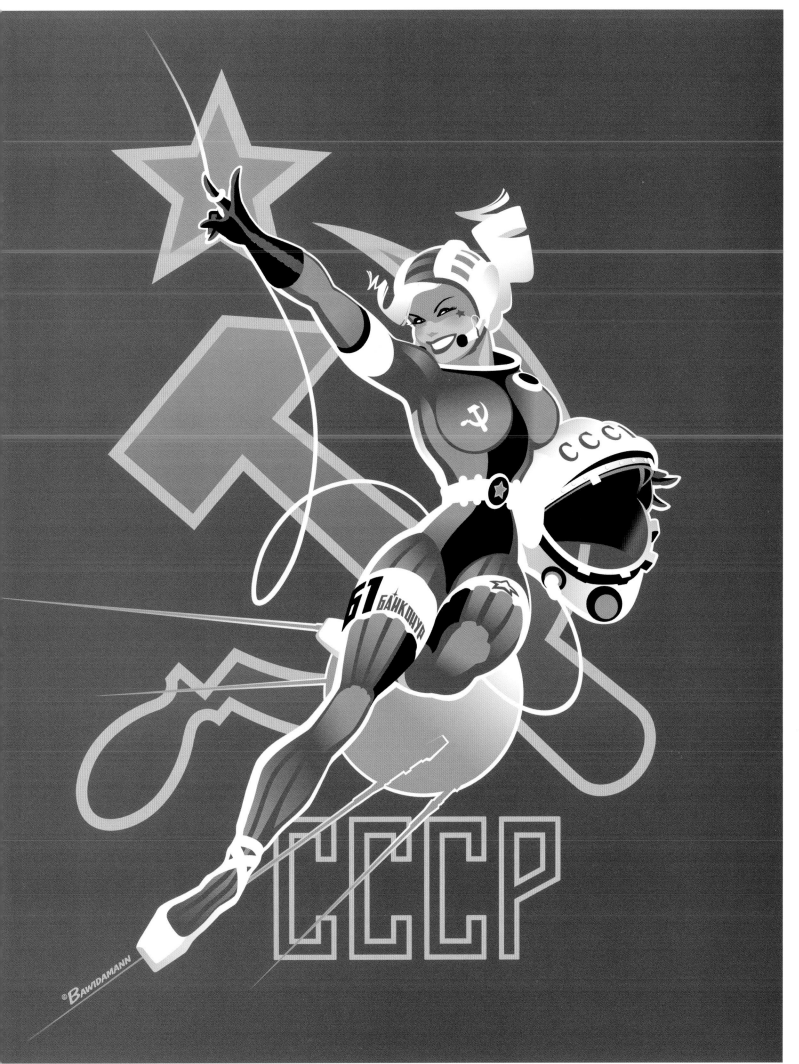

artist: **Steven Belledin**
art director: Jeremy Jarvis client: Wizards of the Coast title: Seedcradle Witch medium: Oil

artist: **Philip Straub**
art director: Jeremy Jarvis client: Magic: The Gathering title: Llanowar Reborn medium: Digital size: 13"x12"

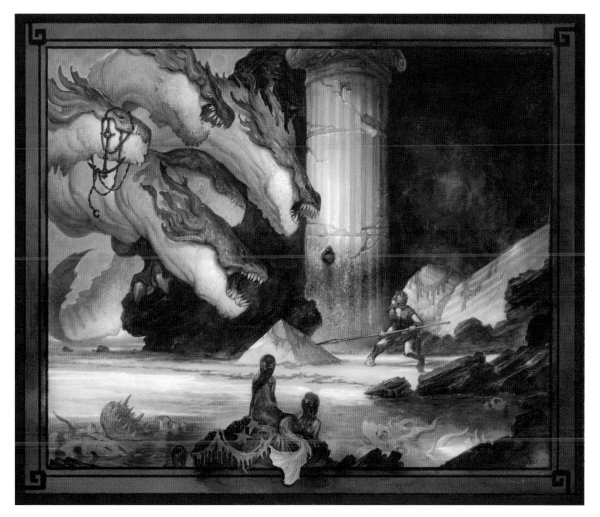

artist: **Justin Gerard**
art director: Justin Gerard *client:* Monsters, Gods, & Heroes *title:* Hydra *medium:* Digital *size:* 24"x20"

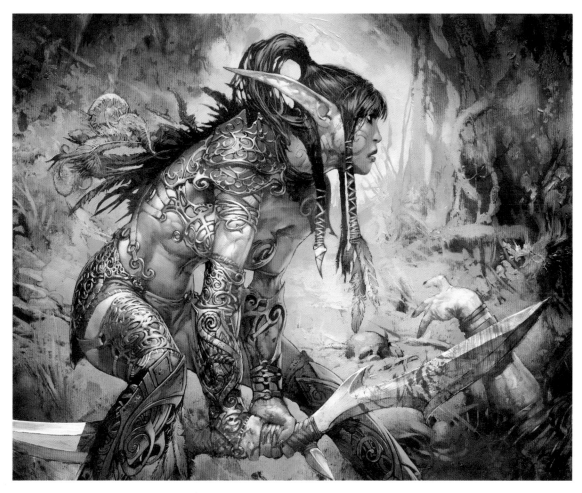

artist: **Jim Murray**
art director: Jeremy Cranford *client:* Upper Deck Entertainment *title:* Kavai the Wanderer *medium:* Acrylics *size:* 9"x7"

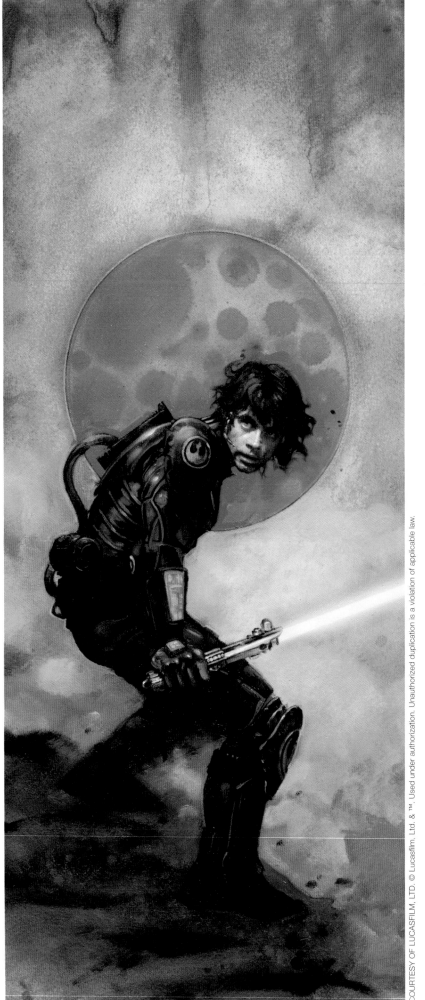

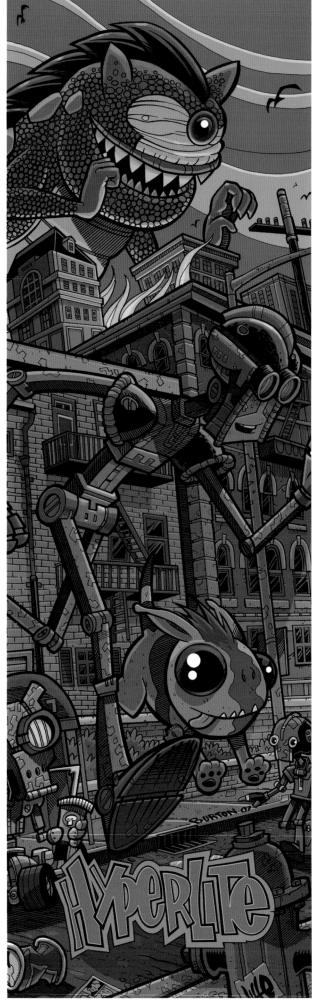

artist: **Terese Nielsen**
art director: Paul Hebron *designer:* Leon Cortez
client: Lucasfilm Ltd/Wizards of the Coast *title:* Star Wars

artist: **Jamie Burton**
art director: Son Duong *client:* Hyperlite
title: Wake Board 2 *medium:* Ink, digital *size:* 8"x23"

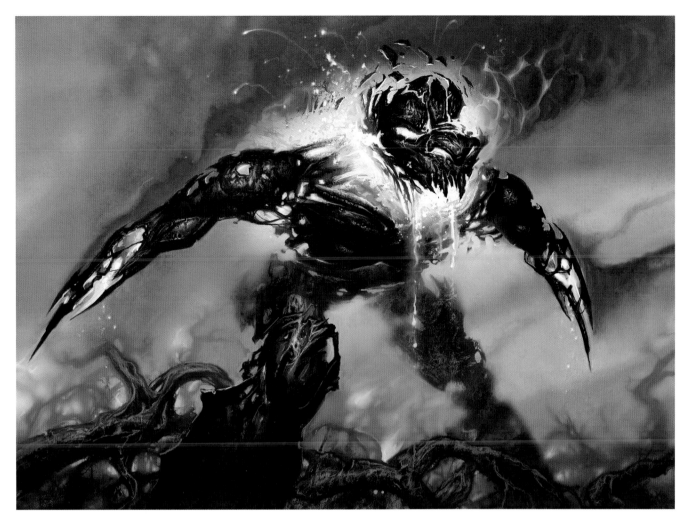

artist: **Matt Cavotta**
art director: Jeremy Jarvis *client:* Wizards of the Coast *title:* Cinderfolk *medium:* Digital *size:* 9"x6¹/₂"

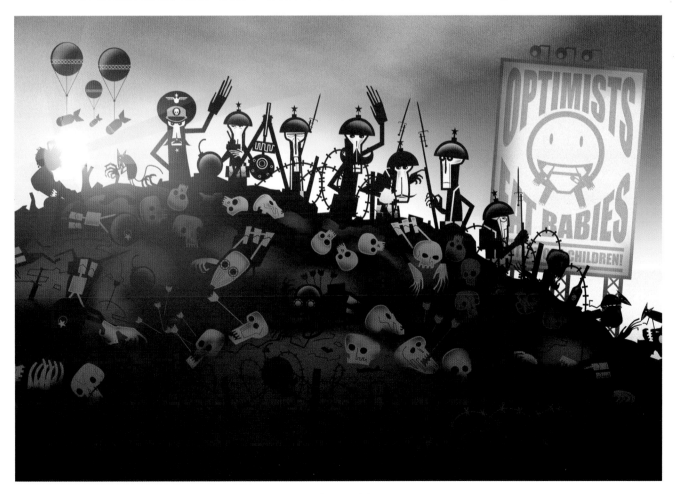

artist: **James Turner**
client: SLG Publishing *title:* NIL—Battlefied *medium:* Digital *size:* 6¹/₂"x4¹/₂"

1 *artist:* rk post
art director: Jeremy Jarvis
client: Wizards of the Coast *title:* Knight of Dusk
medium: Digital *size:* 12"x12"

2 *artist:* Matt Dixon
client: Tanango *title:* Deadna and Pitkin
medium: Digital

3 *artist:* Luis Royo
art director: Luis Royo
client: Norma Editorial *title:* Death and Life
medium: Acrylics *size:* 10"x18"

4 *artist:* Donato Giancola
client: Cathy & Arnie Fenner *title:* Red Sonja
medium: Oil on paper on panel *size:* 21"x29"

1

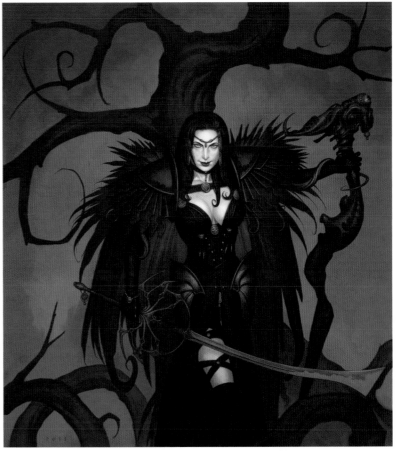

2

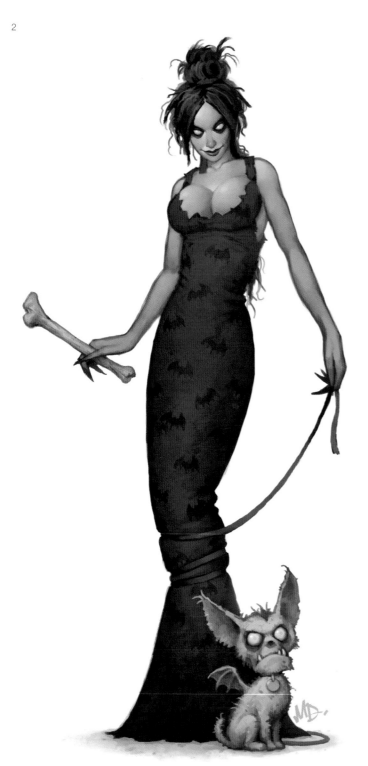

3

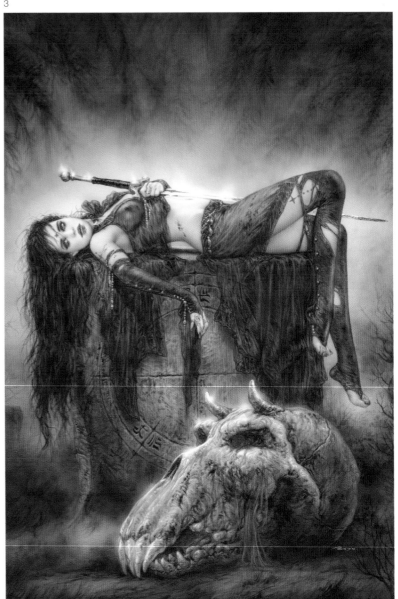

4

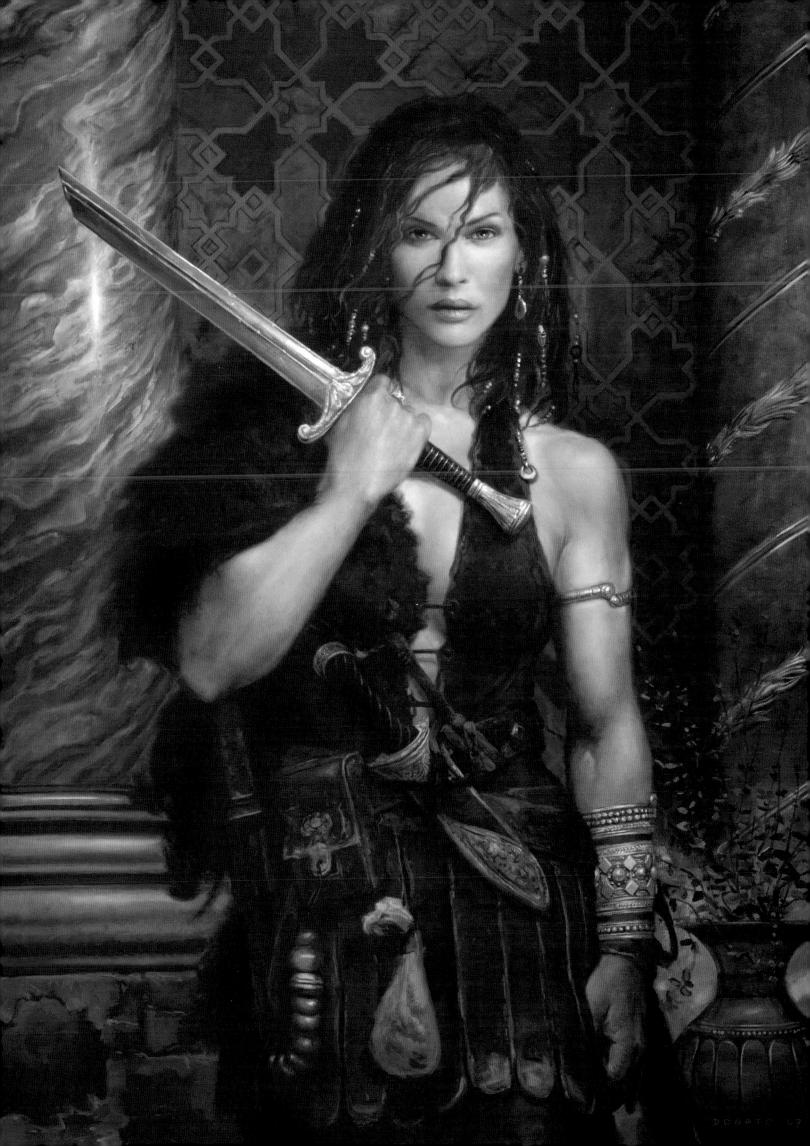

1 *artist:* Brian Despain
client: John Brophy
title: The Discovery
medium: Oil on panel *size:* 6"x8"

2 *artist:* Ragnar
client: Baby Tattoo Books
title: Spooketto
medium: Digital *size:* 17"x11"

3 *artist:* Gary Baseman, James Jean,
Lola, Tara McPherson, Amanda Visell,
Ragnar, Luke Chueh, Jeff Soto,
Jeffrey Scott (1019),
Tim Biskup, Frank Kozik, Gris Grimly
art director: Bob Self
client: Baby Tattoo Books
title: Baby Tattooville 12-in-1 Limited Edition
medium: Mixed *size:* 17"x22"

1

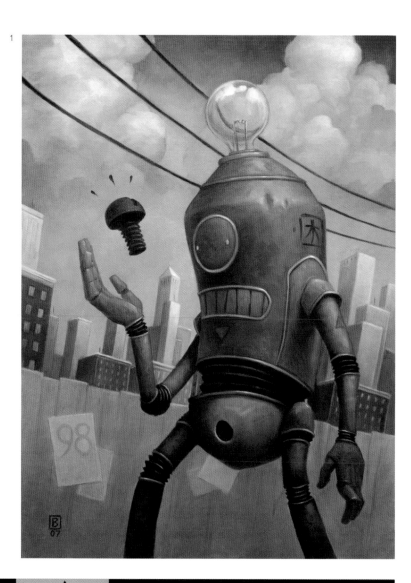

2

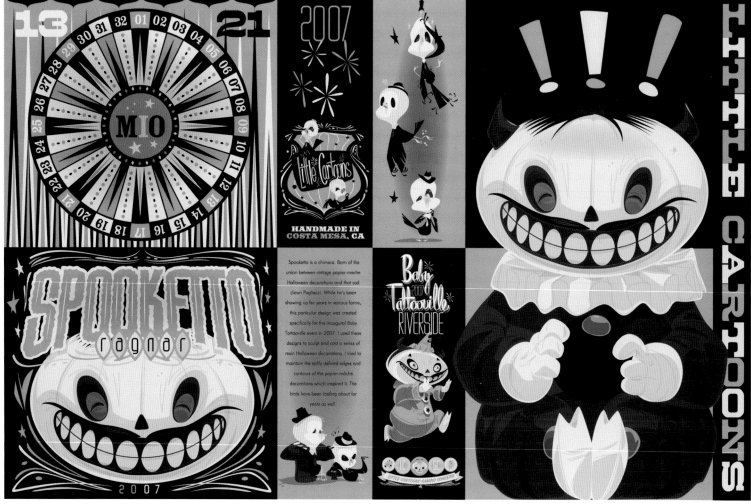

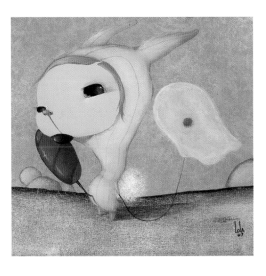

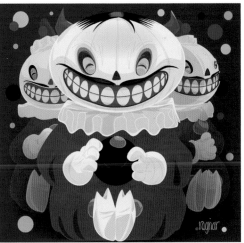

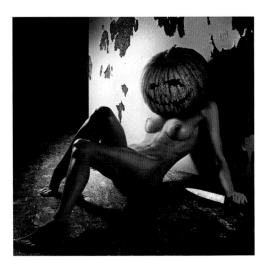

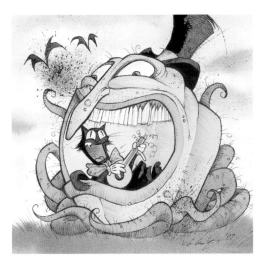

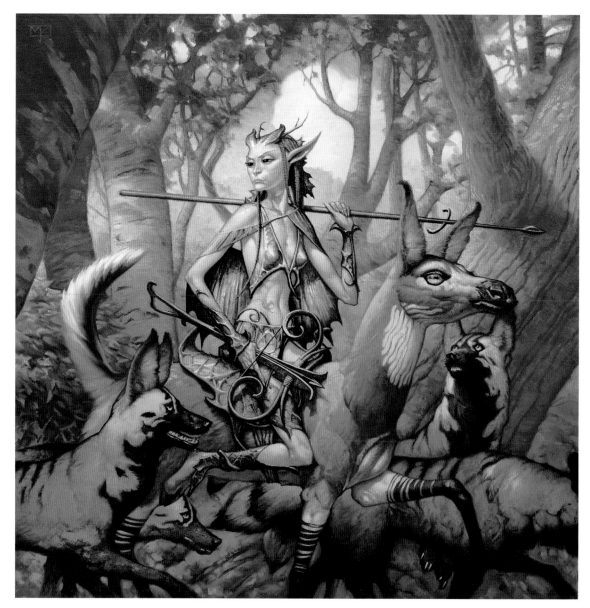

artist: **Mark Zug**
art director: Jeremy Jarvis *client:* Wizards of the Coast *title:* Wren's Run Packmaster *medium:* Oil

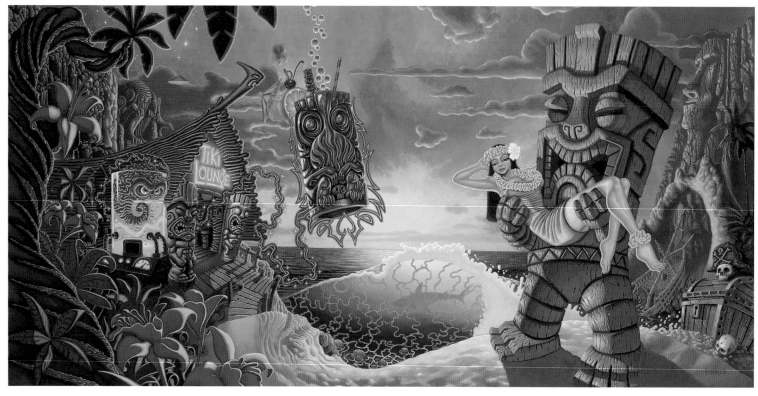

artist: **Brad Parker**
art director: Brad Parker *client:* Tiki Shark Hawaii, Inc. *title:* Forbidden Island *medium:* Acrylics on canvas *size:* 46"x24"

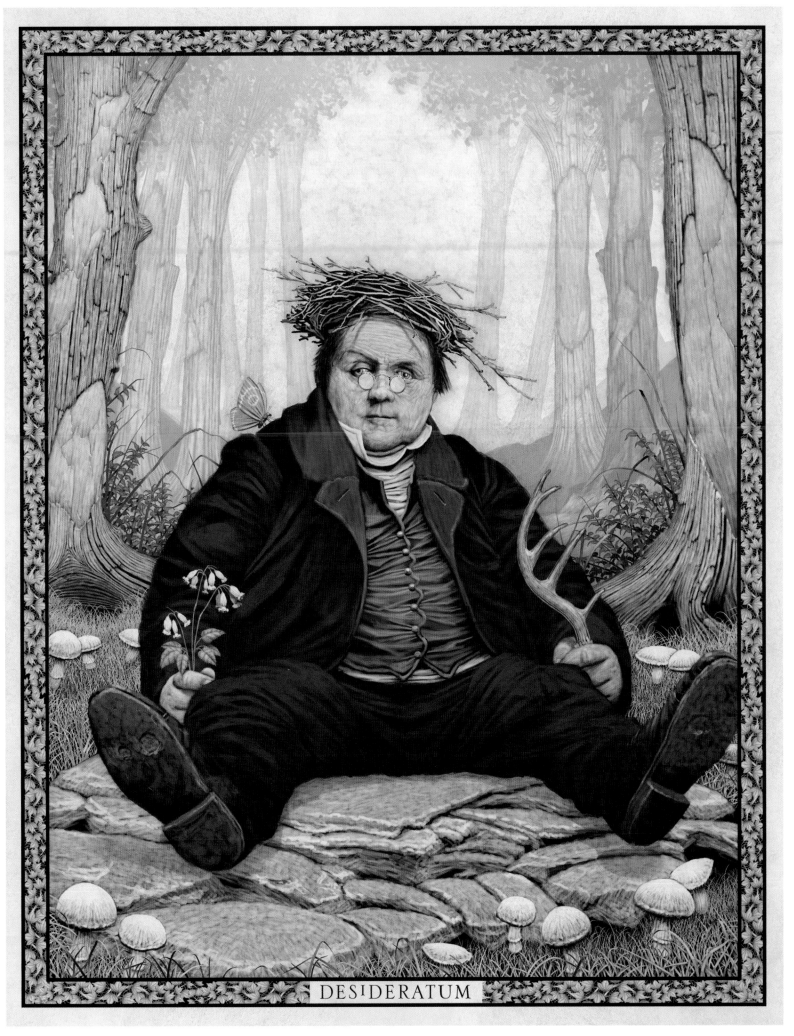

DESIDERATUM

artist: **Edward Binkley**
title: Desideratum medium: Digital size: 13"x17"

1 *artist:* Artgerm
art director: Stanley "Artgerm" Lall
client: Self-promotion *title:* Ten Brothers
medium: Digital

2 *artist:* Lisa L. Cyr
art director: Mary Aarons *designer:* Maureen Mooney
client: Rockport Publishers *title:* The Creative Spirit Within
medium: Acrylics, oil, collage & assemblage
on canvas over masonite with wood framework
size: 17¹/₂"x22"x1³/₄"

3 *artist:* DCWJ
title: AHHHH *medium:* Digital

4 *artist:* Bill Carman
title: Icons: Saints of Early Vices
medium: Acrylics *size:* 4"x6"

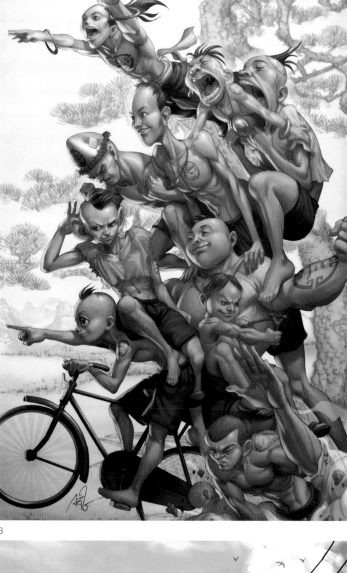

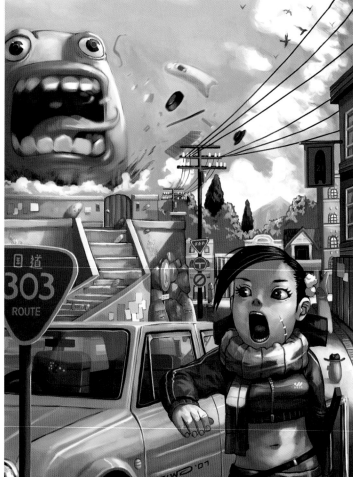

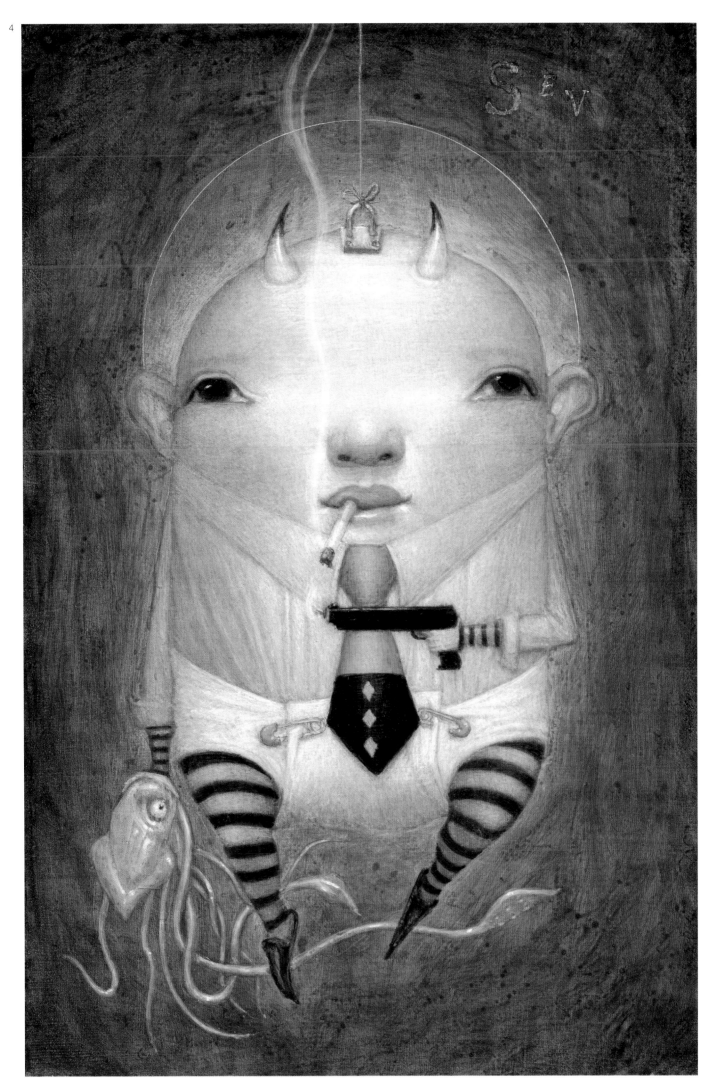

1 *artist:* **Brom**
art director: Kirk Dilbeck
title: Morgan Le Fey
medium: Oil on board

2 *artist:* **Jim Murray**
art director: Jeremy Jarvis
client: Wizards of the Coast *title:* Wolf-skull Shaman
medium: Mixed

3 *artist:* **Boris Vallejo**
client: Workman Publishing *title:* Freedom
medium: Oil *size:* 18"x24"

4 *artist:* **Julie Bell**
client: Workman Publishing *title:* Sea Witch
medium: Oil *size:* 18"x26"

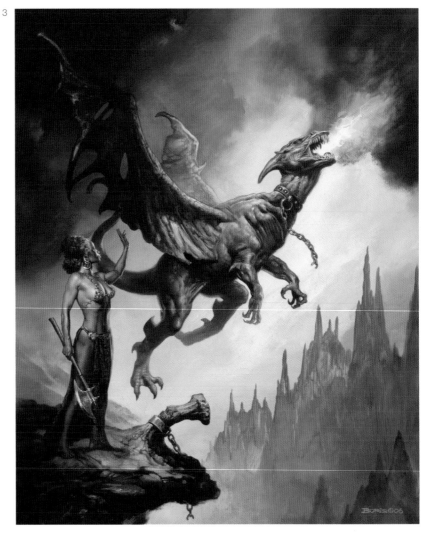

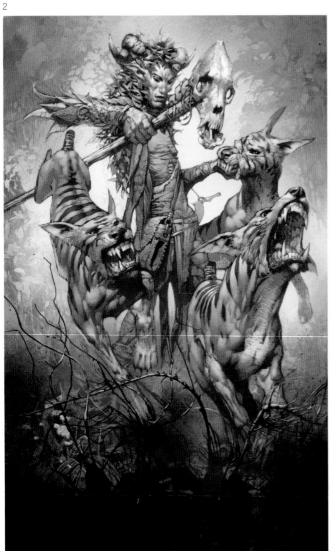

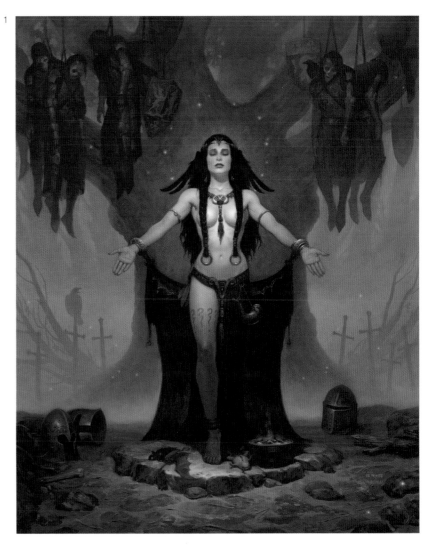

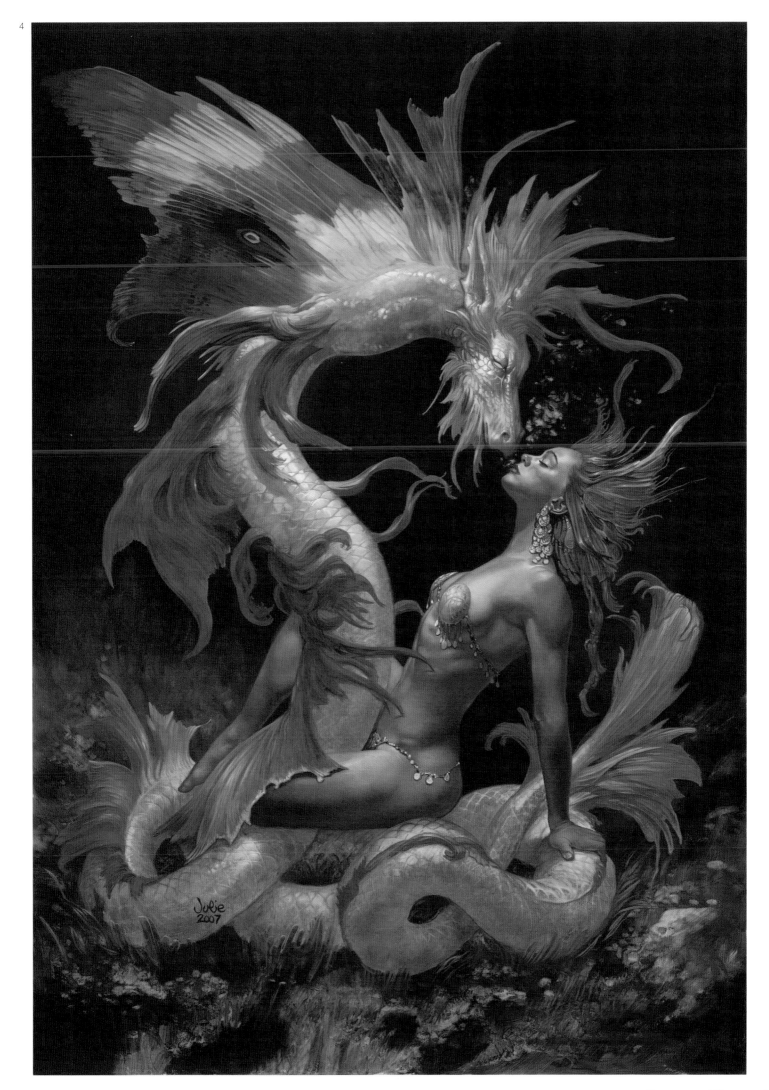

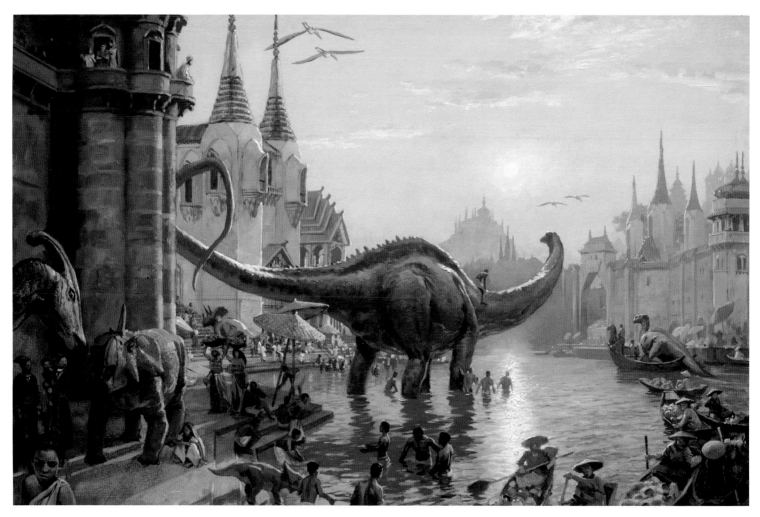

artist: **James Gurney**
art director: Arnie Fenner client: Andrews McMeel Publishing LLC title: Light on the Water medium: Oil size: 18"x12"

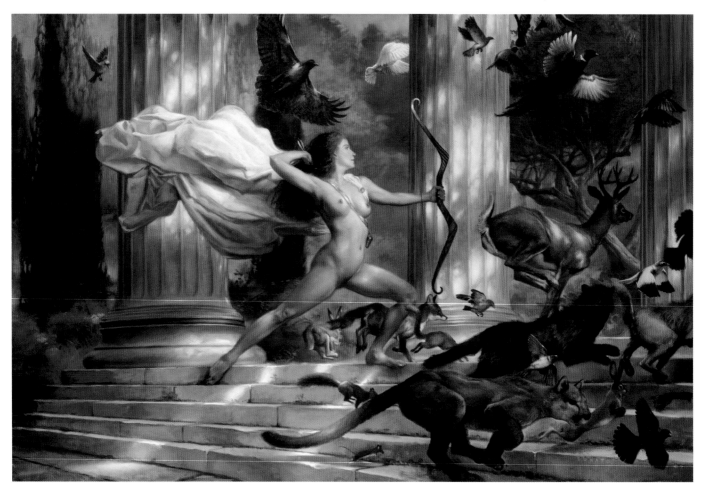

artist: **Donato Giancola**
client: Ken Clark title: Artemis medium: Oil on paper on panel size: 30"x20"

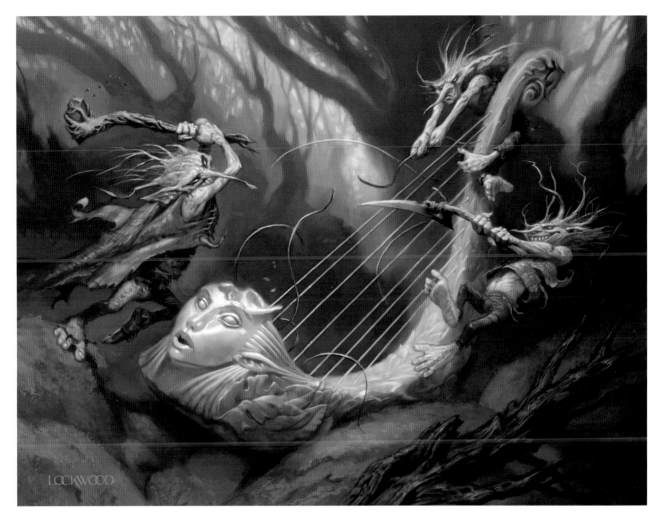

artist: **Todd Lockwood**
art director: Jeremy Jarvis client: Wizards of the Coast title: Wrecking medium: Digital size: 12"x9"

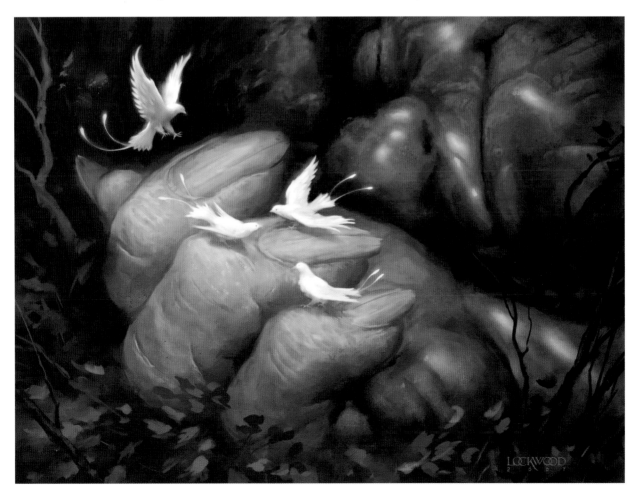

artist: **Todd Lockwood**
art director: Jeremy Jarvis client: Wizards of the Coast title: Peaceful Calm medium: Digital size: 12"x9"

1 *artist:* Bill Carman
title: I Am Leavened: The Last Twinkle on Earth
medium: Acrylics *size:* 11"x14"

2 *artist:* Andy Brase
art director: Andy Brase *designer:* Andy Brase
client: www.mastersinprint.com *title:* Twisted Walls
medium: Ink, digital *size:* 11"x15"

3 *artist:* Eric Fortune
client: MicroVisions/Society of Illustrators
medium: Acrylics *size:* 5"x7"

4 *artist:* Eric Fortune
art director: Michael D. Petteys
client: National Labor Federation *title:* Famine
medium: Acrylics *size:* 12"x16"

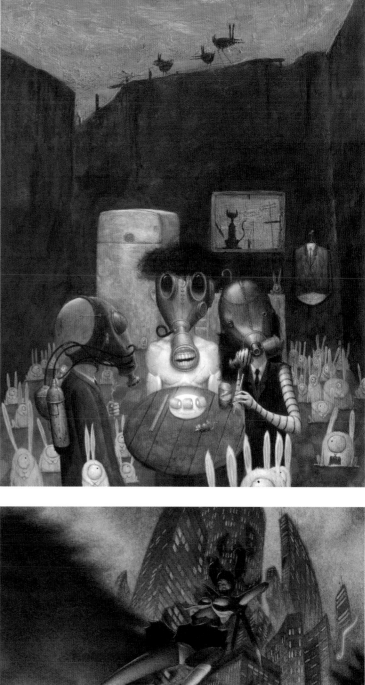

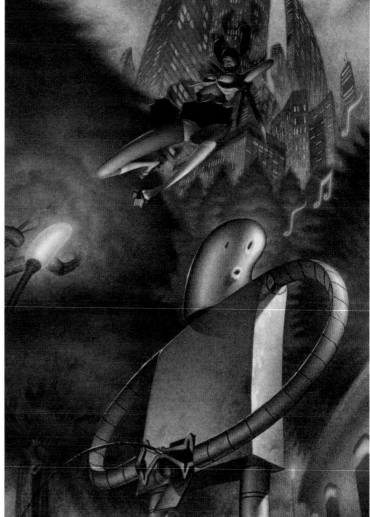

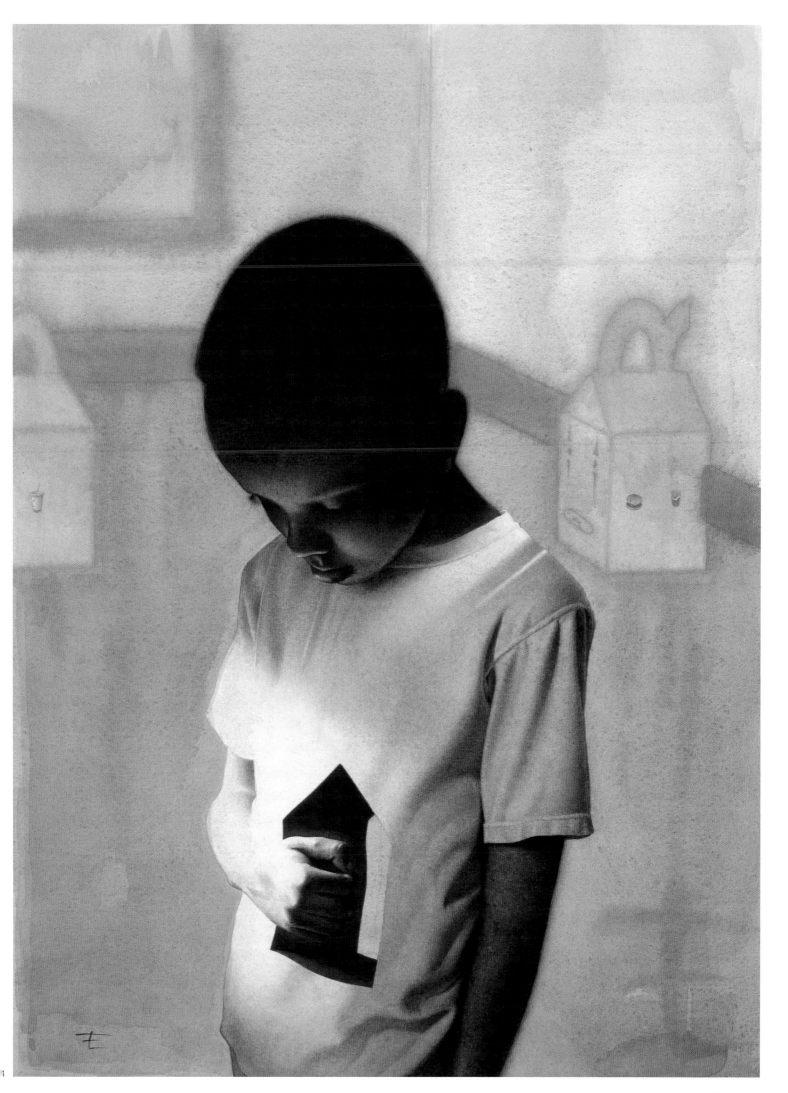

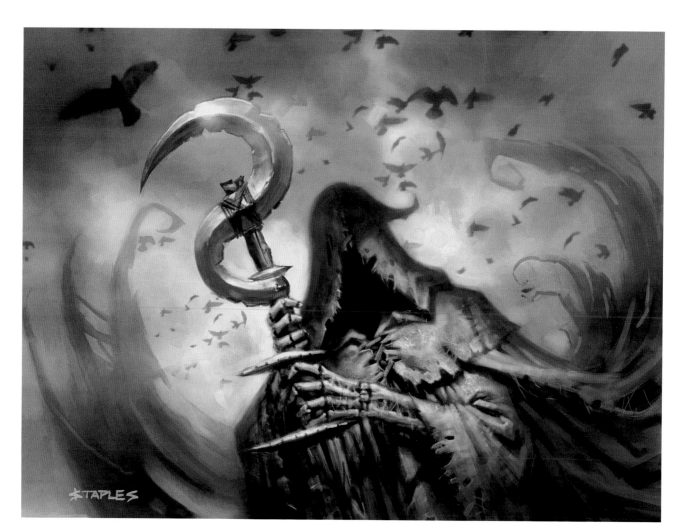

artist: **Greg Staples**
art director: Jeremy Cranford client: Upper Deck Entertainment title: Reaver of the Initiates medium: Digital

artist: **Matt Cavotta**
art director: Jeremy Jarvis client: Wizards of the Coast title: Duergar Mine Captain medium: Digital size: 9"x6 1/2"

artist: **Adam Rex**
art director: Jeremy Jarvis *client:* Wizards of the Coast *title:* Woodfall Primus *medium:* Oil

artist: **Jim Murray**
art director: Jeremy Jarvis *client:* Wizards of the Coast *title:* Vigor *medium:* Mixed

artist: **Brian Despain**
client: Tim Berry *title:* The Exchange *medium:* Oil on panel *size:* 20"x16"

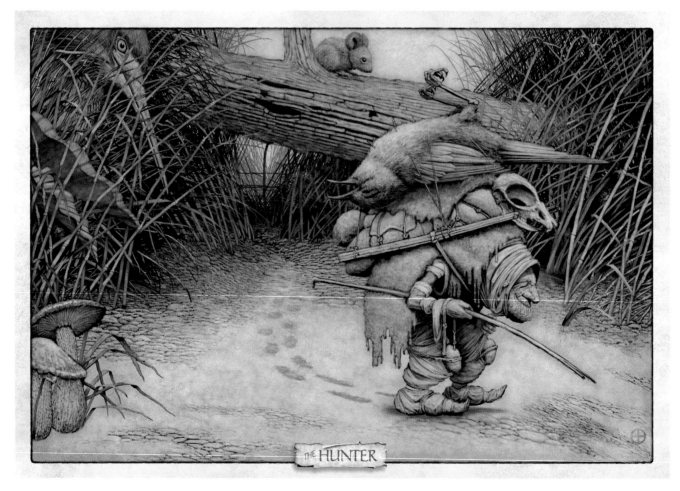

artist: **Edward Binkley**
title: The Hunter *medium:* Digital *size:* 13"x9"

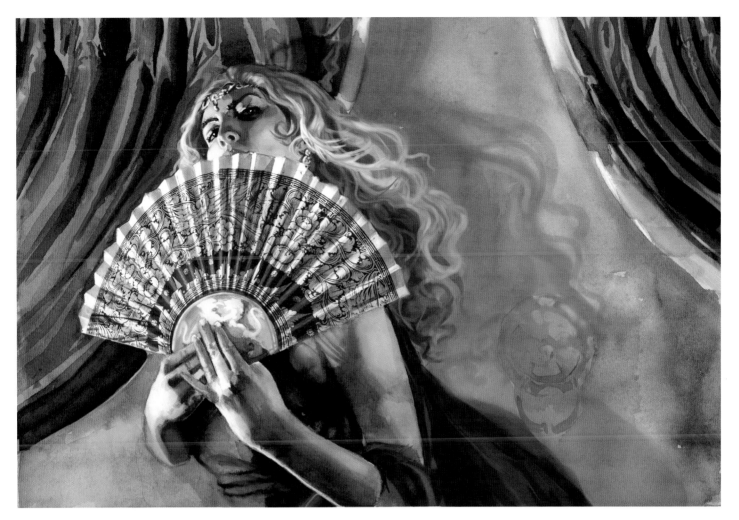

artist: **Gabrielle Portal**
art director: Zoë Robinson client: Fantasy Flight Games title: Devious Intentions medium: Watercolor, digital size: 13"x9"

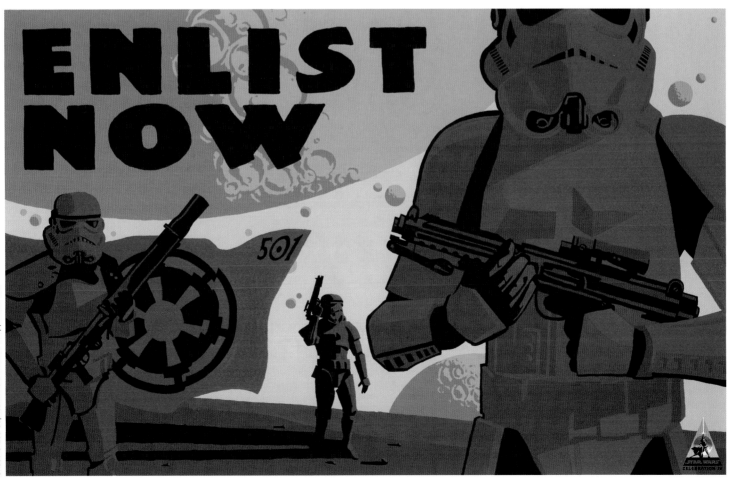

artist: **Mark Chiarello**
client: Lucasfilm Ltd. title: Enlist Now medium: Gouache size: 28"x17"

1 *artist:* **Bruno Werneck**
title: The Aviator
medium: Digital *size:* 10"x13"

2 *artist:* **Michael Dagata**
title: Underneath It All
medium: Digital *size:* 8"x5"

3 *artist:* **Tae Young Choi**
title: Space Cowboys
medium: Digital *size:* 10"x14¹/₂"

4 *artist:* **Tae Young Choi**
title: Shark Rider
medium: Digital *size:* 10"x13"

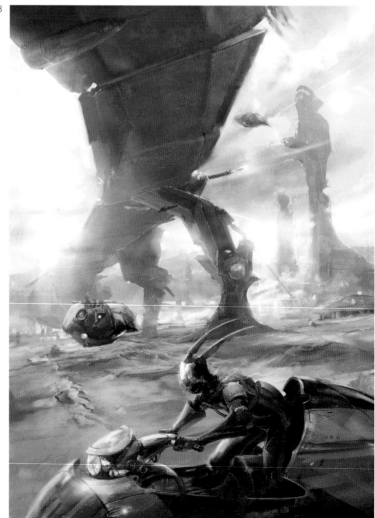

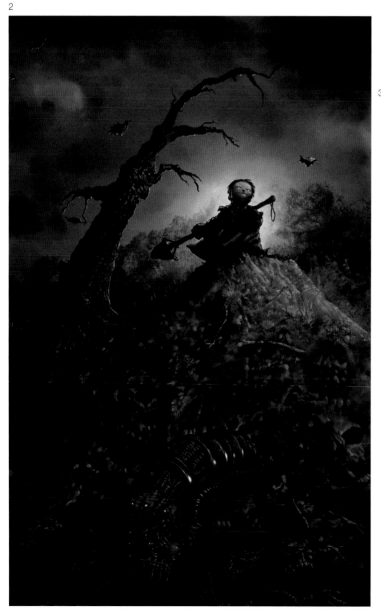

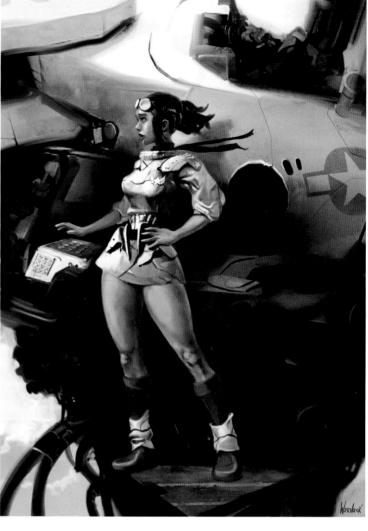

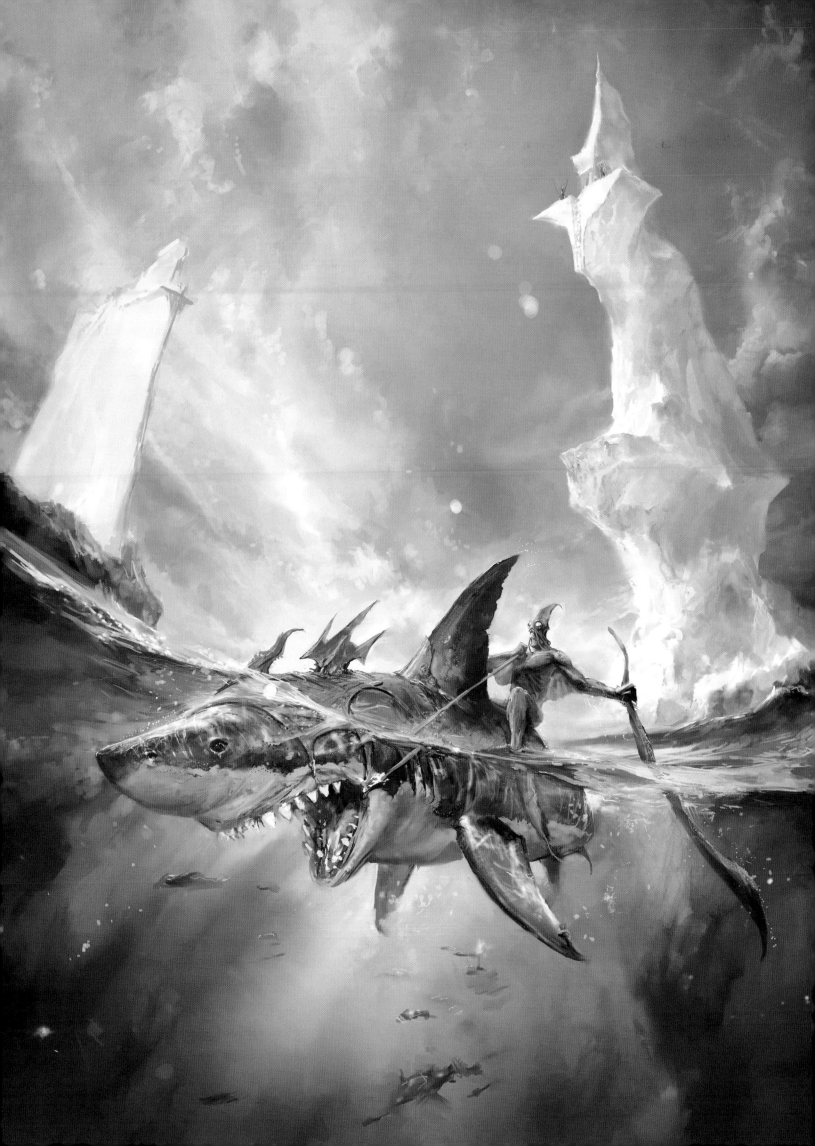

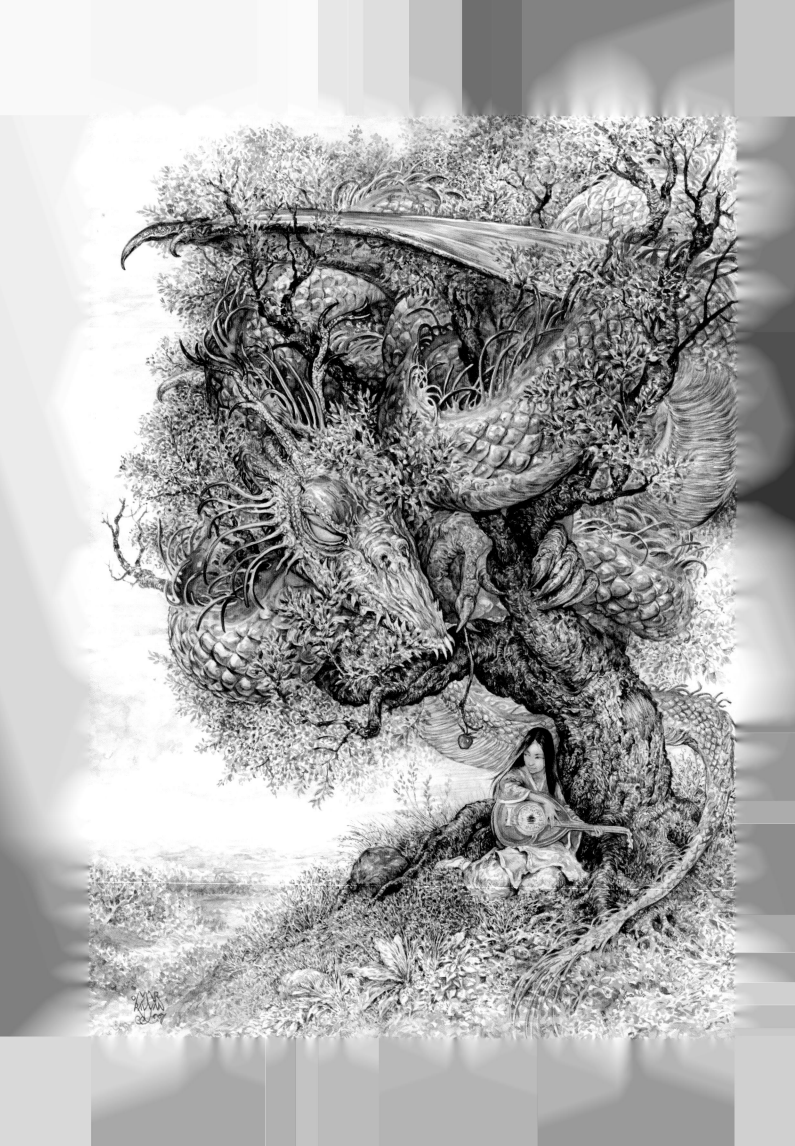

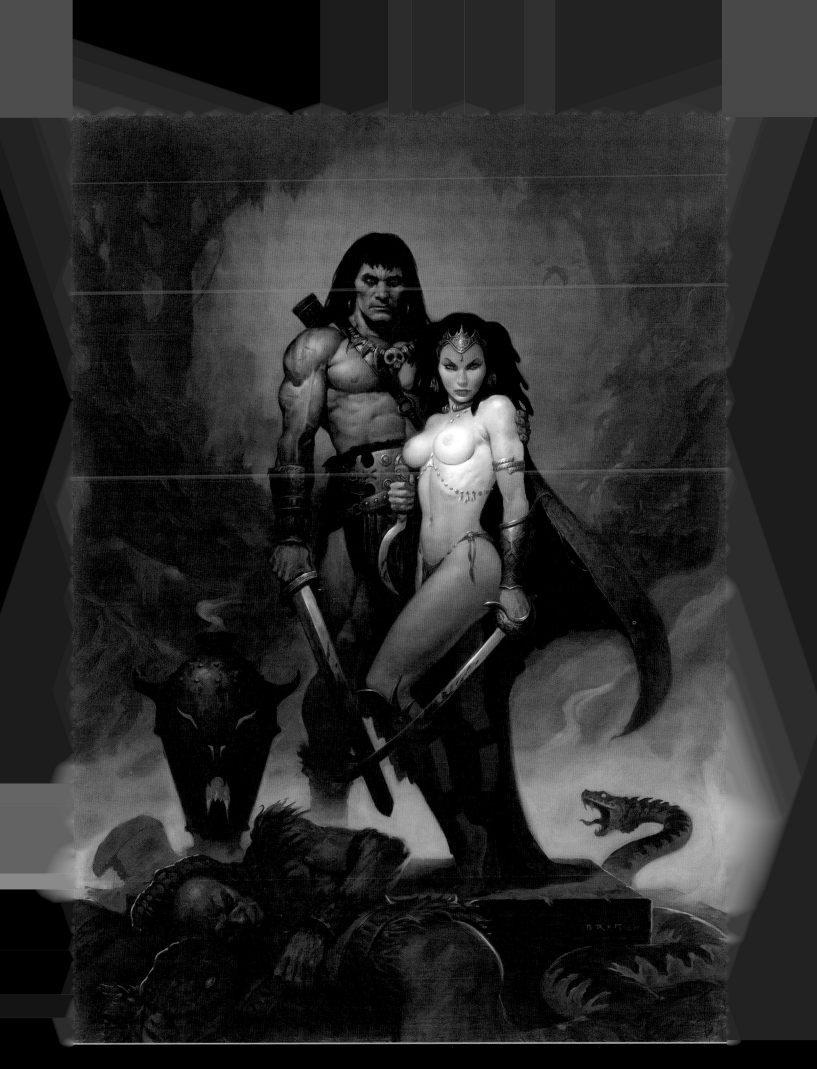

artist: **Brom**

art director: Arnie Fenner title: Black Coast: "…and their memory was a bitter tree…" medium: Oil size: 22"x30"

1
artist: **Leah Palmer Preiss**
title: Specimen: Darwin
medium: Mixed
size: 6"x6"

2
artist: **Bruce Jensen**
client: Society of Illustrators: MicroVisions 2
title: Ismo
medium: Acrylics
size: 5"x7"

3
artist: **Peter de Sève**
art director: Françoise Mouly
client: The New Yorker
title: Auld Lanxiety
medium: Pen, ink, watercolor
size: 11"x17"

4
artist: **Peter de Sève**
art director: Peter de Sève
client: Society of Illustrators
title: The Organ Grinder's Monkey
medium: Pen, ink, watercolor
size: 11"x17"

1

2

3

artist: **Rene Zwaga**
title: Heaven's Gate *medium:* Oil *size:* 55"x47"

artist: **Peter Forystek**
client: www.peterforystek.com *title:* "Banished" *medium:* Acrylics on board *size:* 24"x12"

artist: **Sacha Lees**
title: Unit 5 *medium:* Oil *size:* 58"x25"

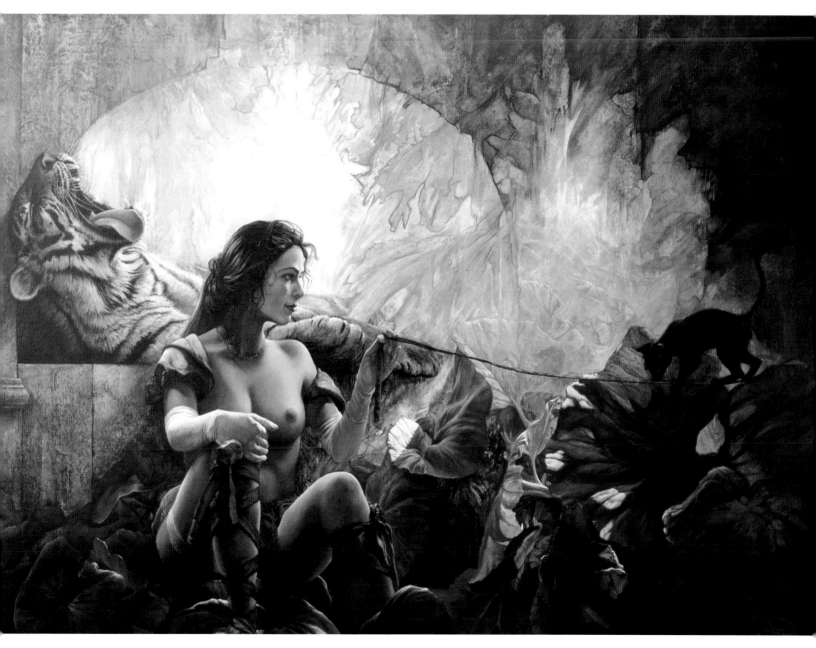

artist: **Rene Zwaga**
title: Pretender to the Throne *medium:* Oil *size:* 47"x31"

1
artist: **Tomas A. Gieseke**
title: The Extrovert Leaves the Introvert
to His Own Devices
medium: Acrylics on canvas
size: 30"x30"

2
artist: **Mike Stanislavsky**
art director: Joko Budiono
title: Steam
medium: Photoshop
size: 7"x11"

3
artist: **Tom Taggart**
title: Single White Robot
medium: Acrylics
size: 7 1/2"x10"

4
artist: **Brian Despain**
title: A Vexing Quiet
medium: Oil on panel
size: 16"x20"

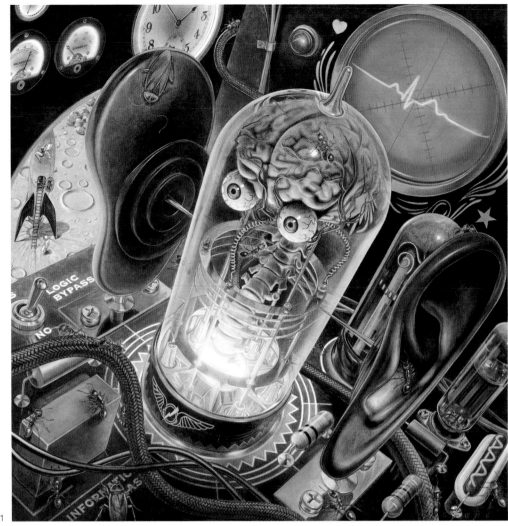

1

2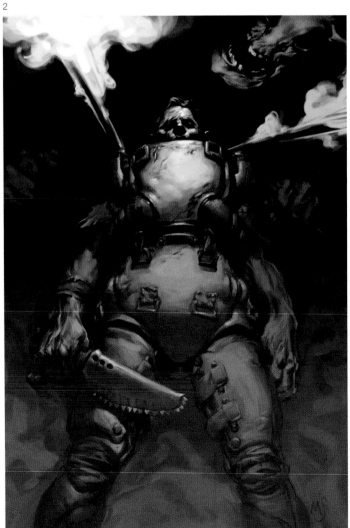

3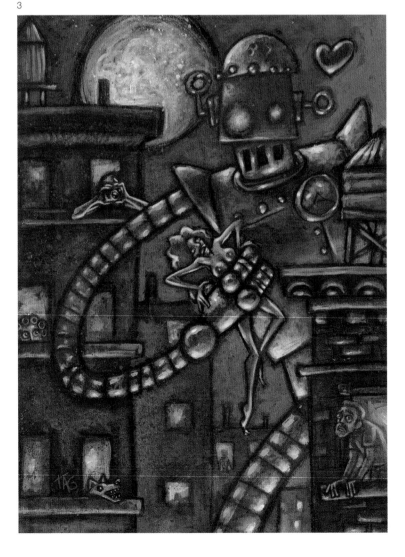

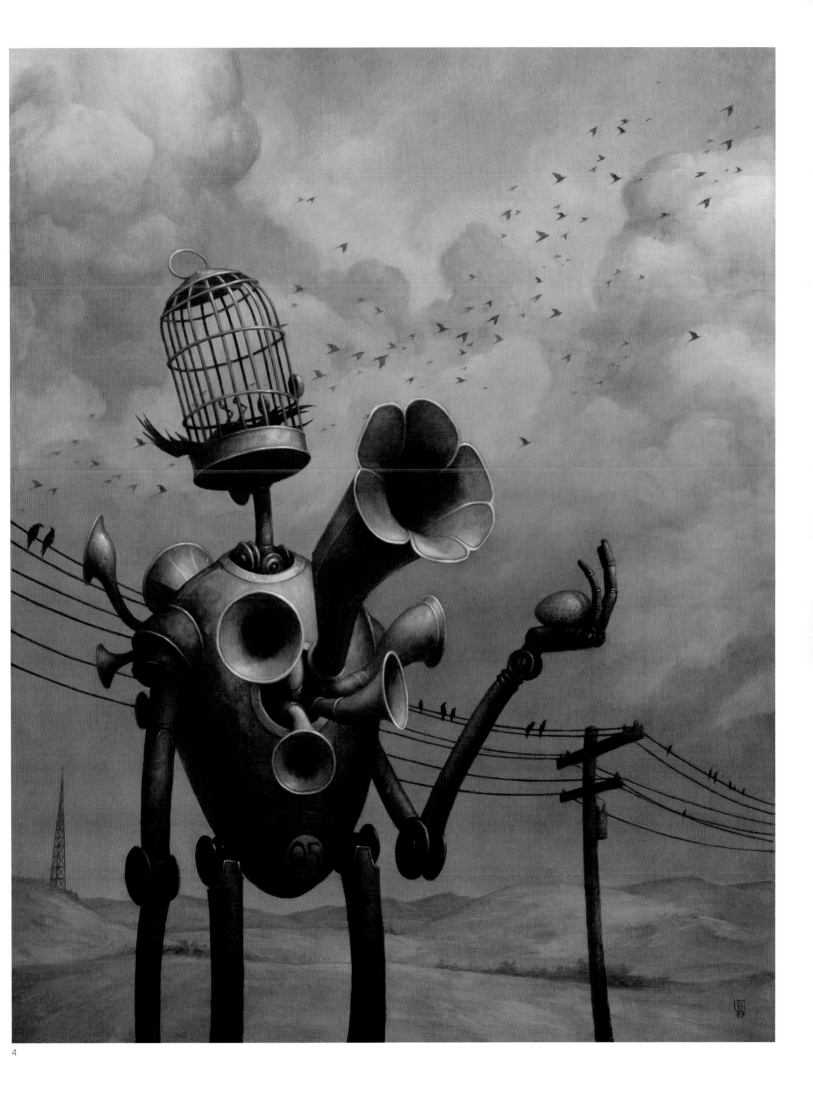

4

1 *artist:* Paul Linsley
title: Seraphim
medium: Digital *size:* 18"x24"

2 *artist:* DCWJ
title: Sunday
medium: Digital

3 *artist:* Jessica Hook
client: ConceptArt.Org *title:* Yuki-onna
medium: Photoshop *size:* 7½"x11"

4 *artist:* Naomi Baker
title: Green Kitty
medium: Mixed *size:* 8"x10"

1

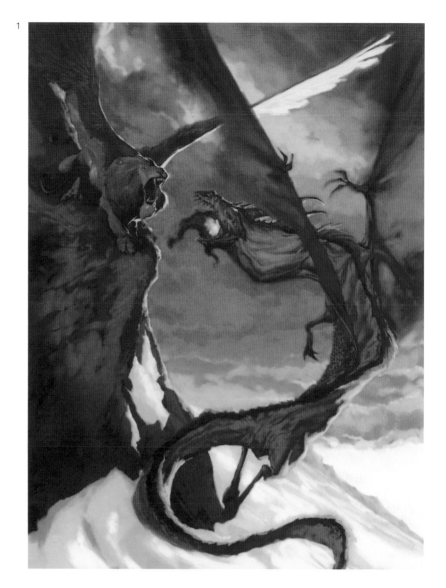

2

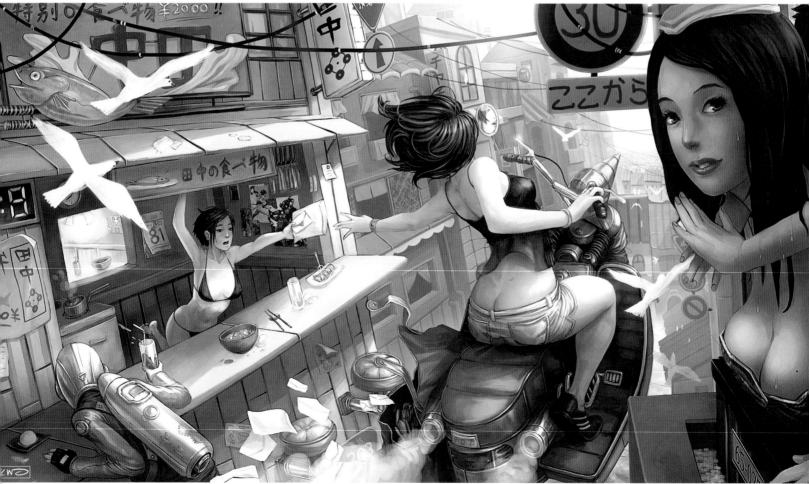

3

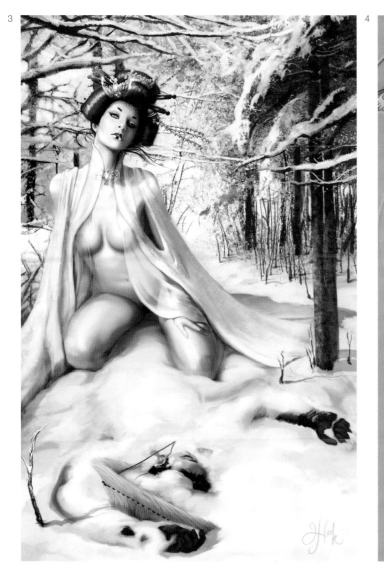

4

1 *artist:* Shawn Amberger
title: Heal it. Break it. Whatever.
medium: Digital *size:* 5"x7"

2 *artist:* Vance Kovacs
art director: Roger Ford
client: Walden Media *title:* Under a Blanket of Turf
medium: Digital

3 *artist:* Tyler Parkinson
title: Cruel Intent
medium: Graphite, digital *size:* 10³/₄"x16¹/₂"

4 *artist:* Bobby Chiu
client: Imaginism Studios *title:* Carrot Run
medium: Photoshop *size:* 7¹/₂"x14"

1
artist: **Dice Tsutsumi**
client: simplestroke.com
title: Superhero's Halloween
medium: Oil
size: 20"x20"

2
artist: **Cyril Vanderhaegen**
title: The Birth of Cthulhu
medium: Digital

3
artist: **Jeff Preston**
client: Self promotion
title: Dear Old Uncle
medium: Marker, color pencil
size: 12"x18"

4
artist: **David Palumbo**
client: lastmanart.com
title: These Things Really Work!
medium: Oil
size: 12"x12"

1

2

3
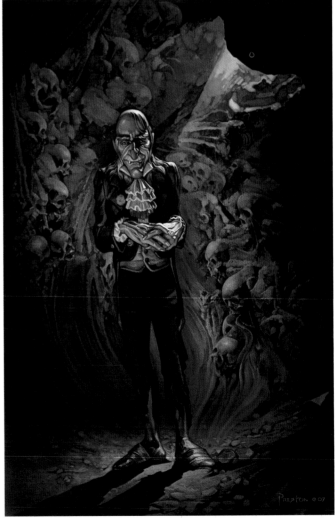

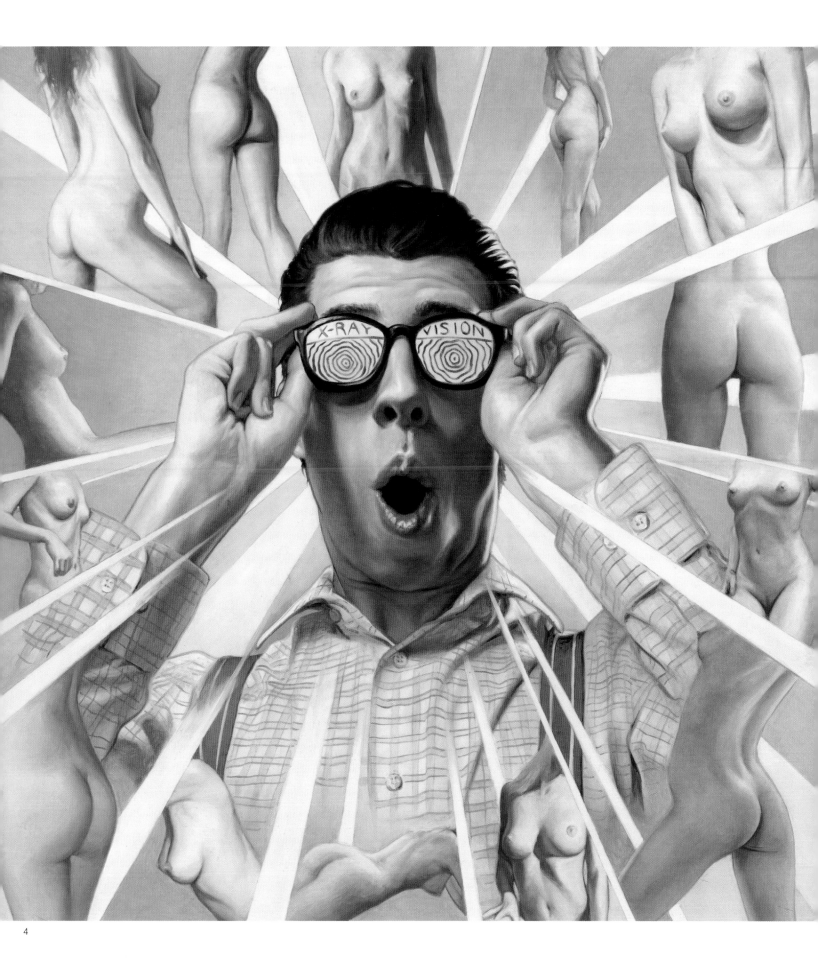

4

1 *artist:* **Bagus Hutomo**
client: Self promotion *title:* RPG
medium: Digital

2 *artist:* **Bill Carman**
title: Race: Cyclopean Bunnies On the Brain
medium: Mixed *size:* 5"x7"

3 *artist:* **Ian Miller**
art director: Jane Frank/Worlds of Wonder
client: Paul & LizAnn Lizotte *title:* Iturris
medium: Ink, acrylics on watercolor paper
size: 17¹/₂"x25"

4 *artist:* **Raphael Lacoste**
title: Arctic Express 2008
medium: Digital *size:* 13"x10"

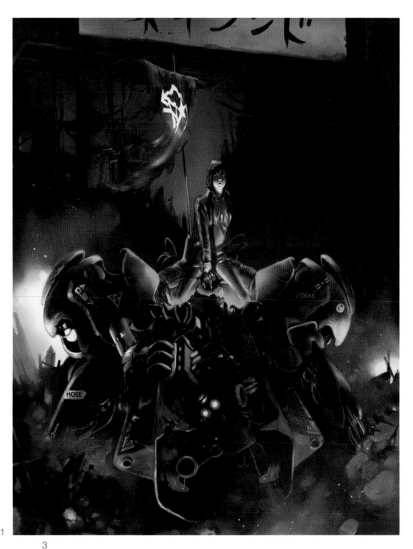

1

2

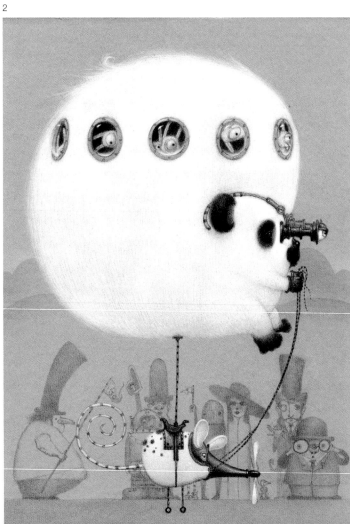

3

4

artist: **Gordon Crabb**
title: Moondance *medium:* Digital

artist: **David Bowers**
title: Suburban Taboo *medium:* Oil on linen *size:* H 22" x 16"

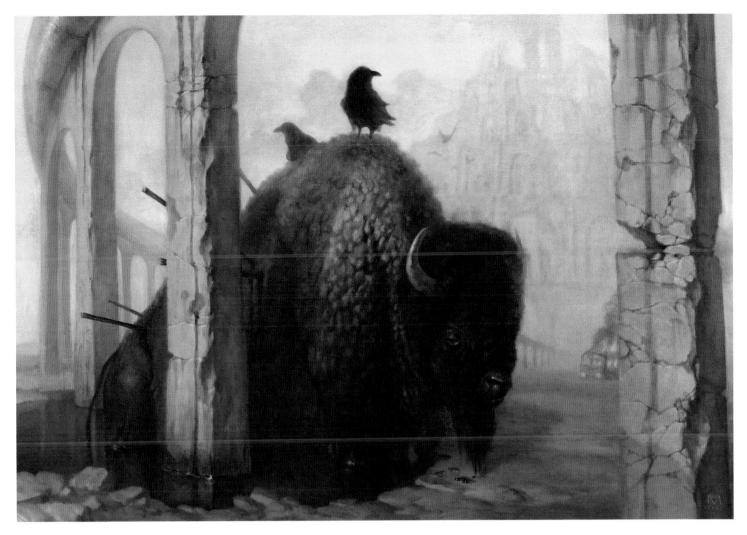

artist: **Martin Wittfooth**
art director: Eric White *client:* Lonsdale Gallery *title:* Along the Western Front *medium:* Oil on canvas *size:* 37"x25¹⁄₂"

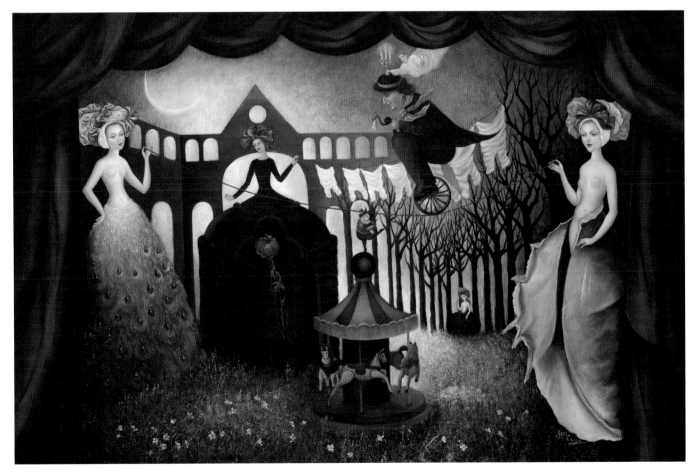

artist: **Daniela Ovtcharov**
title: The Stage *medium:* Oil on canvas *size:* 40"x26"

1 *artist:* David Palumbo
title: Dock Savage: The Eye of Terror
medium: Oil *size:* 16"x24₂"

2 *artist:* Steve Firchow
title: Vernal Thunder
medium: Digital *size:* 11"x17"

3 *artist:* Eric Bowman
client: eric@ericbowman.com *title:* El Santo
medium: Oil *size:* 11¹/₂"x18"

4 *artist:* Volkan Baga
client: Tim Pope *title:* Sauron's Fall
medium: Oil on paper on panel *size:* 16¹/₂"x22¹/₈"

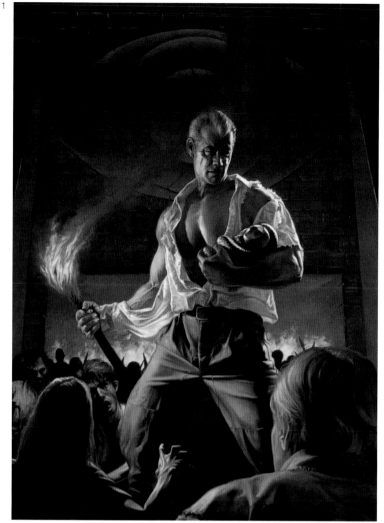

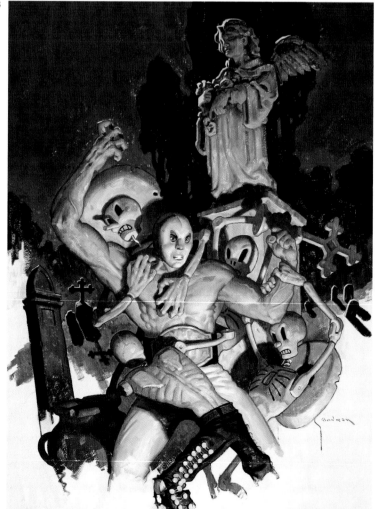

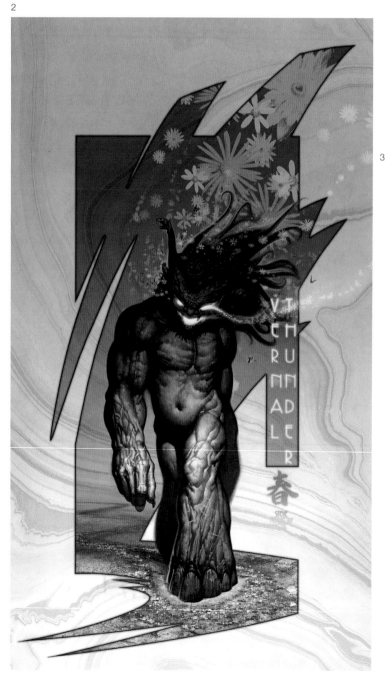

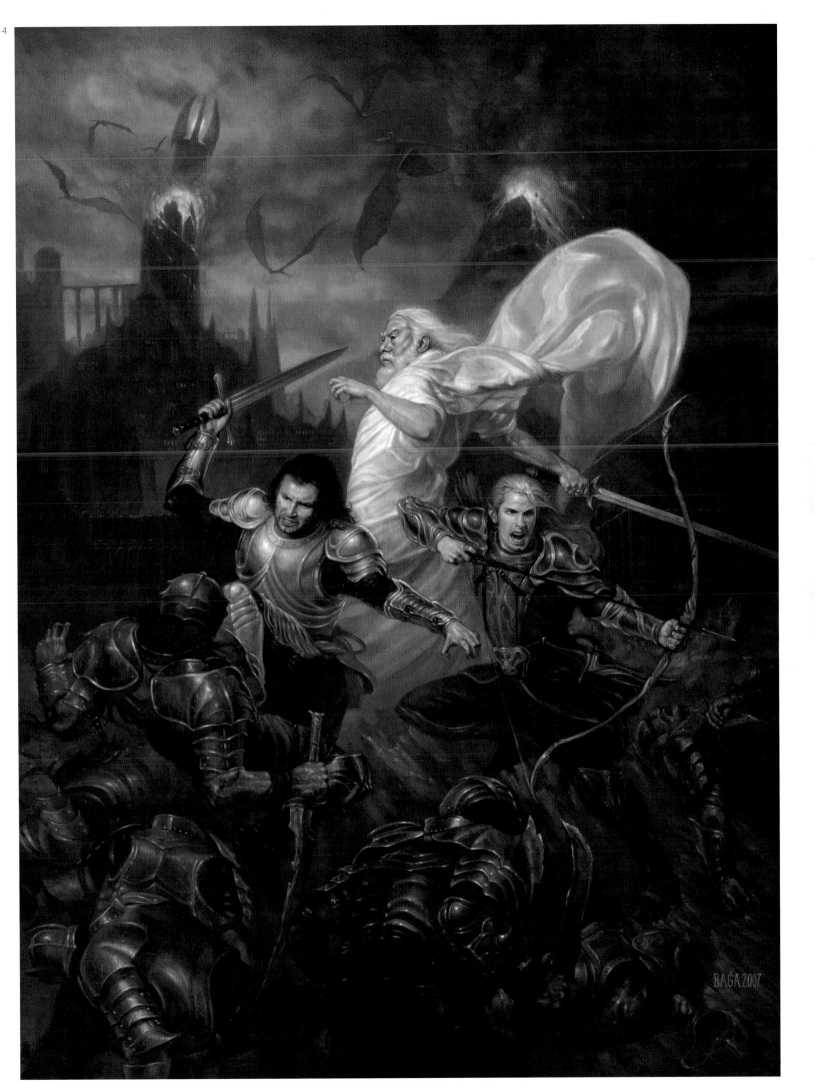

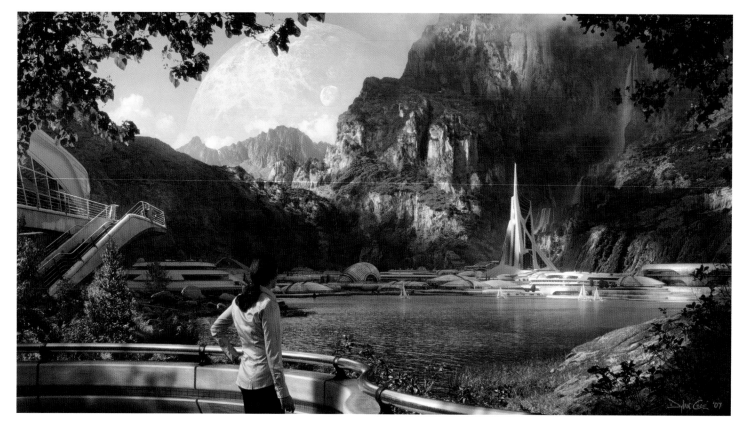

artist: **Dylan Cole**
client: Self promotion *title:* Hudson City *medium:* Digital

artist: **Jerrell Conner**
title: V-80's *medium:* Mixed *size:* 20"x5"

artist: **Ooi Chun Gee**
title: Monster World *medium:* Digital

artist: **Chris Rahn**
client: rahnart.com title: Moment of Truth medium: Oil size: 34"x11"

artist: **Lawrence L. Ruelos**
title: A Bold Gesture medium: Graphite pencil, digital

artist: **McLean Kendree**
art director: Joe Thiel title: Wrinkle In Time medium: Oil

1 *artist:* David Ho
title: The Wedding
medium: Digital *size:* 14"x12"

2 *artist:* Emmanuel Malin
title: Sea of Rocks
medium: Digital *size:* 11³/₈"x15¹/₃"

3 *artist:* Matthew Harrison
client: Self promotion *title:* Virulentis
medium: Digital *size:* 10"x14"

4 *artist:* Lisa L. Cyr
client: Self promotion *title:* Self Awareness
medium: Acrylic, oil, collage & assemblage on canvas
over masonite & board with wood framework
size: 21¹/₂"x30¹/₂"x2³/₈"

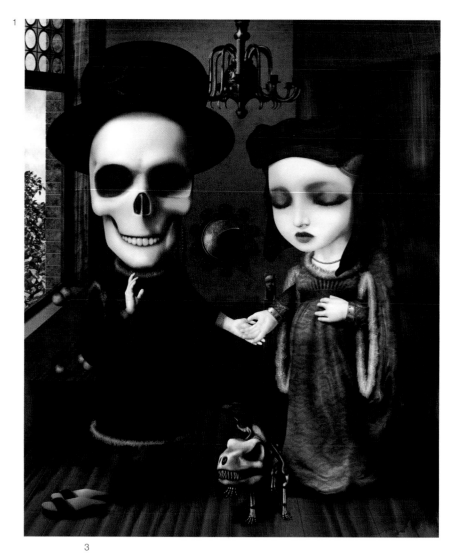

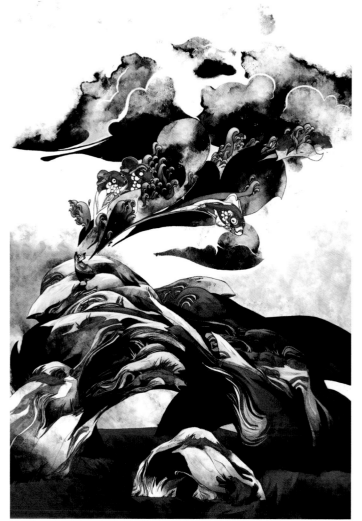

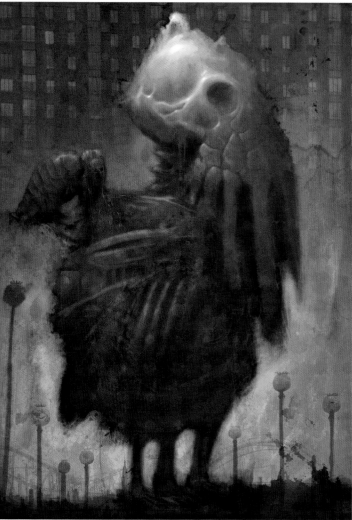

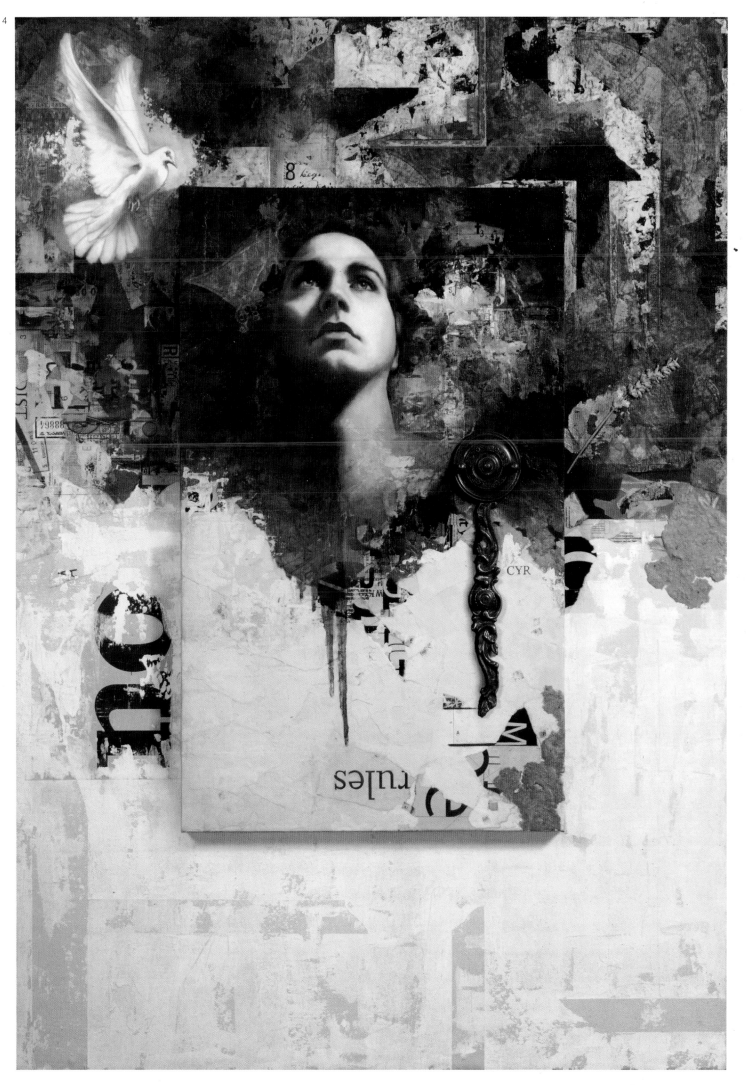

1 *artist:* Yasmine Putri
client: Self promotion *title:* Goodnight, Ganymede
medium: Digital

2 *artist:* Xiao Chen Fu
client: Environmental Protection Show/Beijing
title: Sadly True
medium: Pencil, Photoshop *size:* 21"x31⁷⁄₈"

3 *artist:* Kelley Ruth Harris
title: Hatchling
medium: Digital *size:* 7¹¹⁄₁₆"x11"

4 *artist:* Andrea Kowch
art director: Dave Chow, Don Kilpatrick
title: No Trespassing
medium: Acrylics on canvas *size:* 24"x30"

5 *artist:* Cynthia Sheppard
title: The Creation Game
medium: Digital

6 *artist:* Miguel Lantigua
art director: Octavai Perez
client: The Life of PI
medium: Digital

7 *artist:* Matt Dalluhn
title: Books
medium: Digital *size:* 11"x16"

1

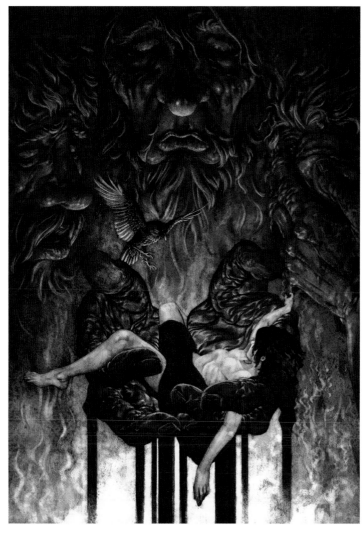

2

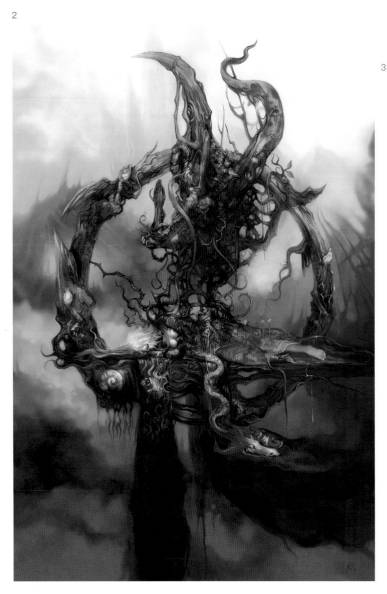

3

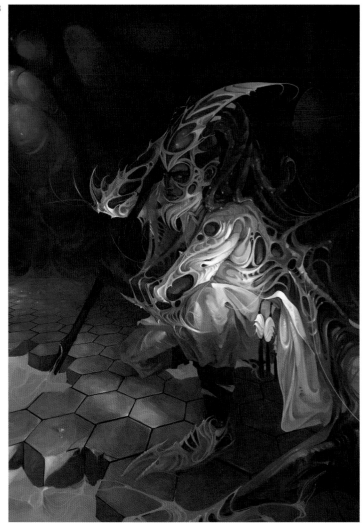

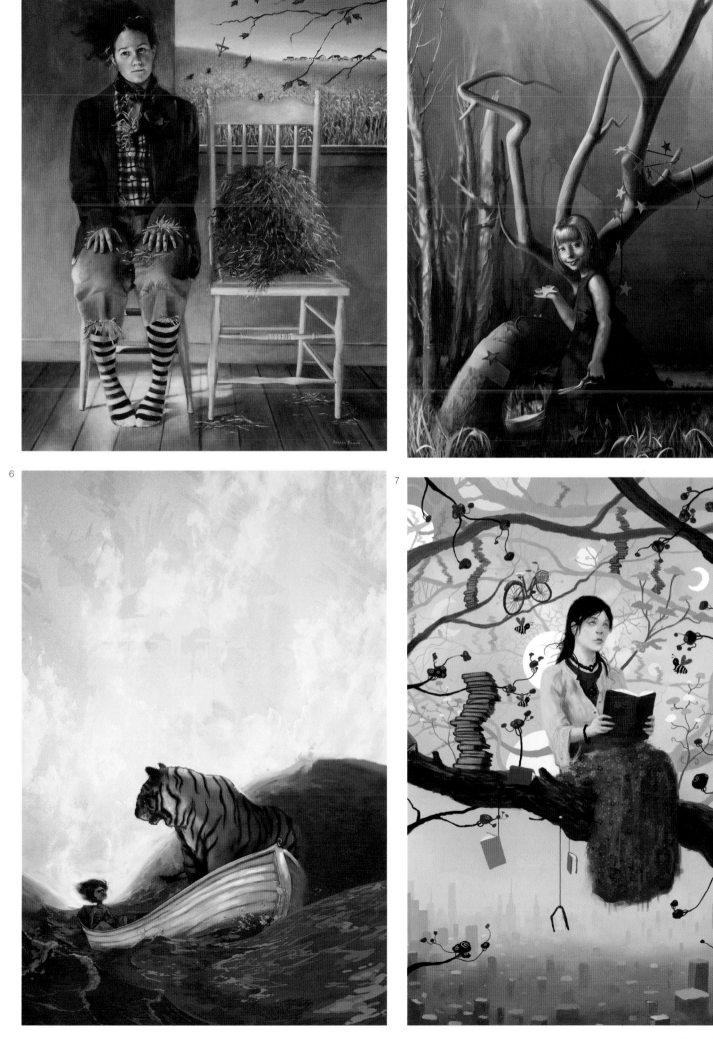

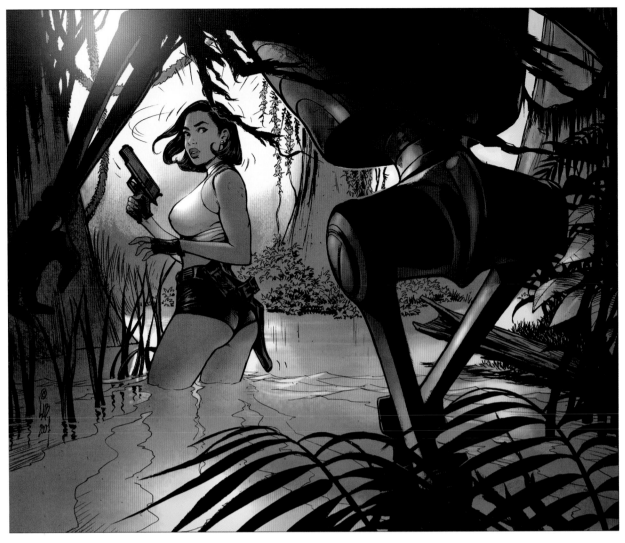

artist: **Thierry Labrosse**
title: Junglebot II *medium:* Ink, digital *size:* 17"x14"

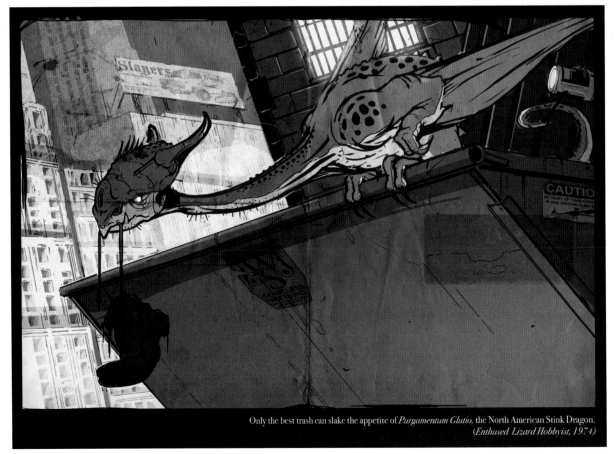

Only the best trash can slake the appetite of *Purgamentum Glutio*, the North American Stink Dragon.
(Enthused Lizard Hobbyist, 1974)

artist: **Josh Viers**
title: Stink Dragon *medium:* Digital *size:* 17"x11"

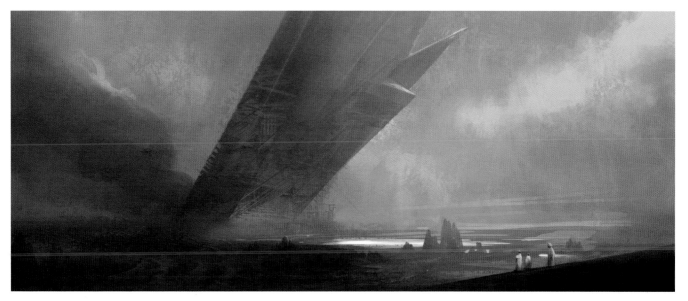

artist: **Tyler West**
title: Desert Monolith *medium:* Photoshop *size:* 44"x18"

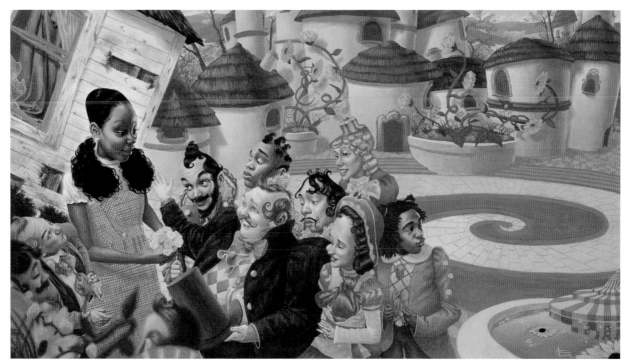

artist: **A.G. Ford**
title: Dorothy and the Munchkins *medium:* Acrylics *size:* 29"x15"

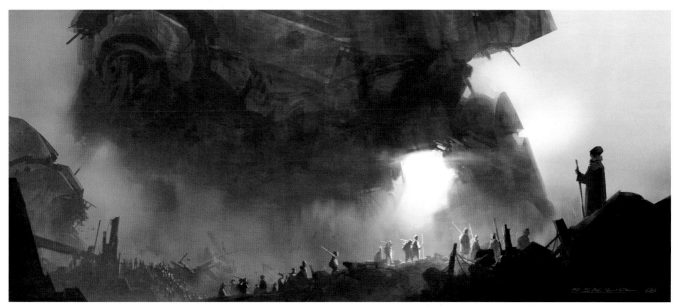

artist: **Ritche Sacilioc**
medium: Digital

1
artist: Kuang Hong
title: Elegy of War
medium: Digital

2
artist: Michael Aspengren
title: Guns, Guns, Guns
medium: Digital
size: 12"x18"

3
artist: Jeffrey Scott (1019)
client: Baby Tattoo Books
title: Portrait of the Red Queen
medium: Photography, digital
size: 15"x22"

4
artist: Daren Bader
title: The Giant's Tomb
medium: Digital

5
artist: John Blumen
client: Self promotion
title: Night
medium: Digital
size: 18"x24"

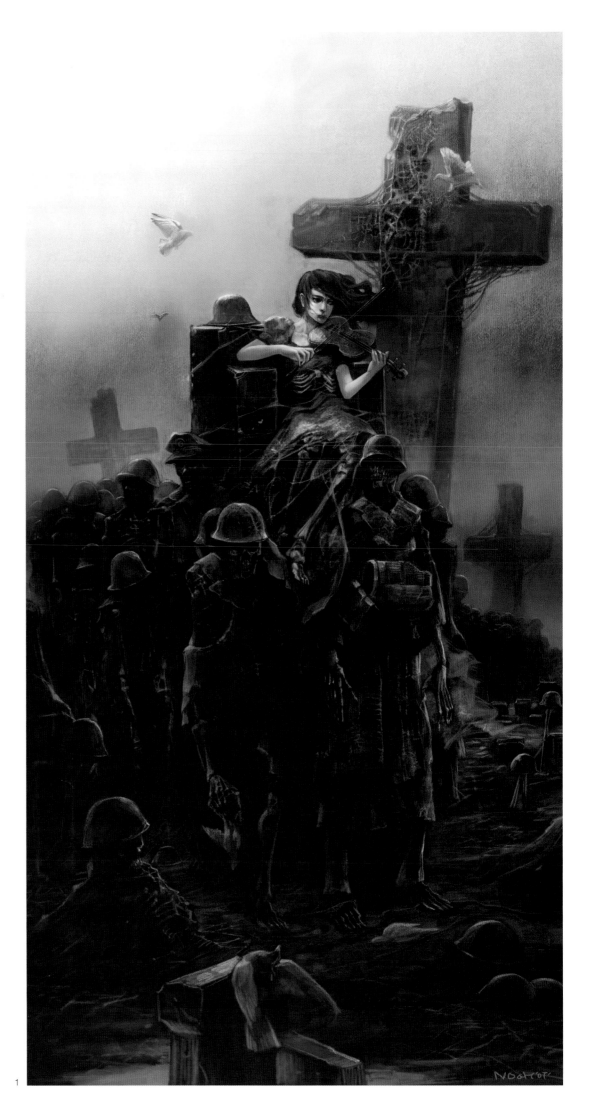

1

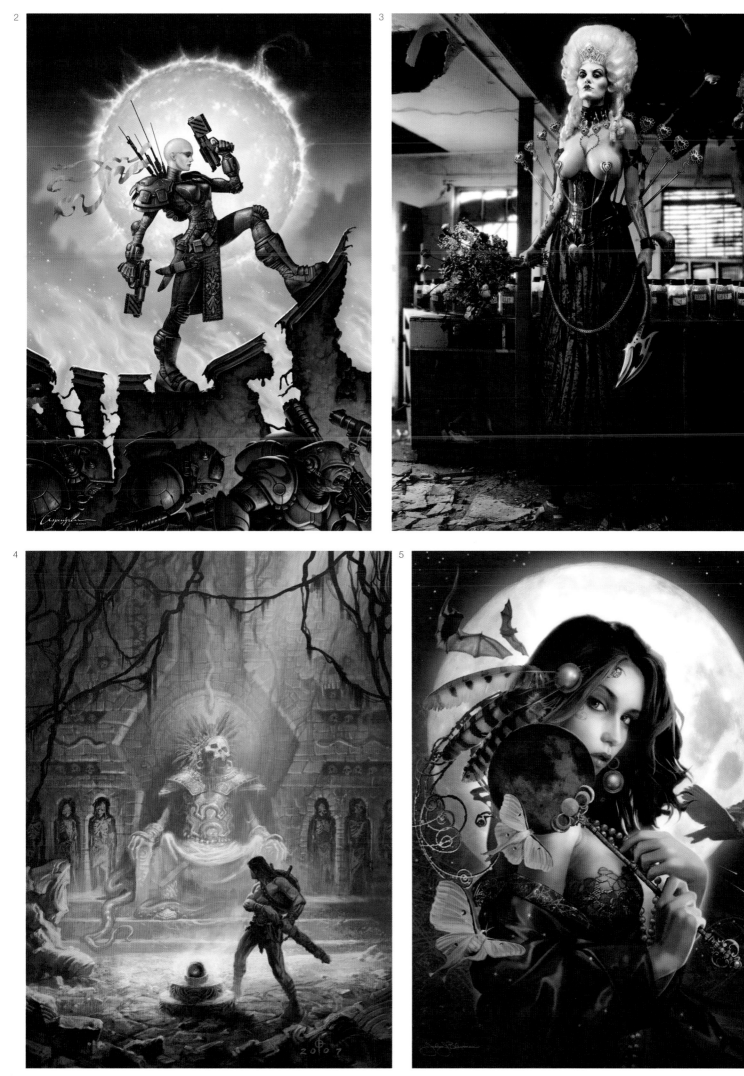

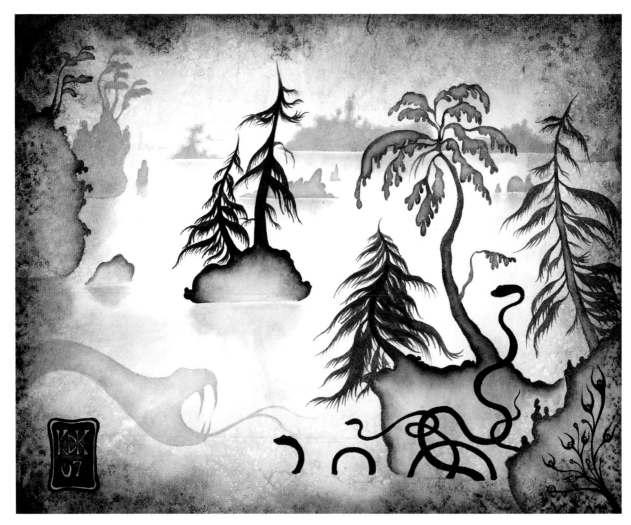

artist: **Kamala Dolphin-Kingsley**
title: The Wisely Undisclosed Inlet *medium:* Watercolor, acrylics, pen & ink, glitter *size:* 10"x8"

artist: **Joe Hoskins**
title: Edmund and Amy *medium:* Oil *size:* 36"x24"

artist: **Vance Kovacs**
client: Frank Beddor title: The House of Hearts medium: Digital

artist: **Vance Kovacs**
client: Frank Beddor title: The House of Diamonds medium: Digital

1
artist: Misa Tsutsui
title: Kiyohime
medium: Digital
size: 22"x21⅛"

2
artist: Michelle Dreher
title: Maybe I'll finally let it go...
medium: Printed records & linocut
size: 13½"x19½"

3
artist: Joe Vaux
title: Blitz
medium: Acrylics on wood
size: 16"x24"

4
artist: Joe Vaux
title: Grass Is Greener?
medium: Acrylics on wood
size: 16"x24"

1

2

3

1
artist: **Richard Anderson**
title: Gunfighter #1
medium: Mixed
size: 13³/₄"x59¹/₂"

2
artist: **Lee Moyer**
client: Rob Heinsoo
title: Nepenthe
medium: Mixed
size: 8¹/₂"x32"

3
artist: **Richard Hescox**
title: The Token
medium: Oil
size: 24"x30"

4
artist: **Corinne Aiello**
title: Oga and Ghost
medium: Illustrator, Photoshop
size: 6¹/₂"x12"

5
artist: **Patrick J. Jones**
title: Vampyre Planet
medium: Oil, digital
size: 14"x16"

6
artist: **Augie Pagan**
client: Creature Features/
"October Shadows" Show
title: The Unholy Trinity
of Mexican Folklore
medium: Acrylics on wood
size: 16"x31¹/₂"

artist: **Jonathan Padilla**
title: "Waiter, There's Something In My Soup…" *medium:* Photography, digital *size:* 14"x11"

artist: **Matt Dangler**
client: Gallery 1988 *title:* Wolverine—A New Beginning *medium:* Oil *size:* 20"x16"

artist: **Lars Grant-West**
art director: Peter Whitley client: Wizards of the Coast title: Dreamstorm medium: Digital size: 29"x22"

artist: **Kei Acedera**
client: Imaginism Studios title: Bath Time medium: Digital

artist: **Robert Kondo**
title: A Rampant Imagination *medium:* Digital *size:* 12"x12"

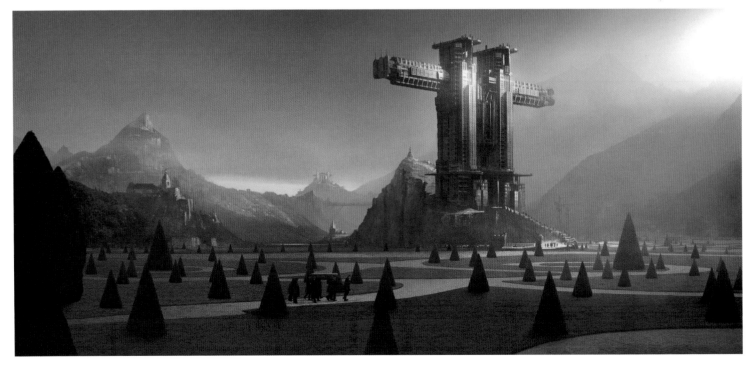

artist: **Emmanuel Shiu**
client: Cemetery Procession *medium:* Digital *size:* 17"x11"

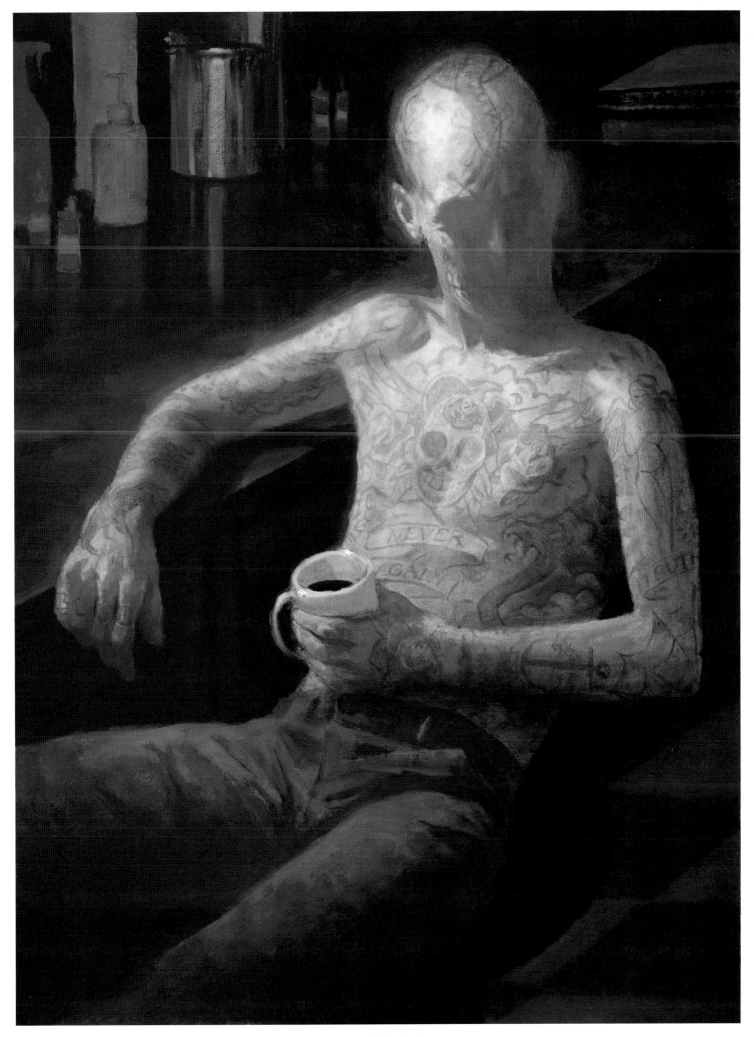

artist: **Chris Rahn**
client: www.rahnart.com title: Blue Tattoo medium: Oil size: 14"x18"

1 *artist:* **Steven Kenny**
title: Semaphore
medium: Oil on linen *size:* 18"x22"

2 *artist:* **Frank Lin**
art director: Stephen Player
title: Princess
medium: Acrylics, digital

3 *artist:* **Meghan Martin**
title: Butterflies
medium: Acrylics on canvas *size:* 2'x3'

4 *artist:* **Rene Zwagor**
title: Inspiration
medium: Oil *size:* 35³/₈"x51¹/₈"

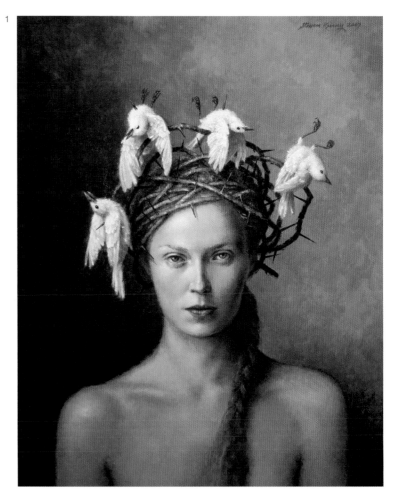

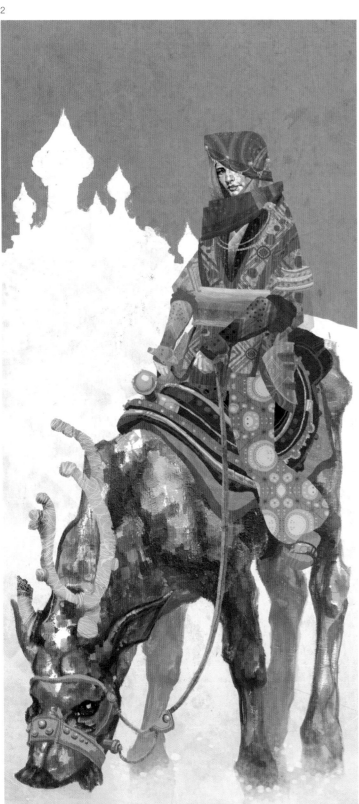

1 *artist:* **William Basso**
title: The Halloween Lady
medium: Mixed, collage on canvas *size:* 16"x24"

2 *artist:* **William Stout**
art director: Taylor White *designer:* William Stout
client: Creature Features/"October Shadows" *title:* Celtic Conjuror
medium: Ink, watercolor on board *size:* 9¹/₂"x18¹/₂"

3 *artist:* **William Basso**
title: Gifts for Ill-Mannered Children
medium: Mixed, collage on canvas *size:* 15"x24"

4 *artist:* **Greg Capullo**
title: Nun *medium:* Digital

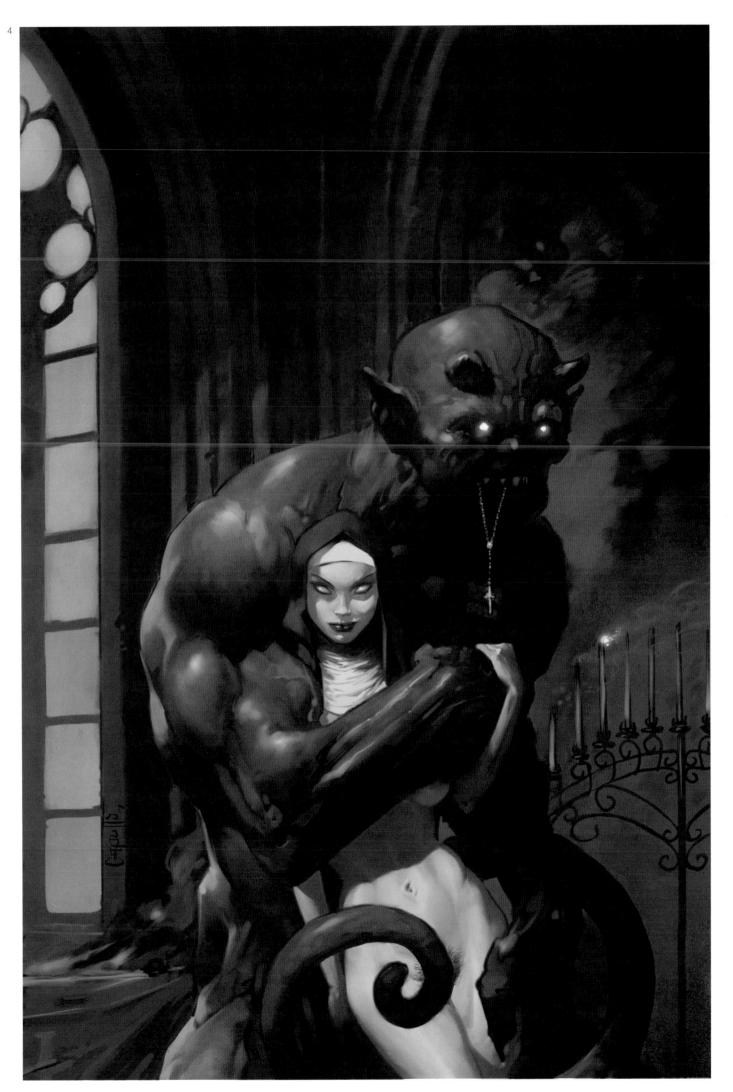

1
artist: Erik Jones
title: South Virginia
medium: Acrylics, color pencil, watercolor
size: 22¹/₂"x23¹/₂"

2
artist: **Jeremy Geddes**
title: Alley
medium: Oil on linen
size: 50"x31"

3
artist: **Dave McKean**
art director: Allen Spiegel
client: ASFA
title: Blood of a Poet
medium: Mixed
size: 12"x9"

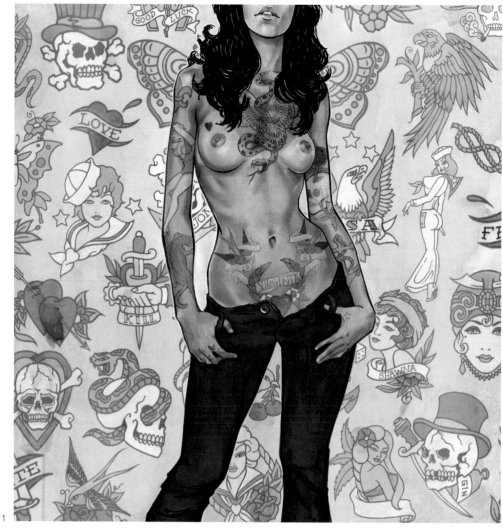

1

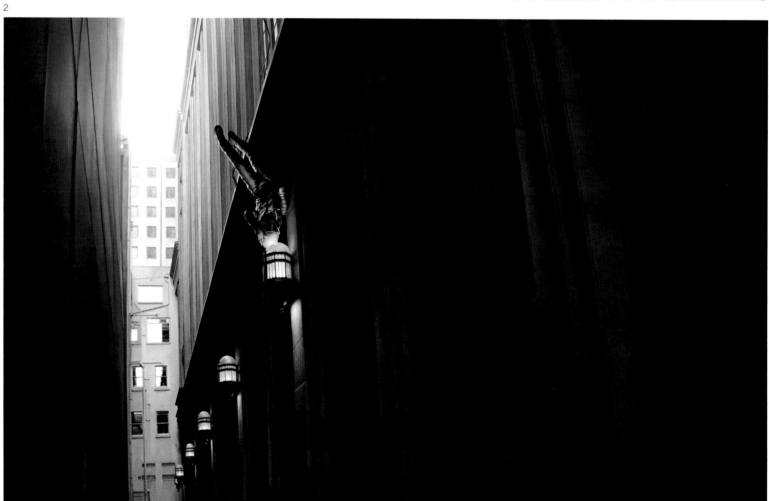

2

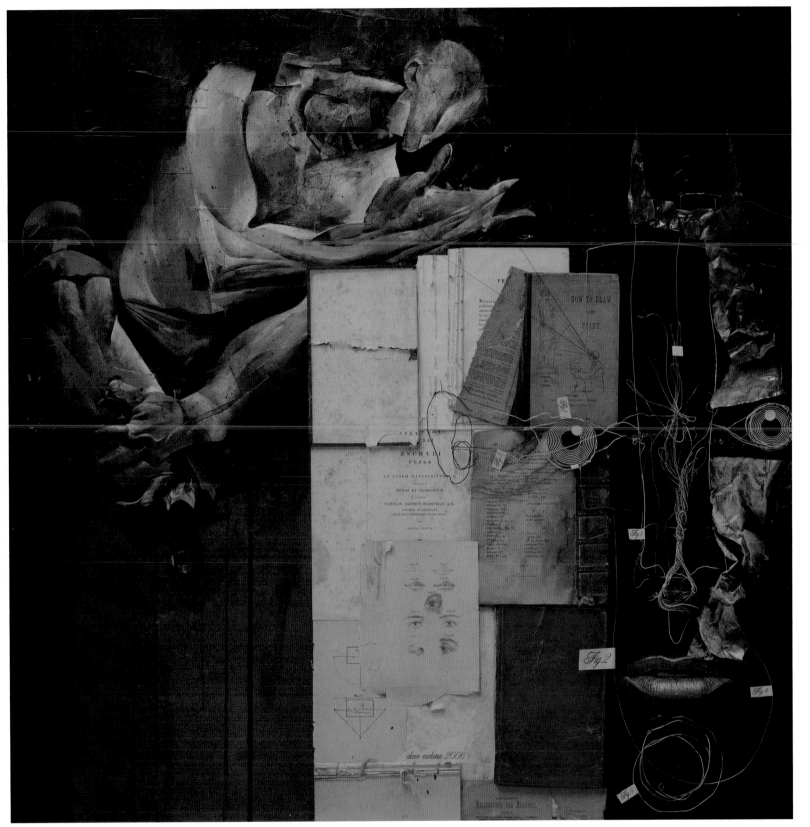

3

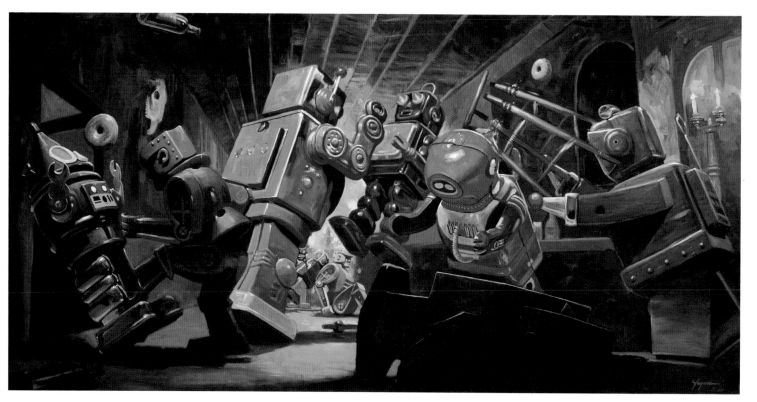

artist: **Eric Joyner**
client: *The Shooting Gallery* title: Malfunction medium: Oil on wood size: 96"x48"

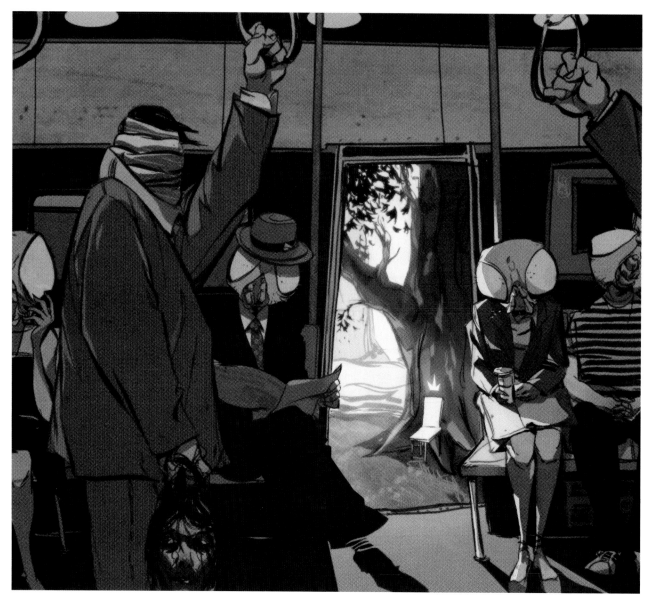

artist: **Francis Vallejo**
title: Melancholia medium: Ink, digital size: 16$^{1}/_{2}$"x18$^{5}/_{8}$"

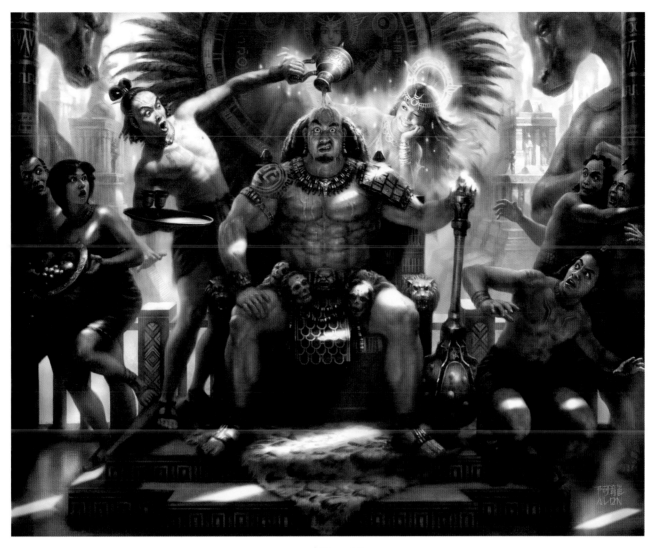

artist: **Alon Chou**
title: Oh God! *medium:* Digital *size:* 13⁷/₈"x11"

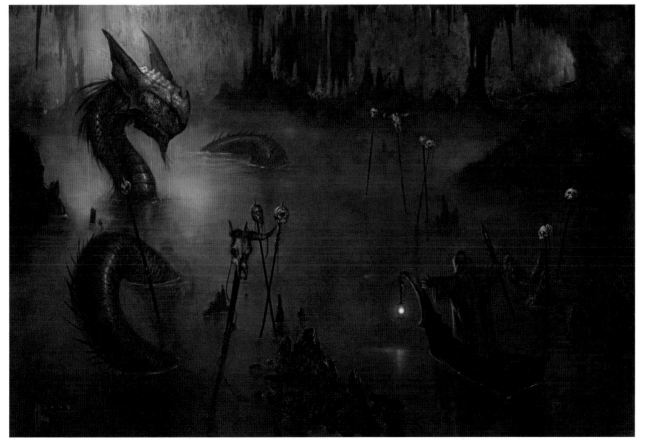

artist: **Scott Altmann**
art director: Cody Tilson *client:* ConceptArt.Org: Last Man Standing 3 *title:* Rodin *medium:* Digital *size:* 11¹/₂"x9"

1 *artist:* **Armand Baltazar**
title: Jason & Medea
medium: Mixed *size:* 13"x17"

2 *artist:* **Michael Whelan**
client: Tree's Place Gallery *title:* Rising
medium: Acrylics on panel *size:* 24"x36"

3 *artist:* **Omar Rayyan**
title: On the Road
medium: Watercolor *size:* 11"x14"

4 *artist:* **Yasmine Putri**
title: Fireworks
medium: Digital

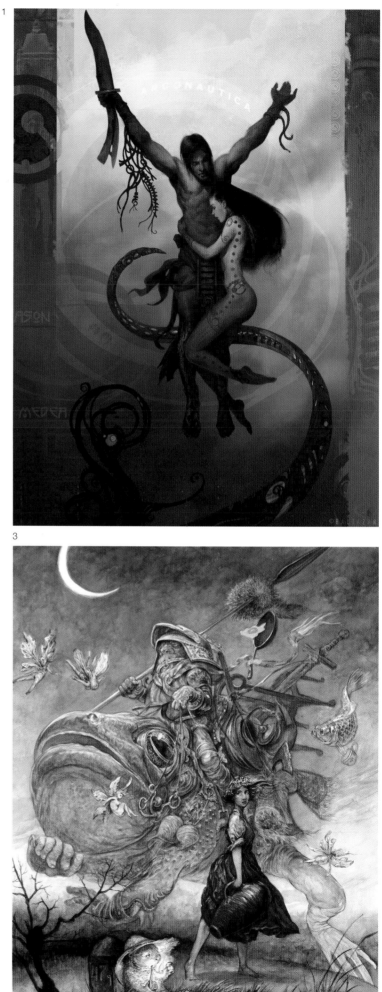

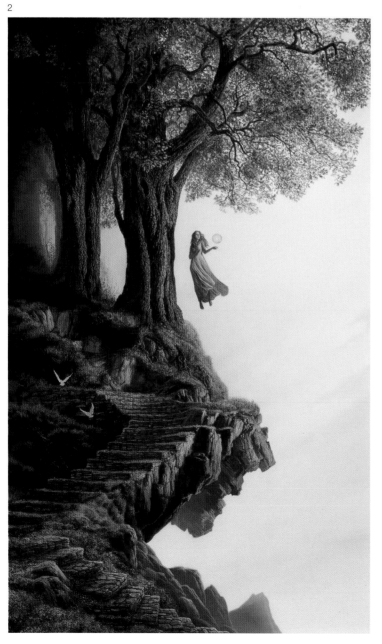

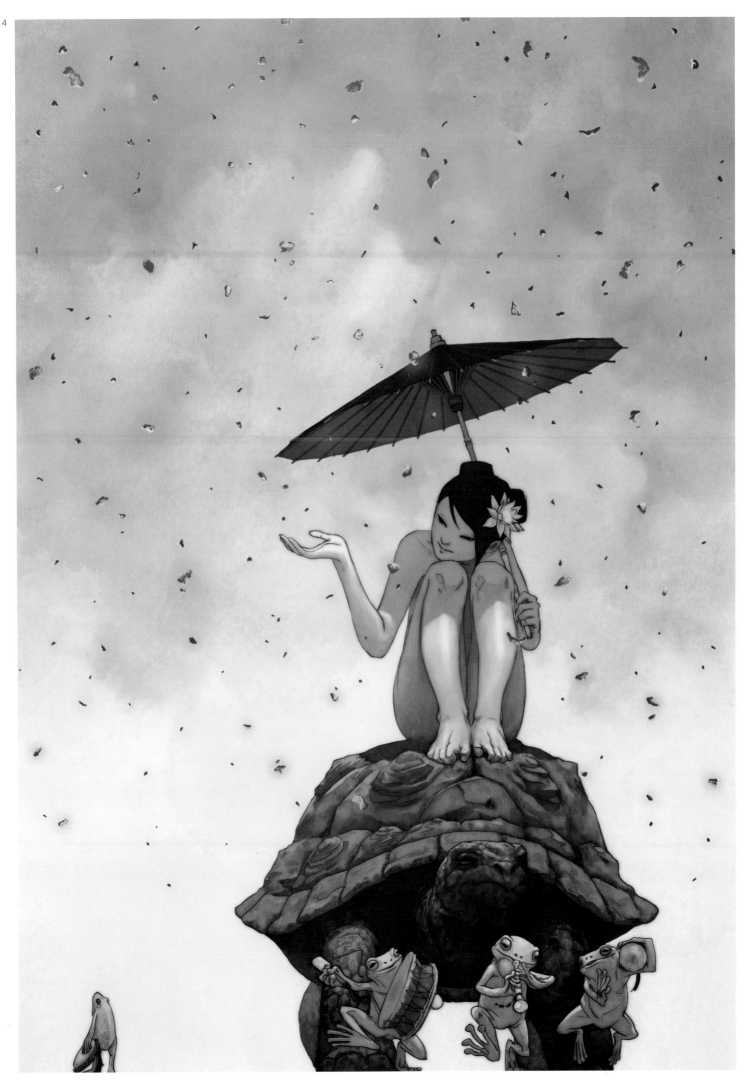

1
artist: **Jasmine Becket-Griffith**
title: Alchemy Angel
medium: Acrylics on wood
size: 24"x20"

2
artist: **James Paick**
art director: Philip Straub
title: Palace Entrance
medium: Photoshop
size: 5³/4"x10"

3
artist: **William Stout**
art director: Ted Mendenhall
designer: William Stout
client: Mendenhall Gallery
title: Happy Easter!
medium: Oil on canvas
size: 12"x24"

4
artist: **Jaime Zollars**
client: Copro Nason Gallery
title: Sunday Mourning
medium: Collage, acrylics
size: 8"x10"

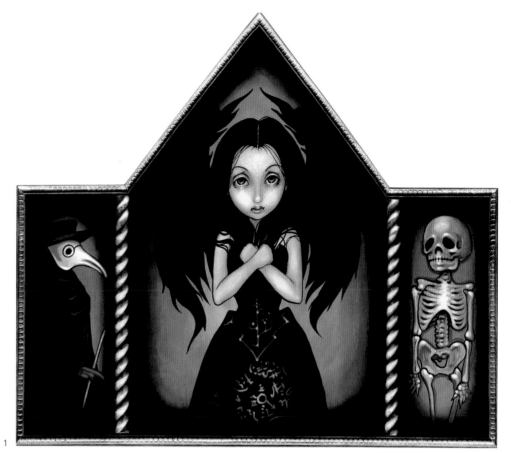

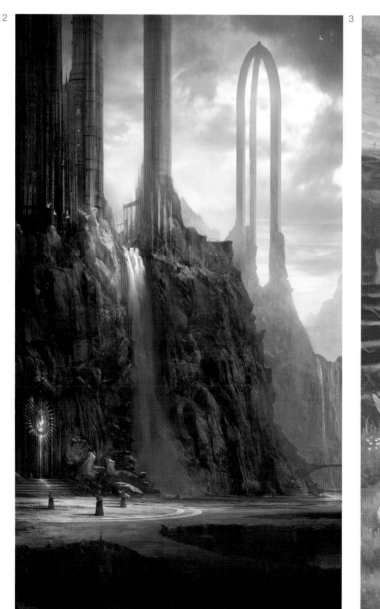

4

1
artist: Bob Pitt
title: Rolling Into Mecca
medium: Acrylics on canvas

2
artist: Brian Demeter
title: Foreshadow
medium: Acrylics on panel
size: 8½"x8"

3
artist: Stewart Mekissick
title: Monster and Telephone Pole
medium: Digital
size: 10"x13"

4
artist: Francis Vallejo
title: Underneath
medium: Digital
size: 11⅞"x17½"

5
artist: Jim Mahfood
colorist: Steve Struble
client: The Insects
title: The Insects
medium: Mixed
size: 9"x12"

6
artist: Aly Fell
title: Lucy Westenra
medium: Photoshop
size: 7⅞"x14¹⁵⁄₁₆"

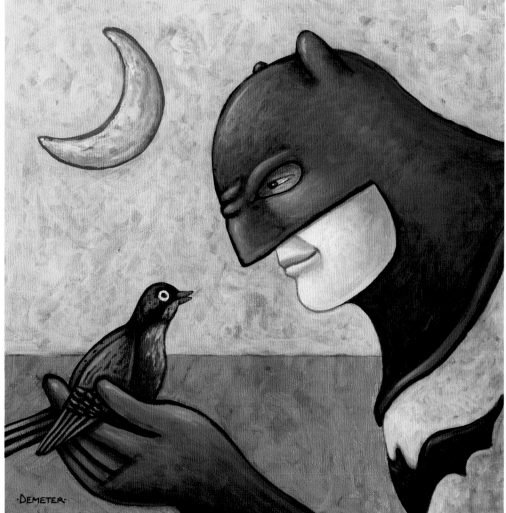

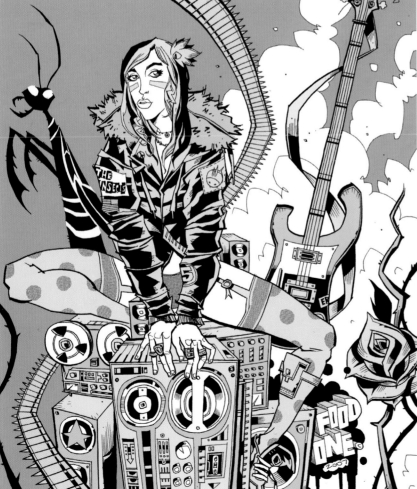

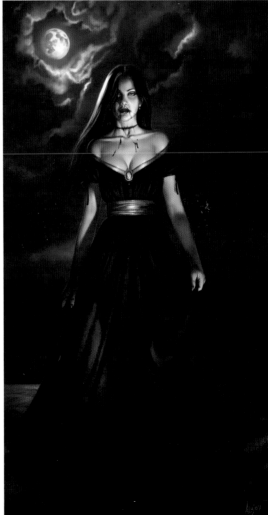

1
artist: **Robert Venosa**
client: Pomegranate Publishing
title: Martina
medium: Oil *size:* 26"x25"

2
artist: **Jessica Oyhenart**
client: ConceptArt.Org: Last Man Standing
title: Ophelia
medium: Digital *size:* 9"x17"

3
artist: **David Bowers**
title: It's Coming
medium: Oil on linen *size:* 16"x20"

4
artist: **David Bowers**
title: Mysteries of Medus
medium: Oil on linen *size:* 16"x22"

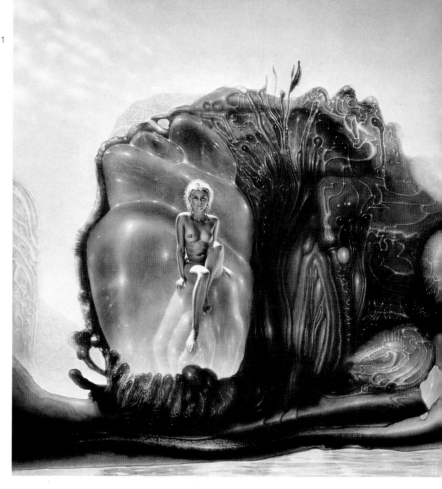

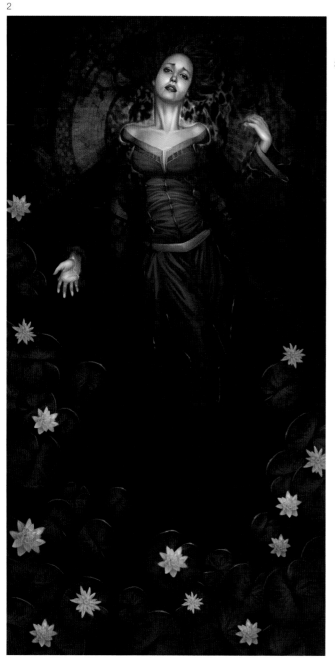

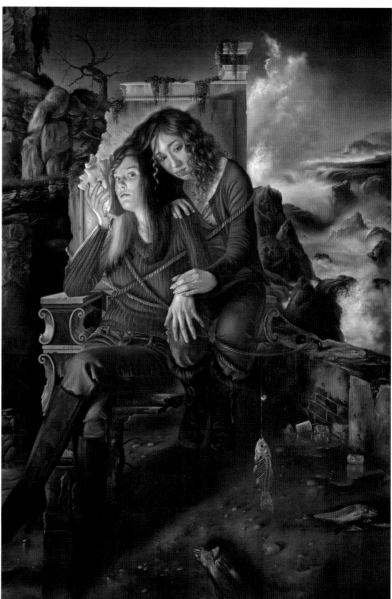

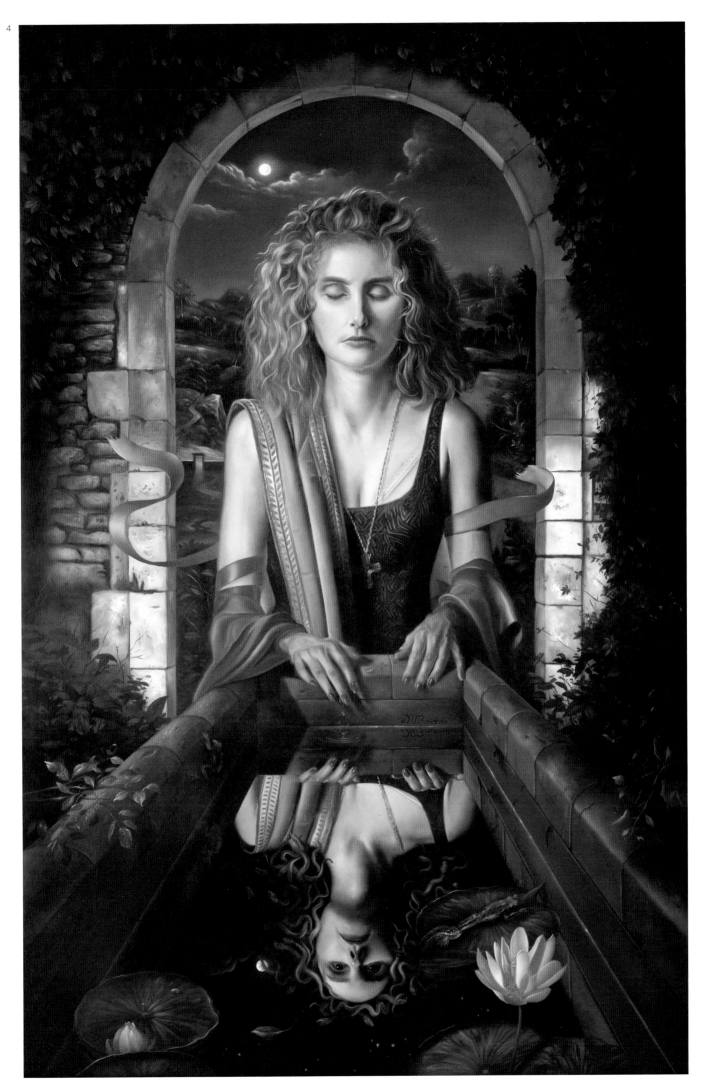

4

1 *artist:* Anita Kunz
title: Pieta 2
medium: Mixed *size:* 12"x19"

2 *artist:* Christian Alzmann
title: The Bogey Pool
medium: Mixed, digital *size:* 7"x16"

3 *artist:* Raoul Vitale
title: The Storm
medium: Oil on masonite *size:* 14³/₄"x22"

4 *artist:* Anita Kunz
title: Pieta 1
medium: Mixed *size:* 12"x19"

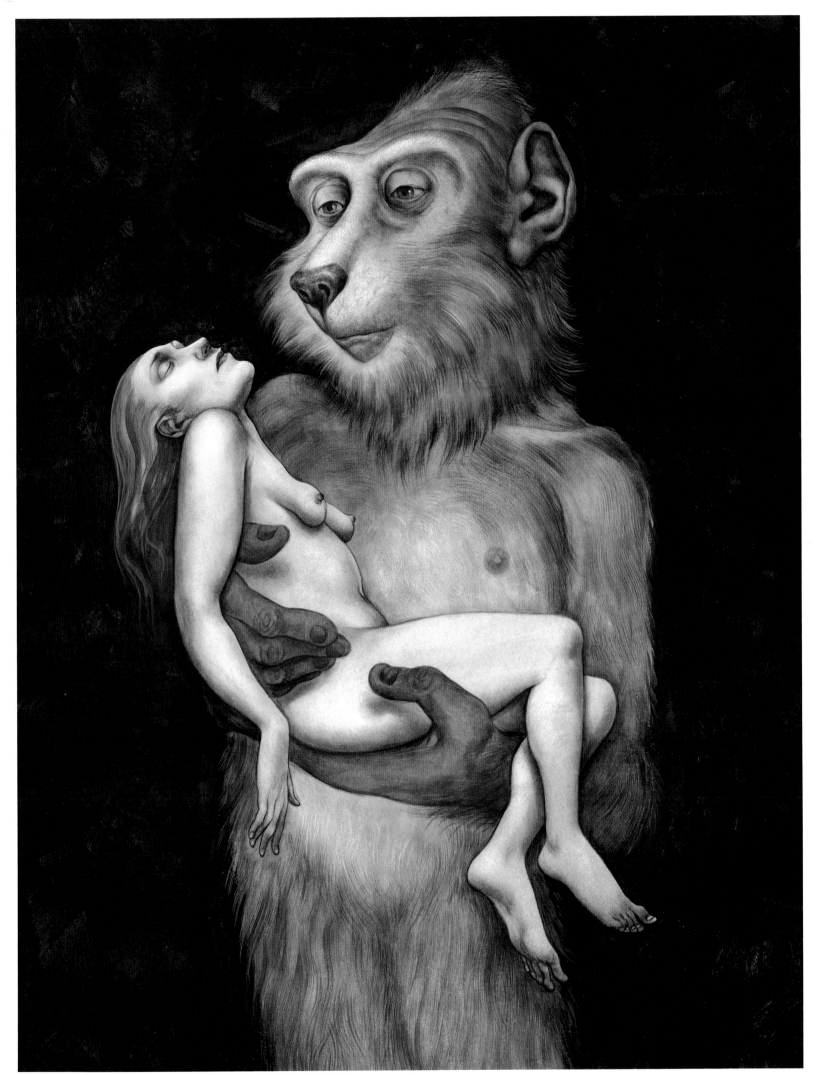

4

1 *artist:* Nic Klein
client: ConceptArt.Org *title:* Underneath It All
medium: Acrylics, digital

2 *artist:* Sean Chapman
art director: Joe Thiel
title: Tosca *medium:* Digital

3 *artist:* Sang Han
client: sanghanart.com *title:* The Faint Archer
medium: Digital *size:* 8¹/₂"x9¹/₂"

4 *artist:* Petar Meseldžija
client: Zmaj-Novi Sad
title: The Legend of Steel Bashaw 11
medium: Oil on masonite *size:* 23¹/₂"x31¹/₂"

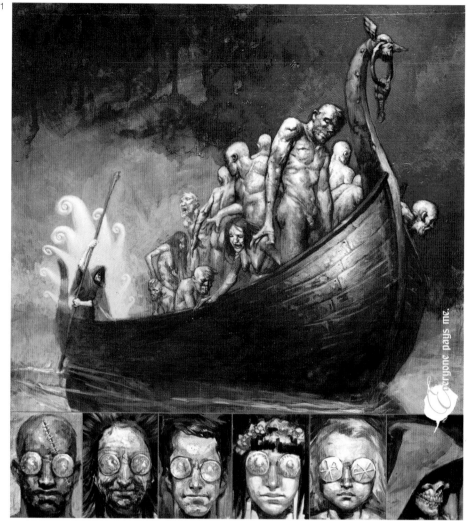

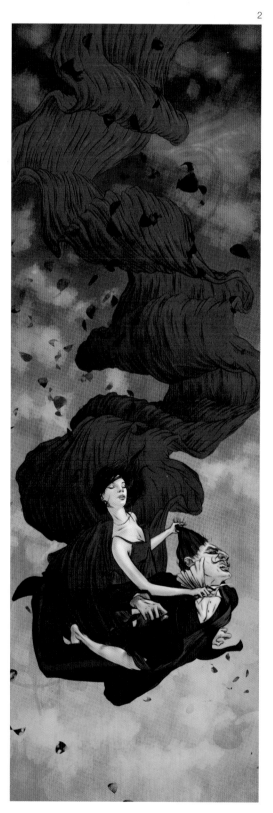

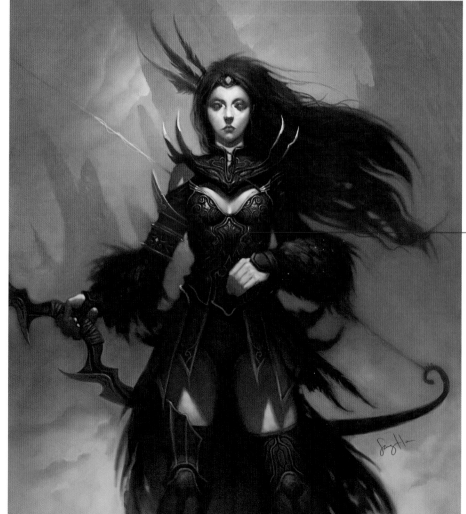

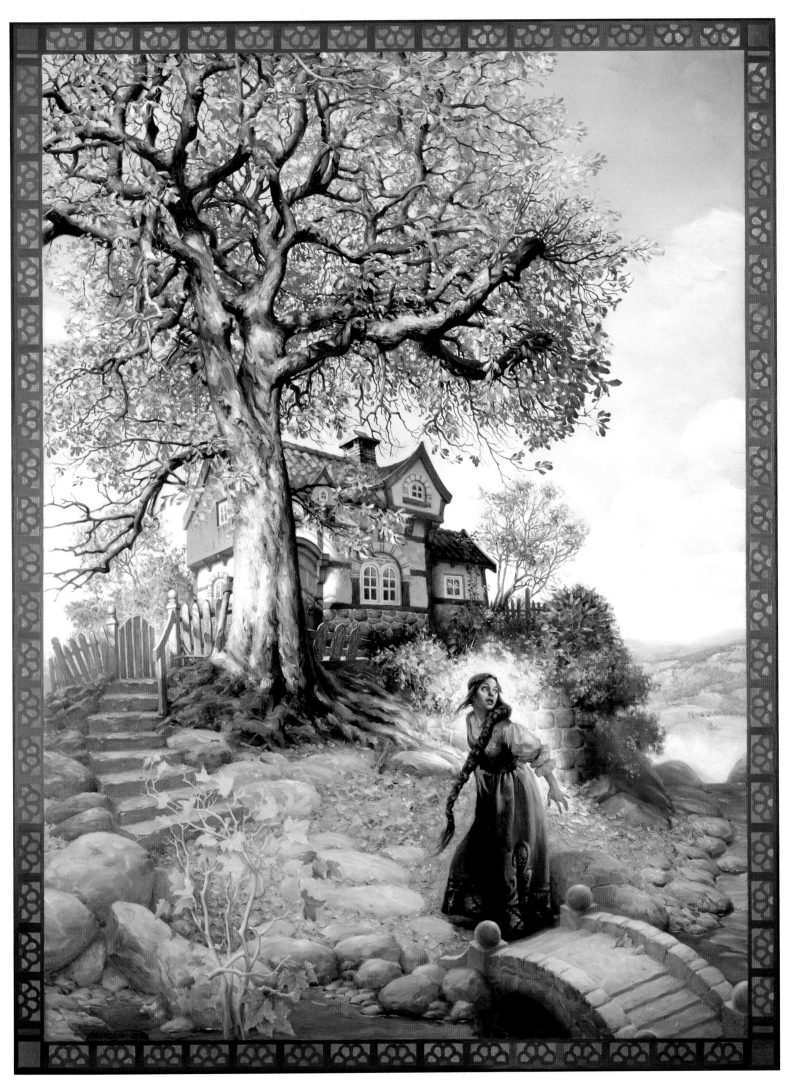

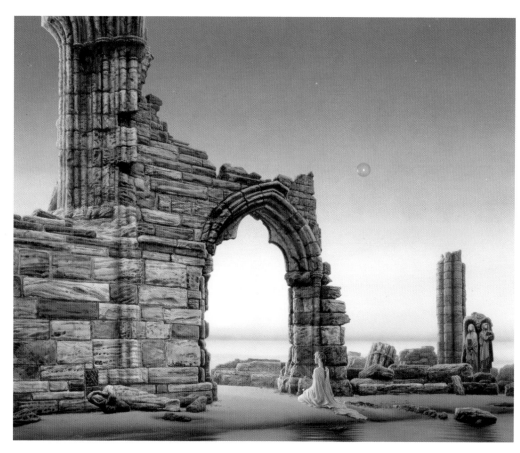

artist: **Michael Whelan**
client: *Tree's Place Gallery* *title:* Dawn's Passage *medium:* Acrylics on panel *size:* 36"x24"

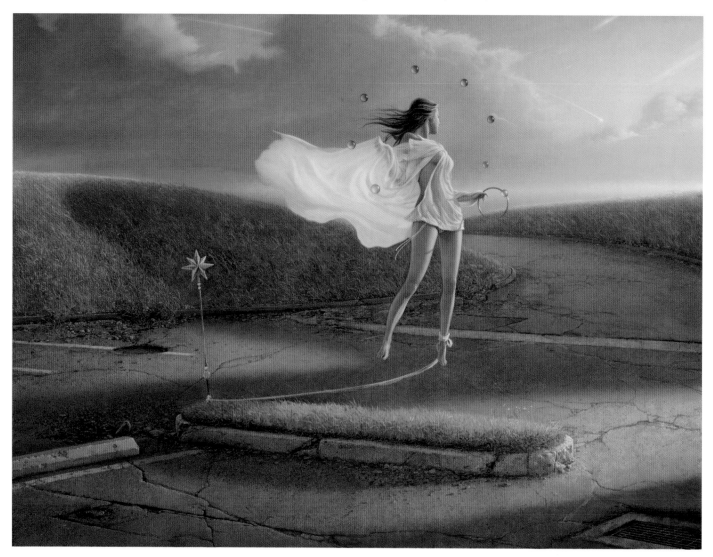

artist: **Michael Whelan**
client: Tree's Place Gallery *title:* Island #1 *medium:* Acrylics on panel *size:* 40"x30"

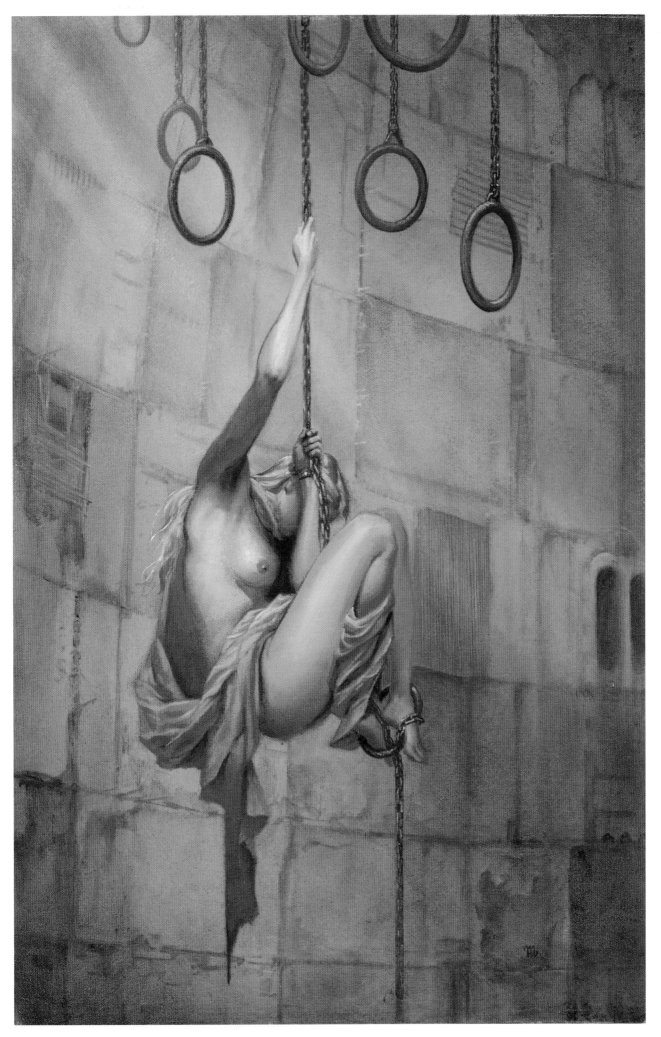

artist: **Michael Whelan**
title: Dependent *medium:* Oil on canvas *size:* 12"x18"

Chris Gibbs 63
c/o Alan Lynch Artists
116 Kelvin Pl
Ithaca, NY 14850
alan@alanlynchartists.com
www.alanlynchartists.com

Thomas A. Gieseke 206
7909 W 61st St
Merriam, KS 66202
913-677-4593
www.artbytom.com

Erik M. Gist 44, 48
760-633-1370
emgist@erikgist.com
www.erikgist.com

Michael Golden 104
PO Box 27
West Haven, CT 06516
213-931-8280
Evalnk@aol.com

Christian Gossett 100
11042 Camarillo St #9
North Hollywood, CA 91602
818-754-0802
christian.gossett@gmail.com

Lucas Graciano 44
675 Diamond Way #138
Vista, CA 92083
lucasgraciano@yahoo.com
www.lucasgraciano.com

Lars Grant-West 154, 237
133 Greenwood Ave
Seekonk, MA 02771
www.larsgrantwest.com

Igor Grechanyk 147
Vul Anishchyenka 14 Ap. 68
Kyiv 01010 UKRAINE
igor@grechanyk.kiev.ua
www.grechanyk.com

David Grove 82, 87
382 Union St
San Francisco, CA 94133
415-433-2100

Rebecca Guay 68
www.rebeccaguay.com

James Gurney 42, 190
PO Box 693
Rhinebeck, NY 12572
845-876-7746
jgurneyart@yahoo.com

Scott Gustafson 61, 79, 88
773-725-8338
scott@scottgustafson.com
www.scottgustafson.com

Brian Jon Haberlin 94
28411 Rancho de Linda
Laguna Niguel, CA 92677
haberlinstudios@aol.com
www.digitalarttutorials.com

Phil Hale 150
www.mockingbirdsrelaxeder.com

Sang Han 258
11825 Hunters Run Rd
Cockeysville, MD 21030
sang@sanghanart.com
http://sanghanart.com

Randy Hand 136
1421 Stover St
Fort Collins, CO 80524
970-214-2620
www.randyhand.com

John Harris 73
c/o Alan Lynch Artists
116 Kelvin Pl
Ithaca, NY 14850
alan@alanlynchartists.com
www.alanlynchartists.com

Kelley Ruth Harris 224
6780 Stornaway Dr
Memphis, TN 38119
gkruth@gmail.com
www.krhart.com

Arich Harrison 147
1075 Lighthouse Ave #120
Pacific Grove, CA 93950
arichstudio@yahoo.com
www.arichharrison.com

Mark Harrison 40
353 Ridgacre Road
West Midlands
Birmingham B32 1EH UK
www.2000ad.org/markus

Matthew Harrison 222
1343 Sacramento St Apt 1
San Francisco, CA 94109
mbharrison1@mbharrison1.com
www.mbharrison1.com

James Hawkins 118
7105 Capulin Crest Dr
Apex, NC 27539
www.hawkprey.com

Dehong He 124
87 Beach Road
#04-02, Singapore 189695
REPUBLIC OF SINGAPORE
www.hdhcg.com

Richard Hescox 235
PO Box 61701
Reno, NV 89508
triffid@charter.net
www.richardhescox.com

Woodrow J. Hinton III 152
4650 Glenway Ave
Cincinnati, OH 45238
(513) 225-4067
woodrow@cinci.rr.com

David Ho 80, 222
3586 Dickenson Common
Fremont, CA 94538
510-656-2468
ho@davidho.com

Brad Holland 59
www.bradholland.net

Jason Holley 154
www.jasonholley.com

Kuang Hong 228
www.zemotion.net/noah
noah@zemotion.net

Jessica Hook 209
PO Box 302705
Austin, TX 78703
jessica@jessicahook.com
www.JessicaHook.com

Daniel Robert Horne 143
900 Edgemoor Rd
Cherry Hill, NJ 08034
www.geocities.com/danielrhorne

Ralph Horsley 70
32 Parkside Crescent
Leeds L56 4JU UK
email@ralphhorsley.co.uk
www.ralphhorsley.co.uk

Joe Hoskins 230
4503 Watersedge Dr
Lee's Summit, MO 64064
blackwingbird.com

Kurt Huggins & Zelda Devon 151
419 Myrtle Ave #2D
Brooklyn, NY 11205
zelda@teeteringbulb.com
www.teeteringbulb.com

Adam Hughes 91, 108
P.O. Box 190823
Atlanta, GA 31119-0823
www.justsayah.com

Bagus Hutomo 214
131 East Coast Road #03-01
Singapore 428816
REPUBLIC OF SINGAPORE
zik_zag04@yahoo.co.uk
www.p0p5.deviantart.com

Akihito Ikeda 131, 147, 149
24303 Woolsey Canyon Rd #20
West Hills, CA 91034
panther3black@yahoo.co.jp

Mirko Ilic 156
www.mirkoilic.com

James Jean 21, 90, 183
www.jamesjean.com

Bruce Jensen 202
3939 47th St
Sunnyside, NY 11104
516-383 9221
bruce@brucejensen.com

Andrew Jones 35, 36, 112, 113
c/o Massive Black
842 Folsom St / 2nd Floor
San Francisco, CA 94107
512-771-6665
www.androidjones.com

Jaime Jones 124, 125
11818 97th Ln NE Apt C416
Kirkland, WA 98034
jaime@artpad.org
www.artpad.org

Patrick J. Jones 235
deanjo@pjartworks.com
www.pjartworks.com

Eric Joyner 246
111 New Montgomery St #401
San Francisco, CA 94105
415-305-3992
www.ericjoyner.com

Jason (Wei-Che) Juan 127
924 NE 174th St
Shoreline, WA 98155

Joe Jusko 76, 108
PO Box 1106
McMurray, PA 15317
www.joejusko.com

Lim Ri Kai 40
33 Sunbird Avenue
Singapore 487345
REPUBLIC OF SINGAPORE
kai@imaginaryfs.com
www.ukitakumuki.deviantart.com

Agata Kawa 60
25, boulevard du Lac
95880 Enghien-Les-Bains
FRANCE
www.agata-kawa.com

Jim & Ruth Keegan 64
fornobulax@aol.com

Ken Keirns 156
279 Santiago Ave
Redwood City, CA 94061
kencoart@yahoo.com
www.kenkeirns.com

McLean Kendree 221
3257 Wild Horse Dr
Conway, SC 29526
mclean311@juno.com
www.mcleannews.blogspot.com

Steven Kenny 240
3 Quail Roost Ln
Huntly, VA 22640
540-631-9026
www.stevenkenny.com

Tim Kirk 60
4030 Chestnut Ave
Long Beach, CA 90807
www.kirkdesigninc.com
tim@kirkdesigninc.com

Jonathan Kirtz 126
(703) 501-9962
jdkirtz@gmail.com

Nic Klein 26, 94, 107, 258
Murhardstrasse 15
34119 Kassel, GERMANY
0049 178 232 9889
me@nic-klein.com

Rich Klink 144
165 Fair St
Berea, OH 44017
440-826-4781
threeklinks@sbcglobal.net

Viktor Koen 153
310 E 23rd St / Suite 11J
New York, NY 10010
212-254-3159
www.viktorkoen.com

Michael Komarck 84
118 Deer Path Ln
Battle Creek, MI 49015
269-964-0593
mkomarck@comcast.net

Robert Kondo 238
23 Home Place West
Oakland, CA 94610
626-274-9771

Karl Kopinski 72
57 Bourne Street
Netherfield
Nottingham N94 2FJ UK
karl@karlkopinski.com
www.karlkopinski.com

Kekai Kotaki 114, 122, 123
901 Taylor Ave N Apt 202
Seattle, WA 98109

Joe Kovach 161
6733 Lower Brook Way
New Albany, OH 43054
(614) 746-7599
www.joekovach.com

Vance J. Kovacs 62, 210, 231
7072 Cedar Creek Rd
Corona, CA 92880
951-272-0911
vance@vancekovacs.com

Andrea Kowch 225
c/o Dave Chow/CCS Illustration Dept.
201 E Kirby
Detroit, MI 48202

Thomas S. Kuebler 136, 137
520 Campground Rd
Selma, NC 27576
919-965-3130
www.tskuebler.com

Anita Kunz 156, 256, 257
218 Ontario St
Toronto ON M5A 2V5 CANADA
416-364-3846
www.anitakunz.com

Thierry Labrosse 226
6502A Louis-Hebert Ave
Montreal QC H2G 2G7 CANADA
www.thierrylabrosse.com

Raphael Lacoste 120, 215
4402 De Bordeaux St
Montreal QC H2H 1Z7 CANADA
www.raphael-lacoste.com

Stephen Lambert 135
114 Pembroke Rd
Northland
Wellington 6012 NZ
steve@scoobasteve.co.nz
www.scoobasteve.co.nz

Miguel Lantigua 225
864 41st St
Sarasota, FL 24234
mail@whoisglue.com
www.whoisglue.com

Stanley "Artgerm" Lau 159, 186
131 East Coast Road #02-01
Singapore 428816
REPUBLIC OF SINGAPORE
stanley@imaginaryfs.com
www.imaginaryfs.com

Sacha Lees 205
136 Hill Road
Belmont
Lower Hutt 5010 NZ
sacha@sachalees.com
www.sachalees.com

David Leri 162, 163
6050 Sunlawn Dr
Westerville, OH 43081
daveleri@aol.com
http:// www.daveleri.com

Kendrick Lim 121
131 East Coast Road #02-01
Singapore 428816
REPUBLIC OF SINGAPORE
kendrick@imaginaryfs.com
www.imaginaryfs.com

Frank Lin 240
705 Midcrest Way
El Cerrito, CA 94530
contact@ftongl.com
www.ftongl.com

Paul Linsley 208

Wayne Lo 27
(w Andrea Blasich, David LeMerrer)
c/o Factor5 Art Dept.
4046 Ashbrook Cr
San Jose, CA 95124
waynelo.art@gmail.com
www.wayneloart.com

Todd Lockwood 69, 191
20523 125th St Ct E
Bonney Lake, WA 98391
todd@toddlockwood.com
www.toddlockwood.com

Howard Lyon 68
www.howardlyon.com

Larry MacDougall 165
38 Jenny Ct
Stoney Creek ON L8G 4N8
CANADA
905-662-7747
underhillstudio@cogeco.ca

David Mack 100
c/o Allen Spiegel Fine Arts
221 Lobos Ave.
Pacific Grove, CA 93950
831-372-4672
asfa@redshift.com

Jim Mahfood 253
c/o Allen Spiegel Fine Arts
221 Lobos Ave.
Pacific Grove, CA 93950
831-372-4672
asfa@redshift.com

Emmanuel Malin 118, 162, 222
5, rue Leon Dierx
75015 Paris, FRANCE
emmanuel.bastid@hotmail.com
www.emmanuelmalin.com

John Malloy 158
3444 Elm Ave
Baltimore, MD 21211
johnfusion19@gmail.com
www.johnmalloy.net

Gregory Manchess 168, 172
15234 SW Teal Blvd #D
Beaverton, OR 97007
manchess@mac.com
www.manchess.com

Julie Mansergh 143
P.O. Box 6538
Santa Rosa, CA 95406
707-481-7212
julie@faeriesintheattic.com

Giuseppe Manunta 108
Via Leonardo Murialdo 32
00041 Albano Laziale RM ITALY
info@giunchiglia.it
www.giunchiglia.it

Meghan Martin 240
265 Staples Ave
San Jose, CA 95127
meghan@meghanmartin.net
www.meghanmartin.net

Stephan Martiniere 39, 54, 73, 84
754 William St
River Forest, IL 60305
martiniere@comcast.net
www.martiniere.com

KD Matheson 132
8555 Russell Rd #2019
Las Vegas, NV 89113
702-241-2561
kdmatheson@cox.net

Kouei Matsumoto 139

Mike Mayhew 96
121 West Lexington Dr / Suite 242
Glendale, CA 91203
www.mikemayhewstudio.com

Dave McKean 30, 245
c/o Allen Spiegel Fine Arts
221 Lobos Ave.
Pacific Grove, CA 93950
831-372-4672
asfa@redshift.com

Stewart McKissick 253
2500 Edington Rd
Columbus, OH 43221
sam33@aol.com
www.stewartmckissick.com

David Meng 132, 133, 134
PO Box 15250
Miramar
Wellington 6243 NZ
davidmeng_2000@yahoo.com

Petar Meseldzija 54, 259
Kogerwatering 49
1541 XB Koog a/d Zaan
NETHERLANDS
petarmeseldzija@planet.nl
www.petarmeseldzijaart.com

Rene Milot 29
49 Thorncliffe Park Dr / Suite 1604
Toronto ON M4H 1J6 CANADA
www.renemilot.com

Ian Miller 214
c/o Jane Frank
Worlds of Wonder
PO Box 814
McLean, VA 22101
www.mikemayhewstudio.com

Jeff Miracola 160
3846 S 37th St
Greenfield, WI 53221
www.jeffmiracola.com

Jeremy D. Mohler 84
5530 NW 25th St
Topeka, KS 66618
jer@jeremymohler.com
www.jeremymohler.com

Lee Moyer 234
7432 N Kellogg St
Portland, OR 97203
503-737-3344
www.leemoyer.com

Sho Murase 94
c/o Maverix Studios
1717 17th St #108
San Francisco, CA 94103
sho@shomurase.com
www.shomurase.com/

Jim Murray 177, 188, 195
143 B Elm Ave
Beaconsfield, QC H9W 2E1
CANADA

Sean "Muttonhead" Murray 173
78 Mountain View Ave
Kingston, NY 12401
sean@seanandrewmurray.com
www.seanandrewmurray.com

Mark Nagata 132
1948 Leavenworth St
San Francisco, CA 94133
www.marknagata.com

Mark A. Nelson 170, 173
3738 Coachman Way
Cross Plains, WI 53528
gdpmark@chorus.net
www.grazingdinosaurpress.com

Hoang Nguyen 24
2202 Duvall Ct
Santa Clara, CA 95054
hoang@liquidbrush.com
www.liquidbrush.com

Terese Nielsen 178
9661 Las Tunas Dr Suite C
Temple City, CA 91780
626-286-5200
artist@hiddenkingdom.com

Lawrence Northey 134
1574 Gulf Road
Point Roberts, WA 98281
lawrence@robotart.net
www.robotart.net

Ben Olson 98
sketchthing@gmail.com
www.sketchthing.com

Glen Orbik 66
www.orbikart.com
glenandlaurel@earthlink.net

Daniela Ovtcharov 217
1113 Westerfield Dr
Albuquerque, NM 87112
www.ovtcharovart.com
daniela64@msn.com

Painting by Joe DeVito / www.jdevito.com

Artists, art directors, and publishers interested in receiving
information for the SPECTRUM 16 competition should send their
name and address to:

Spectrum Design
P.O. Box 4422, Overland Park, KS 66204
or visit our website: www.spectrumfantasticart.com

Painting by Paul Bonner